SILENT WITNESS

OSPREY
PUBLISHING

DEDICATION

To my wife, Jane, for her understanding and patience,
helpful advice and steadfast support.

SILENT WITNESS

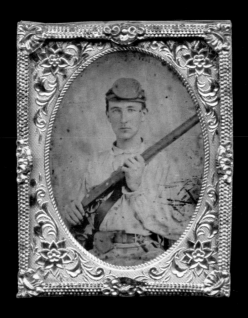

THE CIVIL WAR

THROUGH PHOTOGRAPHY AND ITS PHOTOGRAPHERS

RON FIELD

Osprey Publishing
c/o Bloomsbury Publishing Plc
PO Box 883, Oxford, OX1 9PL, UK
Or
c/o Bloomsbury Publishing Inc.
1385 Broadway, 5th Floor, New York, NY 10018, USA
E-mail: info@ospreypublishing.com
www.ospreypublishing.com

OSPREY is a trademark of Osprey Publishing Ltd, a division of Bloomsbury Publishing Plc.

First published in Great Britain in 2017

ISBN: HB: 978 1 4728 2276 5
 ePub: 978 1 4728 2277 2
 ePDF: 978 1 4728 2278 9
 XML: 978 1 4728 2279 6

17 18 19 20 21 10 9 8 7 6 5 4 3 2 1

Index by Zoe Ross
Typeset in Adobe Garamond and Walbaum
Originated by PDQ Digital Media Solutions, Bungay, UK
Printed in China through C & C Offset Printing Co., Ltd.

To find out more about our authors and books visit www.ospreypublishing.com. Here you will find extracts, author interviews, details of forthcoming events and the option to sign up for our newsletter.

Osprey Publishing supports the Woodland Trust, the UK's leading woodland conservation charity. Between 2014 and 2018 our donations are being spent on their Centenary Woods project in the UK.

CONTENTS

ACKNOWLEDGMENTS

The author is greatly indebted to Bob Zeller, President of the Center for Civil War Photography, for support and advice in the preparation of this study. Others who provided invaluable help include Carol Johnson, Curator of Photography, Library of Congress, Prints and Photographs Division, Washington, DC; Josephine Cobb, Chief of the Still Photo section at the National Archives, Washington, DC; Erin Beasley, Digital Image Rights & Reproduction Specialist, National Portrait Gallery, Smithsonian Institution, Washington, DC; Kelly Kerney, Curator of Archives, Valentine Richmond History Center, Cook Collection; Patricia M. Boulos, Boston Athenæum, Boston, Massachusetts; Christopher Morton, Assistant Curator, New York State Military Museum, and Jim Gandy, Librarian/Archivist, New York State Military Museum, Saratoga Springs, New York; Germain Bienvenu, Special Collections Public Services, Louisiana State University Libraries, Baton Rouge, Louisiana; Malia Ebel, Reference Librarian/Archivist, New Hampshire Historical Society; Nathan Pendlebury, Image Reproduction Administrator, Photography, National Museums Liverpool, UK; Dr. David Bush, Director of The Center for Historic and Military Archaeology, Ohio; The Friends and Descendants of the Johnson's Island Civil War Prison Site; Bill Griffing, Spared & Shared website; Jennifer Ericson, Assistant Curator, Abraham Lincoln Presidential Library, Springfield, Illinois; Peter Harrington, Curator, Anne S. K. Brown Collection, Brown University, Rhode Island; Tom Liljenquist, Michael J. McAfee, Dan Miller, Jeffrey Kraus, John O'Brien, George S. Whiteley IV, Craig Heberton IV, Steve Woolf, Mike Medhurst, David Wynn Vaughan, John Beckendorf, Mark Dunkleman, Ronald S. Coddington, Dan Binder, Bryan Watson, Dan and Brandy Schwab, Matthew Oswalt, Dr. James W. Milgram, Neill Rose, Peter Searle, Terry Burnett, David Quattlebaum, Francois Xavier Prevet, and Dominic Serrano.

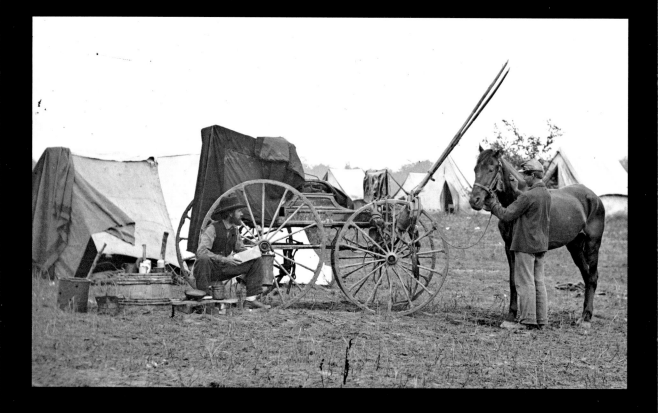

Battlefield photographer David B. Woodbury holds a full-plate sized
piece of photograph glass as he sits by his wagon in a Union army
campsite near Cold Harbor, Virginia, in 1864. An assistant for
ambrotypist Edward Whitney, at Fairfield, Connecticut, before the
Civil War, he was working for Matthew Brady when this photograph
was produced. (Library of Congress)

INTRODUCTION

A silent witness to history, the Civil War photographer has left a treasure trove of images providing an invaluable record of the dramatic events that helped to shape the American nation. The albumen prints produced by these intrepid individuals under extraordinarily difficult circumstances on battlefields such as Manassas, Antietam and Gettysburg encapsulate the tragedy of war. In small cased images or in *cartes de visite*, they also preserved the pride, determination and courage of the individual soldier as he left home for the war or struggled with adversity in camp or on campaign. In 1882, veteran cameraman and artist Andrew J. Russell wrote one of the most fitting dedications to the battlefield photographer who left the comfort of the studio and gallery to follow the armies in the field to record victory and defeat:

> The memories of our great war come down to us and will pass on to future generations with more accuracy and more truth-telling illustration than that of any previous struggle of ancient or modern times; and the world is indebted to the photographic art and a few enterprising and earnest men, who were not backward in furnishing means, and to a score or less of daring workers – men not afraid of exposure and who could laugh at fatigue and starvation, could face danger in odd shapes, and were at all times ready to march, often between the two armies, in the trenches, on the ramparts, through the swamps and forests, with the advance guard, and back again at headquarters – not a flank movement, but the willing and indefatigable artist at his post of danger and adventure.[1]

Although few in number, the likes of George N. Barnard, Alexander Gardner and David B. Woodbury created the first extensive photographic record of war, often arriving in their flimsy wagons within hours of the last shot of the battle being fired. Beyond the battlefield photographers working for Matthew Brady and Edward and Henry T. Anthony, there

existed countless "daguerrean artists," "ambrotypists," and "photographists" who operated in small attic galleries in virtually every city and town throughout the Union. A similar situation existed in the Confederacy, but to a lesser extent during the Civil War years as the Union naval blockade increased in efficiency and prevented essential chemicals, paper and other supplies from reaching their destination. Before the war many photographers North and South hit the road during the summer months in "cars," or wagons, carrying portable dark rooms. Traveling from town to town, they set up their studios wherever there was sufficient custom for their art. When the war began these adventurous entrepreneurial souls took readily to the idea of setting themselves up in cabins and tented galleries in the thousands of military encampments established in 1861.

As with the many daguerreotypists of the 1840s and 1850s who were portrait painters and "drawing masters" before they took to photography, so the Civil War photographer was talented in other art forms such as painting, engraving, music, or writing. Andrew Russell painted panoramas as well as flags in 1861. Henry P. Moore was an engraver, fine singer and banjo player, and would entertain the New Hampshire men around the camp fire during his visits to Port Royal, South Carolina, in 1861 and 1862. William D. McPherson was an accomplished flautist and singer and charmed audiences in the Phoenix Hall in Concord, New Hampshire, before the war. No doubt countless other Civil War photographers possessed similar additional talents which have gone unrecorded.

A surprising number of antebellum photographers enlisted in the ranks of either the Union or Confederate armies during the war. This was particularly the case in the South, where a growing shortage of man-power, the threat of the invader on their doorsteps, and a lack of photographic supplies meant that artists such as George S. Cook and C. J. Quinby in South Carolina, Charles R. Rees and Nathaniel Routzahn in Virginia, and Gustave and Bernard Moses in Louisiana volunteered to join the ranks, albeit for a short period of time in most cases. In the North, "enlisting artists" such as William C. Cady of Albany, New York, and William B. Roper of Curllsville, Pennsylvania, tragically did not survive the conflict for very different reasons. The soldier turned photographer also seems to have been more the case in the North, as Captain Andrew Russell began his classic work for the United States Military Railroad in 1862, and Private William Frank Browne became an army photographer in 1863.

Because of the chemicals required for the "art," photographic galleries were often situated above or near a chemist shop. Some photographers, such as Ira C. Feather, who established a gallery in 1862 at Union-occupied Port Royal on the South Carolina coast, were chemists in their own right. Others often advertised that they prepared their own chemicals, which probably indicated to prospective customers that costs were reduced. Being constantly exposed to dangerous chemicals, photographers and their assistants occasionally suffered as a result. In 1859, Edward T. Whitney was forced to close his gallery in Rochester, New York, having succumbed to cyanide poisoning. The inflammable nature of the chemicals meant photographers' premises were vulnerable to fire. Indeed in 1856, Anthony's chemical factory at the Harlem Railroad Depot in New York City was destroyed by fire. On a smaller scale during the Civil War years, a bottle of collodion was accidentally dropped in the chemical room of the gallery owned by Case & Getchell in Boston, Massachusetts, on March 1, 1864, and the fumes caused a fire that seriously burned the face and hands of several operators. The "Photographic Rooms" of the Moore Brothers, in Springfield, Massachusetts, caught fire during the same year, destroying about 15,000 wet-collodion negatives.[2]

As traveling "artists" set up tented galleries in virtually every Union army camp within months of the beginning of the war, the Federal government saw this as another source of revenue to help pay for the war effort. As a result, by October 1862 all photographers were required to apply for a license to operate their studios within specific brigades, divisions and corps of the army. Hence, even the likes of Matthew Brady and his assistants presumably had to pay for the privilege of having a camera at the headquarters of General Ulysses S. Grant at City Point in 1865. On April 24, 1863, a tax act passed by the Confederate government required all photographers to pay $50 plus 2½ percent of the gross amount of sales made in a year. However, monies collected must have been small, with few photographers working in the South by that time.[3]

Out of necessity, some of the more determined photographers operating in the Confederacy, such as W. J. McCormack in Tennessee, were prepared personally to smuggle essential supplies from the North through enemy lines in order to carry on their work. Georgia-based Andrew J. Riddle was twice arrested by the Federal army provost guard for such activity but persisted until successful. In Virginia, Nathaniel Routzahn would probably

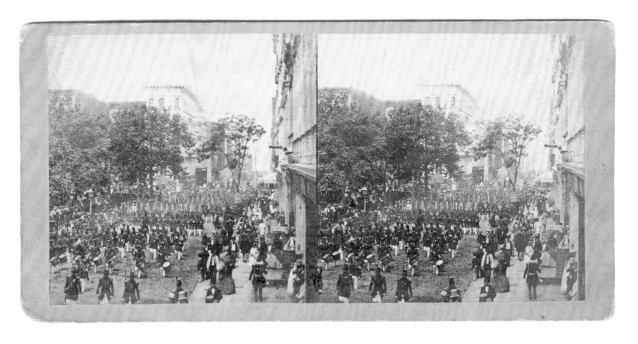

A regiment of New York State militia, plus regimental band, march along Chambers Street in Manhattan during the Fourth of July Parade in 1860. Many of the militiamen marching by the stereoscopic camera of the Anthony brothers that day would be defending the Union, and in some cases dying for it, in about ten months' time. (Author's collection)

not have produced the classic images of General Thomas "Stonewall" Jackson in November 1862 had he not "run the blockade" through Northern lines. Photographers in the South caught up in Union occupation manifested differing attitudes toward the invading armies. Known as "the camera-spy of the Confederacy," Andrew D. Lytle photographed the Union encampments and gunboats at Baton Rouge, Louisiana, and is believed to have passed valuable visual intelligence to Confederate authorities. Others, such as Jesse L. Cowling at New Bern, North Carolina, were happy to have Union as opposed to Confederate soldiers in front of their cameras.

The shortage of accurate and up-to-date maps caused the military in both North and South to employ photographers such as George N. Barnard

and Richard S. Sanxay to reproduce multiple copies of maps in various photographic forms for use by field commanders. Similarly, important documents and orders were photographed for widespread distribution, and the reproduction of the "Dahlgren" letter by the latter artist in June 1864 had dire repercussions during the days after the surrender of the Army of Northern Virginia on April 9, 1865.

Much of this story has been painstakingly gleaned from unpublished soldiers' diaries and letters, plus the newspapers of the day. In particular, the latter is a resource hitherto not fully considered. The thousands of daily and weekly journals often reported, or mentioned briefly, the activities of photographers both North and South. Advertisements in these newspapers provided detail of photographic studios with exotic names such as the "Temple of Fine Art" or "Excelsior Sky-Light Gallery." Soldiers' letters submitted for publication in their news columns also occasionally supplied gems of information concerning visits to galleries or the activities of photographers in military camps.

The images created by these intrepid "artists" of the camera, explored in the pages that follow, were produced by four photographic processes: the daguerreotype, ambrotype, melainotype or ferrotype (also known as the tintype), and wet plate collodion glass negative from which positive albumen prints could be made. In order to provide a greater understanding of the challenges and difficulties faced by the Civil War photographer in producing these beautiful time capsules of history, a brief explanation of each process follows.

Named after Frenchman Louis Jacques Mandé Daguerre, and invented by 1839, the daguerreotype was a unique, one-off reversed image produced on a polished sheet of silver-plated copper made light-sensitive by a combination of bromine and chlorine fumes. When exposed to light in the camera, the resulting "latent image" left on the plate was made visible by fuming it with mercury vapor. Any further sensitivity to light was removed by liquid chemical treatment, following which it was rinsed and dried, and sealed behind a protective brass mat and glass cover in a case. A painstaking process, this method was outdated by 1861 due to the widespread introduction of cheaper types of photography, and by the eve of the Civil War photographic artists were more likely to offer to copy old daguerreotypes into *cartes de visite*, ambrotypes or tintypes.[4] Nonetheless, leading studios such as Matthew Brady's Gallery in New York City,

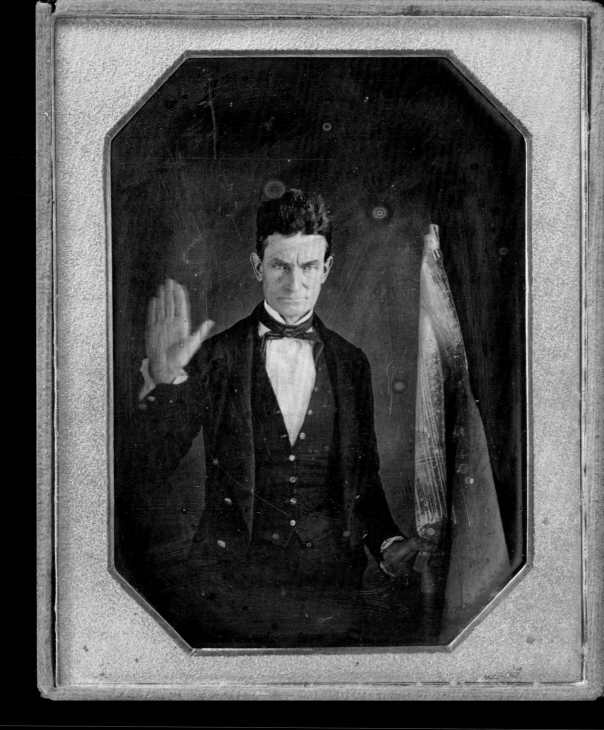

(Left) African American photographer Augustus Washington produced one of the most significant daguerreotypes of the antebellum period. Abolitionist John Brown posed for this image *circa* 1846–47 at the "Washington Daguerreian Gallery" in Hartford, Connecticut. Making an oath to support the cause of abolitionism, Brown was probably told by Washington to raise his left hand instead of his right to compensate for the reversed effect of the daguerreotype process. In his other hand Brown holds what is believed to be the flag of the "Subterranean Pass Way," which was a 2,000-mile-long secret escape route for slaves also later known as the "Underground Railroad."
(Smithsonian Institute)

(Below) Published in the *Connecticut Courant* of October 8, 1852, this advertisement for the Gallery operated by Augustus Washington is accompanied an engraving showing "the world" having its picture taken at his studio. (Author's collection)

WASHINGTON DAGUERREIAN GALLERY,
NO. 136 MAIN STREET,
(A few doors North of the Centre Church.)
WASHINGTON is at home, and daily executing beautiful and correct Miniatures, equal to any in this country, at his uncommonly cheap prices.
oct 8 12d 4w77

Manchester & Brothers in Providence, Rhode Island, and R. L. Wood at Macon, Georgia, still seem to have been offering to produce daguerreotypes as well as other forms of the art.[5]

In 1851, Englishman Frederick Scott Archer invented the wet collodion process that was so essential to the photographic revolution going on during the Civil War period. Collodion consisted of a mixture of gun cotton, alcohol, ether and potassium iodide, which produced a negative image on a glass plate when exposed to the light in a camera. A positive albumen print could then be produced from the negative. Within a few years, collodion could also be used to create a direct positive image on glass, called an ambrotype, or on metal as a tintype.

Invented in 1851, the ambrotype, also known as a collodion positive in Britain, was named from the Greek for "immortal impression." Apart from being a cheaper and quicker form of photography, the glass image was in reverse like the daguerreotype, but could be turned the correct way round and made positive by placing it against a backing, either in the form of a black velvet cloth or a black painted metal plate. Some "ambrotypists" applied black

Depicted in this sixth-plate ambrotype on magenta-colored glass, this militiaman wears the elaborate uniform of the Black Hussars. Although Black Hussars existed in Philadelphia, Chicago, and San Francisco before the Civil War, this is the only known image of a member of one of these mounted militia companies. (Author's collection)

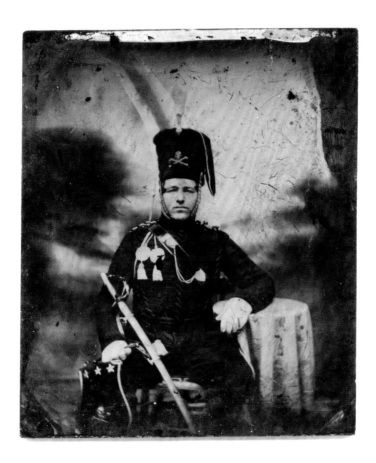

paint to the back of the glass, which eliminated this possibility if they did not turn it before the paint was applied. By 1854 ambrotypes could be made using ruby, magenta, blue or dark green colored glass, which eliminated the need for black backing but meant the image could only be viewed in reverse. Making a wet-plate collodion ambrotype required a series of steps from coating to developing that had to be completed within ten minutes before the plate dried.

Ambrotypes first came into use in the US during the early 1850s. In 1854, James Ambrose Cutting of Boston took out three patents relating to the improvement of the process, and may have been responsible for coining the term "ambrotype." Opening his first gallery in Chelsea, Vermont, in August 1855, future soldier and battlefield photographer William D. McPherson stated that "Cutting's Ambrotypes" were "Beautiful and Never-Changing Pictures" that worked in "less than one fourth the time of the quickest Daguerreotype process." However, this new form of photography was slow to replace the daguerreotype. Recalling when he opened a small gallery in Syracuse, New York, in 1857, Jacob F. "Jay" Coonley commented that the ambrotype was still considered fairly "new at that time."[6]

The melainotype or ferrotype, also known as the tintype, began to supersede the ambrotype during the late 1850s. Invented in 1853 by French academic Dr. Adolphe-Alexandre Martin, the process was patented in the US by Professor Hamilton L. Smith, but not until 1857. Dr. Martin originally used the collodion process to produce a direct positive image on a black varnished, or "japanned," metal plate as an aid to picture engravers who worked on copper and steel. In collaboration with Peter Neff, Jr., Professor Smith developed the idea further for use in photography and patented it on February 19, 1856. He subsequently awarded the patent to Neff, who manufactured the plates which were called "melainotypes" after the Greek word *melas*, meaning black. A similar idea of producing japanned metal plates for photography was developed by Victor Griswold, who called his plates "ferrotypes," after the Latin for *ferrum*, meaning iron. Cheaper to produce, the melainotype and ferrotype became very popular during the Civil War period. Unlike ambrotypes, they could not be reversed to produce a positive image, which caused many Civil War soldiers to compensate for this by wearing their equipment on the wrong side. Tintypes were also unbreakable and very light in weight. Thus, thousands of soldiers and sailors were able to send their portraits in this format through the mail to their loved ones at home.

(Right) Photographed on a sixth-plate melainotype plate made by Peter Neff, Jr., this unidentified Pennsylvania militiaman wears an unusual fringed frock coat. Neff worked in galleries in Cincinnati, Ohio, in the mid-1850s, and opened his own studio and factory to make photographic plates in 1856. Civil War-period images on Neff plates are rare as he went out of business in 1860. Impressed on the top edge of this image is "Neff's Pat 19 Feb 56". (Author's collection)

The first practical negative-positive photographic process was invented in 1839 by Englishman William Henry Fox Talbot. Named the talbotype, or calotype, a word derived from the Greek *kalos*, meaning "beautiful," this process involved treating a sheet of good-quality paper with light-sensitive silver compounds before exposure in a camera. The latent image thus produced was a translucent original negative image from which multiple positive copies called salt prints could be made. But this process produced a very soft photograph compared to the crisp daguerreotype image. Thus portraits could not be made easily with this method.

The albumen print, also called albumen silver print, was invented in January 1847 by Louis Désiré Blanquart-Evrard, and became the first commercially produced photographic print on paper from a glass negative. This process involved floating paper on a mixture of albumen, or egg white, and sodium chloride, or salt. When dry this was floated on silver nitrate, which combined with the chloride to create photographic paper that was placed in contact with the glass plate negative and exposed to sunlight. The resulting image was then fixed in a bath of sodium thiosulfate to prevent darkening. It was then toned with a gold-containing solution to produce a dark, purple-black hue which turned brown over time.

Although it was not possible to use earlier clear glass ambrotypes as negatives from which to produce albumen prints, they could be rephotographed with reflective light against a black background, thereby producing a collodion glass negative from which multiple positive paper copies could be produced. The advent of the glass negatives also made it possible to produce larger and more impressive images. Always at the forefront of new ideas in the photographic art, the well-known Matthew Brady created a high-end portrait format image prized by the elite and known as the "Imperial Photograph" that cost several hundred dollars, a

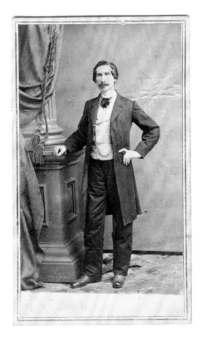

A dealer in daguerreotype cases before the Civil War, German-born Andrew Wenz, alias Wenc, was photographed in this hand-colored *carte de visite* by an unknown artist before he enlisted for three years in the Marine Artillery, a New York regiment organized for naval service on the North Carolina coast and sometimes called "The Horse Marines." Hence the unusual uniform he wears in the second *carte* by Philip Rupp, "Photographic Artist" at 13 Avenue A, New York City. (Author's collection)

tremendous sum in the mid-19th century. Usually measuring 17x20 inches, the most extravagant examples were meticulously colored by artists employed by the photographer.

The *carte de visite* became one of the more popular uses of the albumen method. Although Louis Dodero, of Marseilles, had suggested various uses of *carte*-sized prints, the *carte de visite* was patented in Paris during November 1854 by photographer André Adolphe Eugène Disdéri. Slow to gain widespread use, the *carte de visite* finally achieved mass appeal following the visit of Napoleon III to the studio of Disdéri & Co. at 8 Boulevard des Italiens, Paris, in 1859. Thus began a craze known as "cardomania," which

spread throughout Europe and then to America and the rest of the world. Disdéri also patented a method of producing eight separate negatives on a single plate, which dramatically reduced production costs. Cut out and mounted on a card backing, millions of *cartes de visite* were bought, sold and traded among families and friends. Albums for their display became a common feature in Civil War parlors and the immense popularity of these photographic cards led in particular to civilians on the home front collecting images of prominent persons, as well as of family and friends, especially those in the military.[7]

The stereograph, or stereoscopic view, was another very popular development in the use of the daguerreotype, ambrotype, and albumen photograph. Invented by Englishman Sir Charles Wheatstone in 1838, this involved using a viewer composed of mirrors to create the illusion of depth in an image by stereopsis or binocular vision in which two offset photographs were shown separately to the left and right eye. When these two-dimensional images were combined in the brain, they gave the perception of three-dimensional depth or 3D. Wheatstone used drawings in his rather bulky viewer as photography had yet to be invented, although his original paper on the subject presented to the British Royal Society, with the rather lengthy title "Contributions to the Physiology of Vision – on Some Remarkable, and Hitherto Unobserved, Phenomena of Binocular Vision," seems to have foreseen the invention of a more realistic form of stereoscopic view.

In 1849 Scotsman Sir David Brewster made the first portable 3D viewing device incorporating glass lenses, and "Brewster Stereoscopes" were much admired by Queen Victoria when demonstrated to her at the Great Exhibition of 1851. Unable to find a British instrument maker capable of working with his design, Brewster took his stereoscope to France, where it was improved by Jules Duboscq. Patented in the US by Philadelphian John F. Mascher on March 8, 1853, "Mascher's Improved Stereoscope" incorporated the use of two ordinary lenses set in a supplementary flip-up panel in a photograph case, which allowed two slightly different daguerreotypes of the same subject shot in sequence to be viewed as one 3D image. Later stereoscopic cameras with dual lenses set at approximately the distance between a typical human's eyes exposed two slightly different negatives that produced a 3D effect when positive albumen prints developed from them were seen in a viewer. In 1861 American writer and poet Oliver Wendell Holmes, Sr., invented a simple handheld wooden stereoscope

consisting of two prismatic lenses set in an eye-piece with sliding stand to bring the stereo card into focus, which remained in production for nearly a century. By the eve of the Civil War, E & H. T. Anthony, of New York City, were producing "Instantaneous Stereoscopic Views" that, in the words of a company advertisement, were taken in "the fortieth part of a second," and everything, "no matter how rapidly it may be moving," was "depicted as sharply and distinctly as if it had been perfectly at rest."[8]

Thus, as the result of a remarkable period of invention, a host of artistic, enterprising and entrepreneurial individuals were able to provide for the first time in the history of mankind a comprehensive photographic record of war.

Situated at 501 Broadway, in New York City, Anthony's "Stereoscopic Emporium" was opened in 1860. Visiting this establishment in April of that year, English photographer John Werge exclaimed, "What a wonderful place New York is for photographic galleries! Their number is legion and their size is mammoth … and the most mammoth of all is the "Store" of Messrs. E. & H. T. Anthony, on Broadway." Including Anthony, a total of 95 photographers operated studios in New York City during the Civil War years.
(Author's collection)

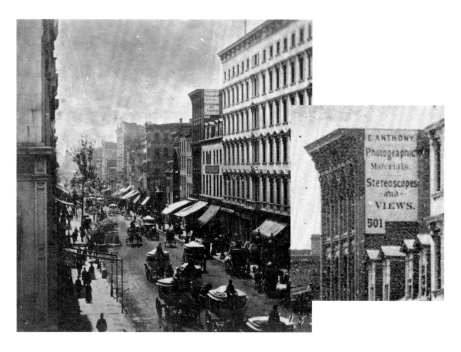

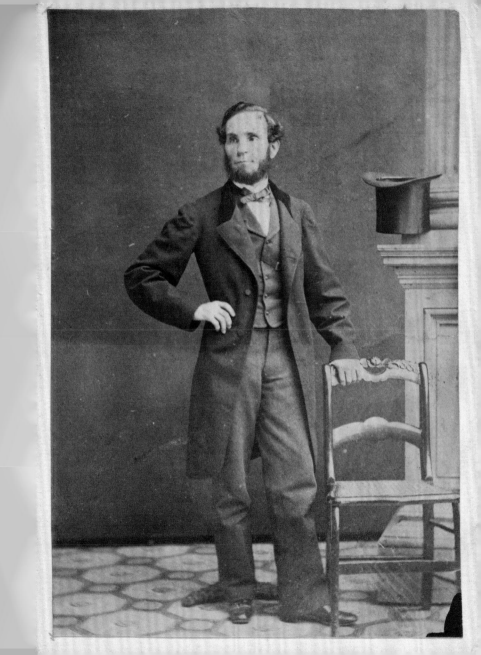

CHAPTER 1

OPENING SHOTS, 1859–61

Many of the tumultuous events leading to civil war in the United States were silently recorded by the cameras of both Northern and Southern photographers from the autumn of 1859 through the early spring of 1861. Following the failed raid on Harper's Ferry in 1859, William Lloyd Garrison, editor of *The Liberator*, pronounced that its leader, the fanatical white abolitionist John Brown, had signaled it was "high noon" for the abolition of slavery, and many thought that civil war seemed inevitable in its wake. At least twelve original photographs of John Brown survive, the last having been produced in May 1859 by John B. Heywood, whose gallery was at 173 Washington Street in Boston. By that time known as "Osawatomie" Brown as a result of a battle with pro-slavery forces in Kansas in 1856, the abolitionist was reluctant to be photographed again. However, he agreed; on the insistence of Dr. Thomas H. Webb, secretary of the New England Emigrant Aid Company, an organization which helped transport immigrants to Kansas to ensure that they entered US territory in a free rather than a slave state. The resulting three-quarter length daguerreotype made by Heywood was probably produced while Brown was in Boston to deliver a fund-raising speech to the Church Anti-Slavery Society at the Tremont Temple on May 24, 1859.[1] In this classic image, the 59-year-old abolitionist has a full beard grown as a disguise after plans for his raid had been disclosed by one of his associates. In this and other earlier photographs, Brown's face shows signs of the mild stroke he probably suffered in the late 1850s, yet his steadfast gaze indicated a determination to carry through his fateful raid on Harper's Ferry.

The Heywood daguerreotype of John Brown was later lost, but not before it was rephotographed as an albumen print in New York City by Martin M. Lawrence, a well-respected New York photographer and

(Right) Produced from a negative made by Martin M. Lawrence from a lost daguerreotype probably taken by Boston photographer John B. Heywood during May 1859, this oval salt print is the only image of John Brown with a beard, and the last photograph of the fanatical abolitionist. Despite Brown's protests, it was produced on the insistence of Dr. Thomas Webb, the secretary of the New England Emigrant Aid Company. About six months after this image was taken, John Brown launched his fateful raid on Harper's Ferry. The card mount has a blind stamp at the bottom right corner stating "Lawrence's Photographs/381/Broadway/Cor. White St./New York." (Library of Congress)

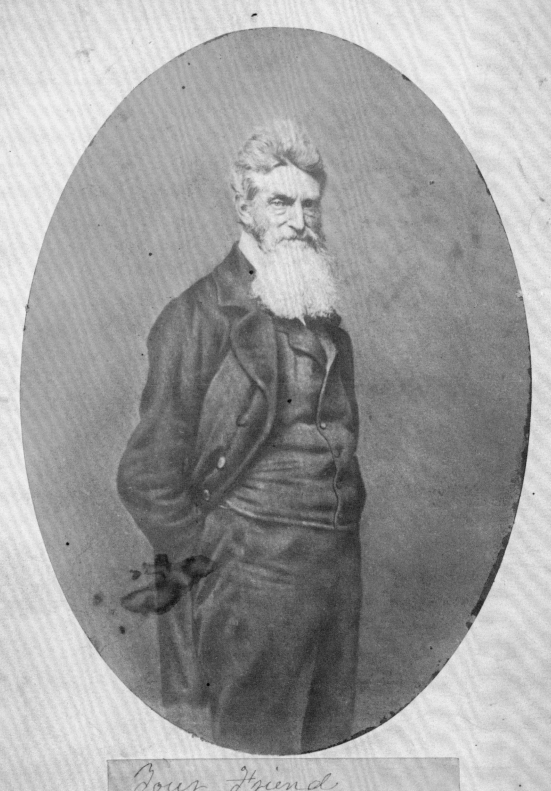

Your Friend
John Brown

president of the American Daguerre Association. Copied possibly at the behest of the subject himself, it has a short inscription on a separate label pasted to the card mount stating "Your Friend John Brown." Thus the iconic view of a full-bearded John Brown was preserved for posterity about six months before he led the fateful raid into Harper's Ferry. After his execution he was martyred in Northern minds; thousands of albumen prints and vignetted reproductions of the same were sold for one dollar as a benefit to Brown's young widow, Mary Brown.

Brown's plan to end slavery had involved arming a small force with the most up-to-date weaponry in order to spark off a rebellion among the nearly four million slaves in the Southern States. Crossing the Potomac River from Maryland into Virginia on October 16, 1859, with a small band of followers consisting of 16 whites and 5 blacks, he captured the US arsenal, Hall's Rifle Works and the fire-engine-house at Harper's Ferry. He also took hostages, including Colonel Lewis Washington, a local slave-owner and great-grandnephew of George Washington, and held them to ransom. According to John Brown, each could be exchanged for a freed slave, but the captives refused, and the expected slave rebellion failed to take place.

With the alarm raised, local militia and armed citizenry drove the raiders from their separate strongholds and surrounded them in the engine-house. Meanwhile, having received news of the insurrection via telegraph, President James Buchanan sent a detachment of US Marines under Lieutenant Colonel Robert E. Lee, 2nd US Cavalry, to Harper's Ferry to quell the insurrection. Faced with a refusal to surrender, Lee ordered his men to batter down the engine-house door, after which Brown and other survivors were captured. During the two-day siege, John Brown received nine wounds, whilst ten of his followers were killed, including one of his sons. Seven of the assailants died. Also present during the siege as an aide to Colonel Lee was future cavalry commander in the Confederate Army of Northern Virginia, J. E. B. Stuart of the 1st US Cavalry.

The surviving insurrectionists were handed over to the Virginia state authorities and charged with treason, insurrection, and murder. During their week-long trial at Charles Town, county seat of Jefferson County, which began just 10 days after the raid, Brown conducted himself with dignity from the cot on which he lay in the court room nursing his wounds. Found guilty, he was hanged on December 2, 1859, whilst

surviving followers were similarly executed by the end of that month. Actor John Wilkes Booth was present at the execution of Brown within the ranks of the Richmond Greys, one of the militia companies sent to police the proceedings. An ardent supporter of slavery, Booth was to assassinate Abraham Lincoln as a last act of vengeance at the end of the Civil War in 1865.

Although Governor Henry A. Wise banned photographs of John Brown or his followers, and prevented photographers from entering the vicinity of Charles Town during the trial and execution, five images of the Virginia militia on duty during the trial have survived, all of which are believed to have been taken by local part-time photographer and clerk Lewis Dingle, who operated a combined "Mercantile and Daguerreotype" establishment in the township. On November 21, 1859, a correspondent of the *Baltimore American*, of Maryland, wrote that he observed a group of militiamen "in the street, in front of a daguerreotype wagon, three lying on the ground and three others in a standing position, who were having their pictures taken to send to their families and friends … in the event of their not being able to return to them until after the close of the war."[2] The cameraman involved is believed to have been Lewis Dingle, and the soldiery photographed consisted of enlisted men of the Richmond Greys and Virginia Rifles of the 1st Regiment of Virginia Volunteers. The remark about war indicates that the correspondent, like many others, believed the trial and forthcoming execution of John Brown and his associates would lead to civil war.

Based on a thorough examination of three of the images believed to have been produced by Dingle, one of the men in the group photographed bears a striking resemblance to John Wilkes Booth. A well-known and successful actor in both North and South, Booth was drawn by the drama unfolding since the failure of the John Brown Raid and, having friends in the Richmond Greys, borrowed a uniform and joined their ranks as they left Richmond on a special train for Charles Town on November 19. According to his sister, Asia Booth Clarke, who claimed that she later saw a photograph of her brother in the uniform of the Richmond Greys at Charles Town, he "left Richmond and unsought enrolled himself as one of the party going to search for and capture John Brown. He was exposed to dangers and hardships; he was a scout and I have been shown a picture of himself and others in their scout and sentinel dresses."[3]

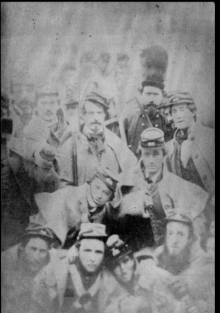

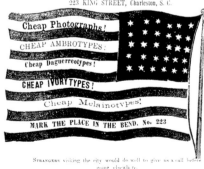

(Top) Born near Charles Town in 1840, James M. Trussell was one of thousands of Virginians who joined the militia in response to the threat posed by the John Brown Raid. Enlisting in the Letcher Riflemen of Jefferson County, he was mustered into state service as a member of Co. H, 2nd Virginia Infantry at Harper's Ferry on May 12, 1861. The 2nd Virginia was one of the five regiments forming the famed "Stonewall Brigade," which turned the tide at First Manassas on July 21, 1861. Wounded during that battle and sustaining a broken leg, Trussell never fully recovered and was listed as "absent, sick" on November 15, 1861. (Author's collection)

(Bottom left) A daguerreotypist in Charles Town, Virginia, Lewis Dingle probably produced this sixth-plate ambrotype of a group of Virginia militiamen gathered outside the Jefferson County Jail on November 21, 1859. The man brandishing a knife at top left bears a striking resemblance to John Wilkes Booth, future assassin of Abraham Lincoln, who joined the ranks of the Richmond Greys as they left via railroad for Charles Town to police the trial and execution of John Brown on November 19, 1859. Those positively identified in the image are Aylett Reins Woodson, kneeling second from left; Albert Hartley Robins, kneeling at right; and Julian Alluisi, of the Virginia Rifles, standing second from right. (Virginia Historical Society)

(Bottom right) Published in the "Charleston Business Directory" in 1860, this advertisement shows the varied types of images produced by photographers Osborn & Durbec at their Photographic Mart at "the place in the bend" on King Street in Charleston, South Carolina. (Author's collection)

Although the John Brown Raid had failed, its effect on relations between the Northern and Southern states was catastrophic. Throughout the South, slave-owners were horrified at the perceived prospect of servile insurrection. Thousands of new military companies were organized, whilst older ones with previously thinning ranks received a fresh influx of volunteers. Many in the South believed that so-called Black Republicans were behind the Raid. Despite Republican disclaimers, many Southerners were convinced that if they won the 1860 presidential election, the Republic Party would abolish slavery. Hence, Southern extremists believed the only course of action left in this eventuality would be secession.

Following news of the election on November 6, 1860, of Abraham Lincoln as the 16th President of the United States of America, the secession movement was further spurred into action. On December 20,

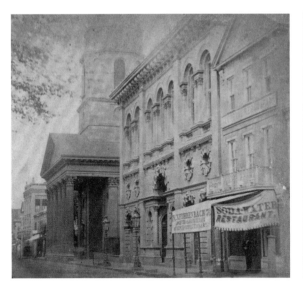

(Left) The location for the signing of the Ordinance of Secession of South Carolina from the Union in December, 1860, the Institute Hall was photographed by Charleston photographer James Osborn. (Robin G. Stanford Collection, Library of Congress)

(Right) Another prominent edifice on Meeting Street, the Charleston Hotel was also photographed by James Osborn in December 1860. (Robin G. Stanford Collection, Library of Congress)

1860, a special state convention held at the Institute Hall in Charleston unanimously passed an ordinance of secession that dissolved "the Union now subsisting between South Carolina and other States." While Congress in Washington, DC, searched unsuccessfully for a compromise that would preserve the Union at the beginning of 1861, President Buchanan, who still had to serve out the last few weeks of his period in office, attempted to protect Federal property in the South. In particular, he concentrated on maintaining possession of one of two forts on the eastern seaboard remaining in Federal hands, namely Fort Sumter off the coast of South Carolina.

One of a series of coastal fortifications built by the US after the War of 1812, Fort Sumter stood in the middle of Charleston Harbor on a

sand bar reinforced with 70,000 tons of granite imported from New England. Designed to hold 146 heavy cannon, only 15 were mounted when South Carolina seceded. The main base for the Federal garrison in the harbor was Fort Moultrie on Sullivan's Island, which contained 60 Regular Army soldiers of companies E and H, 1st US Artillery, commanded by Major Robert Anderson. Being vulnerable to attack from secessionists from inland, Major Anderson decided to move his small force to Fort Sumter during the night of December 26, 1860, and began to strengthen that position.

Several photographers based in Charleston took stereoscopic views, cabinet cards and *cartes de visite* recording the momentous events in and around that city during 1860–61. James M. Osborn and Frederick Eugene Durbec had established Osborn & Durbec's "Stereoscopic and Photographic Depot" at the "Sign of the Big Camera," 233 King Street, in 1858. Although mainly a studio photographer, Osborn began to produce outdoor photographs of Charleston and the surrounding area in 1860. On August 2, the *Charleston Daily Courier* reported:

> J. M. Osborn (of Osborn & Durbec) has been for some time engaged in taking stereoscopic views of the most attractive and valuable features of our city and its suburbs and surroundings. Mr. Osborn has an excellent apparatus specifically prepared for field work, and from the specimens of his negatives we have examined, we predominately predict great success. It is his intention, we learn, to take views in all portions of the state, if proper encouragement be given.

On August 6, 1860, the *Charleston Mercury* reported, "Mr. Osborn on Friday [August 3] visited Mt Pleasant and succeeded in taking some capital views of that place, as well as some views of Charleston and Sullivan's Island in the distance. In the course of a few weeks the sets complete will be ready for sale." Before the end of the month, Osborn's documentary photography was advertised in the local press as consisting of "eight different views of the Battery, the principal hotels, custom house, Accabee [Plantation], Mt Pleasant, Sullivan's Island, Goose Creek …" When produced in *carte de visite* format, these images bore the back mark "Osborn's Gallery, Cor.[ner] King & Liberty Sts., Charleston, S.C.," which suggests that Osborn wished to take entire credit for his outdoor work.

On November 1, 1861, the *Charleston Mercury* again reported, "For four months, Messrs. O. & D. have been steadily engaged in obtaining the most accurate stereoscopic views of places in and around Charleston. Among these we may mention the Charleston Hotel, Mills House, Pavilion Hotel … and a number of plantation scenes, including negro quarters, cotton picking, etc." Taken in and around Rockville on Wadmalaw Island, which is 22 miles southwest of Charleston, the plantation views are particularly important as such photography was generally forbidden. Thus they are among the few documentary images of pre-Civil War enslaved African-Americans that survive, and show plantation homes, slave quarters, an Episcopal church, a slave church, a church service for slaves, a slave cemetery, and even slaves spending some recreational time fishing.

(Left) While the men were probably working in the fields, the women and children gathered outside the slave quarters when James Osborn visited the plantation at Rockville, near Charleston. (Author's collection)

(Right) Overcoming the difficulty presented by low light, Osborn photographed a service taking place in the Zion Chapel, an Episcopal church built for slaves, in 1858 near Rockville. (Robin G. Stanford Collection, Library of Congress)

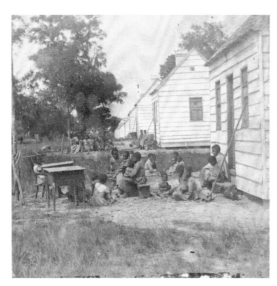

The popularity of the photographs produced by Osborn & Durbec encouraged counterfeiters to copy their work, and as a result the firm placed a notice in the *Charleston Daily Courier* on September 26, 1860 stating: "Caution. To the public generally. Osborn & Durbec … having received information that their "Southern Stereoscopic Pictures" have been purchased by parties for the manifest purpose of copying them expressly for sale … warn the public of the fact that none are genuine without the Osborn & Durbec label on the back." They further warned violators that they would be "prosecuted and dealt with according to law."[4]

Accounts from those who visited a photographic gallery at this time are very rare. A correspondent for the *New York Tribune* and artist for the *Illustrated London News*, English-born Thomas Butler Gunn was sent to Charleston after Lincoln's election in order to report on the growing national crisis in the South and kept a personal diary of day-to-day events. On January 18, 1861, he recorded that he and fellow Englishman William Waud, an artist working for the New York-based *Frank Leslie's Illustrated Newspaper*, walked "to King Street together, to a photographer's or two," where they "purchased the views of Charleston localities." Based on the albumen images Gunn cut out and pasted in his diary, he acquired either stereoscopic views or *cartes de visite* from Osborn & Durbec, including those of the Institute Hall, Charleston Hotel, and a dawn flag-raising ceremony at Fort Moultrie, which Gunn captioned as an "Interior of Fort Moultrie in its summer aspect."

The camera of James M. Osborn was drawn to the Institute Hall on Meeting Street, Charleston, as it was the location for the signing of the Ordinance of Secession which took South Carolina out of the Union on December 20, 1860. This three-story Italianate hall had housed the South Carolina Institute for the Promotion of Art, Mechanical Ingenuity, and Industry from its construction in 1853. Known thereafter as "Secession Hall," it was destroyed by fire that swept through the city in December of 1861. Also prominent in city life during the Civil War, the Charleston Hotel accommodated important Confederate statesmen and military officers at various times, including Governor of South Carolina Francis Pickens, General John C. Pemberton, commanding the Department of South Carolina, Georgia, and Florida, and Captain Robert Baker Pegram, commander of the CSS *Nashville*.[5]

A prominent Southern photographer, George Smith Cook established a permanent gallery in Charleston in 1852, having during the previous

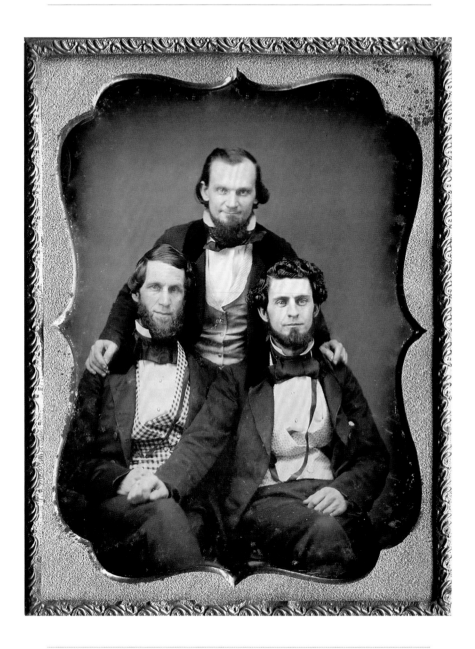

A leading Southern photographer based in Charleston, South Carolina from 1852, George
S. Cook managed to keep his gallery at 265 King Street open until at least June 1864. He
posed for this quarter-plate daguerreotype with two friends or possible gallery assistants in
about 1855. (Collection of George S. Whiteley IV)

Photographed at Cook's Gallery in early 1861, Captain Thomas McDonald Baker commanded the Sixth Infantry Company, 1st Regiment Enlisted Men/1st Regiment Infantry, South Carolina Army. Seen in other images produced by George S. Cook, the painted backdrop shows the vase of flowers on a classical balustrade. (Author's collection)

year managed the New York City studio of Matthew Brady, one of the most famous and influential photographers of the time. By 1856 Cook was considered the "leading Daguerreotypist" in Charleston with a gallery on the third floor at 235 King Street, from where he also sold photographic materials to other photographers. Displaying an ability to keep abreast of the times, on September 2, 1856, "Cook's Portrait Gallery" advertised "good pictures, either in Daguerreotype, Ambrotype, or Colored Photographs."[6] Expanding his business, Cook also opened galleries in Chicago and Philadelphia in partnership with other photographers. A wealthy man by 1860, he paid for the construction of a mansion on fashionable South Battery Street in Charleston, which overlooked the

(Top) Set against a makeshift dark backdrop, Major Robert Anderson and his officers pose for the camera of George S. Cook during his visit to the beleaguered Fort Sumter on February 8, 1861. Seated in the front row are Captain Abner Doubleday, Major Anderson, Assistant Surgeon S. Wylie Crawford, and Captain J. S. Foster. Standing from left in the back row are Captain Truman Seymour, Lieutenant G. W. Snyder, First Lieutenant Jefferson C. Davis, Second Lieutenant Richard K. Meade, and First Lieutenant Theodore Talbot. As officer-of-the-day, Davis wears his waist sash over his right shoulder. Six of these officers eventually rose to the rank of general. (Library of Congress)

(Bottom) As there was no mechanical means to reproduce a photograph in newspaper format during the Civil War, illustrated newspapers such as *Harper's Weekly* depended on teams of engravers to reproduce newsworthy photographs as prints for publication. The group photograph of Major Anderson and his officers made by Cook was published as an engraving on the front page of *Harper's Weekly* on March 23, 1861. The caption explained that it was created from a "Photograph Taken in the Fort," while the accompanying article stated, "Our picture was taken from a photograph recently made by a Charleston photographer." (Author's collection)

White Point Gardens with a panoramic view across the Ashley and Cooper rivers which flowed out of Charleston Harbor into the distant Atlantic Ocean. The official census for the city of Charleston for 1861 listed Cook's Gallery as having been moved to 265 King Street, a property owned by General John Schnierle, former mayor of Charleston.[7]

Following the secession of the Palmetto State on December 20, 1860, Cook's Gallery became busy photographing various officers of the South Carolina Army, an organization authorized on January 7, 1861, by the newly-created and short-lived Republic of South Carolina. Keen to have their likeness captured in their new dark-blue uniforms, various officers stood in Napoleonic pose in front of Cook's distinctive painted backdrop, which included a vase of flowers on a stone balustrade. Pioneering a military use of photography which was used extensively by photographers later in the war, Cook also made photographic copies of maps and drawings for Brigadier General Pierre Gustave Toutant Beauregard when he assumed command of the defenses of Charleston on March 3, 1861.

During mid-January 1861, Cook received a letter from Walter Dinmore, a fellow photographer in Philadelphia, suggesting that a

HARPER'S WEEKLY.
A JOURNAL OF CIVILIZATION.

Vol. V.—No. 221.] NEW YORK, SATURDAY, MARCH 23, 1861. [Price Five Cents.

Entered according to Act of Congress, in the Year 1861, by Harper & Brothers, in the Clerk's Office of the District Court for the Southern District of New York.

Capt. T. Seymour. 1st Lieut. G. W. Snyder. 2d Lt. J. C. Davis. 2d Lt. R. K. Meade. 1st Lt. T. Talbot.

Capt. A. Doubleday. Maj. R. Anderson. Ast. Surg. S. W. Crawford. Capt. J. G. Foster.

MAJOR ANDERSON'S COMMAND AT FORT SUMTER.—From a Photograph taken in the Fort.—[See Page 179.]

photograph of Major Anderson, commanding the Federal garrison then in Fort Sumter, would sell very well throughout the Northern States. Dinmore advised that if Cook could procure a half-plate ambrotype of Anderson, he would copy it into photographs and divide the profits accruing from the sales. Before the end of that month, Cook received a similar letter from Edwin Mayall, an employee of New York City photographer Thomas Faris who served as the main agent supplying E. & H. T. Anthony cameras and chemicals to the South. Mayall informed the Charleston photographer that he had written to Major Anderson advising him, if possible, to visit Cook's Gallery to have his image taken. Mayall further stated that Faris would like the negative in order to produce a life-size portrait of the commander of Fort Sumter. Cook also received a similar request from Edward Anthony several days later.

Clearly it was impossible for Anderson to visit Cook's Gallery. It was equally difficult for Cook to arrange a visit to the beleaguered Fort Sumter, and especially to obtain permission from the South Carolinian authorities to be allowed past their boats that patrolled the waters around the fort. He eventually secured a pass from Governor Francis Pickens thanks to the intercession of Lucy Pickens, his beautiful young wife. Hence Cook rented a boat to ferry himself and one assistant, plus camera and equipment, out across Charleston Harbor to the fort during calm weather on February 8, 1861. Setting up a makeshift dark-colored backdrop within the fort, he attempted unsuccessfully, due to poor light, to take a full-length view of Major Anderson. Therefore, he concentrated on producing a bust view, plus several group shots, which he considered to be "quite successful." Describing his visit to Fort Sumter in a letter the next day to Edward Anthony headed "Confederate States of North America," Cook wrote:

> Friend Anthony:- The Castle or Fort, is taken, or rather its commander and officers, yesterday 8th inst. at two o'clock. I took the Major and an hour after the officers. I had some difficulty in getting them and much in getting the permit to go. Mrs. Pickens kindly interceded in my behalf. I was restricted to one assistant. We had a delightful time; the officers were very kind. Major Anderson is all and more than has been said of him. He is a conscientious, honest, kind and *noble* man ... All his officers seem to adore him; he was most kind to us and treated us handsomely.

Upon return to his gallery, Cook almost immediately made copy negatives of the images he had produced at Fort Sumter, which he displayed prominently in his gallery. On February 11, he sent them North to Faris and Anthony, charging them $25 each. On the same day, English correspondent Thomas Butler Gunn visited Cook's Gallery in the drizzling rain, following which he recorded in his diary: "To King Street, to Cook's the photographer where I saw the recently taken portrait of Anderson and his officers. I should have got some items but Cook had two lady sitters and is not a communicative man." Gunn therefore proceeded to the "Depot of Art" owned by C. J. Quinby, where he purchased a *carte de visite* of Henry C. Covert, of the elite Charleston Light Dragoons, South Carolina Militia, whom he had befriended during his stay in the city.[8]

Also on February 11, the *Charleston Mercury* published a short account of the photographer's visit to Fort Sumter, playing on the words in his letter to Anthony using the title "Major Anderson Taken." Three days later, the *Charleston Daily Courier* also stated:

> As they are denied the pleasure of paying a visit to Fort Sumter, our readers will endure the self-denial with the more ease if they will call on the rooms of that sun-finished artist, Mr. George S. Cook. There they will see the post commandant just as he is. And after enjoying a look at the speaking likeness of Major Robert Anderson, they may regale their eyes on the many faces with whose originals they have been long familiar.

On February 25, Edward Anthony placed a humorous advertisement in the New York press stating:

> On the 8th inst., about 12 hours before midnight, under cover of a bright sun, Col George S. Cook, of the Photographic Light Artillery, with a strong force, made his way to Fort Sumter. On being discovered by the vigilant sentry, he ran up a flag of truce. The gate of the fortress being opened, Col Cook immediately and heroically penetrated the presence of Major Anderson, and leveling a double-barrelled Camera, demanded his unconditional surrender, in the name of E. Anthony and the Photographic community. Seeing that resistance would be in vain, the Major at once surrendered, and was born in triumph to Charleston, forwarded to New-York, and is now for sale in the shape of exquisite Card Photographs at 25 cts. per copy…

Hence, within a few weeks the *carte de visite* of Major Anderson, the hero of Fort Sumter, became a best-selling image for Cook in the South and for Anthony and Faris in the North.[9]

During January and February 1861, the six other cotton states of Mississippi, Florida, Alabama, Georgia, Louisiana and Texas had followed the example of South Carolina and seceded from the Union, thus forming themselves into short-lived republics. Some entrepreneurial photographers took advantage of the custom to be had from the legislators attending the various secession conventions. After Louisiana seceded on January 26, 1861, the *Sugar Planter* of West Baton Rouge published a message from local artist Andrew D. Lytle stating, "Members of the Legislature desirous of leaving some token of remembrance with their Baton Rouge friends, should call at Capt Andy Lytle's daguerreotype and photograph gallery, opposite the Harney House, and get a smashing good picture." One week later, Lytle used the same journal to advise "every body and his wife to go immediately to LYTLE'S and get a picture before Old Abe is inaugurated. After that time everybody will look blue, although a good many are blue now in anticipation of the fact."

Troops from Alabama, Mississippi, Louisiana and Florida had been encamped in and about the US Navy Yard and forts guarding Pensacola Bay, in Florida, since January 12, 1861, following the withdrawal to Fort Pickens of the small Federal garrison under First Lieutenant Adam J. Slemmer. Photographer Jay Dearborn Edwards arrived shortly after this and began systematically to capture on glass plate negatives the Confederates in camp, drilling, and manning batteries. Born in New Hampshire in 1831, Edwards had operated a short-lived daguerreian gallery in St. Louis, Missouri, before moving to New Orleans in 1859. Building a reputation as a photographer of fine city views, he occupied a studio on Royal Street by January 1861. The "Photographic Views of the Seat of the War" he produced during the following weeks went on sale for $1 each at "book, music, looking-glass and picture stores" throughout the city on May 18 and were listed in the *New Orleans Daily Crescent* as a numbered series of 38 photographs, but, according to negative numbers, there may have been at least 30 more. These images included views of colorful Louisiana units such as the Orleans Cadets, Crescent Rifles, Chasseur a Pied, and the Battalion Louisiana Zouaves, as well as various companies of Mississippi and Alabama regiments.[10] Without referring to Edwards by name, the

Produced from one of three of J. D. Edwards' negatives seized by US authorities after the fall of New Orleans on April 25, 1862, this albumen print shows volunteers of the Home Guards (Co. B), 9th Mississippi Infantry in camp at Pensacola, Florida. Seated holding a newspaper is 52-year-old Thomas A. Falconer, of Holly Springs, Mississippi. The man tending the frying pan is his 21-year-old son Kinlock Falconer, who received promotion to major and served as acting assistant adjutant general in the Army of Tennessee. Standing at center is planter James Cunningham. Measuring 6 feet 2 inches in height, he was probably the tallest man in his regiment. (Library of Congress)

New Orleans Bee commented that they had been produced by "an excellent artist of this city," and suggested that they would "form an interesting souvenir for the parlor, particularly in the event, considered now so near at hand, of the capture of Fort Pickens."[11]

Several of Edwards' photographs quickly made their way north. One of them, a view of volunteers of the Home Guards (Co. B), 9th Mississippi

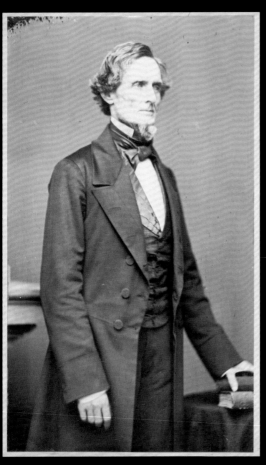
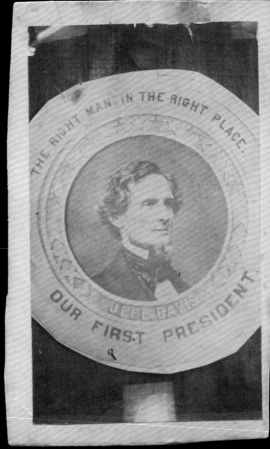
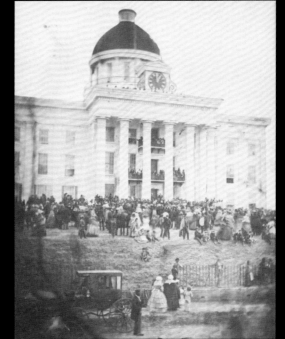

(Top left) Future President of the Confederate States of America, Jefferson Davis was one of hundreds of politicians, dignitaries and famous people photographed by Matthew Brady during the 1850s. Visiting the "National Photographic Art Gallery" at Washington, DC, in 1859 during his second term in the US Senate, Davis' likeness was produced in what Brady called his "Imperial"-sized photograph. This later became known as his "stately portrait," and copies in *carte de visite* format were reproduced by numerous photographers both North and South. (Library of Congress)

(Top right) A bust view of the Brady portrait was reproduced in a patriotic button-sized rosette designed by St. Louis photographer John H. Fitzgibbon, which bore the legends "The Right Man in the Right Place" and "Our First President." This was available to wear for those attending Davis' inauguration at Montgomery, Alabama, on February 18, 1861. This *carte de visite* showing an example of the Fitzgibbon rosette was produced and sold by Isaac Tucker and Jabez W. Perkins, photographers of Augusta, Georgia. (Courtesy of John O'Brien)

(Bottom) Having set his camera at a high vantage point several hundred yards from the Capitol building in Montgomery, Alabama, on February 18, 1861, Archibald Crossland McIntyre captured the ceremony as President Jefferson Davis drew to the end of his inaugural speech. The clock on the Capitol dome reads one o'clock, and Davis stands with his hands behind his back, while the two figures to his right are probably Vice President Alexander Stephens and Howell Cobb, presiding officer of the Provisional Confederate Congress. The gathered crowd contains many family groups, including youths and small children. (Boston Athenaeum)

Infantry, was the basis for a wood engraving captioned "Bivouac of Rebel troops at General Bragg's camp at Warrington, Pensacola – [From a Photograph]" published in *Harper's Weekly* of New York City on June 22, 1861. The appearance in a northern illustrated newspaper of this, and another engraving based on an Edwards image of a sand-bag battery bearing on Fort Pickens, may have encouraged Matthew Brady, who thus far had mainly concentrated on portrait work in his New York studio, to take his camera into the field.[12]

Despite his pioneering work as a photographer, little is known of J. D. Edwards during the Civil War after June 1861. He may have photographed men of the 5th Company, Washington Artillery, at Camp Louisiana prior to the battle of Shiloh in Tennessee during early 1862, but

beyond that he seems to have disappeared into obscurity until the 1880s when he resurfaced in the photography trade in Atlanta, Georgia.

Dreams of a Southern Confederacy had long appealed to many Southerners and finally, on February 4, 1861, the seven seceded states met at Montgomery, Alabama in order to draw up a constitution and choose a president for the Confederate States of America. The Montgomery Convention took three days to adopt a constitution, based largely on that established by the Federal government in 1787, and chose Jefferson Davis of Mississippi as President. The inauguration of Jefferson Davis took place in Montgomery on February 18, 1861. Present to observe the ceremony, a reporter for the *Macon Daily Telegraph* of Georgia wrote:

> The day dawned a little inauspiciously. By ten o'clock, however, the sun broke upon the scene and poured, not a darting, but a soft and hazy light upon the city, field and hill. This calm radiance continued throughout the day. By 10 o'clock the streets were thronged with joyous, expectant, eager crowds … Several splendid volunteer companies manoeuvred in sight of the multitude – music and musketry, flags and sashes – the dashing horseman – the curious countryman – the grave statesman – youth, age and even decrepitude, gave piquant variety to the exhibition.[13]

This historic occasion was photographed by Archibald Crossland McIntyre. Working in Montgomery since at least 1851, McIntyre had opened his "Great Southern Photographic Art Gallery" at 43 Market Street in November 1860, where he exhibited "a life-like resemblance" of leading secessionist William Lowndes Yancey. He also advertised "hundreds of other likenesses, from miniature to full size," which he believed challenged "competition in the Union as it is, or in the 'SOUTHERN CONFEDERACY,' that is likely to be."[14]

Two weeks later, during a cold and blustery day on March 4, 1861, a much larger crowd of 30,000 people gathered to watch the inauguration of Abraham Lincoln as the 16th President of the United States at the east front of the Capitol in Washington, DC. The following day a report in the *New York Tribune* commented on the presence of the camera for the occasion, stating:

> Several of those indefatigable persons, photographers, were on the ground to take an impression of the scene – one corner of the portico being occupied by

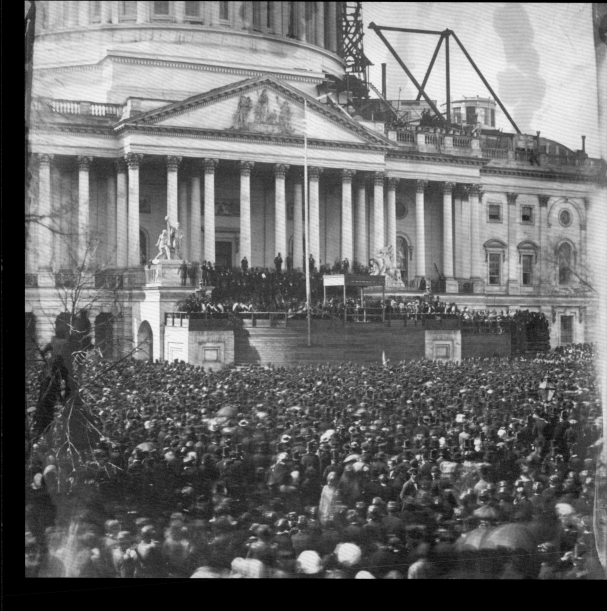

Photographed by Alexander Gardner for Matthew Brady's Washington Gallery on March 4, 1861, President Abraham Lincoln delivers his inaugural speech on a specially-built wooden platform in front of the Capitol. Note the open windows to the right on the Capitol building. Sharpshooters were posted there to guard against assassination attempts by Southern sympathizers. Ready to play "Hail, Columbia," the Marine Band are at far right of the platform. Given the responsibility of guarding "the immediate neighborhood of the President," the District of Columbia volunteer militia consisting of the National Guard Battalion, commanded by Colonel J. A. Tait, can be seen standing in front of the crowd. Other militia officers in gray uniforms, plus "Wide Awakes," or paramilitary supporters of the Republican Party wearing oil-cloth covered caps, are lined up in the foreground.

(Library of Congress)

the requisite chemicals, etc. A small camera was directly in front of Mr Lincoln, another at a distance of a hundred yards, and a third of huge dimensions on his right, raised on a platform built specially for the purpose.[15]

One of the surviving views of this historic event was produced for Matthew Brady by Alexander Gardner, and was exhibited at the National Photographic Art Gallery eight days later, with the advice that Lincoln would "soon to sit for his picture" again.[16] The image taken by Gardner captures the scene from the right of the wooden platform in front of the Capitol building and was produced from a vantage point above the crowd, and so Brady's camera was probably the one placed on the "raised platform" mentioned in the *Tribune* report.

However, the Brady camera was not the only one in an elevated position to photograph Lincoln's inauguration. New York photographer George Stacy also had his camera poised. According to the *Evening Star* of Washington, DC, he had with permission "erected a stand in the east grounds of the Capitol, about one hundred yards from the scene of the inauguration, from the summit of which he had mounted an immense photographic lens, and during the ceremonies was busily engaged in taking impressions of the crowd."[17] Unfortunately, none of Stacy's images appear to have survived. Perhaps an explanation may be found in a letter written by Maria M. Sheetz, who was one of the thousands to witness the occasion. The wife of Benjamin F. Sheetz, editor of the Virginia-based Leesburg *Democrat Mirror*, she wrote to a friend on the same day as the inauguration: "The day passed ... in quiet and peace, with no casualty, unless I except the falling of an enterprising photographer's machinery, just at the time when all was ready to take the whole scene, Mr Lincoln's Inauguration – a sudden breeze dashed his pictures and hopes in one heap on the ground."[18]

At the time of Lincoln's inauguration in March 1861, Major Anderson and his men were still holding out at Fort Sumter in Charleston Harbor. Surrounded by Confederate cannon under the command of General Pierre Gustave Toutant Beauregard, of Louisiana, they were running desperately short of food and water. For Lincoln to permit Anderson to surrender would have been tantamount to recognizing the Confederacy. Yet any further attempt to reinforce him might precipitate war. A majority of Lincoln's cabinet was in favor of evacuation, but the President remained determined to send a relief expedition to Fort Sumter. After failure to

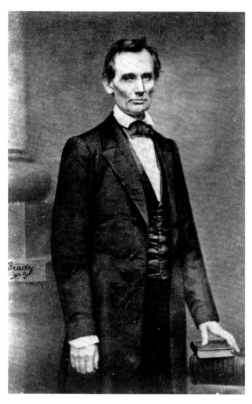

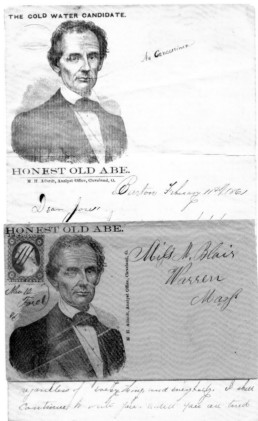

(Left) Several hours before delivering his famous Cooper Institute address on February 27, 1860, Abraham Lincoln was photographed by Matthew Brady at his New York City gallery. Note "Brady N Y" written on the prop. On this occasion, Brady clearly saw promise in Lincoln's rugged dignity and created an iconic image of the as yet beardless presidential candidate. During the months that followed Brady sold thousands of copies of this photograph, which was also reproduced as lithographed prints and engravings in illustrated newspapers and postal stationery of the day. This photograph was so influential that Brady would later recall Lincoln as saying, "Brady and the Cooper Institute made me president." (Library of Congress)

(Right) The Cooper Institute photograph of Lincoln was reproduced as an engraving with the caption "Honest Old Abe" on postal stationery during the presidential election campaign of 1860. The "Cold Water Candidate" indicates this stationery was produced by a temperance organization that supported Lincoln. Note the letter writer has added a balloon to Lincoln's mouth stating, "No concessions."
(Collection of Dr. James W. Milgram.)

49

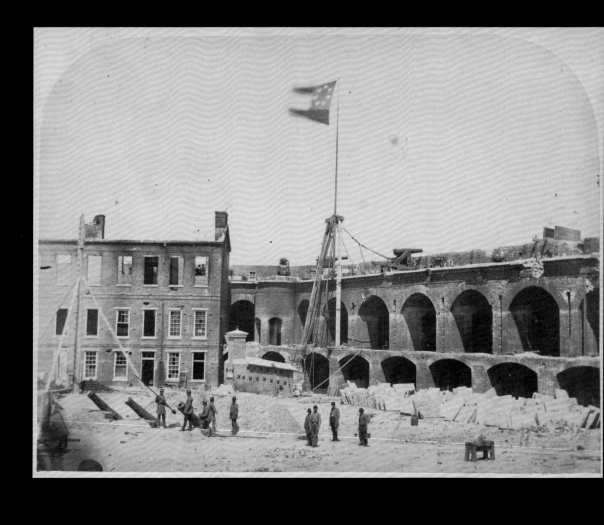

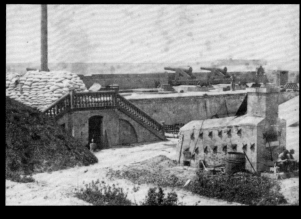

(Top) Photographed from the top of the parapet of the southeast-facing wall of Fort Sumter by Alma A. Pelot, assistant for Charleston photographer Jesse H. Bolles, enlisted men of Co. B, Battalion of Artillery, South Carolina Army pose as if loading one of the gun tubes arranged as mortars by the Federal garrison to fire on Morris Island. With its top half shattered off by shot from the "Iron Battery" at Cummings Point during the bombardment, the base of the original flag staff stands at left, behind which is the burned-out enlisted men's barracks. The small hot shot furnace with brick chimney is at center. As a symbol of triumph, the First National flag of the Confederacy has been hoisted on the jury flagstaff lashed to lifting gear by the Federal garrison after their main flagstaff had been shot away. (Library of Congress)

(Bottom left) The dawn flag-raising ceremony was photographed by James Osborn when he visited Fort Moultrie on Sullivan's Island during August 1860. Two officers stand on the terreplein above the main stairs holding the halyards while an enlisted man grasps the fly end of the fort's large garrison flag. Fort Sumter is seen a mile distant across the water in the top right-hand corner. In the foreground stands the hot shot furnace, which would be used by the Confederates to heat the shot that set the officers' quarters and barracks of Fort Sumter on fire during the bombardment of April 12–13, 1861. Neatly kept lawn and hedges form part of the fort's antebellum interior. (Library of Congress)

(Bottom right) Fort Moultrie was again photographed from the same spot after the capture of Fort Sumter. Sand-filled bags remain around the base of the flagpole. Note the lawns have disappeared and the hedges are mostly destroyed. (Library of Congress)

relieve Fort Pickens, off the Florida coast, it was decided on April 6, 1861, to attempt to provision Sumter peacefully and to resort to force only if necessary. This presented Jefferson Davis with a difficult choice, and was designed to force his hand. Either he permitted provisions to be landed at the fort, or he fired the first shot, which would provoke civil war. After Anderson's final refusal to evacuate his post, and with a relief convoy on the way, Davis ordered the Confederate batteries to open fire at dawn on April 12, 1861.

On that momentous occasion, Charleston photographer George S. Cook glumly noted in his account book, "Shut up [gallery], war, war, war," adding in the margin, "Firing com[menced] at Forts 20 to 5 O'clock. At Fort Sumter at 7 am." The bloodless bombardment lasted for 33 hours, none of which appears to have been photographed by any of the Charleston photographers

(Top) The photographer visiting Fort Moultrie after April 14, 1861, took an obvious interest in the guns which helped to subjugate Fort Sumter. Throughout the Civil War, Fort Moultrie performed effective service, both on the Union navy monitors whenever they attempted to approach the inner harbor of Charleston, and on the Federal batteries on Morris Island, most of which were within range. (Robin G. Stanford Collection, Library of Congress)

(Bottom) Never examined in such detail before, this close-up shows Confederate artillerists in their shirt sleeves resting midway along the battery at Fort Moultrie having completed their work. Several hold levers used to thrust into the wheel-holes in order to move and adjust the aim of the gun. (Robin G. Stanford Collection, Library of Congress)

despite the spectacle which ensued and the crowds which gathered on the housetops, wharves, and the battery, to watch the big guns in action. On April 13 Cook was again open for business, noting in his account book, "War. Still firing. Ships also. Fort Surrendered."[19] With interior buildings on fire from the steady stream of hot shot pouring in from the Confederate batteries at Fort Moultrie and Cummings Point, and the arsenal in danger of blowing up, Major Anderson hoisted a white flag at 1.30 pm and agreed to evacuate Fort Sumter. He withdrew with his command to the Federal navy vessels standing outside the harbor on April 14, 1861.

One of the first photographers to gain permission to enter Fort Sumter after its evacuation was 20-year-old Alma Alfred Pelot, who worked as an assistant to Jesse H. Bolles at the "Temple of Art," on the corner of King and Liberty streets in Charleston. Arriving early on the morning of April 15, he set his camera up on the terreplein of the southeast-facing wall of the fort and produced a series of views looking down into the parade. Several civilian dignitaries, including wealthy plantation owner Wade Hampton, and numerous Confederate troops consisting of the Palmetto Guard, 17th Regiment, South Carolina Militia, commanded by Captain George B. Cuthbert, and Co. B, Battalion of Infantry, South Carolina Army, commanded by Captain James H. Hallonquist, are seen in these images. Turning his camera to capture the view along the terreplein, Pelot also captured scenes looking along the guns which had defended the fort. He also visited Sullivan's Island in order to photograph Fort Moultrie and the Floating Ironclad Battery.

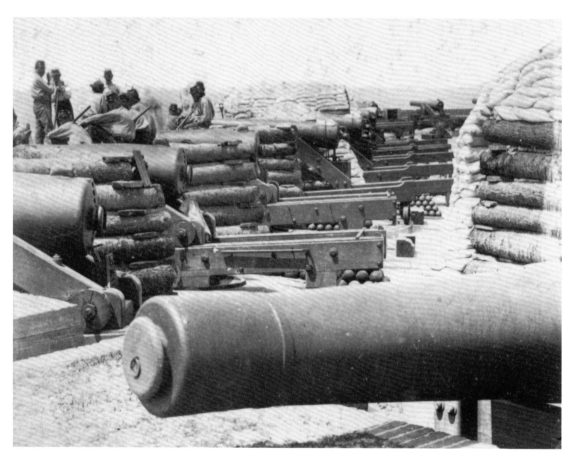

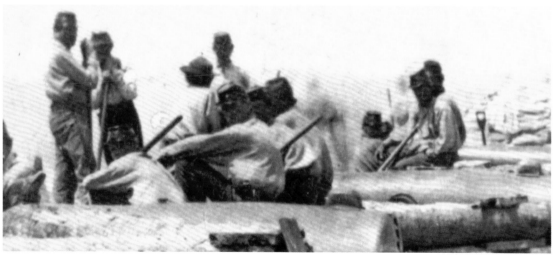

An advertisement placed in the *Charleston Mercury* by Bolles on April 17 stated that he had "Five Different Views" of the internal appearance of the fort. A report in the *Charleston Daily Courier* on April 25, 1861, further advised that Pelot took 16 views of Fort Sumter and the Floating Battery used by the Confederates during the bombardment.[20] Eventually foregoing the camera, Pelot enlisted as a private in the Washington Artillery on February 20, 1862, and served until the end of the war.

On April 17, Charleston photographer James M. Osborn arrived at Fort Sumter with his stereoscopic camera, having also received permission to photograph the aftermath of the bombardment, and produced about 20 views documenting the damage wrought by Confederate artillery and the fires that followed. He also revisited Fort Moultrie, on Sullivan's Island, and crossed to Morris Island and Coles Island, creating at least 20 more images, which form one of the most complete photographic records of any battle or action during the Civil War. Wherever Osborn set up his camera, the Confederate soldiery was keen to be photographed and forever associated with their great and bloodless victory, gathering in informal groups amid the ruins at Fort Sumter, the parapets of Fort Moultrie, or the earthworks at Fort Palmetto on Coles Island.

Another photographer who could not resist the call to arms, Osborn enlisted in the Lafayette Artillery on September 17, 1861. A unit he had photographed five months earlier, he served with them at Coles Island for about six weeks, following which he returned to his Charleston studio. On December 4, 1861, the first-floor gallery of Osborn & Durbec was destroyed when a fire broke out in the ground-floor premises rented by upholsterers and curtain-makers H. W. Kinsman, who had been contracted to make military tents for Confederate troops. The next day the *Charleston Mercury* reported that "Messrs Osborn & Durbec, Artists … lost nearly all their stock and cameras for photographing."[21] One week later the "Great Fire" in Charleston further devastated about a quarter of the city.

On February 21, 1862, what was left of the business partnership of Osborn & Durbec came to an end. Having also gained military experience as a member of the Lafayette Artillery from at least 1858 until his resignation as a corporal during 1860, Durbec enlisted as fifth sergeant in the Beauregard Light Infantry, Regiment of Rifles, South Carolina Militia, on February 21, 1862, and subsequently served as color-bearer for that company.[22] Mustered into Confederate service the next day, the Beauregard Light Infantry later

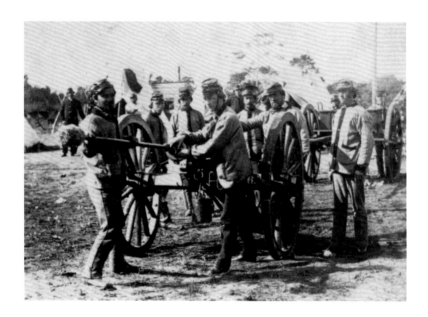

Both James Osborn and Frederick Eugene Durbec served as members of the Lafayette Artillery, SCM, at various times between 1858 and 1861, hence they had good reason to photograph this military company. Produced shortly after the surrender of Fort Sumter, this view shows a gun and limber of the unit at Fort Palmetto on Coles Island. Note the company initials "L. A." and numeral "6" painted on plates attached to the gun axle.

(Robin G. Stanford Collection, Library of Congress)

formed part of the Eutaw Battalion, which was reorganized into the 25th South Carolina Volunteers in July 1862. Durbec was promoted brevet second lieutenant for bravery during the battle of Secessionville fought on June 16, 1862 but resigned on February 17, 1863 due to ill health. Recuperating in Columbia, the state capital, he remained there for the remainder of the war, entering into the auction and commissioning agent business and continuing to practice the "daguerreian art" on a part-time basis.

Meanwhile, James Osborn revived his photographic business during March 1862, establishing a new studio at 281 King Street, which was the recently vacated location of photographer Jesse H. Bolles, who was by this time on duty with the Washington Artillery. On the 24th of that month, the *Charleston Mercury* reported:

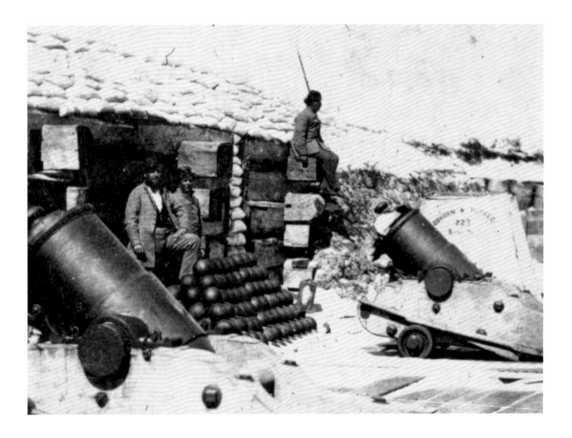

Photographers only had a short time to develop glass negatives when working in the field. Rigged and ready, the darkroom tent of Osborn & Durbec can be seen pitched next to the mortar battery in this detail from a stereoscopic view produced on Morris Island during April 1861. (Robin G. Stanford Collection, Library of Congress)

Mr Osbourne [sic], who has perpetuated the aspect of the ruins of Fort Sumter in his admirable stereoscopic views, has been engaged during the past week in photographing and stereoscoping the ruins of the public buildings as they were left by the great fire December last. Mr Osbourne has some excellent views of the Circular Church, and the Cathedral of SS John and Finbar. They will be ready for sale at his gallery, corner of King and Liberty Streets, early this week.[23]

None of his views of the destruction caused by the "Great Fire" appear to have survived.

Public displays of loyalty to the Union were widespread in the days following the capture of Fort Sumter, the most significant taking place in Union Square, New York City, on April 20, 1861. Known subsequently as the "Great Sumter Rally," it was the largest public meeting Americans had ever witnessed. Only a few days before the rally, leading New Yorkers were vigorously debating how conciliatory the Federal government should be toward the seceded Southern states. Terrified that the Northern economy would collapse if the South increased the amount of cotton it exported directly to Europe, they met on April 14 to plan a rally in City Hall Park to demand a peaceful reconciliation, even if it involved the continuation of slavery. The *New York Herald* predicted that the City Hall rally would be "one of the greatest meetings ever held in the city, and its effect on the government at Washington and the government at Montgomery [would] be very decided."

Before the City Hall rally took place, Lincoln officially declared an insurrection in the South and called for the recruitment of 75,000 volunteers for three months' service on April 15, 1861. As a result, the rally planners altered their position and started supporting speedy retaliation against the South, with Pelatiah Perit, president of the Chamber of Commerce, publicly declaring, "We are either for the country or for its enemies."[24] Wealthy Republicans and Democrats met at the Chamber of Commerce on April 17 to organize a "monster meeting" in order to demonstrate that all New Yorkers were loyal to the Union. As various venues for the meeting were discussed, Simeon B. Chittenden, a Republican dry goods merchant, suggested, "Let it be Union Square – the name is significant – with the statue of the Father of our Country [George Washington] looking over the meeting."[25] The suggested location had been named Union Square because of its position at the union of Bloomingdale and the Bowery streets, now Broadway and Fourth Avenue. Although it was not yet a popular space for public meetings, the organizers agreed to hold the rally there because its name would serve to reinforce their message of loyalty.

On the morning of April 20, over 100,000 people, including rich merchants, brokers, tradesmen, artisans, mechanics and laborers, poured into Union Square from all directions while, relegated to the windows,

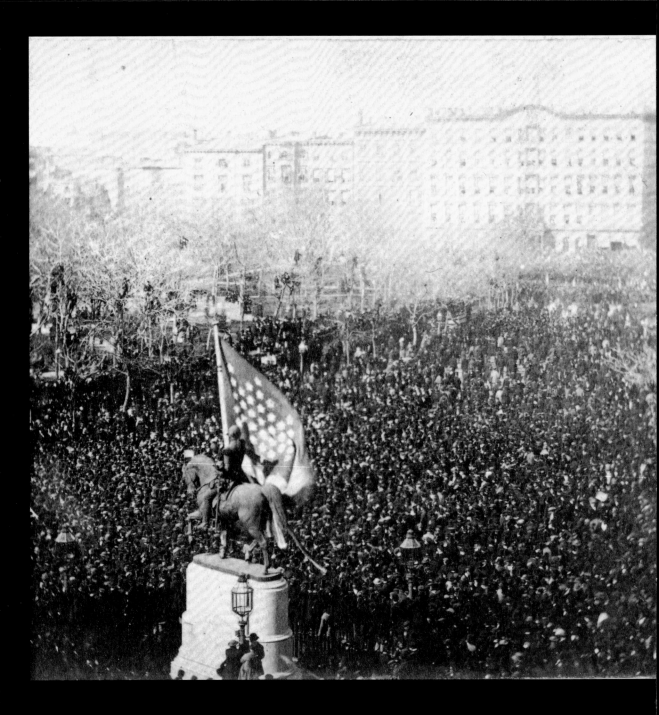

Produced by E. & H. T. Anthony, this detail from a stereoscopic view of the "Great
Sumter Rally" shows the equestrian statue of George Washington in Union Square,
New York City, over which floats from its broken staff the storm flag shot down by
Confederate gunfire at Fort Sumter only seven days earlier. During the largest public
meeting Americans had ever witnessed, the Washington statue became a rallying point for
Union supporters in Union Square, New York City, on April 20, 1861.
(New-York Historical Society)

balconies and rooftops, women and children cheered and waved small flags. Jane Stuart Woolsey, who would become an active member of the United States Sanitary Commission charged with supporting sick and wounded soldiers, observed the rally from the balcony of her family home in the southeast corner of the square. Writing to a cousin, she recalled how a "huge sea of men overflowed the quadrangle of streets where the speakers' stands were." Although unable to hear the speeches, she knew when "'points' were made by the thousands of hats lifted and swung in the air and by the roar of the cheering." Continuing, she stated, "Every house fronting the square, and up and down the side streets, was decorated with flags and festoons, and the Sumter flag, on its splintered staff, hung over the stand where the gentlemen of the Sumter command were."[26]

Speakers included Secretary of the Treasury John A. Dix, famed for his message to Federal Treasury agents in New Orleans during January 1861 ordering "If any one attempts to haul down the American flag, shoot him on the spot." Stating in his speech that "the gathering for battle was at hand, and the country required every man to do his duty," Senator Edward D. Baker would be killed at Ball's Bluff six months later. Mayor of New York City Fernando Wood did most to capture the spirit of the day, urging the multitude to support "the Constitution … the Union, the government, the laws and the flag." Echoing the desire to put party politics to one side, a popular phrase heard around the rally was, "We are all Democrats. We are all Republicans." The greatest cheers were reserved for when Major Anderson, Captain J. S. Foster, and Assistant Surgeon S. Wylie Crawford, plus several enlisted men of the Fort Sumter garrison, took the stand. Later that day Anderson visited Brady's Gallery and sat for an imperial-sized photograph.[27]

During the days following the rally, with Pennsylvania troops known as the "First Defenders" and elite 7th New York State Militia already in or heading to Washington, DC, the raising of a volunteer army for three months' service was pursued at pace throughout the Northern States. In the cities such as New York, Philadelphia, Boston and Chicago, numerous regiments and military companies were formed among the Irish, German, Italian or Polish communities. Many free African Americans were eager to fight, but were barred from enlistment. Womenfolk in every community gathered to prepare bandages and supplies to ship south. Despite such enthusiasm, the early days of the war in the North were extremely chaotic,

(Right) Enlisted men from regiments receiving clothing, equipment and outfit from the Union Defence Committee were photographed at various galleries in New York City. The rush to uniform and equip so many regiments resulted in a great variety of uniforms. Some regiments, such as the 12th and 14th New York State Militia (NYSM) (bottom middle and right), wore French influenced chasseur-style jackets and pants. Others, like the 13th NYSM (top middle), wore gray which would later lead to confusion on the battlefield, as much of the Confederate Army wore that color. The 62nd New York Volunteers, or Anderson Zouaves (top right), were named in honor of Colonel Robert Anderson, of Fort Sumter fame. The tartan trews worn by the enlisted man of the 79th NYSM (top left) reflects the Scottish origins of many in this regiment, while the 71st NYSM, or American Guard (bottom left), wore a somber dark blue.
(Top row and bottom left, Michael J. McAfee collection. Bottom middle and right, Dan Miller collection)

and most of the men volunteering to fight lacked discipline and training. Uniforms, arms and supplies were scarce and the makeshift barracks established in parks in every city were insanitary.

As a result, volunteer organizations such the Union Defense Committee (UDC), of New York, stepped in and added some order to the chaos. Led by businessmen from Republican and Democrat parties, the mayor, comptroller and leaders of the Common Council of the city of New York, the UDC raised millions of dollars for "the organization, outfit, and equipment" of volunteer soldiers, and support for their families. Following the Union Square rally, President Lincoln ordered newly appointed Secretary of the Treasury Salmon P. Chase to transfer two million dollars to the leaders of the UDC, and over the next few months New York City appropriated almost the same amount. By the end of 1861, mostly through private subscription, the UDC had helped clothe, equip and outfit 10 regiments of militia and 26 regiments of volunteers in New York State. It also provided relief to thousands of families and sent millions of dollars' worth of supplies to the army at the front. Were it not for the enthusiasm generated by the "Great Sumter Rally" of April 20, 1861, which was converted into action by the UDC, the South might have gained a much greater advantage in the early days of the Civil War, thereby dramatically changing its outcome.

CHAPTER 2

"Pictures may be taken by the thousand... "

PHOTOGRAPHY ON THE HOME FRONT

Photographers in both Northern and Southern cities and townships during the Civil War years produced images in studios variously called galleries, depots, or temples of art. Whether in a luxurious city emporium or a humble small-town attic the "artist" behind the camera captured on glass, iron or paper the enthusiasm and apprehension of the soldier as he left home and family for the war. Usually situated on the top floor of city buildings, these studios invariably had large skylights set into the roof in order to maximize the sunlight essential to their art. The larger galleries were usually lavishly furnished with carpets, tables, and armchairs to create the illusion that the portrait was taken in a homely-looking front parlor. If the size of the premises permitted, lower floors served as reception rooms displaying the work of the photographer as if paintings in an art gallery, with cases, mats, frames and other photographic accessories for sale.

In the larger cities, a visit to a photographic gallery such as Matthew Brady's National Photographic Portrait Gallery, in New York City, or W. L. Gorman's Temple of Art, in Philadelphia, was often considered to be a social occasion, where prospective customers could meet friends and exchange polite conversation while waiting their turn to have their "likeness" made. One of the most well-known of photographers during the years before the Civil War, Brady arrived in New York City at the age of 16. He worked as a department store clerk before starting his own small business manufacturing jewellery cases. He also learned the daguerreotype process and by 1844 had his own daguerreotype studio at 359 Broadway in New York City. During the 1850s he acquired a reputation as one of America's greatest photographers producing portraits of the famous.

Brady's National Photographic Art Gallery in Washington, DC, was opened in 1858 and managed by Alexander Gardner. The location presented him with access to the nation's leaders and foreign dignitaries. In 1891 Brady recalled, "From the first, I regarded myself as under obligation to my country to preserve the faces of its historic men and mothers." In 1860 he opened his extensive National Photographic Portrait Gallery at 643 Broadway in New York City. Situated on the west corner of Broadway, it extended down Tenth Street about 150 feet. A correspondent for *Frank Leslie's Illustrated Newspaper* described it on January 5, 1861 as:

> ... fitted up in admirable taste, and ... richly and handsomely furnished. A costly carpet covers the entire area, while elegant and luxurious couches abound in

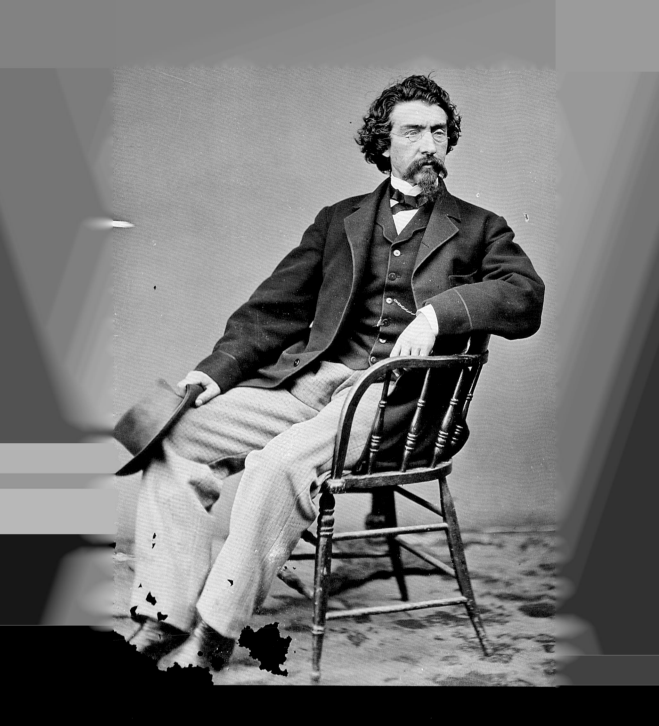

Born near Lake George, New York, in 1823, Matthew Brady opened his first daguerreotype
studio in New York City in 1844 and photographed thousands of famous people of his day.
Probably disenchanted by his experience attempting to photograph the battle of First Bull Run
in July 1861, he employed a staff of camera operators to document subsequent battles and

Published in *Frank Leslie's Illustrated Newspaper*, this engraving depicts the first-floor reception area of Matthew Brady's "National Photographic Portrait Gallery" at 643 Broadway in New York City. (Author's collection)

liberal profusion … The ventilation, light and heat, being under complete control, give the finishing touch to this most artistic and altogether unique establishment … But the crowning attractions of this splendid Gallery are the countless exquisite pictures which fill every available inch of the walls. So vast a collection of masterly photographs, plain and colored, was never before brought into one Gallery. The operating-rooms are replete with all the modern conveniences and improvements; among the latter we must mention the successful use of colored glass, which Mr. Brady has found to work with magical effect.

The report concluded, "There is a private entrance in Tenth street, for ladies in full dress, which leads directly to the operating-rooms, thus obviating the unpleasant necessity of passing, so attired, through the public gallery."

Typical of the small-town photographic gallery in the mid-West was that operated by
I. N. Conrad at Minerva, Ohio. The photographer and his assistants gather at the front
entrance of the building. A large skylight admitting the sunlight essential for the
production of bright photographs can just be seen in the sloping roof above the first-floor
window in the side wall. The posters hung in the ground floor windows probably advertise
his services and fees. (Author's collection)

A report in the *New York Herald* proclaimed that Brady's Broadway
gallery was "the most complete establishment of the kind to be found on
either side of the Atlantic," with many Imperial-sized enlargements of
earlier daguerreotypes displayed on the walls. By the end of May 1861, this
included an Imperial Photograph of Colonel Elmer Ellsworth, who had
been killed while removing a Confederate flag from the roof of the Marshall
House in Alexandria, Virginia, on the 24th of that month. Also for sale in
Brady's "Gallery of Heroes" were "Stereoscopic and Card Portraits" of
General Winfield Scott and Colonel Robert Anderson.

A rare example of a visit to a city photograph gallery was recorded in
the diary of Mary Chesnut, daughter of Stephen Decatur Miller,
ex-governor of South Carolina, and society lady in Charleston during

Since at least 1860, Jesse L. Cowling had operated his "Ambrotype & Daguerreotype Gallery" over Jonathan Whaley's drug store on Craven Street in New Bern, North Carolina. When the Union army occupation began in March 1862, Cowling was content to keep his business running, which was successful according to the number of men of the 25th Massachusetts Infantry standing around his door. Seen at the window above his gallery sign with one hand on his camera, Cowling died of yellow fever during September-October 1864. (United States Army Heritage & Education Center, Military Order of the Loyal Legion of The United States)

antebellum and Civil War times. Following a visit to the studio of Quinby & Co. on King Street in Charleston on March 26, 1861, she wrote, "Then to Quinby's, bought 2 dozen *cartes de visite* of all the celebrities." She added, "I am to have my *carte de visite* made." Two days later, she went again to Quinby's studio with her husband, presidential aide-de-camp James Chesnut, Jr., after which she wrote, "Made Mr C.

dress and go with me – had his [photograph] taken. Bought an album. Gen. [John H.] Means gave me his. Met at the artist's rooms Hal Fraser & his sister, Mrs Frederick Frazier, Mr [John L.] Manning & Gen [James] Simons. Mr M. promised me his likeness." On March 29, Mary Chesnut received her small photographic portrait, as did her husband his, following which she recorded in her diary, "Mr Chesnut very good – mine like a washer woman."[1]

Enterprising photographers in both North and South, operating galleries large and small, did their utmost to increase patronage throughout the Civil War. The "American Daguerreotype Depot" was established in New York City in 1851 by brothers Charles and Henry Meade. A talented daguerreotypist, Charles Meade had traveled to Europe in 1848 and photographed Louis Daguerre, inventor of the daguerreotype. When he died in 1858, the gallery continued to be known as "Meade Brothers," although Henry worked thereafter in partnership with his sister Mary Ann Meade, who was also an accomplished photographer. Keen to obtain custom from the Federal three-month volunteers in 1861, Henry and Mary Ann Meade advertised in the *New York Herald* on April 20, 1861, "War – Soldiers of 1861 wishing Photographs for friends, call at Mead [sic] Bro.'s, 233 Broadway." Having included the image of the recent hero of Fort Sumter in their gallery of famous people, the Meade Brothers added, "Major [Robert] Anderson's photograph [is] on view."

Of the constant custom received at the "Daguerrean Gallery" run by John S. Young, the *Reporter and Tribune* of Washington, Pennsylvania, commented on July 18, 1861 that "the soldier in dress and undress uniform, alike flock in crowds to have a facsimile of themselves, their families and their friends, artistically done up in Photograph, Daguerreotype, &c, to leave as heirlooms to their posterity and the rest of mankind." A prominent anti-slavery supporter in Philadelphia, photographer Benjamin F. Reimer had produced several portraits of black abolitionist leader Frederick Douglass. Aware of the fact that many soldiers were struggling to provide for their families while away at the front, Reimer advertised in *The Press*, of Philadelphia, on March 1, 1862 under the heading "Change Makes Changes" that he had reduced "the price of those invaluable portraits."[2]

On March 7, 1862, the McClellan Photograph and Ambrotype Gallery at 520 Seventh Street in Washington, DC advertised in the *Daily National Republican* that soldiers could have their picture taken from "50 cents …

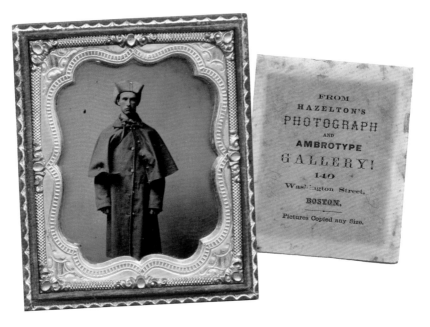

During a visit to the "Photograph and Ambrotype Gallery" of Benson C. Hazelton on Washington Street, Boston, during the cold New England spring of 1861, this unidentified three-month volunteer of the 4th Massachusetts Volunteer Militia wears an infantry overcoat and "Edmands"-pattern hat. Photographer Hazelton had previous military service himself, commanding a company of the 5th Regiment Light Infantry, Massachusetts Volunteer Militia from 1853 through 1854. The trade card found in the back of this image advises that photographs could be "Copied any Size." (Author's collection)

and mailed free of charge to your friends at home." Another artist on Seventh Street, Washington, DC, Mrs M. E. Phipps, announced in the same journal on March 14 that she would not give the ordinary soldier "a Likeness of a colonel, general, or anybody else," but their "own true and perfect Likeness."

A counterpart in the Confederacy, Mrs Elizabeth Beachabard, is the only identified female gallery proprietor advertising in New Orleans in 1861 with an "ambrotype saloon" at 173 Rampart Street. During May of that year, the *Daily Picayune* of that city suggested that a photographer was needed at Camp Moore, the rendezvous and training ground for Louisiana volunteers situated north of Lake Pontchartrain in Tangipahoa Parish,

Trade cards advertising photographic galleries were often placed inside the case behind the photographic plate. Those for G. K. Proctor and James & Co. are illustrated with engravings of the large cameras of the day, the latter being a stereoscopic camera taking "Two Likenesses at Once." All types of cases, frames and lockets were also included on Proctor's card, while D. A. Simons advertised "A large assortment of Frames and Cases cheaper than the cheapest." (Author's collection)

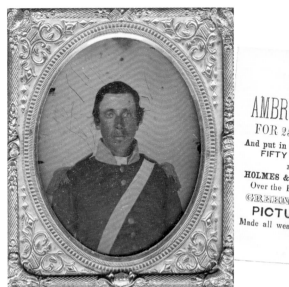

The ambrotype of this unidentified militiaman was produced by Holmes & Burdick, who operated a gallery "Over the Post Office" in Greenwich, Rhode Island, and claimed to work in "all weathers equal." Deterioration of the outer layer of the wood and pressed paper case in which it is housed reveals that newspaper was used to pad it out.
(Author's collection)

stating, "posterity will have a fine chance of being delighted. Their pictures may be taken by the thousand." Elizabeth Beachabard appears to have responded to this advice. On May 21, 1861, a report in the *New Orleans Bee* described the layout of Camp Moore and referred to what may have been her studio as "the shanty of an enterprising ambrotype artist, who furnishes handsome warriors with their 'counterfeit presentments.'" Beachabard died and was buried at Camp Moore of unknown causes on November 22, 1861.[3]

To attract more custom to his "Photograph and Fine Art Gallery," A. J. Styles, a photographer at St. Albans, Vermont, advised in the *Messenger* on February 6, 1862, that he had just received for his studio "NEW BACK GROUNDS, [and] BALUSTRADES, &c., &c." Born in Brandenburg in the Kingdom of Prussia in 1832, William Reiterman opened an

"Ambrotype Gallery" in Findlay, Ohio, in 1858. On February 5, 1864, the *Hancock Jeffersonian*, reported "Reiterman is making photographs and *carte de visites* [sic] daily of returned soldiers in as good style as at any other gallery in the State. He gives soldier boys an especial invitation." With the casualties of war in mind, Matthew Brady's National Photographic Art Gallery in Washington, DC stated in the *Evening Star* on August 10, 1864, that they "WANTED – A SALESMAN. An invalid soldier preferred."

The Southern press of 1861 also did much to encourage the photographic trade. In Louisiana, the *Daily Picayune* of New Orleans exclaimed:

> Every young man who goes to war ought, before starting, leave his likeness with his mother, sister, wife or other dear parent, and every lady whose husband, or brother, or son is sent to Pensacola ought also to give her miniature to the gallant young volunteer, for, during the long night watch, or around the camp fire, it may be his only solace to look at the picture and kiss it.[4]

The outbreak of Civil War in 1861 prompted a surge of patriotism throughout the Northern States as volunteers enlisted to preserve the Union formed by their forefathers. An engraving of a clean-shaven Abraham Lincoln clipped from an 1860 newspaper and tucked in behind this ninth-plate tintype of a Michigan corporal by an unknown photographer leaves no doubt of his support for the president and commander-in-chief. (Author's collection)

This young Rhode Island volunteer was photographed at the "Ambrotype and Photograph Rooms" of George C. White in 1861. White was one of 19 "Daguerreotype, Ambrotype, and Photograph Artists" listed as having studios on Washington Street, Boston, in 1861. The patriotic mat with stars compliments the military content of this image. (Author's collection)

On April 26, 1861, the *Alexandria Gazette* of Virginia announced, "The military boys of Lynchburg … are having their photographs taken, to leave as momentoes [sic] with the loved ones at home." A center of commerce and manufacture in central Virginia, Lynchburg had several well established photographers at that time. N. S. Tanner had a studio at 124 Main Street in November 1860 where he produced "Photographs Plain" as well as ambrotypes and melainotypes. George W. Kyle ran "Kyle's Gallery" at 136 Main Street and advertised in the *Lynchburg Daily Virginian* a "New Photographic Process," which was probably the albumen print. When Camp Davis was established near Lynchburg in May 1861, volunteers from many other parts of the state also frequented these studios.

Before inserting the photographic plate in a small case, the photographer put a brass mat over it, on top of which was placed a plain glass cover. This "sandwich" of plate, mat and cover glass was then held together by a brass preserver, which was wrapped around all four sides of the image forming a frame. Although there is no reference to the use of patriotic mats in contemporary sources, they are commonly found in cased images produced in the North. The patriotic imagery incorporated on these mats included the Stars and Stripes, eagles, cannon, drums, sailing ships and mottoes such as "E PLURIBUS UNUM (out of many, one)," and "THE UNION NOW & FOREVER." (Author's collection, except top right Dan Binder collection)

Incorporating a rare example of patriotic motifs linking the US with Great Britain, these details of a rare brass preserver, or frame, is sometimes found with pre-Civil War images, and may have been produced in anticipation of the well-publicized visit of the Prince of Wales to Canada and the US in 1860. (Author's collection)]

Little is known of the photographers that volunteers would have patronized in North Carolina at the beginning of the war. According to the *Semi-Weekly Standard* of Raleigh, Esley Hunt operated his Photograph Gallery on Fayetteville Street, with portrait painter Joshua P. Andrews working as a colorist. In the *Weekly Progress* of New Bern, John W. Watson requested on September 3, 1861, that customers wishing to have their "likenesses taken" should call between the hours of 8am and 5pm, as he intended to close his "Daguerrean Gallery" on Craven Street "for the purpose of drilling with a military company." This is probably "J. W. Watson" who enlisted in Confederate service at New Bern on January 27, 1862, in Co. F, 36th Regiment North Carolina Troops, also known as the Cape Fear Regiment of Artillery. Employed on extra duty as a "Boatman" at Fort Caswell, he was eventually captured at Fort Fisher on January 15, 1865. At Smith Grove, near Winston-Salem, photographer W. M. Dulin may also have joined the military as he advertised for sale in the *Spirit of the Age*, of Raleigh, on August 14, 1861 "a complete Set of instruments suitable to the Ambrotype and Melainotype process. Also a

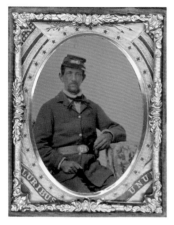

(Left) The photographer who produced this ambrotype had presumably run out of smaller ninth-plate patriotic mats. When asked for one by this unidentified Union soldier, he cut down a sixth-plate Holmes, Booth & Hayden "E PLURIBUS UNUM" mat to fit in the smaller case. (Dan Binder collection)

(Center) Although patriotic mats and cases were not available to photographers in the Confederacy due to a lack of industrial means to produce them, some Southern volunteers showed their patriotism by wearing small flags about their person. This unidentified soldier has tucked a miniature First National flag into the strap at the front of his fatigue cap. (Dan Schwab collection)

(Right) Demonstrating the same gesture of Southern patriotism, this photographer has placed a small First National flag combined with ribbon and a dogwood flower in this cap. This ninth-plate ambrotype must have been produced in April 1861, as this is the only month in which the dogwood tree flowers in the South. (David Wynn Vaughan collection)

lot of cases, fancy and plain, Melainotype plates, preservers, mattings and chemicals."

In Alabama, William H. Chalmers advised in the *Montgomery Daily Post* on April 5, 1861 that he had a "Great Rush for Ambrotypes!" at his gallery on Market Street, which illustrates the enthusiasm among volunteers for photographic souvenirs. In Selma, Wilde & Mosher claimed in the *Morning Reporter* of June 1, 1861 to produce "Ivorytypes, in style unsurpassed in the Confederacy," while at a more rural location in his "Gallery of Fine Arts" at

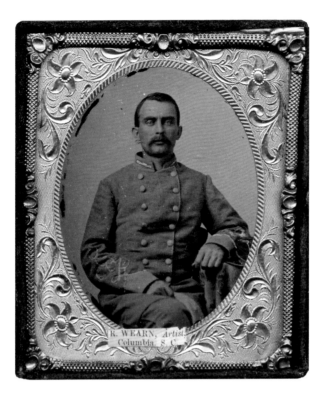

The small and roughly cut printed label stuck to the mat of this image of an unidentified
Confederate second lieutenant reads "R. WEARN, *ARTIST*, Columbia, S.C.," which
indicates it was produced by Richard Wearn, who opened a photographic gallery in
Columbia in 1859 and ran it until his death by suicide in 1874.
(Matthew Oswalt collection)

Florence, Alabama, ambrotypist C. W. Prior stated that "country produce"
would be taken "in exchange for pictures." In Canton, Mississippi,
John E. Hulbert was also experiencing hard times in July 1861 as, when
advertising his ambrotypes in the *American Citizen*, he stated, "Owing to the
panic in general, and the collapsed condition of his pocket-book in particular,
he will finish pictures at half the regulation price."

Farther west, photographers in Confederate Tennessee made the most
of that state's secession from the Union on June 8, 1861. At his "Southern
Photographic Temple of Fine Arts" in Nashville, Charles C. Giers was

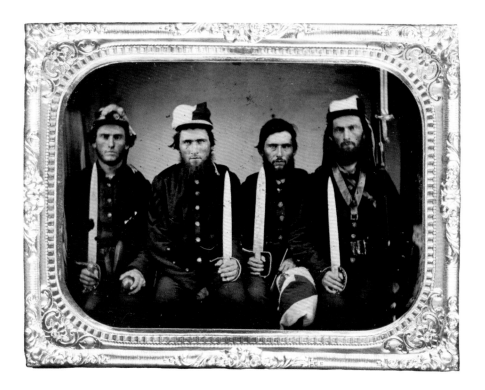

All four Pattillo brothers enlisted in Co. K, 22nd Georgia Infantry in 1861. They each hold D-guard Bowie knives. The man at left appears to hold a grenade while the man at right must have been a color bearer, as he has around his neck a leather harness for carrying a flag. Three of the brothers wear "Sicilian" caps with "Havelocks" made from small First National flags. The fourth brother has another flag draped over his knee. (David Wynn Vaughan collection)

producing, "Ambrotypes!! Photographs!!! *Carte de Visite*. French style, with column railing background etc." Continuing to ply his trade following the Union occupation of the city on February 25, 1862, Giers displayed images of "Major-General Rosecrans, Rousseau, Negley, Sheridan, and a great other Feds, and Confeds."[5] Owning a "Picture Gallery" on Public Square in Clarksville since 1857, Irish-born W. J. McCormack did his best to support the war effort in August 1861 by donating "the entire proceeds of a week's photographing" to the fund being raised to provide winter

(Top and left) Locks of hair were often place behind images as a memento of loved ones. Two locks of hair were found behind this ambrotype of James H. Ray, 11th Virginia Infantry. The pad has been inscribed with "LYNCHBURG RIFLES/J. Ray/Co. E 11 Va. Regt./ Lynchburg, Va." (Liljenquist Family Collection, Library of Congress)

(Right) Another patriotic symbol worn by many Confederate volunteers was a secession cockade. Farmer Peter S. Arthur enlisted in the Southern Guards (Co. B), 11th Virginia Infantry, on April 23, 1861, and died of typhoid fever at Camp Harrison near Fairfax courthouse on September 10, 1861. In this sixth-plate tintype he has a large blue cockade attached to his shirt. (Liljenquist Family Collection, Library of Congress)

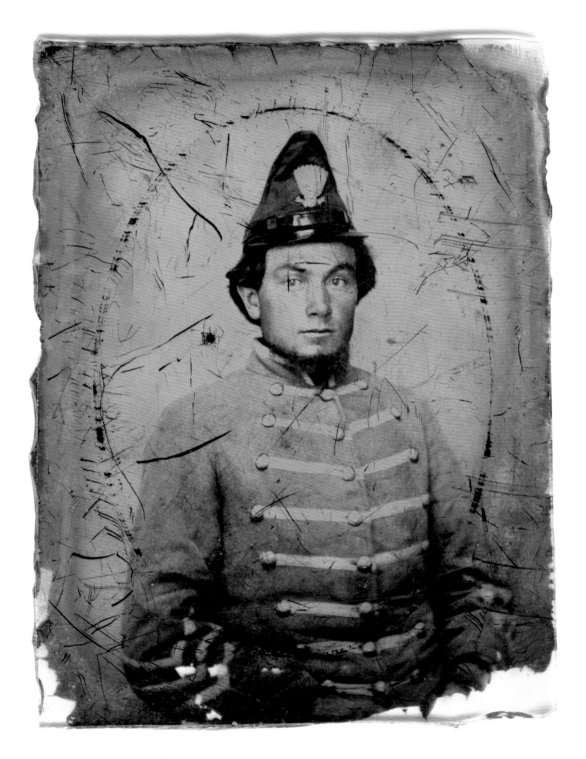

Based on the "Sicilian" cap popularized by the Italian revolutionaries led by Giuseppe Garibaldi in 1860, the headgear worn by the unidentified militiaman in this clear glass ambrotype consists of a bag-like cap designed to drape to one side. However, the brass pattern 1851 Pompon Eagle badge attached to its front has enabled the wearer to stand the cap upright for the camera. (Author's collection)

Very few antebellum or early Civil War militia or volunteer companies wore red coats. One such unit was the Abbeville Minute Men, of Abbeville District, South Carolina, who enlisted for six months' state service as the Abbeville Volunteers, becoming Co. D, 1st South Carolina (Gregg's) in January 1861. The local Abbeville press made several references to the distinctive dress of the young men who joined that company, stating on one occasion that they wore "a red frock [coat] and dark pants," and a few days later commenting that their "red coats" made them "very conspicuous." Perhaps this unidentified red-coated soldier with small secession cockade pinned to his chest was a member of the Abbeville Volunteers and one of thousands of South Carolina militiamen who assembled in Charleston Harbor intent on capturing Fort Sumter in April 1861. (Author's collection)

According to the label on the reverse of this ninth-plate tintype, this unidentified Confederate or "Border Ruffian" was photographed by "R. F. Adams, Kirkwood, Mo." About 50 miles west of St. Louis, Missouri, Kirkwood had strong Confederate affiliations at the beginning of the Civil War. Rodney F. Adams was listed as a daguerreian, ambrotypist and photographer at the corner of Main and Lexington Streets, Harrodsburg, Kentucky in 1859–60, and probably arrived at Kirkwood during 1861–63, as by July 1863 his gallery was at Fourth and Chestnut streets in St. Louis. (Print in author's collection)

clothing for the "gallant boys" of the 14th Alabama Infantry serving in Virginia. Indicating a growing shortage of photographic supplies in the South, the *Clarksville Chronicle* added that "Photographs [or albumens] only will be taken, as Mr Mac. hasn't the stock to spare for other pictures." By mid-October, McCormack was again able to produce "all kinds of Pictures … Having been quite successful in several smuggling operations," running chemicals and supplies through the Union lines.[6]

Another Confederate "artist" having experienced a shortage of chemicals and materials, A. L. Warner advertised in the *Washington Telegraph* of Hempstead County, Arkansas, on January 22, 1862:

Not blockaded, My Picture Gallery is again opened and a good selection of cases in hand. Those who desire Types either of themselves or friends would do well to make an early application, as my present stock of material will soon be consumed, and no more to be had except at exorbitant prices.

Although the photographer responsible has not been positively identified, it is possible that R. L. Wood, of Macon, Georgia, produced this image of the Oglethorpe Infantry, of Augusta, Georgia. Photographed on April 6, 1861, after their arrival at Camp Oglethorpe, Macon, *en route* for Pensacola, Florida, the company marched into town in their dress uniform and paraded outside Wood's Gallery, where they were photographed in sections and then as a whole unit. Curious citizens can be seen in the background standing in front of the armory at Macon.
(Miller's Photographic History of the Civil War)

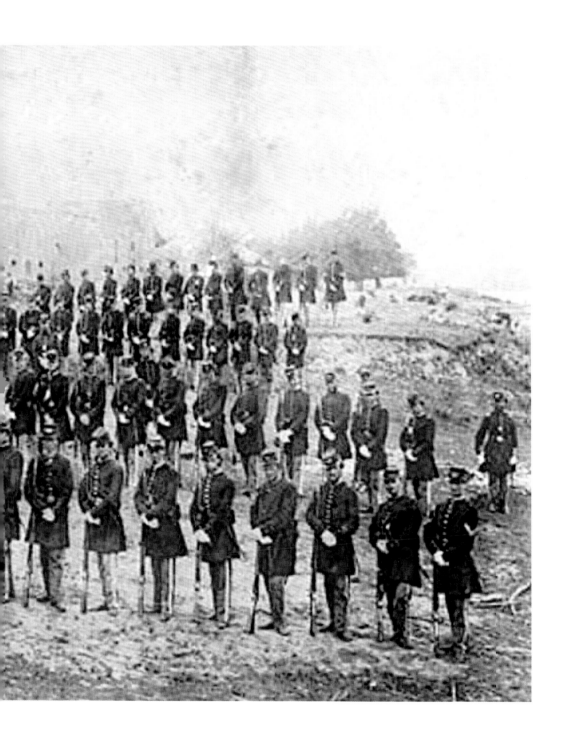

Unlike most other Confederate states, many photographers in Texas continued to work throughout the war due to largely uninterrupted supplies being run through the Union blockade into Galveston, which remained open until June 1865. A 50-year-old native of South Carolina, R. E. Curlee announced in the *Tyler Reporter* on April 11, 1861 that he had resided in Texas for several years and indicated "now that Texas has suceded [sic]," he expected to remain right there. Peter Vivier and Gustavus A. Fagersteen in San Antonio attracted custom in the *Hempstead Courier* of April 6, 1861 by warning, "Mothers! Fathers! Brothers! Sisters and Friends! what would you not give if the image of the absent or lost, might still ever smile upon you as in life! Then delay not. 'Secure the shadow ere the substance fade.'" In the *Northern Standard* of Clarksville on September 13, 1862, E. T. Dudley informed patrons who wanted their picture made, "Call soon[,] as I belong to Gould's Regiment." Dudley had enlisted in Co. A, 23rd Texas Cavalry, commanded by Colonel N. C. Gould, on April 12, 1862. By September 7, 1863 he was listed as being on "detached service," which may indicate he became an army photographer in Confederate service. A photographic and ambrotype artist on Avenue H in Galveston, Rudolph Cordes joined the Lexington Grays (Co. H), 2nd Texas Infantry, and by January 1865 was also on detached service as a "detective" in the Provost Marshall's office.[7]

In Georgia, the *Macon Daily Telegraph* of April 6, 1861 declared:

> If the soldier wishes ... to try to keep his hold on the affections of the girl he's left behind, he will secure a good likeness of himself by calling into the palatial establishment of R. L. Wood, on Mulberry street ... Wood offers facilities which will undoubtedly attract the attention of those who are desirous of procuring an accurate likeness of themselves to leave to some near friend before they take their stand in front of the yawning cannon of Fort Pickens.

The *Telegraph* also stated, "A Fine Likeness of our Popular Governor can be seen at Wood's Gallery, the same having been taken previous to his departure from our city yesterday morning."[8]

Born in Connecticut in 1820, R. L. Wood had operated a gallery in Macon, Georgia, since 1850. With volunteers gathering at Camp

Oglethorpe near Macon in February 1861, he became busy photographing whole military companies such as the Oglethorpe Infantry and Clinch Rifles, as well as producing portraits of individual soldiers. Part of the first call made by the Confederate Government for troops for service in Pensacola against Union-held Fort Pickens, the Oglethorpe Infantry of Augusta, Georgia arrived at Camp Oglethorpe on April 2, 1861, and mustered in as Co. D, 1st Georgia Infantry, commanded by Colonel James M. Ramsey, the next day. Writing home from Camp Oglethorpe on April 5 using the pseudonym "Lennox," Third Lieutenant William O. Fleming stated, "At the particular request of Mr Wood, the Photographist of Macon, we parade to-morrow morning for the purpose of allowing him to execute a photograph of the company. I have several times visited his Gallery, and have been highly delighted each time, examining the beautiful specimens of his art there displayed, and visitors to this city should by all means pay it a visit." Recording the occasion which occurred the next day, the *Macon Daily Telegraph* reported:

> The Oglethorpe Infantry, Capt [Horton B.] Adams, marched up from the Camp Ground last Saturday Morning and drew up in front of R. L. Wood's Photograph Gallery, where a photographic view of the Company, in sections, was taken. After being taken in this position, they were wheeled into line by sections and another photograph was taken. According to an announcement in our columns that they would drill in the streets, a large crowd had assembled to witness the scene. But, we learn that they were too much fatigued, having gone through their usual drill early in the morning … Considerable disappointment was manifested on the countenances of many as the Oglethorpes marched back to their quarters; but the expression was general that no better drilled men have ever appeared on the streets of Macon.[9]

Another Macon photographer, J. A. Pugh, had operated Pugh & Bro's Celebrated Gallery at the Triangular Block in the city since 1859. Also very busy in April/May 1861, he published a humorous "battle report" on April 6, 1861, declaring that his operators had "taken," or photographed, "One Regiment and One Battalion of Volunteers at Camp Oglethorpe yesterday … Numbering, in all, about 1,200 Soldiers! Including The

Governor of the State! And a large number of the Citizens!" Elaborating on his work, Pugh explained:

> The attack was made on the right wing of the camp, taking the gallant Company from Houston [Southern Rights Guards], Capt Houser, commanding. The Heads of each Member all taken off, so that *Each Private is Distinguished!!* A charge was then made on all the Companies, just as they formed into line; and again as the Governor passed in Review; and again as the Regiment passed in Review; and again as His Excellency was addressing the Regiment; the whole force was taken at each charge, and the result can be seen at Pugh's Celebrated Photographic Gallery.

As a last shot, the photographer added, "Soldiers can have their Ambrotypes taken AT HALF PRICE, on the Camp Ground, during the encampment." Elaborating on the latter promise and addressing the 5th Georgia Infantry, which had just organized at Camp Oglethorpe, Pugh advertised on May 13, 1861, that the "Color of the Uniform" would be rendered true to nature, and stated, "To accommodate those in Camp, who wish their Pictures with their guns, knapsacks, and everything on, to start for the seat of the war, one of the firm will be on the ground, in the building in the center of the Camp, with Apparatus, Cases, and everything ready to put up fine pictures on the spot."[10]

Before they arrived at Camp Oglethorpe to join the 5th Georgia, the Clinch Rifles of Augusta were photographed by Tucker & Perkins. Established in Augusta since 1851, Isaac Tucker, with J. W. Perkins, operated the Photographic Gallery of Art opposite Adams' Express Company in Broad Street, and also supplied materials and chemicals to other photographers. On March 9, 1861, this firm photographed a flag presentation to the Clinch Rifles and five days later had an albumen print of the occasion "suspended near the entrance to their Art Gallery." They presented a copy of this photograph to the Rifles as they departed for Macon on May 7, 1861. By the end of September 1862, Tucker & Perkins had sold all their "Photographic and Ambrotype Stock" and closed their gallery. On September 11, 1863, J. W. Perkins was enrolled "for the war" in the Wheeler Dragoons, which formed part of the 1st Georgia Regiment of Local Troops.[11]

Active as a "daguerreian" in Baltimore, Maryland, in 1851, Andrew J. Riddle had moved farther south to Columbus, Georgia, by

The decorative velvet pad inside image cases occasionally had the photographer's name impressed on it. That at left was used by Andrew J. Riddle, who operated the "St. Nicholas Daguerrean and Photographic Gallery," also known as "Riddle's Picture Gallery," in Jones' New Building, corner of Broad and Randolph streets, in Columbus, Georgia, from 1856 through 1860. The pad in the half-plate sized case at center advertised Charleston photographer George S. Cook. From the same city, C. J. Quinby used the pad at right in some of his cases. (David Wynn Vaughan collection/Citadel Archives, Charleston, SC/ courtesy of Neill Rose)

November 1856, where he opened "St. Nicholas Daguerrean and Photographic Gallery," also known as "Riddle's Picture Gallery." Listed as an "Artist" resident at Rome, Georgia, by 1860, he moved to Richmond, Virginia in September 1862 and opened a gallery at 151 Main Street. In order to keep his business going, he twice attempted unsuccessfully to smuggle photographic materials from the North and was eventually arrested by Federal authorities. In 1863, pleading for release in a statement to Major Levi C. Turner, Judge Advocate for the Union Army around Washington, DC, he explained that in November 1862 he was arrested in Charles County, Maryland, with "two trunks full of photographic stock." Taken to the capital, his goods were confiscated and he was fined $100, but "set at liberty to return home with limited means." Back in Richmond, he borrowed money and continued to run his gallery, saving "a few thousand 'Confederate'

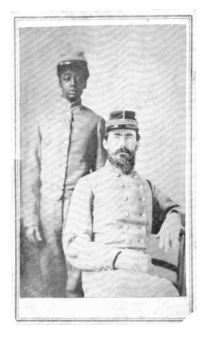

Only a few Civil War images show African Americans in Confederate uniform. This *carte de visite* by Andrew J. Riddle of Macon, Georgia, is of particular interest as it was unusual for either a Confederate officer or enlisted man to be photographed accompanied by a servant or slave. Note the officer, whose rank of captain is distinguished by the three bars on his collar and three strands of lace on his cap, is completely in focus, while the African American, in neat round jacket and cap, is slightly out of focus as he stands farther away from the camera, which may have been an intentional part of the photographer's composition. (David Wynn Vaughan collection)

money," with which were purchased "Gold and Greenbacks [US dollars] in Richmond."

Attempting to run the "underground Rail Road" again in April 1863, Riddle reached New York City where he purchased more stock, probably from E. & H. T. Anthony, and started for home, but on June 4, 1863 was "overtaken and arrested by the 8th Pa. Cavalry, on the road at Mattox Creek in Westmoreland County, Virginia." Taken to the headquarters of Brigadier General Marsena R. Patrick, Provost Marshall of the Army of the Potomac, his illicit stock was once again confiscated and he was

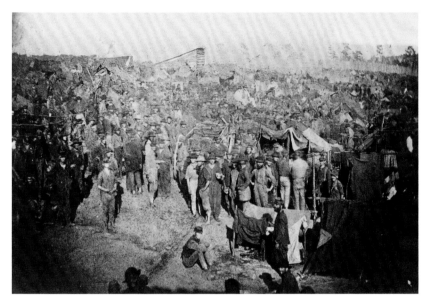
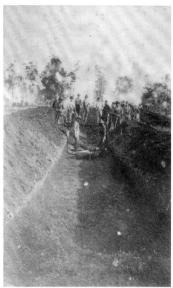

(Left) When first published in New York City by A. J. Riddle in September 1865, this albumen print was entitled "Andersonville Prison, Georgia. *View from the Main Gate.* Issuing Rations to thirty-three thousand Prisoners." (Library of Congress)

(Right) Originally captioned "How they buried them at Andersonville, Georgia," this albumen was also produced by A. J. Riddle on August 16, 1864.
(Albumen courtesy of David Wynn Vaughan)

incarcerated in the prison barge *Wallkill* anchored off Anquia Creek in the Potomac River, and thence moved to the Old Capitol Prison in Washington. Pleading his case, Riddle stated, "To which section did I contribute the most money? I bought Gold in the South with 'Confed' scrip, and spent it in the North for articles that are no earthly use … This is a plain and truthful statement, asking you to be lenient with me as possible, and permit me to return to my wife and children."[12] He was released and returned south to Macon, Georgia, where he established a gallery on Mulberry Street at "Wood's Old Stand," once occupied by R. L. Wood, which was later known as "Riddle's Photographic Temple." By May 1864 Riddle was also involved in supplying photographic

materials to the Confederate States Engineer Department at Atlanta, Georgia, following which he advertised himself as "Chief Photograph/Division of the West."

At some point after this, Riddle was commissioned to photograph Brigadier General John H. Winder and Captain Henry Wirz, commanders of Camp Sumter, otherwise known as Andersonville Military Prison, in Georgia. Completing the 60-mile journey from Macon to Andersonville, he also seized the opportunity to produce views of as much of the prison camp as he could. It is not known exactly why Winder and Wirz permitted him to take views that so graphically depicted the appalling conditions within the 26-acre camp. Although they appear not to have been published in the Confederacy, their unofficial circulation may have been an attempt to persuade the Lincoln administration to resume the prisoner exchanges it had halted in 1863 when the Confederacy refused to treat captured African American soldiers the same as whites.

By August 1864, Andersonville extended across 26.5 acres and contained more than 31,000 malnourished prisoners, many of whom were dying each day from scurvy, diarrhea, and dysentery. Of Riddle's visit, former prisoner Private John McElroy, Co. L, 16th Illinois Cavalry, later recalled, "As a former 'star-boarder' of Andersonville, I well remember seeing a photographer with his camera in one of the sentinel boxes near the South Gate during July or August [1864], trying to take a picture of the interior of the prison." Another ex-prisoner, Sergeant Major Robert H. Kellog, 16th Connecticut Infantry, saw Riddle moving around outside the compound and noted in his diary, "Some artists from Macon have been taking pictures of our misery from posts around the stockade. They will probably adorn the parlor of some chivalrous sons of the South." Following their publication, ex-Andersonville prisoner Sergeant Major Warren L. Goss, Co. H, 2nd Massachusetts Heavy Artillery, produced a detailed description of nine of Riddle's images. He also explained how many of the prisoners were moved to "other parts of the prison limits" to prevent their movement from spoiling the photographs. Having survived the collapse of the Confederacy, Riddle traveled north in September 1865 and published a series of photographs he had taken on August 16, 1864, for sale at 45 Beekman Street, New York City.[13]

In Charleston, South Carolina, C. J. Quinby continued to ply a steady trade in photographing the soldiery defending the harbor, Fort Sumter,

and coastline. On April 8, 1861, the *Charleston Daily Courier* reported that he was "constantly increasing his specimens in every style, and especially in the cards now so popular. A late sitting of the Nestor of the South, EDMUND RUFFIN, secured a striking portrait." About the same time, George S. Cook asked the celebrated Ruffin to sit for a portrait, to which the "firebrand" secessionist from Virginia had replied, "Though he is a superior artist, I do not think his card photographs, at 50 cents, of which I bought a few, are as good [a] picture as Quinby's at 25 [cents]."[14] Quinby also imported and sold photographic supplies run through the Union Navy blockade. In November 1862 he advertised "English Photographic Goods" selected in London expressly for the company, which included 7,200 each of sixth-plate cases, preservers and mats, 21,600 pieces of sixth-plate glass, 10,000 card boards, and two reams of "Extra Super Albumen Paper." In defense of his home state, Quinby served on local duty in Captain Edward Prendergast's Company (Beat Co. No. 5), 16th Regiment South Carolina Militia (SCM) during 1863, and was

A partially surviving ink inscription on the reverse of this Quinby *carte de visite* identifies this officer as a member of the 18th Battalion South Carolina Artillery. Also known as Manigault's Battalion or South Carolina Siege Train, this unit was originally formed from three independent artillery companies during the summer of 1862, and served in the Charleston defenses until the beginning of 1865 when it was broken up, with some men joining field artillery and others becoming infantry. (Author's collection)

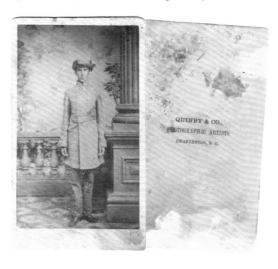

reorganized for six months' service in Co. A, 1st State Troops, also known as the First Regiment Charleston Guard, from September through December 1863.[15]

The Federal capture of Port Royal, South Carolina, on November 7, 1861, caused considerable alarm and panic in Charleston. As a result, the entire 4th Brigade, Second Division, South Carolina Militia, commanded by Brigadier General Wilmot G. DeSaussure, was ordered out on active duty. As a corporal in the same militia company as C. J. Quinby, Charleston photographer George S. Cook closed his gallery on King Street and joined his regiment at Camp Charleston on the Washington Race Course, where he drilled and trained with the rest of his regiment from November 9 through December 12, 1861. However, by December 19 he had returned to the city and reopened his gallery, on which occasion the *Charleston Mercury* reported, "The temporary closing of the establishment was owing to the fact that the proprietor had shouldered the musket, in common with the large majority of his fellow citizens."

On September 8, 1863 the photographic services of George Cook were once again required at Fort Sumter. By order of Brigadier General Thomas Jordan, Beauregard's chief of staff, and accompanied by James M. Osborn, Cook was tasked with producing views of its ruined state. At this time Osborn was on detached military duty, having been called out for about two months' service once again with the 1st Regiment Artillery, South Carolina Militia, in the newly designated Company C. Their visit coincided with the ironclad attacks that occurred that day and resulted in one of the first battle action photographs on the latter occasion (see Chapter 6). With his gallery still open for business as late as June 27, 1864, George Cook was reported in the *Charleston Daily Courier* to be "prepared to furnish photographic portraits of … officers, deceased or living, from the excellent originals, of which he has a large gallery and collection from his own daguerrean efforts."

Active as a daguerreotypist in New Orleans since 1854, Gustave A. Moses had migrated to the US from Bavaria with his family about 1845 and learned the daguerreotype process from his father at an early age. By 1858 he operated the "B & G. Moses Photograph Saloon" at 46 Camp Street with his brother Bernard. During June 1861, this gallery was used as a recruiting office for a militia company called the McClelland Guard, with Bernard being elected captain and Gustave first lieutenant on June 29. When the McClelland Guard was enlisted for Confederate service on July 21 as Co. D,

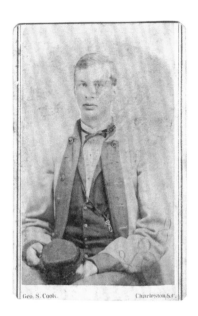

(Left) The young South Carolina second lieutenant in this *carte de visite* by George S. Cook has both lapels on his frock coat buttoned back to display the colored lining. The back mark (top right) is framed by an important Victorian "belt and buckle" motif, which represented the eternal loop protecting "all it encircles." (Author's collection)

(Lower right) Published in the *Charleston Mercury* on December 23, 1861, this "Card" by George S. Cook advised prospective customers that his gallery had reopened after his "five weeks of military duty." (Author's collection)

Jackson Regiment, Louisiana Militia, commanded by Lieutenant Colonel J. B. G. Kennedy, the Moses brothers closed their gallery and marched off to war. When the Jackson Regiment arrived at Columbus, Kentucky, to join the Army of Mississippi in August 1861, General Leonidas Polk ordered it to be reorganized as the 5th Louisiana Battalion, which served as infantry support for the heavy artillery batteries during the battle of Belmont on November 9, 1861. The 5th Battalion was expanded into the 21st Louisiana Infantry in February 1862, and Gustave Moses deserted for unknown reasons while this regiment was guarding African American slaves building fortifications at Randolph, Tennessee in May 1862.

Nothing further is known about Gustave Moses until August 1864, when he reappeared in Union-occupied New Orleans and established a gallery with Eugene A. Piffet at 93 Camp Street. In late September of that year, Brigadier General Richard Delafield, US Army Chief of Engineers, commissioned Moses and Piffet to photograph Fort Morgan and Mobile Point, in Mobile Bay, Alabama, which had been captured by Union forces led by Major General Gordon Granger. The Confederate surrender of that installation helped close down Mobile as an effective Confederate port city. By late 1864, Moses and Piffet were selling photographs of Fort Morgan.[16]

Advertising for Ohio-born photographer Andrew D. Lytle on April 11, 1861, the *Daily Advocate* of Baton Rouge, Louisiana, advised, "It is a fixed fact that we are about to be called on to lend a helping hand at Forts Sumter and Pickens, and it would be advisable to leave your likeness with your

In this roof-top photograph by Andrew Lytle produced shortly after Baton Rouge, Louisiana, was abandoned by the Confederates in April 1862, Union infantry form up in the street after disembarking from the recently captured steamer *Sallie Robinson*, which can be seen by the quayside with the Mississippi River in the background. (United States Army Heritage & Education Center, Military Order of the Loyal Legion of the United States)

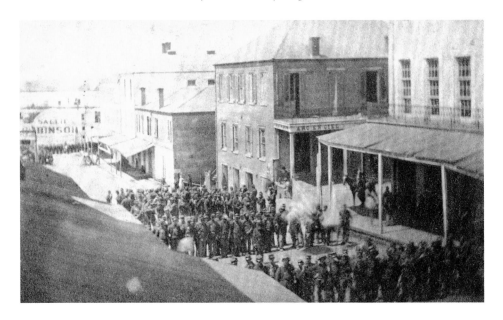

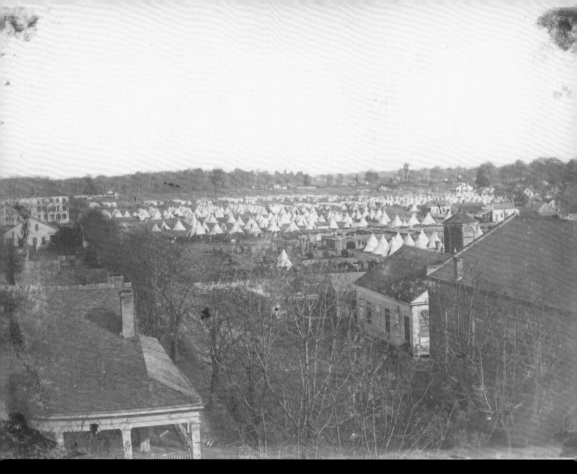

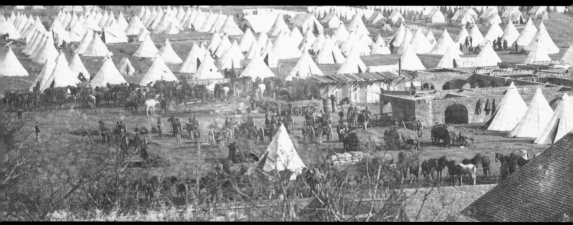

Home-front photographer Andrew Lytle again climbed to a roof-top to obtain this view of the Federal occupying army in Camp Banks outside Baton Rouge in late July 1862. When the Confederate army counterattacked on August 5, 1862, this campsite became a battlefield, and sick and wounded Union troops in the field hospital had to grab their weapons and help repulse the assault. The close-up reveals a six-gun battery of artillery drilling with corralled horses in front and rear. Such information would have been very valuable if passed on to Confederate authorities by Lytle. (Andrew D. Lytle collection)

One can imagine the pleasure that Colonel Benjamin H. Grierson experienced when asked by Andrew Lytle to sit with his staff for a photograph after his successful cavalry raid from La Grange, Tennessee to Baton Rouge, Louisiana in 1863. He poses with chin in hand with an expression of complete assurance, and was obviously unaware that the man behind the camera was a Confederate spy. (Miller's Photographic History of the Civil War)

friends before going; so go at once and have Lytle make a fine picture of yourself. Gallery opposite the Harney House." A well-respected photographer in Baton Rouge throughout the Civil War, Lytle later became known as "the camera-spy of the Confederacy." Having learned the daguerreotype process during the mid-1850s at the Art Palace operated by William Southgate Porter in Cincinnati, Ohio, he traveled through Alabama, Georgia, and Tennessee during the warmer seasons of the year, and by 1857 had arrived in Baton Rouge, where he established a permanent studio in the Heroman's

Brick Building. In 1859 Lytle moved his studio to Main Street a few blocks from the Mississippi River and close to the Harney House, one of the busiest hotels in Baton Rouge. As the nation moved toward Civil War in late 1860 he advertised in local newspapers in both East and West Baton Rouge parishes. He likely stayed busy in 1861 creating portraits of Confederate soldiers, as on May 2 the *Daily Advocate* advised its readers in mock military terms, "The latest dispatches say Lytle's Gallery is crowded every day with 'our boys,' getting their pictures before leaving home for the wars. Go early and do the same, opposite the Harney House." However, few of Lytle's Confederate portraits are known to have survived.

In true entrepreneurial style, when Federal forces occupied Baton Rouge on May 9, 1862, Lytle began his photographic relationship with the US Army and Navy creating numerous images of the occupying military encampments on the north edge of town and elsewhere in the locality. It seems he began by photographing the occupying forces and their naval vessels from his studio. However, to capture better images of Farragut's fleet he moved his camera to the riverfront and occasionally aboard vessels on the river (see Chapter 6). He also gained access into other buildings in town to create birds'-eye views of Federal army camps, and set up a canvas studio in the camps to visually document Union troops at leisure.

As a result of special arrangements with the military, Lytle was able to procure chemicals and supplies from E. & H. T. Anthony in New York. However, his work had a clandestine purpose missed by the Union authorities, as he is believed to have worked as an agent or spy for the Confederacy. According to his son, Howard Lytle, following the initial Federal occupation of the city in May 1862 he "used to signal with flag and lantern from the observation tower on the top of the ruins of the Baton Rouge capitol to Scott's Bluff, whence the messages were relayed to the Confederates near New Orleans; but he found this provided such a tempting target for the Federal sharpshooters that he discontinued the practice."[17]

More significantly, Lytle's camera work focused on the activities of both Union Army and Navy at Baton Rouge, and prints from the negatives were possibly smuggled to the Confederate leaders, providing graphic evidence of the concentration and movement of enemy forces. Most of these images were produced after the main battle for the city. The Union brigades of Brigadier General Thomas Williams were encamped on the outskirts of the city when Confederates under General John C. Breckenridge attacked in a dense fog and

seized the enemy camp. But the tide of battle turned when Union troops counterattacked and finally seized full control of the area, although Williams was shot in the chest and killed. Very busy during this period, Lytle photographed the Union encampment before the battle. After the occupation he produced views of troops at drill or demolishing private dwellings so that their gun boats in the river might have a commanding view of the city.[18]

In Union terms, Lytle got a scoop when he persuaded Colonel Benjamin H. Grierson to pose for him after that general's famous march from La Grange, Tennessee, south through Mississippi. Marching 600 miles in 16 days, Grierson destroyed about 60 miles of railroad track and telegraph lines, plus numerous stores and munitions. He evaded Confederate patrols sent out to intercept him and brought his command safely through to Baton

(Below and right) Produced by Nathaniel Routzahn at his "Temple of Art" in Winchester, Virginia on November 2, 1862, this portrait of "Stonewall" Jackson is significant because it reveals the button, fourth from top in the right-hand row, hurriedly sewn back on by the general minutes before being photographed. (right) Jackson sat for his portrait again when Daniel T. Cowell, of Minnis & Cowell, in Richmond, Virginia, visited his headquarters at Fredericksburg, Virginia, during April 1863. (National Archives/Valentine Richmond History Center, Cook Collection)

☞ *IN PRESS—*
AND WILL BE ISSUED IMMEDIATELY,
THE LIFE
OF
STONEWALL JACKSON,
THE HERO OF THE
PRESENT WAR FOR INDEPENDENCE,
ACCOMPANIED WITH A SPLENDID
LITHOGRAPHIC LIKENESS,
From a Photograph taken expressly for us, one week before his death, by Mr. D. T.
COWELL, the excellent artist at the Minnis Gallery.
The book will contain a carefully prepared Biographical Sketch of the great General.

Published in the *Southern Illustrated News*, July 11, 1863, this advertisement refers to one of
three photographs taken by Daniel T. Cowell shortly before the mortal wounding of General
Thomas J. "Stonewall" Jackson by "friendly fire" at Chancellorsville on May 2, 1863.
(Author's collection)

Rouge in May 1863. Earlier, as Grierson's column approached the city, Lytle had climbed up a Feliciana hillside and opened the shutter to capture an image of the Federal horsemen as they arrived in camp.[19]

In order to overcome the shortage of photographic materials and supplies, Nathaniel Routzahn was prepared to smuggle them through the Union lines to keep his studio open at Winchester, Virginia. Born in 1828 in Frederick County, Maryland, Routzahn worked as a merchant and sailor before turning to photography during the 1850s, being listed as an "Artist" in the 1860 census, with a gallery called the "Temple of Art" located in the Masonic Hall at 107 Main Street in Winchester. Following the commencement of civil war, Routzahn was enrolled as a private in Co. C, 31st Virginia Militia, from October through December 1861. However, his service record for this period indicates he was "On detached service. Exempted by the Governor," which may indicate he was working as a photographer in the Confederate service.

On November 1, 1862, General Thomas J. "Stonewall" Jackson posed for a portrait at Routzahn's gallery at the behest of a member of the family of Dr. H. H. McGuire, with whom he dined that day in Winchester. On arrival for the sitting, the general was reminded that a button had dropped

off the breast of his coat. Retrieving it from his pocket, he requested a needle and cotton and promptly sewed it back on, but in his haste it was not aligned correctly. This caused a minister who had accompanied him to the sitting to joke that while Jackson could successfully outwit and destroy enemy forces, he was unable to perform the simple task of sewing a button in a straight line!

Presumably still attempting to operate as a photographer by smuggling chemicals and supplies through Union lines by December 1864, Routzahn was arrested and imprisoned at Fort McHenry, Maryland by order of Major General Philip Sheridan commanding the Middle Military District, being described on this occasion as "a dangerous character." He was eventually released without charge on December 31, 1864.[20]

Regarded as one of the most prosperous photographers south of New York by 1861, Pennsylvania-born George W. Minnis had operated galleries in Petersburg, Lynchburg and Richmond, Virginia since 1847. At the outbreak of civil war, he worked with Connecticut-born Daniel T. Cowell at a studio at 217 Main Street, Richmond. After a visit to the "Gallery of Fine Arts" in August 1860, a correspondent of the Richmond *Dispatch* observed that there were "no idlers in Mr MINNIS' establishment," with three persons "constantly employed in the Photographic department – one in oil colors [John Toole], one in water and pastille [G. M. Ottinger], and one in India ink [A. S. Bradley] – six in all."[21]

Minnis and Cowell produced some of the most important photographs of Confederate statesmen and generals, including Jefferson Davis, Robert E. Lee, and Thomas J. "Stonewall" Jackson. Their classic image of Jackson was taken about two weeks before he was mortally wounded by "friendly fire" at Chancellorsville on May 2, 1863. On July 11, 1863, a message from Ayres and Wade, the editors of the *Southern Illustrated News* of Richmond, who published a book that year entitled *The Life of Stonewall Jackson: The Hero of the Present War of Independence*, stated:

Through the kindness of a friend we were enabled to procure for Mr Cowell a letter of introduction to Gen Jackson, who, immediately upon the arrival of the artist at his headquarters at Fredericksburg, consented to sit for the picture. Three different photographs were taken at the time, one of which was spoiled by the shaking of the instrument. Of the other two, it is needless for us to speak. The *habitues* of the Minnis Gallery know full well the style of

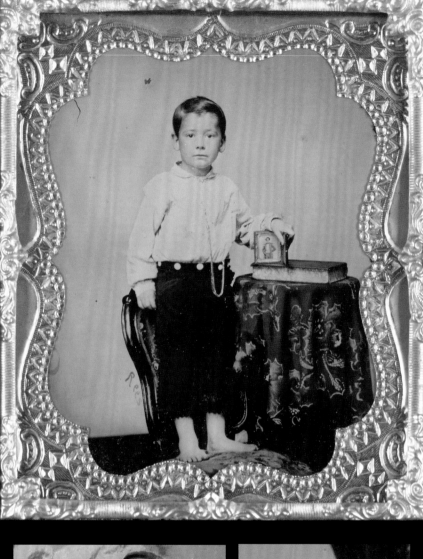

(Left) Photographed standing on a chair by Charles Rees, this unidentified infant holds open an ambrotype of a Confederate soldier. Was the young man mourning his father killed in battle? Beyond the symbolism suggested in the composition, we will never know. The unobtrusive "Rees" signature is written near the chair.
(Liljenquist Family Collection, Library of Congress)

pictures taken at this first class establishment. The three negatives are now in possession of Mr Cowell, who will immediately after the publication of our Book furnish all who wish photographs for the purpose of framing, with a copy of the only life-like picture of the distinguished general in existence.[22]

Having produced wet plate negatives as well as an ambrotype, Cowell's portrait of "Stonewall" Jackson was indeed for sale at the "Gallery of Fine Arts" before the end of the year, as on November 14, 1863, the *Southern Illustrated News* advised, "The likeness of Stonewall Jackson can be had of Messrs Minnis & Cowell, of this city. Large size, $10.00; *carte de visite*, $5.00; both beautiful and truthful pictures." The editorial staff of the *Daily Richmond Enquirer* of August 13, 1863 reviewed a collection of photographs of Southern generals, including Jackson, taken by Minnis and Cowell, and at least 13 engravings based on photographs of Confederate leaders produced by Minnis and Cowell were published on the front page of the *Southern Illustrated News* between September 1862 and October 1863.

One of the most respected photographers in the South, Charles R. Rees, was born in Allentown, Pennsylvania, in 1830, and learned the art of the daguerreotypist in Cincinnati, Ohio, around 1850. By 1851 he and his brother Edwin had opened a gallery in Richmond, Virginia, as Rees Brothers, but Charles relocated to 385 Broadway in New York City, where he had established Rees & Co. by 1854. With fierce competition from nearby photographers including Matthew Brady, E. & H. T. Anthony, and Jeremiah Gurney, he attempted to set himself apart by adopting the name "Professor Reese" and pretended to be a European political refuge with a new process called the "German method of picture making." This involved a division of labor in his gallery, with customers purchasing a ticket in the gallery area, after which they were taken into a dressing room to prepare

(Right) Many photographers employed artists who were also painters of portraits or landscapes to color their images with a hint of pink on the cheeks and lips of the face of the subject, and gold on buttons, belts, rings or jewelry. This beautifully-colored half-plate ambrotype by Rees was probably produced in 1861, and depicts a French-looking Confederate soldier wearing a uniform reminiscent of that worn by officers of Coppens' Battalion of Louisiana Zouaves. The "Rees" signature appears at the base of the photographer's prop. (Liljenquist Family Collection, Library of Congress)

for a "sitting," and next into the "operating room" where they were offered a choice of props and posed for the photograph. Arriving back in the gallery, they waited while the "chemist" worked wonders with chemicals in a separate room before finally receiving their portrait beautifully presented in a thermoplastic or pressed paper and wood case. Although advertising a successful business, Rees had also closed this studio by 1856.[23]

Returning to Virginia by 1858, Charles Rees was probably one of "25 Artists" employed by Tyler & Co. Successful merchandisers of the daguerreian era, they had studios in New Orleans, Louisiana, and Charleston, South Carolina, and operated what they claimed in the *Daily Dispatch* of Richmond, Virginia, on April 18, 1858 was "the largest Gallery in the country." By July of that year, Rees had taken over management of the Richmond concern and advertised "Steam Ambrotypes, Photographs, and Reesotypes (new style)" at his "Headquarters of Art." By February 1859, "Rees & Co's Steam Gallery" had "facilities for taking 500 Portraits daily," and described their premises as occupying "two floors 30 by 70" with skylights "constructed on an optical principle."[24]

When Richmond became the new capital of the Confederacy in May 1861, an influx of politicians and a flood of soldiers meant a dramatic increase in business for the Rees brothers. Having moved their gallery to 145 Main Street, over West and Johnston's bookstore, they advertised "improved Pearl Ambrotypes," which were claimed to be "the most beautiful and durable picture made." Continuing to provide the rapid service achieved by the division of labor developed in his earlier New York City gallery, Rees informed customers on May 8, 1861 that they would not be "detained more than ten minutes to have any number of Likenesses taken," many of which were discreetly signed with "Rees" on the plate. A

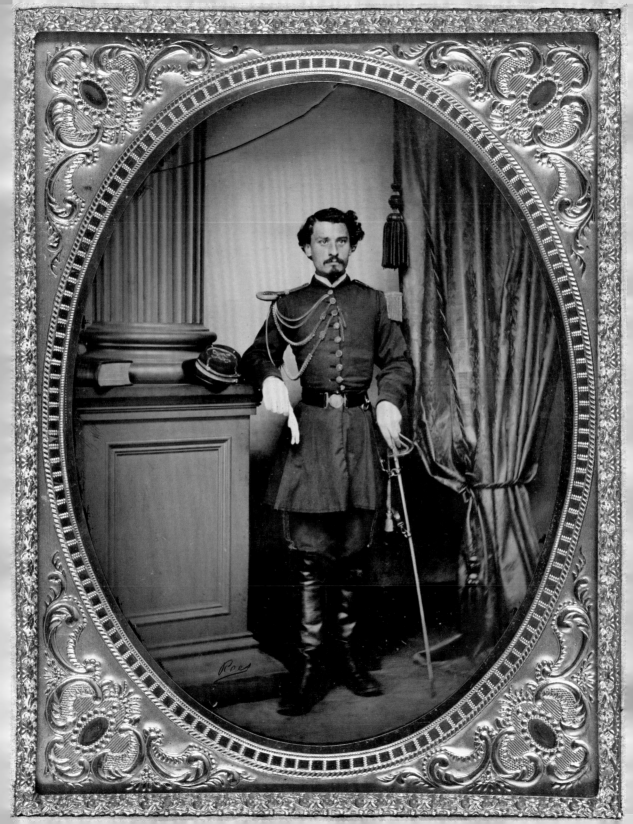

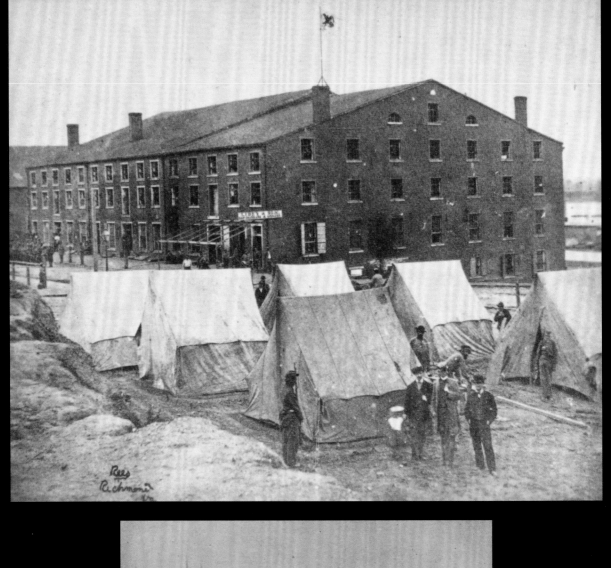

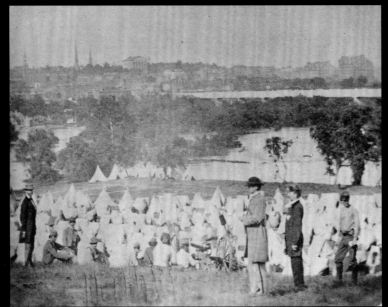

(Top) Photographed by Charles Rees on August 23, 1863, Libby Prison in Richmond developed an infamous reputation for overcrowding and harsh conditions, holding over 1,000 Union prisoners of war, all of whom were officers. The sign for "Libey & Son/ship chandlers & grocers" still hanging above its door indicates the original owners of the building. Prison commandant Captain Thomas P. Turner stands in the foreground, with several civilians including a small girl. (Library of Congress)

(Bottom) Also produced by Rees *circa* 1863, this view shows the prison camp for Union enlisted men on Belle Isle in the James River, which detained a total of about 30,000 prisoners of war from 1862 through 1865, of which at least 1,000 died of disease and malnutrition. Among the officers and standing third from right in the foreground is Captain Turner. Following the collapse of the Confederacy he escaped to Canada via Cuba with General Jubal A. Early. (Library of Congress)

"competent Artist" was "employed at each branch" in his studio, which permitted photographs to be taken "rapidly and successfully, producing a gem every pop." Like many other photographers in the South, Charles Rees showed his allegiance to the Confederacy when called into service as a private in Co. C, 2nd Virginia State Reserves on July 2, 1863. When his term of duty expired on March 5, 1864, he had been absent from the ranks for unknown reasons for only nine days.[25]

The most resourceful of Confederate photographers was Robert M. Smith. Mustered into Confederate service at Blountville, Tennessee, on November 10, 1862, as second lieutenant of Co. E, 61st Tennessee Infantry, he was one of about 290 men of his regiment captured at Big Black River, Mississippi, on May 17, 1863. While incarcerated in Ohio at Johnson's Island prisoner-of-war camp for Confederate officers, he managed to secretly construct a wet plate camera using a spyglass lens, a knife, a pine box and a tin can. He also procured chemicals for the developing process from the prison hospital. Taking advantage of rather lax prison security, he set up a makeshift studio in the attic of Block 4 where he produced tintypes of his fellow prisoners, which he placed in carved hard rubber cases and sold for $1.00 each, thus having a thriving business while in prison. Smith was eventually paroled and forwarded for exchange to City Point on February 24, 1865.[26]

When Charles J. and Isaac G. Tyson established their "Excelsior Sky-Light Gallery" at the "North-East Corner of the Diamond [or center]" in

Both of these Confederate officers of the 61st Tennessee Infantry were captured at Big Black River, Mississippi, on May 17, 1863, and taken to Johnson's Island prisoner-of-war camp on the coast of Lake Erie in Ohio. Shown in the postwar tintype at left, Second Lieutenant Robert M. Smith constructed a makeshift camera and secretly photographed numerous fellow prisoners during his period of incarceration from June 1863 to February 1865, when he was paroled. At right, one of the men he photographed was Captain Francis M. Jackson, Co. G, 61st Tennessee, who was Smith's roommate in Block 3. Jackson was also eventually paroled on February 20, 1865. The original label identifying him remains pasted across the bottom of the ninth-plate tintype.
(Courtesy of Dave Bush and Friends and Descendents of the
Johnson's Island Civil War Prison Site)

Gettysburg, Pennsylvania, during August 1859, they had no idea what the future held for their business and community. By January 1861 they had moved to their "New Establishment" on York Street, "opposite the Bank, and one door below their old gallery," which they later claimed had been

"erected under their immediate supervision." Keeping abreast of the latest developments in photography, the Tyson brothers, with their 12-year-old apprentice William H. Tipton, announced in March 1862 that they were producing "the new style 'Carte de Visite'" and had introduced "a splendid massive column" as a prop in their studio.[27]

Of the events prior to the battle of Gettysburg on June 26, 1863, Charles Tyson recalled the scene outside his house as elements of Early's division of Ewell's corps entered the town after chasing off newly raised Pennsylvania militia, stating that they consisted of "numerous mounted men, some with hats, some without; some in blue and some in gray." Yelling and discharging their carbines and pistols as they rode by, several Confederates tried the locked door of his home and he heard one fellow spell out from the door plate "'T-Y-S-O-N.' Wonder who the hell he is!" Hearing them next start breaking up his wooden doorstep, he let them in saying, "You look warm and dry; we have a well of good cool water in here. Come in and refresh yourselves." Upon entering, some of them wanted bread and butter, but Tyson replied that they did not have enough to share, so they left. The photographer recalled, "They were satisfied far more easily than I expected; they were very polite and gentlemanly."

Five days later, Charles Tyson awoke to find Gettysburg swarming with Union troops, but all the stores were still open for business. Opening his gallery, he was kept busy for several hours, presumably photographing soldiers, until it was too dangerous to stay in his studio and so he closed up. Of his hurried walk home, he recalled, "Cannonading was then going on in good earnest and the people living in Chambersburg street were advised to go further up the town … when I got nearly down to the square, I met one of our officers riding up the street, warning all women, children and non-combatants to leave the town as General Lee intended to shell it."[28] Seeking refuge in Littlestown, ten miles to the south, the Tysons returned to Gettysburg several days after the battle and Confederate retreat to find their gallery largely undisturbed, although a barrel of 95 percent alcohol in the cellar had been emptied.

Working in the wake of the visit of Alexander Gardner and Matthew Brady during July of that year, the Tyson brothers eventually produced for sale their own "Photographic Views of the Battle-field of Gettysburg" during December 1863. At the same time they advertised *cartes* of "Generals, and the old hero John L. Burns, for sale at the counter of the Excelsior Gallery."[29]

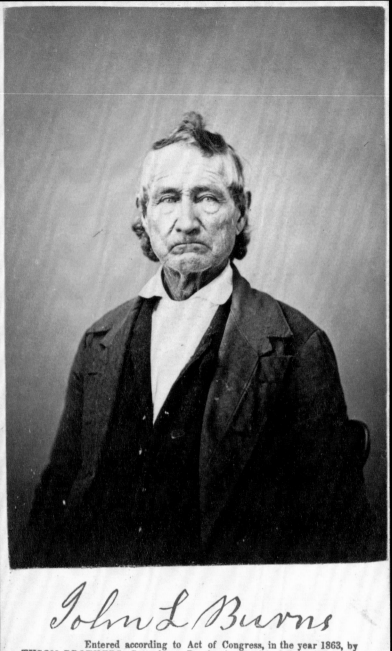

John L Burns

Entered according to Act of Congress, in the year 1863, by
TYSON BROTHERS, Gettysburg, Pa., in the Clerk's Office of the District Court, of the Eastern District of Pennsylvania.

Seventy-year-old John L. Burns was photographed by Charles J. and Isaac G. Tyson, who operated the "Excelsior Photographic Gallery" in Gettysburg, as a result of his heroic participation as a civilian in the Battle of Gettysburg, July1–3, 1863. Picking up his flintlock musket and powder horn, he left his house on Chambersburg Street and walked to McPherson's Farm to join the ranks of the Iron Brigade to fight Lee's invading army. Wounded three times and captured, he escaped back to Union lines. When Lincoln came to Gettysburg to deliver his historic address on November 19, 1863, he asked to meet Burns after the dedication ceremony at the Soldiers National Cemetery, to congratulate him for his bravery. (Library of Congress)

William H. Tipton took over the Tyson gallery in 1868 and soon after began to reissue, or publish for the first time, some of the Tyson brothers' battlefield photographs in a series of 27 stereoscopic views entitled "Sights and Scenes from the Battlefield of Gettysburg." Strangely, he explained on the reverse label that they were "very inferior specimens of Photography," and that he only continued to produce them from the original glass plates because "the public want them, and the opportunity for securing finer results is gone."

Published by William H. Tipton after he took over the Excelsior Gallery in 1868, this view was produced by the Tyson brothers in November 1863. Presumably to sensationalize the image in hopes of increasing sales, the Tysons asked Union troops at Gettysburg for Lincoln's Address to play "dead" among the rocks at Devil's Den on the old battlefield. The man lying at bottom left is Private Jacob Shenkel, 62nd Pennsylvania Volunteers. On November 11, 1863 he wrote in his diary, "went to Round top with an artist to take Some Scenes of the Battle field[.] took one Scene of Dead men…" Thirteen-year-old Tipton likely stands at right while the figure at left may be one of the Tyson brothers.
(Author's collection)

CHAPTER 3

"There is an ambrotypist in camp ..."

PHOTOGRAPHY IN CAMP AND BARRACKS

Photographers could be found in or near virtually every large military encampment in both North and South during the first few months of the Civil War, and individual portraiture was in great demand. "Photographic rooms" established under canvas or in shacks or cabins in these tented cities were primitive establishments compared to galleries found in cities and townships. Although they lacked the space for many furnishings and trappings, they often attempted to create a parlor-like atmosphere by using simple props such as a chair and table covered with cloth. Some campsite "artists" managed to incorporate painted screens as backdrops showing military settings or Greek classical revival-type scenery. Others simply used a plain white screen. Both photographic and written evidence indicates that they were often crowded with customers, especially when regiments of new volunteers arrived in camp.

The presence of photographers in Union encampments continued throughout the conflict. As a result, Northern newspapers often reported their activities. With the Union Ninth Army Corps, Army of Virginia, near Fredericksburg, Virginia, on August 20, 1862, a correspondent for the *New York Tribune* stated:

Decidedly one of the "institutions" of our army is the traveling portrait gallery. A camp is hardly pitched before one of the omnipresent artists in collodion and amber-bead varnish drives up his two-horse wagon, pitches his canvas-gallery, and unpacks his chemicals. Our army here is now so large that quite a company of these gentlemen have gathered about us. The amount of business they find is remarkable. Their tents are thronged from morning to night, and "while the day lasteth" their golden harvest runs in.[1]

With the Army of the Cumberland in March 1864, a reporter for the *Boston Traveler* wrote:

It is remarkable with what persistence the army photographer follows up his profession. I saw the tent of one of them the other day with our advance at Morristown, and another with the forward brigade at Ringgold. They do a good business, for if the soldier has one great weakness it is to have his likeness taken. A good portion of his pay goes in this way, and the mails are loaded with the shadowy momentoes [sic] he sends to those at home.[2]

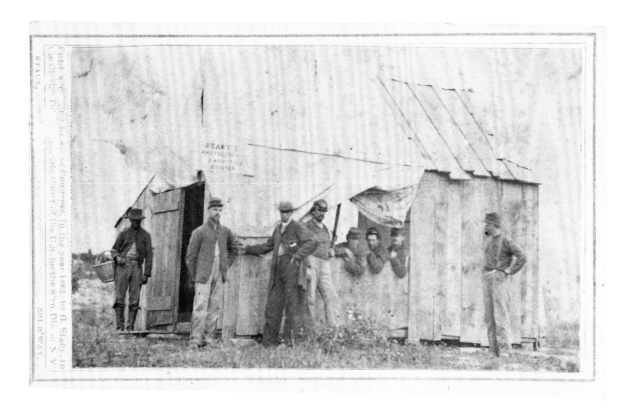

George Stacy was a photographer in New York City from 1859. By the summer of 1861 he had established "Stacy's Photographic Ambrotype Rooms," which amounted to a wooden shack near Fortress Monroe on the Virginia Peninsula where he photographed the Union volunteers encamped there. The canvas of a wall tent covers his skylight and three prospective customers sit waiting inside. Stacy possibly stands third from the left.
(Liljenquist Family Collection, Library of Congress)

Indeed, letters and packages filled the mail bags of the Union postal system and bear witness to the constant presence of the campsite photographer. Writing to his sister Amelia from Bridgeport, Alabama *en route* for Lookout Valley, Tennessee, on October 4, 1863, Lieutenant Peter C. Sears, Co. D, 33rd Massachusetts Infantry, stated, "There is an ambrotypist near hear [sic] and I intend to have a picture taken as soon as possible. You must not expect a very nice one. They only cost one or two dollars." Pay day invariably

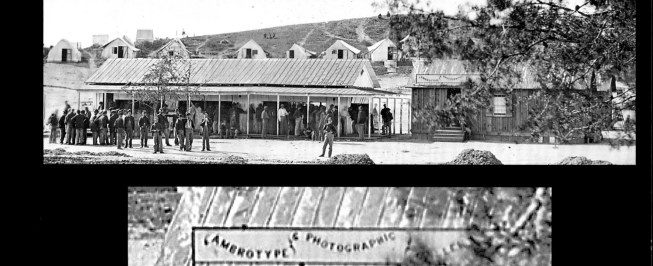

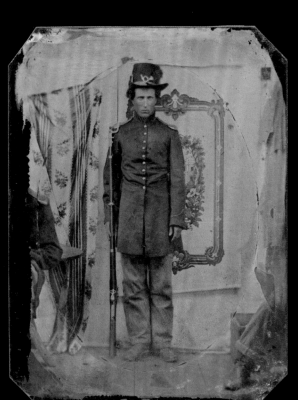

(Top and middle) At this unidentified military encampment, an "Ambrotype & Photographic Gallery" occupies a timber-built cabin next to Sutler's Row, where the troops could also spend their meager pay on clothing, food, and supplies. (National Archives)

(Bottom left) In this quarter-plate tintype of a Union infantryman in full-dress produced in a campsite gallery in 1862, the foot of a waiting soldier can be seen at bottom right, while another man sits at left waiting for his turn in front of the camera. (Author's collection)

(Bottom right) This unidentified Ohio infantryman stands in front of a small plain screen in rather a chaotic studio, with a chair not entirely out of view at bottom left and another screen leaning off to the right. The stand for the neck clamp helping to hold him still is seen behind his feet. He holds a Model 1816 conversion smoothbore musket with fixed bayonet, which may have been his issue weapon, although the revolver was probably a photographer's prop. (Author's collection)

encouraged the soldiers to visit a photographer. In a letter to his sister from Fortress Monroe, Virginia on April 27, 1864, Private Levi McLaughlin, Co. L, 3rd Pennsylvania Heavy Artillery, explained, "I just come from Camp Hamilton. I was there to get my likeness taken on purpose to send to you ... but I never got it taken … But I will … when I get my dress hat if I am here yet." Private Charles Parker, Co. I, 31st Maine Infantry, had a similar experience. Encamped near Parker Station, Virginia, on March 4, 1865, he wrote to his sweetheart Clara Dyer, "Our regiment was paid last Wednesday and the [photographer's] saloon is so full that I could not get near it or I would have had an ambrotype taken to send you."[3]

Volunteers were always eager to be photographed when newly uniformed and armed. With knapsacks slung for the first time, the 19th Massachusetts Infantry broke camp and took the cars into Boston *en route* for Washington, DC, on August 28, 1861. Arriving in the city, Corporal John G. B. Adams was anxious that his "best girl" should see him in "the full garb of a warrior." In his memoirs he recalled, "I arrayed myself in heavy marching order and went to an ambrotype saloon to have my picture taken." Examining the end result, he remarked, "In an ambrotype everything is reversed, so my musket is at my left shoulder, haversack and canteen on the wrong side – in fact, I was wrong to in every respect."

The message written in period ink found behind this image states, "Taken [in] camp east of the Capitol May 8, 1862. Washington D.C. - I was pretty mad at the time as I had to set three or four times…" This may account for the frown on this cavalry sergeant's face. He wears for full dress a Pascal-pattern hat with 1858-pattern crossed sabers plus company and regimental insignia pinned at its front. Brass shoulder scales and white cotton dress gloves complete his full dress, and he presents his Model 1860 Light Cavalry Saber with sword knot and metal scabbard to the camera. (Bryan Watson collection)

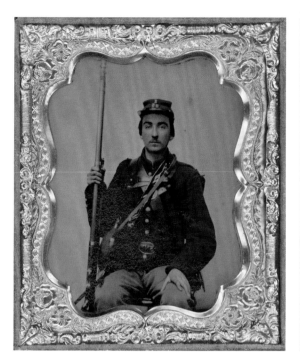
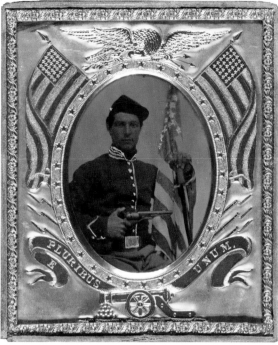

(Left) Images of well-equipped soldiers in "full marching order" are rare, as the soldier seldom had the opportunity or inclination to visit a photographer so attired. This unidentified enlisted man of Co. K, 85th New York Infantry, has his semi-rigid knapsack slung, plus haversack, canteen and cartridge box on shoulder belt. His waist belt is fastened with a "SNY" oval brass plate, and he holds a US Model 1842 .69-cal musket. (Dan Binder collection)

(Right) Keen to show his patriotism to the Union cause, the unidentified cavalry trooper holds a small "Stars and Stripes" flag as well as a Colt Army Model 1860 revolver and saber. The whole is set in a Holmes, Booth & Hayden patriotic mat. (Liljenquist Family Collection, Library of Congress)

When the 2nd Ohio Cavalry were finally issued arms at Camp Dennison, near Cincinnati, in December 1861, Private Isaac Gause recalled, "I was so proud of my saber that I borrowed a long knife, strung it on my belt also, stalked over to the picture gallery, and had my picture taken, and placed it in the nicest case that could be found and sent it home."[4]

On May 2, 1862, Joseph Quattlebaum, 13th South Carolina Infantry (right) mailed this image of his brother home to their mother with an accompanying letter explaining, "Jefferson had his tipe taken today." (Courtesy of Terry Burnett and David Quattlebaum)

The thermoplastic and paper-covered cases within which images were bought often displayed patriotic imagery, such as cannon, flags, and muskets. The same theme was borne on some of the brass mats and preservers behind which the image was sealed. Photographers often included the "Stars and Stripes" flag as the ultimate patriotic prop pinned to a screen, draped like a curtain or tablecloth, or held by the customer on a staff. The average price paid by the Union soldier for an ambrotype or tintype throughout the war ranged from 25 cents for the smallest gem-sized images to $5 for the largest quarter-plate and half-plate sized ones.

Prior to departure from the encampment near Richmond, Virginia, on May 1, 1862, 17-year-old Private Jefferson Quattlebaum of the De Kalb Guards (Co. G), 13th South Carolina Infantry, had his photograph taken

South Carolina-based photographer Charles H. Lanneau produced this ambrotype of Corporal
Ezekial Bray of the Madison County Grays (Co. A), 16th Georgia Infantry, Cobb's Brigade,
during the siege of Chattanooga in October/November 1863. The ruby glass plate is housed in
a very rare and crudely made case of Southern manufacture, complete with "CONFEDERATE
CASES" impressed into the velvet pad. As the dimensions of the case were slightly smaller than
that for a standard sixth-plate case, the maker trimmed the brass mat down in order to fit, and
was not able to include a preserver. The mat has "JEFFERS" stamped in the bottom left corner,
indicating it was previously used by "daguerrean artist" George A. Jeffers, who had a gallery in
Savannah, Georgia, at the beginning of the war and traveled through the state using temporary
studios in 1861. (David Wynn Vaughan collection)

and asked his older brother Joseph, who served in the same regiment, to
send it home for him. Dutifully mailing off a package containing the
image, Joseph explained to his mother in an accompanying letter, "Jefferson
had his [ambro] tipe [sic] taken today and as he did not haf time to write
to you and send his tipe to you … I will do with pleasure." At a later date

(Right) Ambrotypes on blue glass are extremely rare, particularly those produced by a Confederate photographer, who would have found great difficulty obtaining chemicals and supplies. The use of colored glass in photography began in 1854 in England and 1856 in the US, but would have been very hard to come by in the Confederacy after the first few months of the Civil War. The youthful Southern patriot in this ninth-plate image wears a pleated white shirt and forage cap and proudly holds a Pattern 1853 Enfield rifle-musket. (Author's collection)

Jefferson wrote home explaining, "Mother I got mi amber tipe taken when I was at Richmond and I went up to the baggage car and giv it to brother Joseph to doo up and put in the [mail] office as I left camp that morning … If you get the picture rite to me and let me no if it looks like me … Mother, the picture did not cost me but $3 be Side the postage on it…"[5]

Writing from Camp Mangum, near Raleigh, North Carolina, also in May 1862, Private James K. Wilkerson, Co. K, 55th North Carolina Infantry, poignantly advised his parents on June 13, 1862 that he wanted to have his "pikter taken," adding "I dont know as you all will ever have the opportunity of See[ing] me any more or not."[6]

After visiting the "Picture Gallery" operated by David Le Rosen while stationed near Shreveport, Louisiana, headquarters of the Trans-Mississippi Department of the Confederate Army after the capture of Opelousas on May 20, 1863, Assistant Surgeon Junius N. Bragg, of Crawford's Battalion of Arkansas Infantry, wrote to his wife in April 1864:

The Gallery was a little den of a place with its sides covered with old faded blue cambric, and two little rickety screens. The floor was of pine slabs, as well as I could judge through the stratum of dirt and wash, which had been apparently accumulating for the past half dozen years. There were fifteen soldiers ahead of us, who were going to have their "picture took." As each one brought from one to four friends with him, to see the operation, they made quite a sizable crowd, in the 'Gallery' which was not sixteen feet square. All these men had their Ambrotypes taken in the same jacket – a black one, with blue collar. Eleven of the number, had a large old rusty 'Navy six shooter' in their hands, which made the warriors look very sanguinary. No doubt their friends will think they are all well uniformed and all armed with pistols. They all wet their long ambrosial

Known only as "MacCarthy" based on a note found behind the image, the Confederate
infantryman in this clear glass ambrotype, with an unusual ruby-colored glass backing
plate, stands in front of a typical plain backdrop of the type found in many campsite
galleries. He holds a Model 1822 musket altered to percussion and stares intently at the
camera. The colorist was at great pains to pick out his red shirt while not obscuring its
many folds. The red "Garibaldi" shirt, also known as a fireman's shirt, was very popular in
both Confederate and Union armies at the beginning of the war. (Author's collection)

locks and slicked them down, so as to look "gay and festive" … [Mine] is not a
good picture, and as I never did get a good one, I do not think I am one of those
who take well. I only paid forty dollars for it.[7]

Although the cost of ambrotypes and tintypes in the Confederacy was
comparable to prices charged in the North, by 1862 the number of

Rarely do examples of loved ones exchanging images during the Civil War survive. Sometime in late 1862 or early 1863, Mary Elizabeth Harman sat for her portrait cradling her sleeping daughter Indiana in one arm and holding up a photograph of her husband, Samuel, as he appeared before the war, in her other hand. She mailed the image off to her husband, who had enlisted as a private in Co. K, 82nd Indiana Infantry in the summer of 1862. Receiving the photograph, Samuel had his portrait taken in camp holding the "likeness" he received from home and sent it to his wife. Thus the family was reunited, if only in collodion on glass. Samuel Harman survived the war and returned to his family and farm near Nebraska, Indiana in 1865. (Dan Schwab collection)

(Right) Writing to his father on December 18, 1861, Private Daniel A. Darrow, Co. K, 9th Iowa Infantry mailed this letter home enclosed inside the case containing his image, which was a sixth-plate tintype. In his letter Darrow related that his regiment had a "sham battle" with blank cartridges, and mentioned there had been two inches of snow in camp. He was also concerned about the civilian clothes he had sent home being lost in the mail. He was killed while in "line of his duty" on March 7, 1862 at the battle of Pea Ridge in Arkansas. (Author's collection)

commercial photographers had dwindled considerably in the South, due to the great need for manpower in the military and the lack of chemicals and supplies caused by the Union naval blockade. A few city-based Southern photographers, including George S. Cook in Charleston, South Carolina and Charles R. Rees in Richmond, Virginia, kept their galleries going by raising prices to compensate for the high price of photographic supplies and the inflated Confederate dollar. Thus, these artists, like David Le Rosen, could charge as much as $40 for a portrait.

Images of loved ones sent to soldiers at the front were always looked for at mail-call in camp. Clearly asking for cased photographs of the folks at home, English-born Private William Chickering, Co. G, 11th Massachusetts Infantry, wrote to his mother and sister from Camp Winfield Scott, near Yorktown, Virginia, on April 4, 1862:

> About those pictures. If you can, I wish you would start them early next week. Yours and Cads [his sister Caroline] can be enclosed in any letter … A double case will cost about 15 cents more or less … Do set it up in strong brown paper and take it to the [post] office and ask … how "much stamp" it will take to send that to me. Many of the company have had them come so and I guess there'll be no trouble.[8]

On June 14, 1864, Captain Drury James Burchett, Co. K, 14th (Union) Kentucky Infantry, wrote touchingly from a "Camp in front of Lost Mountain in the woods, [Cobb County] Georgia," to his sweetheart Annie: "I must surely acknowledge the receipt of the photograph of your noble self. Oh how glad was I when I opened the letter and found what I so anxiously looked for. I can't tell nor express myself here."[9]

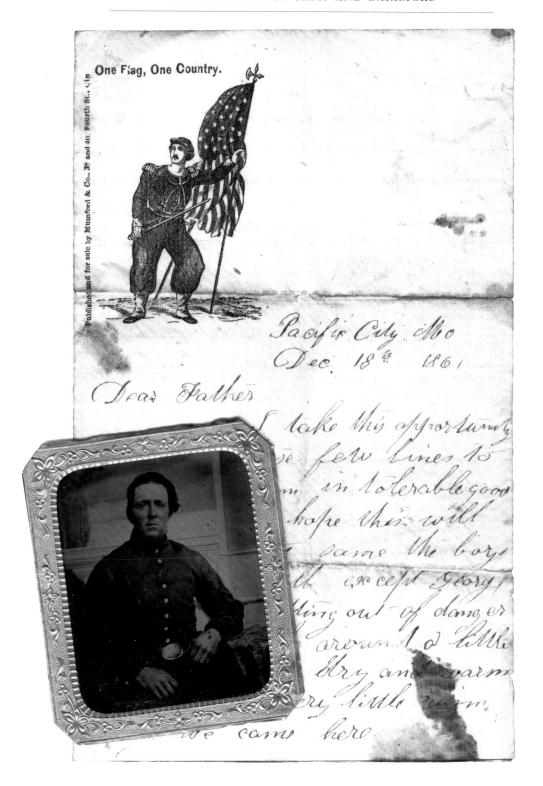

Images of loved ones were often kept together in the same case and treasured by the womenfolk at home. These two ruby ambrotypes show an unidentified Confederate soldier, who may have served in the 15th Georgia Infantry, and child, who could have been his son or daughter as both sexes wore dresses until about age three. (Author's collection)

While his regiment was bivouacked near Donaldsonville, en route for Thibodeaux, Louisiana, 45-year-old Private Asa Holmes, Co. A, 114th New York Infantry, wrote poignantly to his family on July 21, 1863, enquiring of his grandson, "… is he well? If he is, I would like to see him. I will pay for his likeness if you will take the pains to send it to me … I am here & you are there — all of you — & I am but one alone by myself." It is not known whether Private Holmes ever received the photograph he so desired, as he died of chronic diarrhea at the Barracks Hospital in New Orleans on November 1, 1863.[10]

Photographs of loved ones were inevitably carried on campaign and in battle by both Union and Confederate soldiers, and were doubtless a great source of comfort in the face of danger and possible death. As John D. Billings of the 10th Massachusetts Light Artillery later wrote, the soldier "tucks his little collection of photographs, which perhaps he has encased in rubber or leather, into an inside pocket, and disposes other small keepsakes about his person."[11] Sometimes these "portraits of home" became poignant and sorrowful reminders of the fallen. Eight days after the Federal defeat at Bull Run or First Manassas on July 21, 1861, a report in the *Carolina Observer* of Fayetteville, North Carolina commented, "A large number of muskets and other relics were brought to Richmond. Not the least interesting among these were daguerreotype likenesses of females, found in the pockets or haversacks of those who expected to whip the 'rebels.'"[12]

Instances of individuals carrying family photographs in battle are rare. As the 27th New York Infantry went into action at Bull Run as part of the division of Brigadier General David Hunter, Private Florence Sullivan had a premonition that he was going to be killed. Advancing by his side, Private John Biggs later recalled, "there was something singular about him; when he reached the field … he requested me to take a likeness he had and send it to Geneseo [his hometown in New York]; he had the impression he was about to be shot; I tried to talk him out of it but in vain – in less than five minutes he was a corpse. I will send the likeness as he requested."[13]

Several days after facing his baptism of fire at Chancellorsville, Sergeant Amos Humiston of the 154th New York Infantry received a letter from his home in Portville, New York, containing an ambrotype portrait of his three children. In response he wrote to his wife Philinda, "I got the likeness of the children and it pleased me more than anything that you could have sent it. How I want to see them and their mother is more than I can tell. I hope that we may all live to see each other again, if this war does not last too long."[14] Humiston was mortally wounded in battle on the first day at Gettysburg, July 1, 1863, and came to final rest by a rail fence on Stratton Street in the town. After the battle his body was found by a local citizen, who discovered the ambrotype clutched in his hand. The image was passed to Dr. J. Francis Bourns, a Philadelphia physician who was in Gettysburg having volunteered to tend to the wounded. Returning to Philadelphia, Bourns had *carte de visite* copies made of the ambrotype and took the story

SERGT. AMOS HUMISTON,
Of the 154th N. Y. Vols.

(Left) Published before the Humiston children had been identified by their mother in November 1863, this tinted version of the *carte de visite* produced by Dr. J. Francis Bourns of 1104 Spring Garden, Philadelphia, depicts eight-year-old Frank sitting on the left, while Alice, who was six, is on the right. In a photographer's high chair specially designed for children, four-year-old Fred sits at center. At least 11 other versions of the pre-identification *carte de visite* were sold by various photographic galleries before the children were identified, and another ten versions identifying the children and captioned "The Soldier's Children," or "The Children of the Battle Field" were produced.
(Mark H. Dunkleman collection)

(Right) This *carte de visite* portrait of Amos Humiston in uniform was sold by photographer Frederick Gutekunst, Jr., of Philadelphia, in order to raise funds for the Orphan's Homestead opened by Dr. Bourns in 1866. (Mark H. Dunkleman collection)

to the editor of the *Inquirer,* who published it in his newspaper on October 19, 1861. Entitled "Whose Father Was He?" the short piece described the children as "two boys and a girl … apparently, nine, seven and five years of age, the boys being respectively the oldest and youngest of the three. The youngest boy is sitting on a high chair, and on each side

of him are his brother and sister. The eldest boy's jacket is made from the same material as his sister's dress." The story was reprinted in other Northern papers during the following weeks, and in mid-November Philinda Humiston saw it and responded to the query and received a *carte de visite* copy, which she confirmed as a portrait of her children. The original ambrotype and the proceeds from the sales of *cartes de visite* of the original image were presented to the widowed Philinda. Various other versions of the *carte*, sometimes captioned "The Soldier's Children," or "The Children of the Battle Field," continued to sell well, with proceeds going toward an Orphan's Homestead established in Gettysburg by Bourns in 1866.

<p style="text-align:center">***</p>

At the beginning of the war, the demand to have a "likeness" made to send to the folks back home was particularly great among the three-month Union militia regiments as they flooded in to Washington, DC, to protect the Capitol, and Matthew Brady and Edward Anthony took full advantage of the great desire for military portraiture. Working for E. & H. T. Anthony by 1861, both George N. Barnard and Jacob Coonley were heavily involved during this busy period. Having been trained in photography by Barnard in 1856–57, Coonley had joined Edward Anthony in 1859 to manage his new stereoscopic printing department. During the winter of 1860–61, as part of an agreement between the firms of Anthony and Brady, Barnard and Coonley were busy making *carte de visite* negatives of all Brady's vast collection of daguerreotypes of "distinguished people" produced during the previous decade. Having completed the task in New York City, they arrived at Brady's Washington gallery during March 1861 to continue the work there, and soon became involved in the great demand for war photography as the events of the following April, 1861, unfolded.

During the next few months both Barnard and Coonley appear to have worked for Brady and E. & H. T. Anthony at the same time, using the former's Washington gallery as a base of operations. Of this period, Coonley recalled:

> A great many notables both military and civilian began to frequent the Capital, and we were kept very busy in making pictures of them for publication. Within a very few days Washington and its environs was swarming with soldiers, who reached it almost hourly. We were engaged in

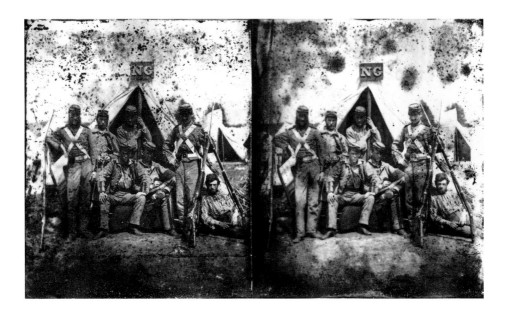

Taken by George Barnard and C. O. Bostwick, this photograph of the 7th New York State Militia, or National Guard, at Camp Cameron on Meridian Hill near Washington, DC, is one of numerous glass stereoscopic views probably commissioned by the subjects and not produced for commercial purposes. (National Archives)

making portraits in the Brady gallery until July, when I went into the field for the purpose of making pictures of officers and subordinates in the army of the Potomac. A great portion of our work consisted of large groups, such as the line and staff officers, regimental bands, officers and chaplains, tents, with groups of officers and men surrounding them, etc. I was assisted in this work by Mr T.[imothy] O'Sullivan during part of the time, and, when not alone, I had the help of Mr. David Woodbury.[15]

Meanwhile, George Barnard was assisted by C. O. Bostwick, who probably worked as a junior operator at Brady's gallery in Washington. Among the earliest images produced by Barnard and Bostwick were those of the celebrated 7th New York State Militia, also known as the National Guard, one of the first regiments to come to the defense of the Federal capital, thus easing Lincoln's

fears that the Confederates might seize it. Arriving on April 25, 1861, the regiment established Camp Cameron, located on Meridian Hill about two miles northwest of the Capitol building. As many of its officers and men were young professionals from New York City, and friends or acquaintances of Matthew Brady, they were only too pleased to pose for one of his cameramen during their regiment's short period of 30 days' service. Many members of the 7th New York also visited Brady's gallery at 438 Pennsylvania Avenue to be photographed. While the numerous Camp Cameron images were probably all made with a stereoscopic camera, only six of Brady's views were mass-produced and offered for sale by Edward Anthony. This suggests that the remainder were commissioned by their subjects, and once prints had been privately purchased the glass negatives were stored away.

A rare series of entries in a diary kept by Henry F. Pitcher of the Elmira Cornet Band attached to the 33rd New York Infantry, or Ontario Regiment, provides a brief glimpse into the work of either Barnard or Coonley and their assistants at Camp Lyon, near the Chain Bridge, DC, during this period. On July 30, 1861 Pitcher noted:

> Business quite lively in camp as there is a Photograph gallery of Brady's inside the lines taking pictures of men and their tents. Some make very fine pictures. Their tents forming a good background. They are to stay in camp as long as business lasts. They intend to take a picture of the band tomorrow if the members can keep thier [sic] mouths shut from jawing long enough to get a good likeness of their features. If they do it will be bully for she!!!

The next day he wrote, "Nothing going on in camp of any importance except picture making by Brady." Finally on August 2 he recorded, "In afternoon our band had a picture taken in uniform and another as we dress in camp when not on parade consisting of shirts, pants, and shoes … once in a while a straw hat. Some were smoking, some playing cards…The Col [Robert F. Taylor] had himself and staff taken." Albumen prints from the negatives had been purchased and received by August 18, as on that day Henry Pitcher again wrote in his diary: "presented the Adjutant with a photograph of the Band." With a photographer still visiting their camp by the end of that month, Pitcher wrote again on August 31: "The Drum Major and staff had their likenesses taken in the rear of his tent. Picture supposed to be terrific."[16]

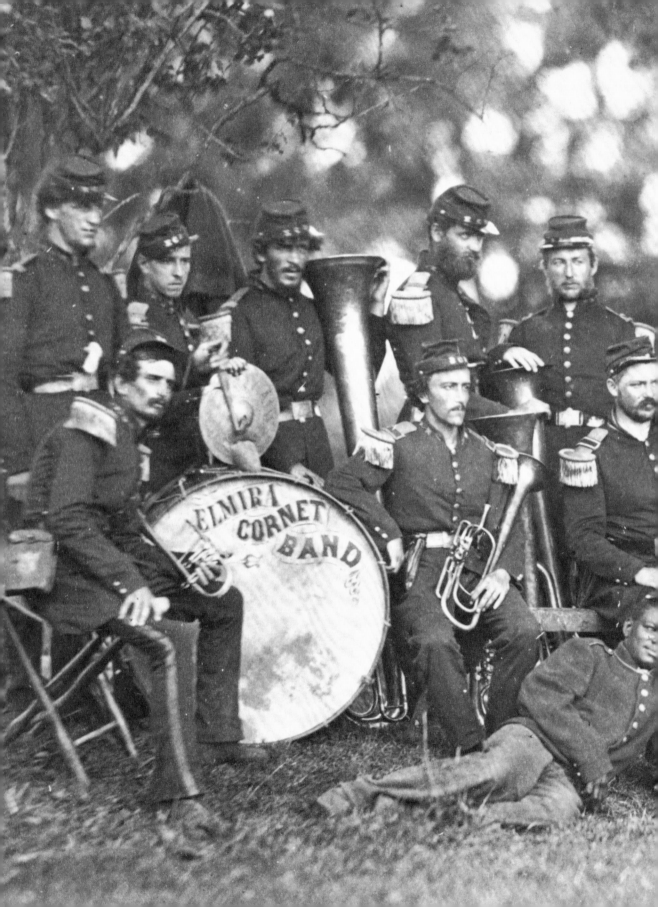

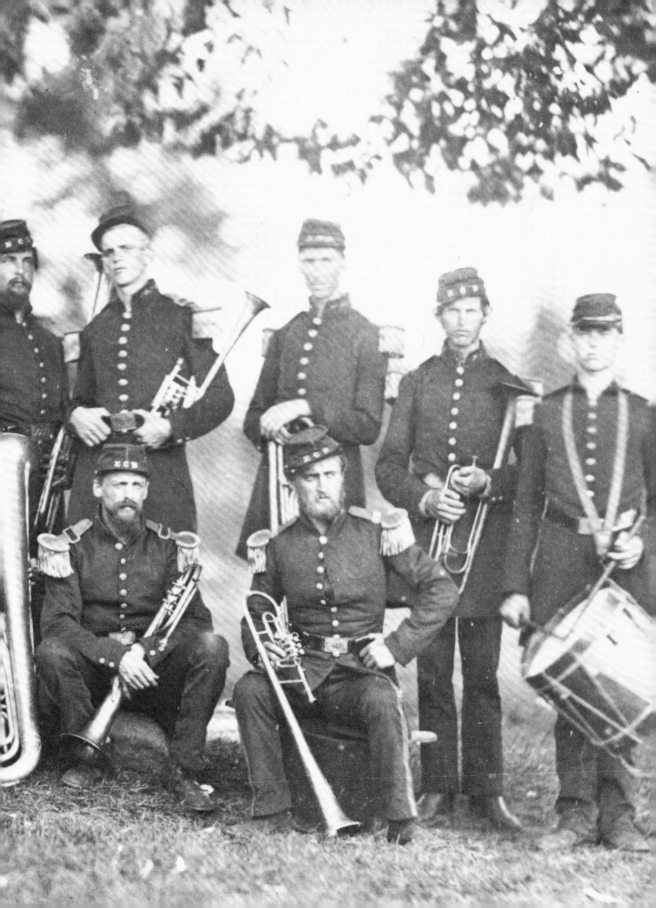

Another photographer active in military encampments in both New York City and on the Virginia Peninsula was George Stacy, who had operated a gallery at 691 Broadway since 1859. Stacy's connections with the colorful 5th New York Infantry, also known as the Advance Guard or Duryee's Zouaves, began during May 1861 when the assembly rooms and recruiting station of the regiment were established at 632 Broadway, across the street from his studio. On the 18th of that month, Stacy joined a crowd of about 2,000 other New Yorkers at a dress parade at Fort Schuyler, about 15 miles northeast of Manhattan, where many volunteer regiments were initially trained. There he took his first known photographs of the 5th New York. On May 22, 1861, the *New York Times* reported, "Photographs of the regiment in line, in close column in mass, of each company separately, of the Field and Line officers, and of many individual members, were taken on Saturday by STACY, of No. 691 Broadway…"

The 5th New York left for New York City the next day and by May 25 had reached Fortress Monroe, where they established Camp Butler, soon to be known as Camp Hamilton. Stacy probably accompanied the Zouaves to Virginia, and by June 4 had established a gallery near the main encampment. In a letter to a loved one four days later, an enlisted man of the regiment wrote:

I have often thought that a description of our camp, and of the daily routine therein carried on, might not be unpleasant or unprofitable for you to hear. The pen, however, can convey but an imperfect idea. Would you obtain a

clear notion of matters and things, you must visit Mr. STACY, No. 691 Broadway. This gentleman – a well known photographer and stereoscopist – came on with the regiment, and has, since his arrival, been busy in "taking" us, in which he has been very successful – much more so than will be the enemy, I assure you.

On June 12, 1862, the *New York Tribune* reported that George Stacy had just returned from Fortress Monroe with "a number of stereoscopic pictures of that work, and its surroundings, including views of the troops now encamped in its vicinity, and points of interest in the neighborhood." Within hours these photographs were probably for sale in his Broadway gallery as "Stacy's Fortress Monroe Stereoscopic Views."[17]

Operating his "Picture Rooms" at No. 2, The Granite Block, in Brattleboro, Vermont, from 1859, George H. Houghton also followed the volunteers from his state to war in 1861. Returning to Brattleboro by December of that year, he advertised for sale "Photographs from the Seat

Arriving at Camp Hamilton near Fortress Monroe with the 5th New York Infantry, commanded by Colonel Abram Duryee, toward the end of May, 1861, George Stacy photographed the colorfully-uniformed zouaves in camp and on parade.
(Library of Congress)

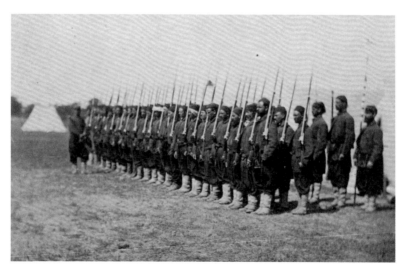

The "Picture Gallery" at Camp Griffin, near Lewinsville, Virginia was operated by George H. Houghton, a photographer from Brattleboro, Vermont, who followed the volunteers from his home state to war in 1861. Houghton stayed with the Vermont brigade during the winter of 1861–62, and joined them again later in 1862. The timber-built cabin with "Picture Gallery" sign probably served as his gallery and sales room, while his studio would have been in the larger tent, which typically has a skylight in its roof. (Library of Congress)

of the War," which included images of the "Camp of the 4th Vermont," a "Soldier's Burial," a "scene in Crandall's sutler's tent," and a "street view of the 5th Vermont." Returning to Brattleboro, Houghton left for Virginia again in 1862, as in September of that year he advertised that he was "home again" and could be found at his gallery. In October 1864, he presented the Vermont Historical Society with "a beautiful gilt edged quarto volume of Photographic views taken in Virginia during the last three years, exhibiting truthful and life-like scenes, and photographs of most of Vermont field officers, making in all one of the most valuable and historical collections made since the commencement of the rebellion."[18]

Listed in the 1860 census as a daguerreotypist, Stewart L. Bergstresser was an enterprising and experienced photographer who later established an extensive operation in the camps of the Army of the Potomac. Before the war he had traveled from town to town in his studio "car" and also

Originally entitled "Burial of Union soldier at Camp Griffin," this image by
George H. Houghton shows a single coffin about to be lowered into the ground close by at
least three other grave sites. The Vermont regiments suffered greatly from measles and
typhoid fever while in camp during the winter of 1861–62. The drums of the musicians
standing at right are muffled, and the guard of honor has muskets reversed. Some of the
burial party hold scarves or mufflers up to their faces, possibly in an attempt to protect
them from the smell or infection. Two men standing at left still hold the spades with
which the grave was dug. (Library of Congress)

operated a gallery in Milton Borough, Pennsylvania. By mid-1861 he
and his brother Jacob were campsite photographers in Virginia and by
1862 ran two galleries near General Burnside's Ninth Army Corps
headquarters at Fredericksburg. Reporting on their activities, the
New York Tribune stated:

> They have followed the army for more than a year and have taken, the Lord
> only knows, how many thousand portraits. In one day, since they came here,
> they took, in one of their galleries, 160 odd pictures at $1.00 each (on which
> the net profit was probably ninety-five cents each). If anybody knows an
> easier and better way of making money than that, the public should know of
> it. The style of portrait affected by these travelling-army-portrait-makers is
> that known to the profession as the melainotype or tintype.[19]

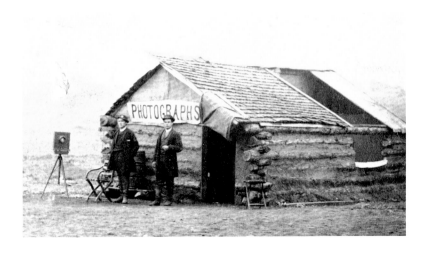

The Bergstresser brothers photographed their makeshift studio while encamped near the 3rd Division, Fifth Army Corps, Army of the Potomac, at City Point, Virginia *circa* 1863–64. A whole section of the shingle roof of the log-built structure could be slid along to allow the sunlight in. Also note the cloth blackout over the door and window. Standing to their left is one of their cameras on a tripod. (United States Army Heritage & Education Center, Military Order of the Loyal Legion of the United States)

Originally a convalescent camp for wounded or sick soldiers known as "Camp Misery," the Rendezvous of Distribution near Alexandria, Virginia became an encampment for recruits awaiting orders, stragglers, and other men fit for duty on February 8, 1864. Several weeks later, a campsite newspaper called *The Soldier's Journal*, established by Nurse Amy Bradley, who was herself recovering from severe illness, reported the presence of a photographer in their midst, stating:

> The Photograph Gallery of camp under charge of Mr Jones, an old and experienced hand at the business, is visited daily by the soldiers, having their bronzed faces taken to send to families and friends. The pictures taken in that establishment can compete with any in our principal cities, and the charges as moderate. Mr Jones, always obliging to the soldier, allows no room for complaint on the part of his work. He is a regular "*E pluribus Erin ga brath.*"[20]

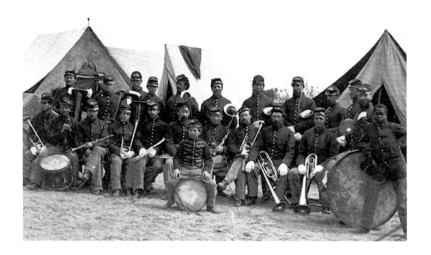

The band of the 3rd New Hampshire were still in their dress uniforms with white gloves after being mustered in for pay when photographed in camp at Hilton Head, South Carolina, by Henry P. Moore on February 28, 1862. Seated third from the left, English-born Henry S. Hamilton migrated to the US in late spring of 1861. An accomplished bugler, he enlisted in the regimental band on August 8, 1861. The boy astride the side drum is 13-year-old Irish-born Nathan M. Gove, while bandmaster Gustavus W. Ingalls sits behind him. The identity of the African American youth was revealed in a letter by bandsman John W. Odlin to his father the day before this photograph was taken, stating, "I believe I never told you about our contraband. We have got one, and a 'right smart one.' He hails from the plantation of 'Massa' James Seabrook, and calls himself 'William Butler, boss.' He is bright and intelligent, and has already learned to spell and read many words correctly. He has been provided with a uniform and carries the bass drum." (Library of Congress)

Following the capture of Port Royal, South Carolina by Union forces on November 7, 1861, sprawling army encampments developed around Port Royal, Hilton Head and Beaufort to accommodate the troops commanded by Brigadier General Thomas W. Sherman. A well-known lithograph artist and photographer from Concord, New Hampshire, Henry P. Moore arrived at Hilton Head on February 21, 1862. A member of the band of the 3rd New Hampshire, John W. Odlin described the photographer's arrival in a letter to his father that was published in the *Independent Democrat* of Concord, two days later:

Men of Co. F, 3rd New Hampshire, photographed by Henry P. Moore at Hilton Head, South Carolina, during February or March 1862. In a few short months they would be involved in the battle of Secessionville, where the regiment sustained 27 killed and 77 wounded out of a total of 26 officers and 597 men. (Library of Congress)

Night before last we had a sort of surprise party. As we were sitting around our fire after supper, discussing the various questions of the day, Captain Ranlet came from the main camp bringing a person whom he introduced to the Band as a 'Secesh' prisoner; and who was but our friend H. P. Moore just from Concord, and natural as life. If you could have seen us pitch into him and shake him up, you might have a very small idea as to the strength of our "home feeling." He comes with the intention of taking views of the camps and plantations, and has had over one hundred applications for large sized pictures. He is just the man we want, for it has been impossible to obtain pictures of any kind worth having, or durable enough to retain their color even a month.[21]

One week later, John Odlin wrote again from Port Royal, "Henry Moore is prospering finely; has a tent and apparatus ready, and will begin to take views to-morrow. He gives an entertainment now and then, accompanying his voice with his noted banjo, and never wants for a 'large and appreciative audience.'" The 3rd New Hampshire was mustered in for pay on February 28, 1862, following which Moore took advantage of the neat turn-out of the regiment and began work. According to the regimental history, he took them "principally in groups, among them being one of Lieuts [William H.] Maxwell, [George W.] Emmons, [John H.] Thompson (the Commissary), Adjt [Alfred J.] Hill and Adjutant's Clerk Dodge." On the same day Odlin reported, "We (the Band) had our picture taken after dismissal from duty; one in full dress, with instruments, and one of our cook tent and stoves, with the boys *en dishabille*, (bad French I'm afraid,) waiting for dinner. Henry threw himself hugely and succeeded in getting good pictures in each instance."[22]

On March 19, 1862, the *Daily Mirror* of Manchester, New Hampshire, confirmed that Moore was still with the 3rd New Hampshire Infantry, "taking photographs of soldiers, scenery, and places of note." The same journal continued that he would be returning home to Manchester in a few weeks to finish the pictures taken and deliver them "according to orders. He is having a rush of business, which must be a hint for enlisting artists to bring along their apparatus on their backs as well as their knapsacks."[23]

Returning to his Hilton Head studio during April, 1862, Moore remained until the end of May 1863, during which time he continued to photograph scenes around Hilton Head, including the Signal Station and camps of the 6th Connecticut, 1st Massachusetts Cavalry on Edisto Island, plus Navy ships and their crews (see Chapter 6). The military was not his only interest. Views of plantations and recently freed slaves filled out his portfolio. The glass plate negatives he used measured 5x8 inches, and the prints produced from them were sold at his gallery in Concord, New Hampshire, for one dollar each.

Some photographers served in the Union army before they picked up a camera. Farmer's son and resident of Berlin, Vermont before the war, William Frank Browne enlisted for nine months as a private in Co. C, 15th Vermont Infantry on September 8, 1862. After duty in the Washington defenses, the 15th Vermont guarded the corps trains during

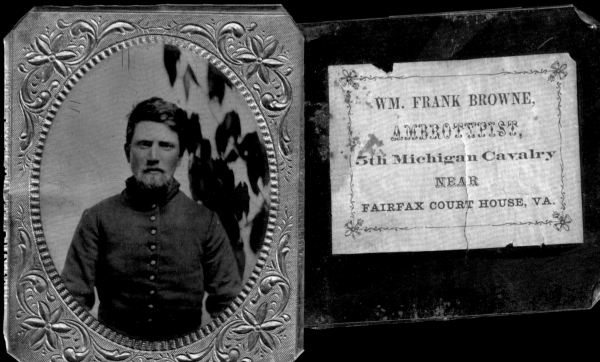

WM. FRANK BROWNE,
AMBROTYPIST,
5th Michigan Cavalry
NEAR
FAIRFAX COURT HOUSE, VA.

(Top) This sixth-plate tintype is the only known hard-case image of Wm. Frank Browne, who enlisted for nine months in the 15th Vermont Infantry on September 8, 1862 and became an "Army Photographer" attached to Kilpatrick's 3rd Division, Cavalry Corps, Army of the Potomac, in 1863. Browne produced the earliest known photographs of George Armstrong Custer as a brigadier general commanding the Michigan Brigade, and by 1865 worked for Alexander Gardner. Returning to his native Northfield in Vermont after the war, Browne died of consumption in 1867. (John Beckendorf collection)

(Bottom) Photographed by Wm. Frank Browne during May/June 1863, the enlisted man of the 5th Michigan Cavalry in this sixth-plate tintype unusually poses outside with leafy tree branches behind him. The reverse of this image is labeled "Wm. Frank Browne, Ambrotypist, 5th Michigan Cavalry near Fairfax Court House, Va." (John Beckendorf collection)

the battle of Gettysburg in July 1863 and took part in the pursuit of Lee's defeated army back into Virginia. At some point before he was mustered out in August 1863 and possibly during the Gettysburg campaign, Browne was detached from his regiment on special duty and became the photographer for the 5th Michigan Cavalry. This occurred at the latest by May/June 1863, as a tintype of an enlisted man of that regiment is labeled on the reverse "Wm. Frank Browne, Ambrotypist, 5th Michigan Cavalry near Fairfax Court House, Va.", and that regiment had moved into Pennsylvania by the end of June of that year.[24]

Before the end of 1863, Browne was licenced as a photographer for Brigadier General Judson Kilpatrick's 3rd Division, Cavalry Corps, Army of the Potomac, with a studio in the winter encampment of the 5th Michigan Cavalry at Stevensburg, Virginia. As that regiment formed part of George Armstrong Custer's Michigan brigade, Browne was able to produce the earliest known photographs of the later famous Indian fighter as a brigadier general. During 1864–65 he also probably established a gallery in Washington, DC, and undertook work for Alexander Gardner. In the aftermath of the Confederate defeat in 1865, Brigadier General Henry H. Abbot, commanding the Siege Train, Army of the Potomac, assigned Browne, who he reported had "a fine stereoscopic instrument," to photograph the James River water batteries around Richmond, Virginia, thus "preserving an invaluable record of their wonderful completeness."

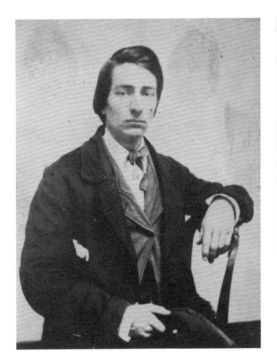 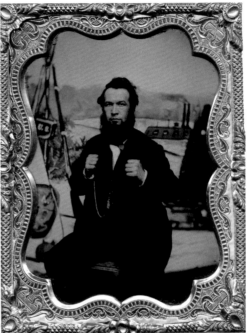

(Left) Nineteen-year-old William Clare Cady was a daguerreotypist and landscape painter in Albany, New York when he was mustered in as a private in the 3rd New York Volunteers on May 14, 1861. Badly wounded at Big Bethel on June 10, 1861, he died four days later in the military hospital at Fortress Monroe. It is not known if he took his camera to war.

(New York State Military Museum)

(Right) Enoch Long poses in front of one of the most distinctive of the painted backdrops used in his photographic gallery at Benton Barracks in St. Louis, Missouri.

(Mike Medhurst collection)

Gardner eventually published 120 of Browne's photographs as "Views of Confederate Water Batteries on the James River."[25]

A number of photographers in both North and South put their cameras aside and picked up a musket. Daniel H. Cross operated a daguerreian studio on Main Street in Whitewater, Wisconsin, in 1858 but returned to Bennington, in his home state of Vermont, to volunteer as a musician

playing the E sharp soprano cornet in the regimental band attached to the 2nd Vermont Infantry on June 15, 1861.[26] After the band was disbanded on December 19, 1861, Cross turned again to his camera and became an "Army Photographer" on his own and in partnership with others in the camps surrounding Washington, DC until the end of the war.

Nineteen-year-old William C. Cady of Albany, New York was not so fortunate in his military service. Described as a "daguerreotypist" in the 1860 census and "landscape painter" in the 1861 Albany Directory, he was "for several months engaged in a daguerreotype saloon on Washington avenue" in Albany prior to enlistment. Mustered in for two years as a private in Co. F, 3rd New York Infantry on April 22, 1861, he was wounded in the abdomen by friendly fire during the opening stages of the battle of Big Bethel on June 10, 1861 and died four days later in the hospital at Fortress Monroe. His last words to his company commander Captain Henry S. Hulbert were "I die perfectly happy … Tell my father that I fell while doing my duty. Bid him good bye. Captain, I hope I will meet you in heaven. I hope you will come out safely. God bless you." Arriving at Fortress Monroe in search of their son's remains, Denice and Elmira Cady were reported to have found that "every thing had been done that could be. The memorials of the young soldier were gathered, his clothes bound together, flowers plucked from his burial spot, the body placed in a metallic coffin and borne away home." Cady's body arrived at New York City via Old Point Comfort aboard the steamer *Alabama* by June 17, 1861, and was escorted to its final resting place by the Albany Zouave Cadets.[27]

Among the most experienced and best known of Union photographers in the West was Enoch Long (1823–98). Born in New Hampshire, he studied in Philadelphia under the guidance of daguerreian pioneer Robert Cornelius. In 1846, Long and his older brother, Horatio, moved to St. Louis, Missouri, where they opened a gallery at the southeast corner of Third and Market Streets. Establishing a reputation for fine photography, they also sold photographic apparatus and offered instruction to would-be photographers. Although Horatio died in 1851, Enoch Long continued to work alone, and at the "Exhibition of the Industry of All Nations" held in New York in 1853 included examples of his photography alongside that of Matthew Brady, Marcus Aurelius Root and other masters of the art of the daguerreotype.

With the outbreak of the Civil War, Enoch Long moved from his gallery in downtown St. Louis to Camp Benton, later known as Benton

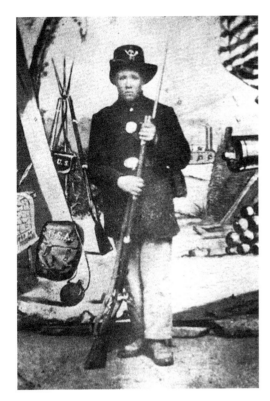

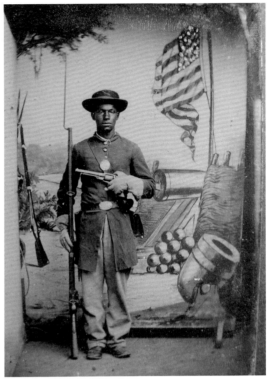

Photographed for the first time in his life at Benton Barracks, St. Louis, Missouri during March 1862, Private Elisha Stockwell, Jr., 14th Wisconsin Infantry mailed this "likeness" home to his grandfather. (*Private Elisha Stockwell, Jr. Sees the Civil War*, 1958)

Minus mat and with part of the backdrop obscured by a screen, this African American of an unknown regiment photographed at Enoch Long's gallery at Benton Barracks holds a Remington revolver and Austrian Lorenz rifle-musket.
(Liljenquist Family Collection, Library of Congress)

Barracks, a training camp for the Union army established by late August 1861 at the site of the city fairgrounds by order of Major General John C. Fremont, commander of the Western Department. Initially intended to facilitate about 17,000 men, by 1863 the site accommodated up to 30,000 soldiers in over a mile of barracks, and also included

warehouses, cavalry stables, parade grounds, a camp of parole, and a large military hospital.[28] Recruits from Missouri and elsewhere in the North poured into this sprawling encampment, where they learned the military arts. Once dressed in their newly issued uniforms, many of these green volunteers were keen to have their likeness made to mail to the folks at home, and they did not have far to go.

After arriving with the 14th Wisconsin Infantry on March 9, 1862, 15-year-old Private Elisha Stockwell, Jr. wrote:

> We landed at St. Louis and went on shore, and marched up through the city with fixed bayonets, colors flying and band playing. As our regiment was nearly all big men and nearly 1,000 strong I thought it a grand sight ... We marched out to Benton Barracks and pitched our tents ... I also got my picture taken and sent to my Grandfather ... the first picture I had ever had taken. It was a tintype, and I have it now.[29]

Based on the backdrop in the published version of his image, Private Stockwell, Jr. was photographed at the gallery of Enoch Long, whose work is commonly identified by an elaborately painted canvas backdrop that symbolically reflected the war in Missouri. Seen in Stockwell's image and numerous other surviving photographs by Long, the scene, as viewed in its reversed condition, depicts at left an open tent with a table upon which sits a state map showing county boundaries, a quill pen and inkbottle, and a small eagle statuette. At the foot of the table rests a knapsack with "USA" on its flap and a canteen. Beyond this is a stand of muskets over which is hung a cartridge box with "US" on the flap. A tree overhangs in the sky above. At right is a cannon and stack of cannonballs, a mortar, and several sections of wicker field fortifications known as gabions, above which floats a Stars and Stripes flag in the shape of a guidon. In the distance an ironclad gunboat steams along the Mississippi River. Lettering on this backdrop was painted backwards to compensate for the reverse effect produced by the ambrotype and tintype process. At the bottom left of the canvas are the initials of the unknown artist who painted the backdrop, which when viewed the correct way round appear to read "L. E. H." Long used at least two other scenic backdrops less commonly seen in his photos. One is a much simpler composition containing at left a cannon with a gunboat in the distance. Apparently painted by a different artist, the other also features a cannon with rows of tents in the distance.

Many other elaborate military-themed backdrops were used by unidentified photographers in the Union. (Left) Brothers William and Philip J. Letsinger, Co. D, 14th Indiana Infantry pose with muskets in front of what has become known as the "Camp Michigan" back-drop. (Right) Almost the entire military backdrop with painted flag is visible behind this unidentified soldier. (Bottom) The pose struck by these two unidentified Union soldiers reveals the total extent of this elaborately painted camp scene.
(Liljenquist Family Collection, Library of Congress)

Other photographers at Benton Barracks included Canadian-born Ansel R. Butts. Relocating from St. Louis sometime in 1864 or early 1865 to a new gallery opposite the quartermaster department at the post, his images are distinguished by a backdrop featuring a fort on a hill and campsite by a river. A partner of Long's at one point, he was not the only photographer named Butts to operate a studio at the camp, as Chris Butts was listed as a photographer at Benton Barracks in 1864. Any family relationship between these two photographers is not known. Another local photographer was Stephen Evans, who operated a studio out of his St. Louis residence at 98 Elm Street from 1864–65. Similar in style and composition, and probably produced by the same artist that painted those used by Enoch Long, the Evans backdrop had "EVANS/ARTIST" written on the flap of a haversack depicted in the entrance to a tent.

Elsewhere in Missouri, a soldier photographer named W. Lewis advertised during the summer of 1861 that his gallery was at the main entrance to the camp of the 13th Illinois Infantry at Rolla, a strategically important railhead in Phelps County, where he would "always be found when consistent with his military duties." A visitor to the camp recalled seeing the "… greatest wonder of all, a daguerreotype gallery in full operation. A hole cut in the roof of an old shanty lets in the light, and bands of cotton sheeting placed around the wall serve for screens and surfaces. Many a sun picture of the 'bold soldier boy' goes from this establishment to delight the eyes of some waiting Catharine, over in Illinois." Several other local photographers received much custom from soldiers, railroad men, and camp followers who flooded into Rolla. Polish-born Albert Neuman operated a "Skylight Gallery" in the town, while R. S. Mitchell advised prospective military customers at his "Fine Art Gallery" to "secure the shadow ere the substance fades."[30]

Painted backdrops used by Confederate photographers invariably showed peaceful pastoral scenery. (Left) Lieutenant Robert Pryor James, Co. E, 20th North Carolina poses in front of a lakeside scene with distant sailing yacht. (Right) This unidentified Confederate sits in front of a painted interior with a balcony view through a doorway. (Bottom) Behind Private Lewis Hicks, Co. H, 53rd North Carolina, is the "gable house" backdrop often found in images from his home state. ((Liljenquist Family Collection, Library of Congress left and lower; author's collection right))

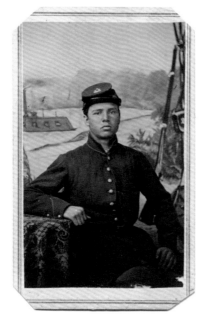

In this late-war *carte de visite* produced by Enoch Long, Private George A. Mantor, Co. A, 52nd Wisconsin Infantry, poses in front of the oft-used backdrop. The photographer, whether Long or one of his assistants, has placed it so that the reversed lettering in it cannot be seen, except for the reversed "S" on the cartridge box at right. This indicates that it was only really intended for use with reversed hard-cased images. Organized at Camp Randall in Wisconsin during April, 1865, Co. A, 52nd Wisconsin was stationed at Benton Barracks from April 7 through May 9, 1865, hence Private Mantor must have visited Long's studio during that period of time. (Ronald S. Coddington collection)

Algernon S. Morse was another prolific photographer in the West. At the beginning of the war, he worked at the "Great Likeness Depot" owned by J. B. Meeker at the corner of Fifth and Main streets in Cincinnati, Ohio.[31] Accompanying Major General William S. Rosecran's Union Army of the Cumberland during the Stones River and Tullahoma campaigns, he photographed soldiers in and around Murfreesboro in his "traveling tent." By July 16, 1863, he had established his headquarters called the "Gallery of the Cumberland" at 25 Cedar Street in Nashville with partner William A. Peaslee. Employing "at great expense" what they believed were

the best operators in New York, Cincinnati and Chicago, Morse and Peaslee professed to have "one of the most talented and largest corps of photographers in the Department of the Cumberland." Possibly closing their city gallery down and following the army during the Chickamauga campaign, Morse was reported to have arrived back in the city "from the front" on November 3, 1863. Still at Nashville by March 25, 1865, he requested permission from Brigadier General Abram O. Miller, commanding the 2nd Division, Cavalry Corps, Military Division of the Mississippi, to "establish a Photograph Gallery at Barrick [sic]," and "erect a house for that purpose."[32]

The requirement that photographers should have permits to work in Union Army encampments and barracks was introduced on

The growth in popularity of photography in the North resulted in the passage of a Federal law on June 30, 1864, which placed a tax on "photographs, ambrotypes, daguerreotypes or any other sun-pictures." As a result, photographers were required to affix a properly-denominated revenue stamp on the reverse of the image and cancel it with a date stamp or by initialing and dating it in pen. (Author's collection)

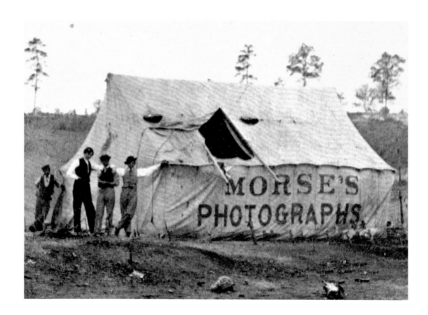

In the case of the tented campsite gallery, large flaps were let into the canvas roof to admit
sufficient light. Algernon S. Morse operated this studio at Camp Jenkins near
Chattanooga, in Lookout Valley, Tennessee, during the winter of 1863–64. Prospective
customers could hardly fail to see the two-feet high "MORSE'S PHOTOGRAPHS"
painted on the side of his large walled tent. (USAHEC- MOLLUS)

March 12, 1862. The following day, Edward T. Whitney wrote home
stating that "all photographing has been stopped by general orders from
headquarters." Crossing over the Chain Bridge into Virginia to reach the
Army of the Potomac, he was allowed through due to ignorance of this
order on the part of the provost guard. Following this, he acquired a pass
from General George B. McClellan and continued to work.[33]

As a result of Federal tax measures introduced in October 1862,
photographers were required to apply for a license that permitted them to
"travel from place to place" within army encampments practising their art.[34]
After this, all photographers were required to register with the camp provost
marshal, or military police chief, before setting up a campsite gallery. They
were also assigned to specific brigades within divisions and army corps, or

(Top right) In 1863, Alexander Gardner was licensed as the "photographist" at General
Headquarters under Major General Joseph Hooker, and included "Photographer to the
Army of the Potomac" in the back mark for his cartes de visite produced from May 1864.
By this time he used Philip & Solomons as his exclusive publisher and wholesale agent.
(Top left) James W. Campbell was listed as daguerreotypist in Winchester, Tennessee, in
1860–61, and by 1863 was photographer for the 20th Army Corps, Army of the
Cumberland, under General Alexander M. McCook. (Middle left) Formerly operating a
gallery at 14 West 5th Street, Cincinnati, Ohio, before the war, Isaac H. Bonsall was
photographer with the 14th Army Corps, Department of the Cumberland, by the same
year. (Bottom left) Joseph C. Judkins, of Hall & Judkins, became photographer of the
24th Army Corps, Army of the James, sometime after December 1864 when that corps
was created. (Bottom right) Wm. Frank Browne became photographer for Brigadier
General Judson Kilpatrick's 3rd Division, Cavalry Corps, Army of the Potomac, in 1863.
(Author's collection top left/National Portrait Gallery top right/Library of Congress
middle left and bottom left/John Beckendorff collection bottom right)

requested permission to be attached to the same. Based on two surviving listings of approved "photographists" in the National Archives, one of which was compiled during the winter and spring of 1862–63 and the other either in 1864 or 1865, at least 56 photographers supported by 99 assistants or clerks were licensed to operate within the Army of the Potomac. Documentation on the number of army photographers following the Union Army in the Western Theater of the war has not survived.

Little specific information survives regarding licensed photographers. On December 22, 1863 E. W. Blake of Philadelphia wrote to Brigadier General J. H. Hobart Ward asking if he could "act as Photographer and Ambrotypist" for the 2nd Brigade, 1st Division, Third Army Corps, Army of the Potomac.[35] A "Daguerrian and Photograph Artist" at Pittsburgh, Pennsylvania, before the war, Thomas P. Adams had an unusually extensive campsite operation by January 1864, involving a partner and four different establishments. On the 15th of that month, he was required by Provost Marshal Brigadier General Marsena R. Patrick to outline his business as "photographer in the Army of the Potomac," as not all of his operatives had been registered. He explained that his partner was the already well-established Stewart Bergstresser with whom he divided all profit, while others in his employ were paid a salary "per day." Adams catered for the 2nd Division, Second Army Corps, with two assistants. By this time Bergstresser was based with the 3rd Division, Fifth Army Corps, with two or three assistants; Thomas P. Adams, Jr., with three assistants, was with the 2nd Division, First Army Corps; and Charles Glenn, with two assistants, was with the 1st Division, Fifth Army Corps. Adams concluded by stating that all of these men were from Pennsylvania and "engaged in photographing, or assisting about the tent, cooking &c."[36]

Photographers also needed permission when carrying photographic materials and equipment into military camps. On March 27, 1865, James Coleman wrote to Lieutenant Colonel F. L. Manning, Provost Marshal General, Army of the James, asking if he could ship the following from Washington, DC, to Bermuda Hundred: "Nine Boxes Plates, Three & Half Gross Matts, Four Dozen Union Cases, Two Negative Boxes … One Thousand Envelopes, One Thousand Cards … Fifty Sheets Albumen Paper … One Scenic Background." The inclusion of plates, Union cases, and card indicates that Coleman was producing cased ambrotypes or melainotypes and *cartes de visite*.[37]

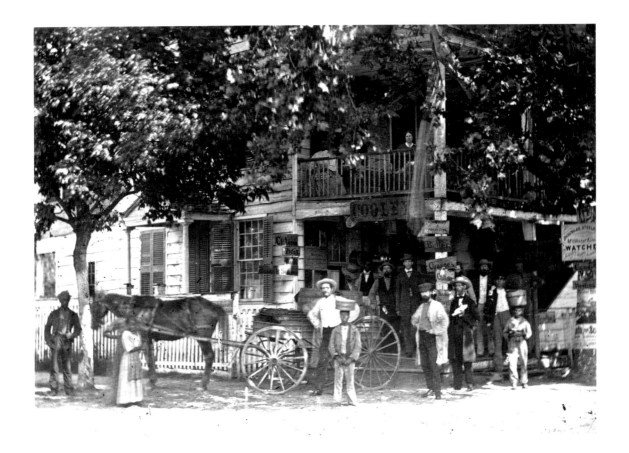

Sam Cooley opened this store on Union Square in Beaufort, South Carolina, soon after his arrival in June 1863. The sign for the neighboring military goods and watches dealer seen at right dates this view to before the end of August 1863, by which time Douglas, Steele & Company had become Douglas & Company. Cooley leans against the buggy at center. Note the signs for various goods nailed to the verandah posts behind. His photographic gallery and studio were on the upper two floors of this building. (United States Army Heritage & Education Center, Military Order of the Loyal Legion of the United States)

Placing further restriction on photographers, an Act of Congress was passed by the Federal government on June 30, 1864 that placed a tax on "photographs, ambrotypes, daguerreotypes or any other sun-pictures." Photographers were required to affix a properly denominated revenue

stamp on the reverse of the image and cancel it by initialing and dating it in pen. As there was not a special stamp created for photography, stamps created for other purposes via the Revenue Act of 1862, such as Bank Checks, Playing Cards, Proprietary, were accepted by the Federal government as long as the denomination was appropriate. The amount of tax paid by the customer was determined by the cost of the image. If it cost less than 25 cents, a blue or orange two cents stamp was required. If it cost 25 to 50 cents, a green three cents stamp was needed. Images costing 50 cents to $1 required a red five cents stamp, and those valued at more than $1 needed a five cents stamp for each additional dollar or fraction thereof. The stamp tax on photographs was repealed on August 1, 1866, and a tax of 5 percent based on the value of the image was levied instead.

Many other traveling photographers built, acquired, or were assigned premises close by military campsites and barracks. Having operated daguerrean rooms in Hartford, Connecticut, during the 1840s and served as colonel of the 1st Regiment Connecticut Militia from 1852 through 1861, Samuel Cooley was the ideal man to establish a gallery to photograph the military on the Union-occupied South Carolina coast. Attached to the 6th Connecticut Infantry as a sutler, he well understood the business potential in establishing a studio at that location. During June 1863 he obtained permission from Brigadier General John M. Brannan, commanding the Department of the South, and Brigadier General Rufus Saxton, military governor of South Carolina, to establish a general store in Union Square, Beaufort on the corner of C and Seventh Streets, above which was a gallery with an "EXTENSIVE SALOON" and "LARGE SKYLIGHT." There, according to an advertisement in the local Union-managed newspaper *The Free South*, he hoped "to catch with the sun's rays the fair features of the belles and the bronzed faces of the officers and soldiers lingering in and around the city."

Employing what he termed as "THREE SKILFUL OPERATORS" from New York City, one of whom may have been Edward W. Sinclair, Cooley also equipped his studio with an "INSTANTANEOUS VIEW CAMERA, for taking MOVING OBJECTS, CAMPS, REVIEWS, PARADES, LANDSCAPES, STEAMBOATS, &c."[38] Extending his business by November 1863, he had also opened up a makeshift studio on Folly Island, South Carolina, near the headquarters of Major General Quincy A. Gilmore, where "the finest *carte de visite*" was "executed by first-

Samuel A. Cooley,
PHOTOGRAPHER,
Savannah, Ga.
Hilton Head, S. C.
Beaufort, S. C.

(Above) This detail from a stereoscopic view taken at Folly Island, South Carolina, may well show the timber-built gallery established there by Sam Cooley by November 1863. Note the roughly made sign for "PHOTOGRAPHS" nailed to its frontage and two men seated on the verandah. (Library of Congress)

(Inset) By 1865 Sam Cooley used an imprint on the reverse of many of his photographs indicating that he had studios in Savannah, Georgia, plus Hilton Head and Beaufort, South Carolina. (Library of Congress)

class artists" who had photographed the "batteries, parallels, and look-outs in the highest style." Folly Island had been occupied by Union forces in August of that year and served as a supply depot and camp for the troops besieging the city of Charleston.[39] During February, 1864, Cooley was granted permission by the military to extend his business to Jacksonville, Florida, where he occupied a vacated gallery. During this period, he corresponded directly with Quartermaster General Montgomery C. Meigs and arranged to supply him with photographs of subjects found in occupied South Carolina and Georgia. As a result, he advertised himself as "Photographer Tenth Army Corps." For unknown reasons, Cooley sold his galleries to Edward Sinclair on May 21, 1864 and returned north.[40]

Other photographers active in Union-occupied South Carolina included Ira C. Feather, who opened the "Military and Naval Photographic

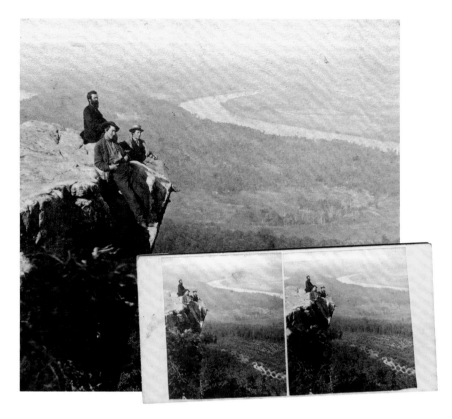

Distinguished by his full beard, Robert "Royan" M. Linn poses in this detail from a stereoscopic view with two of his assistants, who are dangerously close to the edge on Point Rock. The Tennessee River and the city of Chattanooga are seen in the distance below.

(Jeffrey Kraus collection)

Gallery" on Merchant's Row in Port Royal by August 1863. Prior to establishing his gallery at Port Royal, Feather served in Co. K, 7th Pennsylvania Cavalry before becoming an acting assistant surgeon with the 72nd New York Infantry. By July 1865 he advertised that he "prepared his own chemicals" as by profession, he was "a Chemist, Surgeon and Physician."[41] R. V. Balsan arrived at Beaufort during October 1863, and advertised that his gallery was near the camp of the 56th New York Volunteers. On the 24th of that month *The Free South* reported,

(Above) Robert "Royan" M. Linn stands by Umbrella Rock on Lookout Mountain. His makeshift timber studio stands immediately to the rear. The shadow of the photographer and camera that produced this stereoscopic view image can be seen in the right foreground. (Jeffrey Kraus collection)

(Right) Seated behind the counter in this view showing the interior of Linn's Point Lookout Gallery on Lookout Mountain in Tennessee, a clerk looks on quizzically. On the counter next to him is a Becker-style stereocope that held 36 paper or glass views, while farther along is a smaller hand-held Brewster viewer. The wall at the rear is filled with framed albumen prints of images taken by the Linn brothers, including photographs of groups of officers and men posing on Point Lookout. (Jeffrey Kraus collection)

Based on a sketch by army topographical engineer August Ligowsky, this wood engraving
showing soldier/photographer William B. Roper plunging to his death was published in
Frank Leslie's Illustrated Newspaper on April 30, 1864. On this occasion it was incorrectly
captioned "Death of Mr. Wm. F. Porter, the Photographer. – From a sketch by A.
Ligowski, Topographical Engineer." (Author's collection)

"An agreeable hour may be passed by our citizens and soldiers in examining
the beautiful specimens of art at R. V. Balsan's Photographic Rooms, near
the camp of the 50th N.Y. Volunteers [sic], whose pictures are taken by
artists who understand their business, and at reasonable prices."[42]

Probably the most spectacular location for a photographer's gallery was
at the majestic pinnacles of rock atop Lookout Mountain situated at the
northwest corner of Georgia, the northeast corner of Alabama, and along
the southern border of Tennessee. Towering about 2,000 feet above the
Tennessee River, this mountainous ridge offered distant views of five states,
plus the city of Chattanooga, from places such as Point Lookout and
Umbrella Rock. One of the most celebrated photographers associated with
Lookout Mountain was Robert "Royan" M. Linn, who was assisted by his
brother J. Birney Linn.

Royan Linn was listed as a "Photograph Painter" resident at Columbus,
Ohio in the 1860 census. Following victory at Murfreesboro or Stones
River, Tennessee on January 1–3, 1863, Major General William Starke
Rosecrans and his command received the Thanks of Congress for "gallantry
and good conduct" on March 3 of that year. As a result, Linn advertised
himself as a photographer under the heading "Old Rosie is our Man" at
the Commercial Hotel in Nashville, Tennessee, selling "Vignette Card
Photographs" or *cartes de visite* with "facsimile autographs" of Rosecrans
by October 1863.[43] Arriving at Lookout Mountain shortly after the Union
victory there known subsequently as the "Battle Above the Clouds," fought
on November 24, 1863, the Linn brothers realized the business potential
of the location, establishing makeshift shacks next to both Point Lookout
and Umbrella Rock during December of that year. There they photographed
hundreds of Union army officers, enlisted men and civilians. Visitors at
"Linn's Gallery Point Lookout" entered a small reception area with framed

Based on a sketch by army topographical engineer August Ligowsky, this wood engraving showing soldier/photographer William B. Roper plunging to his death was published in *Frank Leslie's Illustrated Newspaper* on April 30, 1864. On this occasion it was incorrectly captioned "Death of Mr. Wm. F. Porter, the Photographer. – From a sketch by A. Ligowski, Topographical Engineer." (Author's collection)

"An agreeable hour may be passed by our citizens and soldiers in examining the beautiful specimens of art at R. V. Balsan's Photographic Rooms, near the camp of the 50th N.Y. Volunteers [sic], whose pictures are taken by artists who understand their business, and at reasonable prices."[42]

Probably the most spectacular location for a photographer's gallery was at the majestic pinnacles of rock atop Lookout Mountain situated at the northwest corner of Georgia, the northeast corner of Alabama, and along the southern border of Tennessee. Towering about 2,000 feet above the Tennessee River, this mountainous ridge offered distant views of five states, plus the city of Chattanooga, from places such as Point Lookout and Umbrella Rock. One of the most celebrated photographers associated with Lookout Mountain was Robert "Royan" M. Linn, who was assisted by his brother J. Birney Linn.

Royan Linn was listed as a "Photograph Painter" resident at Columbus, Ohio in the 1860 census. Following victory at Murfreesboro or Stones River, Tennessee on January 1–3, 1863, Major General William Starke Rosecrans and his command received the Thanks of Congress for "gallantry and good conduct" on March 3 of that year. As a result, Linn advertised himself as a photographer under the heading "Old Rosie is our Man" at the Commercial Hotel in Nashville, Tennessee, selling "Vignette Card Photographs" or *cartes de visite* with "facsimile autographs" of Rosecrans by October 1863.[43] Arriving at Lookout Mountain shortly after the Union victory there known subsequently as the "Battle Above the Clouds," fought on November 24, 1863, the Linn brothers realized the business potential of the location, establishing makeshift shacks next to both Point Lookout and Umbrella Rock during December of that year. There they photographed hundreds of Union army officers, enlisted men and civilians. Visitors at "Linn's Gallery Point Lookout" entered a small reception area with framed

examples of their albumen prints around the walls. After paying for an image they were ushered out on to Linns' posing spot on Point Rock where they were photographed by an operator whose camera was placed on another precarious point about 25 yards away.

The Linn brothers produced stereoscopic views, ambrotypes, tintypes and *cartes de visite* for a steady stream of customers, several of whom commented on their visit. On January 17, 1864, Major Lewis Warner, 154th New York Infantry, wrote in his diary, "Made a trip to Lookout Mountain on horseback ... Sat for [an] ambrotype upon the extreme point."[44] Visiting the Linn gallery five days later, army surgeon James Theodore Reeve, 21st Wisconsin Infantry, was disappointed with costs involved, recalling, "went out to the Point to have a group picture of the Hospital attendants taken, wh.[ich] we could not because of the numbers ahead of us. Crowds are constantly being ambrotyped at the point, the operator charging the enormous price of $3 per picture, wh.[ich] I regard as an imposition on the soldiers." Returning the next day, he succeeded in having the "Hospital Squad" photographed, following which he opined, "The pictures are of little value so far as regards the likenesses but are interesting as mementos of the time & places."[45]

Regardless of costs involved, Lookout Mountain became the single most photographed place in either North or South during the Civil War. Others who hauled their cameras up to the craggy heights included George Barnard and an unfortunate soldier/photographer named William Bryham Roper. Listed as an "artist" resident at Curllsville, Clarion County, Pennsylvania, in the 1860 census, Roper enlisted for three years in Co. C, 78th Pennsylvania Infantry on September 16, 1861. During November 1863, the 78th Pennsylvania was one of several regiments that commenced a five-month period of winter encampment at Summerville, a village high on Lookout Mountain. Taking advantage of the views, Roper began to photograph fellow soldiers and civilians visiting Point Rock. On one of these occasions he tragically slipped and fell to his death, as reported by several contemporary newspapers. On March 25, 1864 the *Evening Telegraph* of Harrisburg, Pennsylvania, stated that he fell "a distance of over a hundred feet, and was instantly killed. He almost dragged a woman down with him. He leaves a wife and family of young children." On April 2, 1864 the *Troy Weekly Times* of New York stated:

The soldiers have a great weakness for having their likenesses taken, and army photographers thrive. A few days ago one of these mirrorists of heroes, by the name of Roper, fell from the highest rock of Lookout Mountain and was instantly killed. He had been engaged there for some time taking pictures, and in adjusting his apparatus inadvertently stepped too near the edge and went over.[46]

According to the memoir of Captain John H. Otto, 21st Wisconsin Infantry, an army sergeant at the Lookout Mountain signal station had arranged for Roper to take the "likeness" to send to his parents of a local girl who had captured his heart. As Roper adjusted his camera near the precipice, he slipped and fell "several hundred feet" onto the rocks. Otto added, "No help could reach him in less than an hour and a half, and no help was necessary as he certainly was dead before he came to a halt." The young lady being photographed fainted at the shock of the accident and fell toward the abyss, but the sergeant was able to hold her dress to save her from also going over the edge! A short distance southwest of Point Rock, the precipice where he fell subsequently became known as "Roper's Rock."[47]

CHAPTER 4

"Views of grim-visaged war…"

PHOTOGRAPHY AT THE FRONT

The limitations of the photographic process, and the threat to life and limb of the photographer, meant that the camera was largely confined to the rear lines or aftermath of battle during the Civil War. But the dangers of war had yet to be learned in 1861. When the Union Army of Northeastern Virginia, commanded by Brigadier General Irvin McDowell, marched out toward Bull Run to meet the Confederates during the first major campaign in the East in July 1861, several photographers joined the newspaper correspondents, artists and large number of civilians who accompanied it. Among the former were veteran photographers George N. Barnard and Matthew Brady. Like others, Brady only received permission to accompany the advance after great difficulty. During an interview in 1891, he recalled that before the war he had often curried favor among those in high places by presenting them with wild ducks obtained at a steamboat crossing of the Susquehanna River. Visiting Major General Winfield Scott, Commander-in-Chief of the US Army since 1841, he gifted him a duck and asked if he could accompany the Union advance, only to be informed by the ancient and obese warrior that he had been replaced in command of the field army by General McDowell. Being finally granted permission from McDowell, Brady became one of the many civilians who thought they were going to witness a resounding Union victory, but were caught up in the stampede of McDowell's army following its defeat on July 21, 1861.

Meeting *New York Tribune* correspondent William A. Croffut as the Union army advanced, he is reported to have said, "I know well enough that I cannot take a photograph of a battle, but I can get a little glimpse of some corner somewhere that will be worth while. We are making history now, and every picture that we will get will be valuable." Of his experience that day Brady later recalled:

I went to the first battle of Bull Run with two wagons from Washington. My personal companions were [Richard C.] Dick McCormick, then a newspaper writer, Ned [Edward H.] House [of the *New York Tribune*], and Al[fred R.] Waud, the sketch artist. We stayed all night at Centreville; we got as far as Blackburn's Ford; we made pictures and expected to be in Richmond next day, but it was not so, and our apparatus was a good deal damaged on the way back to Washington; yet we reached the city. My wife and my most conservative friends had looked unfavorably upon this departure from commercial business to pictorial war correspondence, and I can only describe

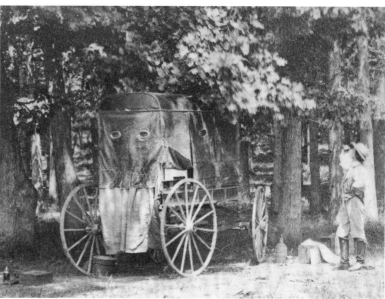

(Left) Photographed the day of his return to Washington after being caught up in the Union defeat and stampede at First Bull Run on July 21, 1861, Matthew Brady poses in straw hat and the long linen duster he was described by eyewitnesses as wearing during the battle. He also wears a sword that he claimed was given to him by a New York Fire Zouave during the retreat. (Library of Congress)

(Right) One of Matthew Brady's mobile dark rooms, nicknamed "Whattizit" wagons by the troops, is seen in this view entitled "Our Artist at Manassas, 4th July, 1862." To make it dark inside in order to develop photographs, heavy sheets of canvas formed a cover around the wagon's wooden top and sides. Unbearably hot inside, the chemicals used made breathing difficult, causing the photographers to become light-headed. The air outside was often not much better if they were close to the smoke of battle. (Library of Congress)

the destiny that overruled me by saying that … I felt I had to go. A spirit in my feet said, "Go," and I went.[1]

A short account of George N. Barnard's experience at Bull Run published in 1902 after his death stated, "Taking his camera, which weighed

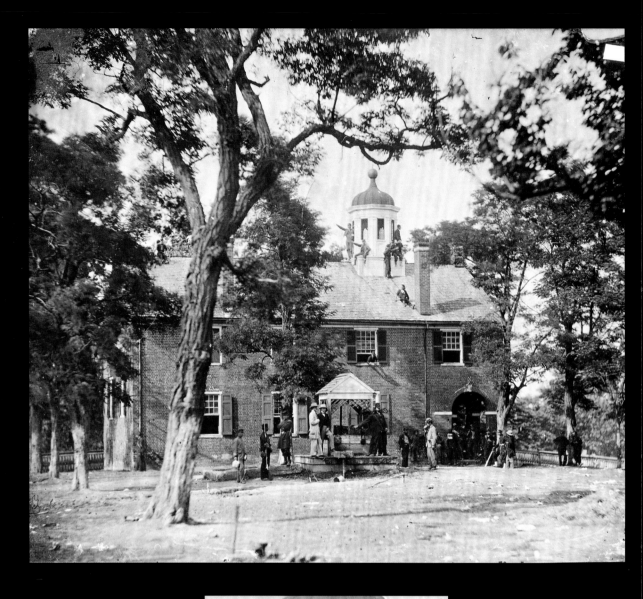

(Left) As it advanced toward Centreville, Virginia, McDowell's army occupied Fairfax courthouse on July 17, 1861. Having probably orchestrated the scene to some extent, Matthew Brady stands at right talking to an officer, while soldiers including enlisted men of the 11th New York Infantry or Ellsworth's Fire Zouaves pose on the roof and others gather around a well. Several of the men on the roof point as if emulating the pose of the equestrian statue of George Washington in Union Square, New York City, around which the "Great Sumter Rally" of April 20, 1861 was held. (National Archives)

something more than a modern instrument, [he] engaged a seat in a carryall, but he got no pictures that day. On the return he overtook a poor fellow, sorely wounded in the leg, trying to get back to Washington. He stopped and put him in his place, shouldered his heavy instrument, and after weary walking he reached Washington, footsore and tired."[2]

In his recollections of the battle, *New York Tribune* correspondent William A. Croffut recounted seeing Matthew Brady during the Union advance on Sudley Ford.

When we were pretty nearly exhausted we halted in a narrow lane … Shortly another civilian came up and joined us. Like myself, he wore a long linen duster, and strapped on his shoulders was a box as large as a beehive. I asked him if he was a commissary. "No," he laughed, "I am a photographer, and I am going to take pictures of the battle." I asked him if he could get the fellows who were fighting to stand still and look pleasant. With a very serious face he said he supposed not, but he could probably get some scenes that would be worthwhile. His name was Brady, he added, and the protuberance on his back was a camera … I saw him afterwards dodging shells on the battlefield. He was in motion, but his machine did not seem effective, and when about two o'clock a runaway team of horses came dashing wildly past us, dragging a gun carriage bottom side up, I saw Brady again and shouted, "Now's your time!" But I failed to stir him. I have often wondered how many pictures he took that day and whether he got out of the battle on our side or the other.[3]

In fact, when the headlong retreat began, Brady escaped and made his way back to Washington, arriving exhausted the next day. Although few of the images of the Bull Run campaign produced by this intrepid photographer survive today, he clearly did take a number of dramatic views of the advance and, possibly, flight of the Union army, as on August 15, 1861 *Humphrey's Journal of the Daguerreotype and Photographic Arts* reported:

> The public are indebted to Brady, of Broadway, for numerous excellent views of "grim-visaged war." He has been in Virginia with his camera, and many and spirited are the pictures he has taken. His are the only reliable records of the fight at Bull's Run … The groupings of entire regiments and divisions, within a space of a couple of feet square, present some of the most curious effects as yet produced in photography. Considering the circumstances under which they were taken, amidst the excitement, the rapid movements, and the smoke of the battle-field, there is nothing to compare with them in their powerful contrasts of light and shade.[4]

Many of the photographs produced by Matthew Brady in the field throughout the rest of the Civil War were taken by a set of skilled camera operators who worked in his employ. This has led to the erroneous belief that he had poor eyesight. In fact, he corrected this throughout his life by wearing spectacles and would have had no problem operating a camera. Thus, it was seemingly his choice to perform a managerial role, artistically composing and orchestrating scenes rather than being involved in preparing chemicals, operating the camera and developing the glass plate negatives. While his operators worked behind the camera and in claustrophobic wagon-bound darkrooms, he arranged soldiers and civilians singly and in groups insignificant locations and often posed with them. One of the first of thesecompositions was a view of elements of McDowell's army at Fairfax courthouse on July 17, 1861. Taken by Timothy O'Sullivan, one of Brady's operators, this study was referred to in a short article entitled "Photographs of War Scenes" in *Humphrey's Journal* of September 15, 1861 as "Zouaves on the look-out from the belfry of Fairfax Court House." Accordingly, a main feature of the photograph is soldiers arranged around the white octagonal belfry on the roof, four of whom are in Zouave uniforms and probably belonged to the 11th New York Infantry, also known as Ellsworth's Fire Zouaves. Others await water to be drawn from a covered well by the red brick building.[5]

(Next page) This detail from a stereoscopic negative of two of Brady's photographers at Gettysburg in 1863 is believed to show David B. Woodbury sitting on the ground at left. Their portable dark room has a blanket draped over it at the back of their wagon. Farther forward can be seen a photographic plate holder and box holding glass or chemicals marked "BRADY'S/WASHINGTON," indicating the gallery which supplied it. (Library of Congress)

Unperturbed by his Bull Run experience, Matthew Brady set about organizing field camera units to photograph the war as it unfolded. Meanwhile Scottish-born Alexander Gardner continued to manage Brady's Washington gallery with great success, and Andrew E. Paradise ran the one in New York.[6] While Major General George B. McClellan recruited and trained the Army of the Potomac for a new offensive, Brady prepared to capture as much of it as possible in photographic form. From January through April 1862 he instructed his crews and made plans to cover the inevitable campaigns that would come with the spring once the roads were in a fit condition for military use. Because of the dangers in the field and boredom of life in camp and bivouac in all kinds of weather, experienced cameramen, or operators as they were called, were difficult to find. Brady seems to have overcome this by largely recruiting from his own galleries. Thus the likes of Edward T. Whitney, David B. Woodbury, Timothy O'Sullivan, Jacob F. Coonley, William R. Pywell, James F. Gibson, John Reekie, and George N. Barnard, who by this time also worked for Brady, became names associated with making some of the most important photographs of the Northern experience of the Civil War. These experienced men were assigned to the various theaters of the war in the east. Regarding equipment, chemicals and supplies, Brady relied upon the New York Photographic Supply House of E & H. T. Anthony, whose customer he had been for many years.

Special vehicles eventually nicknamed "Whatizzit" wagons because soldiers often asked Brady and the other photographers "What is It?" were designed and built specially for photographic work in the field. Serving as traveling, canvas-covered darkrooms, these had built-in compartments, shelves and receptacles for the glass plates, holders, chemicals, and cameras

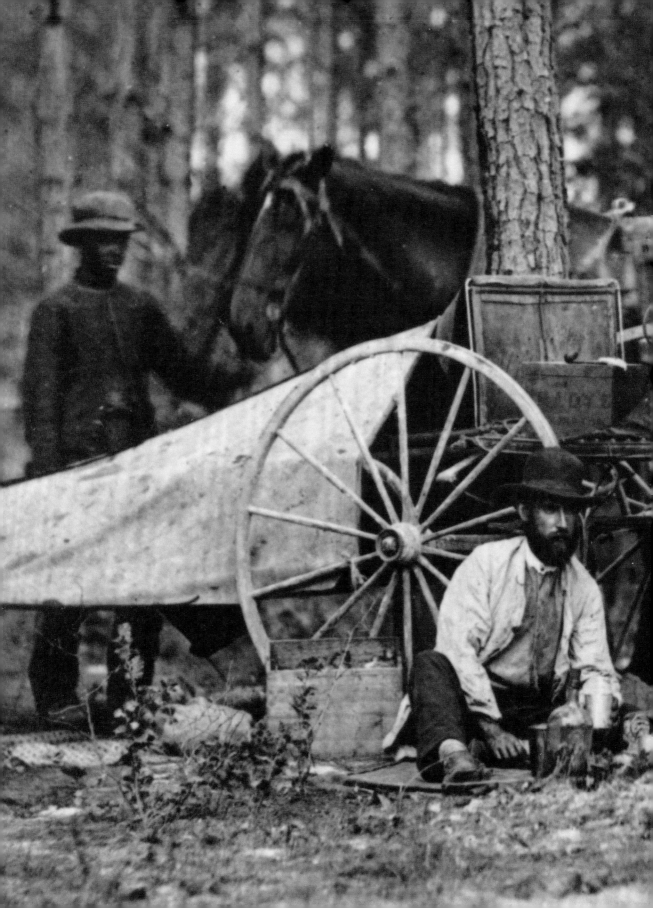

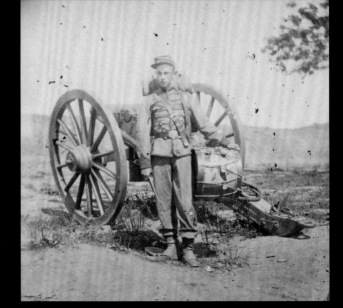

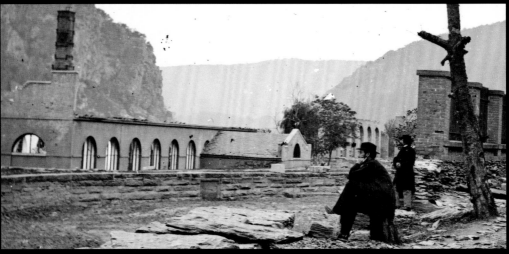

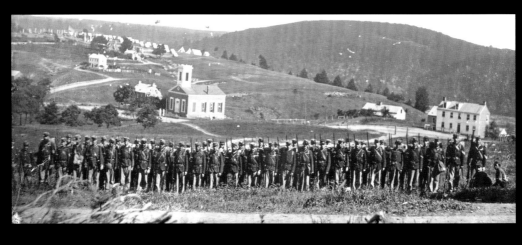

(Top left) Edward T. Whitney learned the daguerreotype process during the early 1840s and opened his "Skylight Gallery" in Rochester, New York, in 1851. During the 1850s he made regular trips to the New York City studios of Matthew Brady and Jeremiah Gurney in order to study the latest improvements in photography. In 1861 Brady commissioned Whitney to assist him in taking photographs of "the fortifications around Washington and places of interest for the Government." This *carte de visite* was produced at Brady's New York gallery. (National Portrait Gallery, Smithsonian Institute)

(Top right) Wearing the full dress gray uniform of a musician of the 22nd New York State Militia, and company letter on his belt plate, this youthful drummer of Co. B is 13-year-old Charles De Mott, who was the son of a blacksmith resident in New York City. As his regiment had sent their full dress coats home by the end of July 1862, this photograph was probably produced before that date. The captured six-pound gun behind him has "CAPT. COCHRAN/HARPERS FERRY VA" painted on its trail, which may refer to Confederate Captain George Moffett Cochran, Jr, who was on ordnance duty at Harpers Ferry in May 1861 and later served as assistant quartermaster with the 52nd Virginia Infantry from September 2, 1861. (Library of Congress)

(Center) In a report on Brady's photographic achievements on September 20, 1862, the New York *Evening Post* stated, "The Harper's Ferry photographs embrace views of the Ferry itself, taking in a view of the pontoon bridge, a long sweep of the river, the railroad bridge, and the ruins of the old government armory. This picture is in every way admirable, and without one of the accidental, and, to all but the best skilled operators, almost inevitable defects." In this detail from the latter described view, a seated Edward L. Whitney, with Matthew Brady standing beyond, gazes toward the ruins of the US Arsenal building, which had been the scene of the John Brown Raid in 1859 and was destroyed by retreating Union forces in April 1861. (Library of Congress)

(Bottom) According to the New York *Evening Post* report, Brady and Whitney went on to "the pleasant encampment of the Twenty-second regiment New York State Militia." One of 50 photographs taken of this regiment, Co. A stands at "Shoulder Arms" with saber bayonets fixed on their Enfield short rifles. Company commander Captain James Otis is at far left, and an African American camp servant is seated at far right. A later report in the *New-York Times* on October 20, 1862 mentioned that Brady and Whitney used a "government barn" as their "laboratory while taking pictures for the Twenty-second New York State Militia." (National Archives)

to guard against breakage along rough country roads. The box-shaped cameras supplied were of different sizes, ranging from the large 16 by 20-inch model to the small 4 by 4-inch Stereoscopic camera imperative for producing views for the popular parlor Stereoscope viewer.

Northern public opinion and prodding from President Lincoln finally goaded General McClellan into beginning the Peninsula Campaign on March 17, 1862, which involved landing the Army of the Potomac at Fortress Monroe on the Virginia Peninsula and advancing on Richmond, the Confederate capital, from the southeast via Williamsburg. Nine days earlier, General Joseph E. Johnston had ordered all Confederate forces east of the Blue Ridge Mountains to abandon the Manassas line and fall back to the Rappahannock River. It was time for Brady to take to the field once again, and he arranged with Edward Anthony to share photographers and resources.

To accompany him to the abandoned First Bull Run battlefield, and during the Peninsula Campaign, Brady chose a group of experienced operators who included Edward T. Whitney, a veteran photographer with galleries in New York City and Norwalk, Connecticut, well known within the fraternity of photographers before the war. Whitney was assisted by 22-year-old David Woodbury, who had been with him since 1860 and had learned wet plate photography from Boston's famed photographer James W. Black in the 1850s. Also involved was Anthony-employee George N. Barnard, assisted by Scotsman James F. Gibson who had worked for Matthew Brady since 1860. Venturing out of the Washington gallery, Gibson photographed the departure of the USS steam frigate *Pensacola* for Fortress Monroe in January 1862 (see Chapter 6), but his first full trip into the field would be with Barnard several months later.

Edward T. Whitney worked closely with Brady during this period. Emulating his managerial style, he preferred to compose and orchestrate photographic scenes rather than work behind the camera, which appears to have been left to David Woodbury. Also like Brady, he often appeared in these photographs posing in a relaxed and thoughtful manner as if contemplating the historical importance of the location. Recalling his time working for Matthew Brady in 1861–62, Whitney wrote in 1884:

When the war broke out, Mr Brady asked me to take my operator, Mr [David] Woodbury, and go into the field and make photographs for the Government of the scenes of the war. We went. Our first pictures were

taken after the battle of Bull Run. We had a large covered wagon with two horses, and a heavy load of glass, apparatus, chemicals, and provisions. Arriving at Manassas, we took possession of a deserted cottage making views of the fortifications, the battle-field, etc., until one morning a regiment came along. The colonel rode up with the pleasing intelligence that we were outside of our lines, and liable to capture. You may be sure we did not waste much time in harnessing the horses and joining the regiment as it moved to a safer place. We spent the winter taking views of the fortifications around Washington and … Yorktown, Williamsburgh, White House, Gaines Hill, Chickahominy, Seven Pines. During the seven days' retreat from before Richmond to Harrison's Landing, photographs were taken of James River from a balloon.[7]

Although working closely with Brady until about March 1863, Whitney received no credit for the contribution he and his assistant David Woodbury made, and did not negotiate an arrangement to copyright in his own name any views created when he was in the field with Brady. Neither did he insist upon receiving credit in any subsequently published catalogs. Based on an 1864 news report of his later partnership with Andrew E. Paradise when he photographed General McClellan, he appears to have been honored that Brady had asked for his help.[8]

Operating for both Anthony and Brady, George N. Barnard and James F. Gibson ventured forth from Washington during March 1862 to spend several days photographing the abandoned Confederate defences around Centreville and Manassas Junction. Sharing the work, they both took credit for producing large 8x10 negatives, while Barnard received sole credit for the stereoscopic views made on this trip. Looking along what remained of the Braddock Road, Barnard and Gibson took several photographs of the stone church and wooden dwellings at Centreville. They next turned their camera on the abandoned Confederate log-built winter quarters west of the village, plus deserted fortifications along the nearby ridge and wooden "Quaker guns" placed along them. Planted there mainly during September 1861 to create the impression that the Confederacy had more firepower than it actually possessed, the "Quaker guns" became a controversial subject and source of embarrassment in the North for months after their discovery. As McClellan's Army of the Potomac of nearly 200,000 had been held at bay by imitation wooden guns and mock field works for nearly six months, several

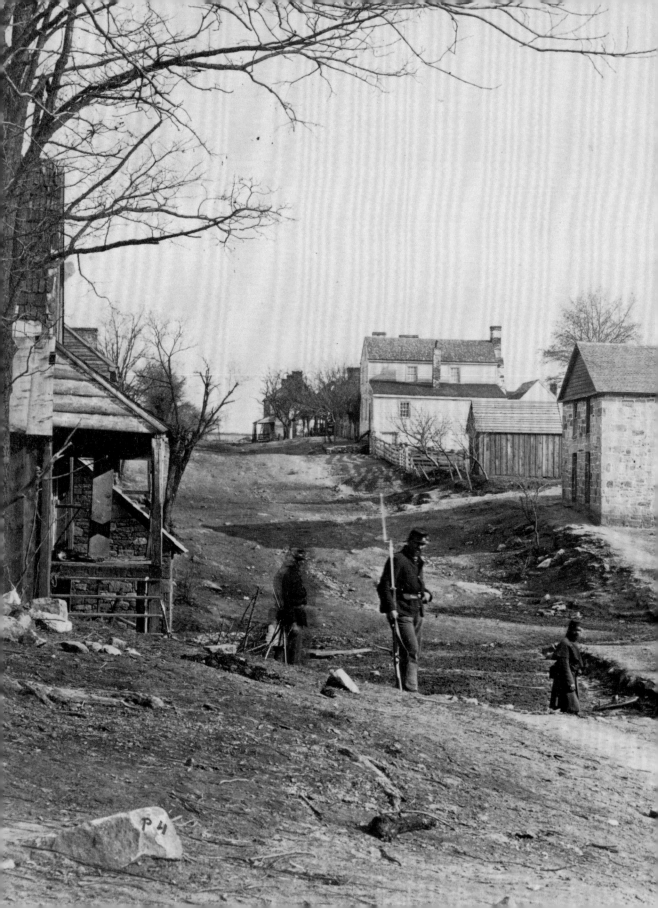

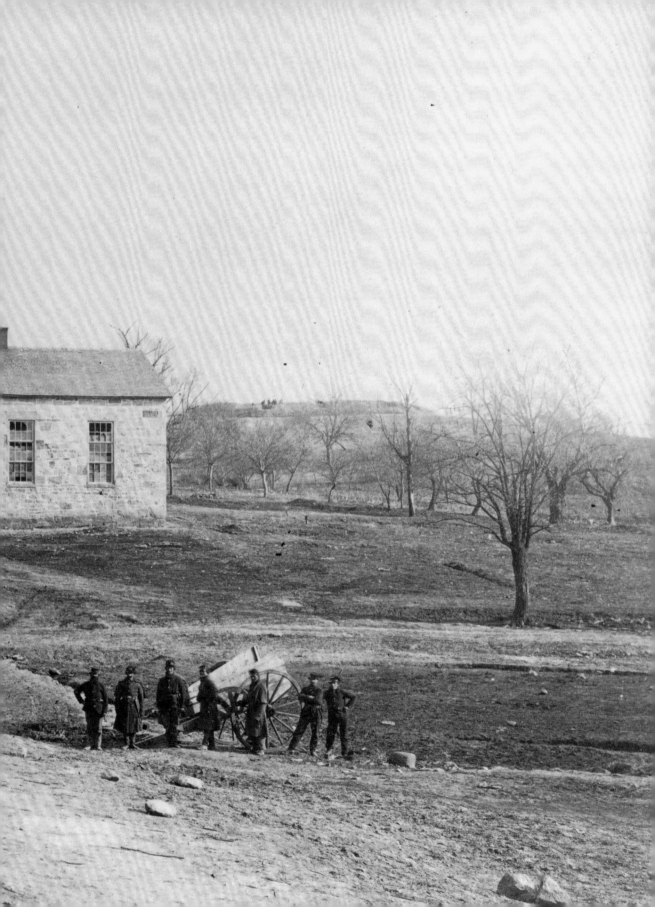

(Previous pages) The stone church at Centreville served as a hospital after the fighting at Blackburn's Ford and Bull Run in 1861, and would serve the same purpose at Second Bull Run in August 1862. With much of their glass shattered, the windows have been boarded up inside, probably to protect the wounded contained there. Much of the road passing by its two front doors has been destroyed or dug up to create earthworks. Six of the Union soldiers brought together for the Barnard and Gibson photograph wear overcoats against the cold spring weather in Northern Virginia. (Library of Congress)

(Top) In a letter to the editor of the *New York Tribune*, an eyewitness counted 81 "Quaker guns" in the fortifications around Centreville. Displaying an admirable sense of humor, Barnard and Gibson chose to take at least six different views of them, possibly to refute any official denial that they existed. Note the carefully carved and painted "gun barrel" and flimsy wickerwork and brushwood breastworks. The civilian pretending to fire the gun is possibly photographer James F. Gibson, who also appears in several other Barnard and Gibson images produced in 1862. (Library of Congress)

(Bottom) Concentrating on the abandoned fortifications on the ridge near Centreville in March 1862, Barnard and Gibson photographed some of the flimsy "wicker work" that a correspondent of the Philadelphia Inquirer reported seeing around some of the mock Confederate embrasures at Centreville. The Union soldiers they found there were probably part of the infantry column that followed the 2,000-strong cavalry which accompanied generals McClellan and McDowell when they advanced to inspect the area. Try as he may, the soldier seated nearest the camera petting the dog could not keep its head still. (Library of Congress)

of his staff officers (Colonel E. H. Wright and Colonel John J. Astor) attempted to deny their existence in the press, only to be rebutted by letters from eyewitnesses describing them in great detail. Hence it was imperative to Barnard and Gibson that they provide photographic evidence of the existence of these mock guns.

Moving a short distance to Bull Run and the site of the battle of July 21, 1861, Barnard and Gibson photographed the remains of the Stone Bridge destroyed by the Confederates when they withdrew in March 1862, plus the Henry, Robinson and Matthews houses around which the battle had raged. When they reached Manassas Junction, where troops under General Joseph E. Johnston had arrived from the Shenandoah Valley to reinforce Beauregard on July 21, 1861, they found utter destruction.

About 2,000 cavalry accompanied McClellan and staff when they arrived to inspect the abandoned Confederate lines at Manassas on March 11, 1862, following General Johnston's withdrawal behind the Rappahannock River. Based on their uniforms, at least two of the Union soldiers in the foreground of this study are cavalry troopers. Empty boxcars stand on the railroad and burned quartermaster and commissary stores lie by the trackside. Five mounted cavalry troopers are seen in the distance, as if lined up especially for Gardner's camera. (Library of Congress)

Describing aptly what the photographers found, a correspondent of the *Philadelphia Inquirer* riding with McClellan and staff wrote, "The sight here cannot be portrayed; the large machine shops, the station-houses, the Commissary and Quartermaster store-houses, all in ashes. On the track stood the wreck of a locomotive, and not far down the remains of four freight cars which had been burned."[9]

Soon after the Centerville/Manassas trip, Brady sent James Gibson to the peninsula in Virginia at the beginning of May 1862, where he photographed officers and civilians in the Union camps, plus the massive

siege guns facing the Confederate fortifications in the Yorktown area. Barnard also arrived on the peninsula in late June 1862, and mostly concentrated on the abandoned Confederate defense works near Yorktown and Hampton. Gibson also produced the only known images of the famed USS ironclad *Monitor* anchored in the James River (see Chapter 6). During the next few weeks he followed McClellan's advance toward Richmond, hoping to witness the conclusion of the rebellion. While busy capturing images of the battlefield in the aftermath of Seven Pines, or Fair Oaks, fought on May 31–June 1, he suddenly became aware of Union soldiers streaming back to the main supply depot at Savage's Station on June 27. With no way to access the scene of actual battle, he withdrew to relative safety and aimed his camera at the wounded of the 16th New York Infantry lying in a temporary field hospital established in a farmyard near the Savage House. The end result was one of the most significant photographs of the Peninsula Campaign. Describing its importance to its readership in November 1862, *Harper's New Monthly Magazine* stated:

> This is Savage's Station, with the wounded there after the battle of the 27th June. There is a tree in the middle; a shed and tents; and around the tree, lying thick and close, so that the ground looks like a dull, heavy sea of which bodies are the waves, lie the wounded soldiers. This scene brings the war to those who have not been to it. How patiently and still they lie, these brave men who bled and are maimed for us! It is a picture which is more eloquent than the sternest speech.[10]

Meanwhile, Alexander Gardner continued to manage Brady's Washington gallery, but developed an association with fellow-Scot Allan Pinkerton, head of Federal intelligence operations that would become the Union Intelligence Service. Impressed by Matthew Brady's idea of photographing the war, Pinkerton recommended Gardner to President Lincoln for the position of chief photographer under the jurisdiction of the US Topographical Engineers, following which he became a staff photographer under General McClellan in November 1861, becoming known as "Captain Gardner." He spent much of the first nine months of 1862 producing photographic copies of maps for the Topographical Engineers, but during September of that year was to photograph for Matthew Brady the aftermath of the single bloodiest day in American military history.

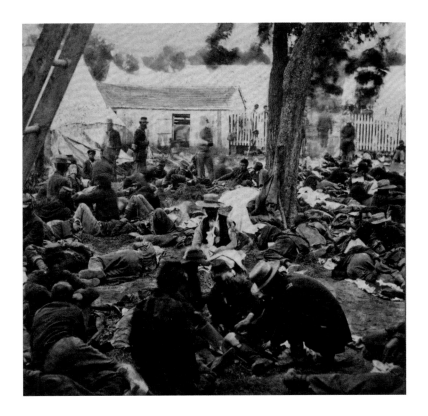

Produced from the negative made by James F. Gibson, this detail from a hand-colored stereoscopic view shows a temporary field hospital in a farmyard at Savage's Station. The surgeon's tent is seen to the rear left. Identified by their straw hats, many of these men belonged to the 16th New York Infantry. This regiment received its baptism of fire at Gaines Mill on June 27, 1862, and sustained over 200 casualties. Most of the men seen in this image were removed to hospitals near Fortress Monroe and escaped capture when Confederates overtook the area during the battle of Savage's Station two days later.
(Library of Congress)

Beginning his first invasion of the North, Robert E. Lee led the Army of Northern Virginia across the Potomac River near Leesburg on September 4, 1862. Two days later troops under "Stonewall" Jackson were in Frederick, Maryland, and shock waves spread throughout the Union. McClellan's Army of the Potomac marched out of Washington on

September 7 intent on finding and destroying the Confederate invaders, and Alexander Gardner was in their midst.

On September 16, McClellan confronted Lee at Sharpsburg, Maryland. Attack and counterattack swept across Miller's cornfield and swirled around the Dunker Church. Eventually the Confederate center was pierced at what became known as the Sunken Road, but the Federal advantage was not consolidated. Later that day, Burnside's Ninth Corps finally got into action, crossing the stone bridge over Antietam Creek and pushing back the Confederate right wing. Arriving from Harper's Ferry at a crucial moment, A. P. Hill's "Light Division" counterattacked and drove Burnside's troops back, preventing a Confederate disaster. Although outnumbered two-to-one, Lee had committed his entire force, while McClellan used less than three-quarters of his army. As a result, Lee fought the Federals to a standstill. During the night, both armies stabilized their lines. Despite crippling casualties, Lee continued to skirmish with McClellan throughout the next day, while removing his wounded south of the river. After dark, he ordered his battered Army of Northern Virginia to withdraw across the Potomac into the Shenandoah Valley.

Among the wounded at Savage Station, the grim expression on the soldier at right sums up the desperation of war, while the sergeant at left tenderly comforts another soldier who appears to have a head wound. (Library of Congress)

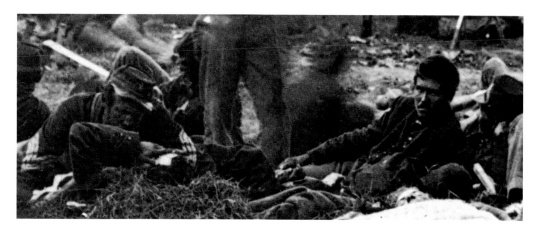

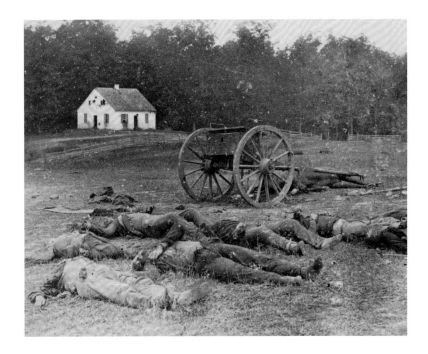

When published in Brady's Album Gallery, this image by Alexander Gardner was aptly
titled "Completely Silenced," and shows seven dead Confederate soldiers lying as they fell
at Antietam, Maryland, on September 17, 1862. The presence of an abandoned limber
with a dead horse nearby suggests they may have been artillerymen. The battle-scarred
Dunker Church, which was the focal point of a number of Union attacks against the
Confederate left flank, stands in the background. After the battle the Confederates used it
as a temporary medical aid station. (Library of Congress)

While Gardner was present in the rear during the course of the battle
of Antietam, there is no evidence that he took any photographs until
several days later. Assisted by James F. Gibson, he exposed at least 25
stereoscopic plates, which included views of the dead strewn across the
battlefield on September 19, and returned on several occasions after that
to take a total of at least 77 images related to the battle. By October 20,
1862, many of these images were on display at the New York gallery of
Matthew Brady and came to the attention of a correspondent of the
New York Times, who wrote:

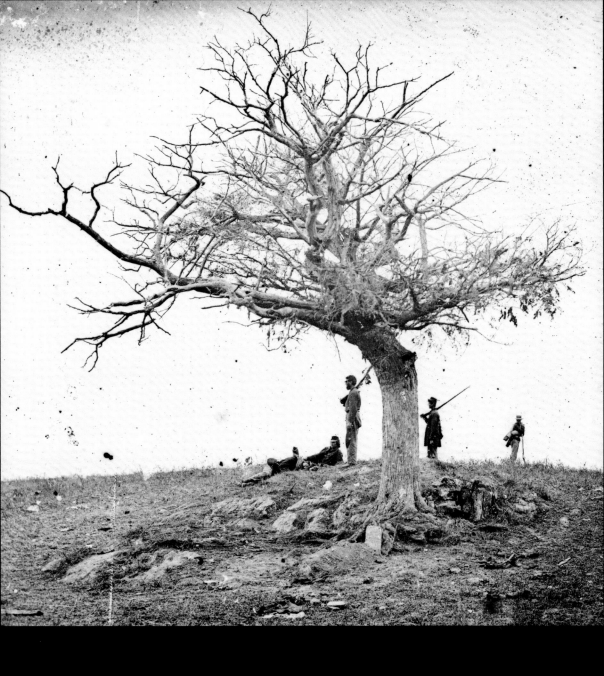

Entitled "A lone grave on battle-field of Antietam," this haunting image taken by
Alexander Gardner several days after the battle shows five soldiers near the grave of Private
John Marshall, Co. L, 28th Pennsylvania Infantry. As if an added mark of courage and
sacrifice, a socketed bayonet is stuck in a tree root next to the grave marker. An Irish-born
stonemason from Allegheny City, Pennsylvania, at 49 years of age Marshall was too old for
military service when he enlisted on July 27, 1861. He left a 30-year-old wife and two
young children. His remains were later reinterred in the National Cemetery at Antietam.
(Library of Congress)

Born in Paisley, Scotland, in 1821, Alexander Gardner became an apprentice silversmith jeweler at 14 years of age and later developed talents in journalism and chemistry, which led him into photography. Deeply disturbed by the exploitation of the working class in Britain, and influenced by socialist ideas advocated by Robert Owen, he established the "Clydesdale Joint Stock Agricultural & Commercial Company" in 1849 as a means of raising funds to acquire land in the US. Emigrating in 1850 with his younger brother James and sister Jessie Sinclair, plus six others, he purchased land and established a cooperative community near Monona, in Clayton County, Iowa. Following the death in 1856 of their sister and her husband of tuberculosis, then known as consumption, the two brothers abandoned the "Clydesdale" community and moved to New York City where they both found employment with Matthew Brady. By 1858 Alexander was running Brady's Washington gallery, assisted by his brother James, with great success.
(National Portrait Gallery, Smithsonian Institution, gift of Larry J. West)

The living that throng Broadway care little perhaps for the Dead at Antietam, but we fancy they would jostle less carelessly down the great thoroughfare, saunter less at their ease, were a few dripping bodies, fresh from the field, laid along the pavement … Mr Brady has done something to bring home to us the terrible reality and earnestness of war. If he has not brought bodies and laid them in our dooryards and along the streets, he has done something very like it. At the door of his gallery hangs a little placard, "The Dead of Antietam." Crowds of people are constantly going up the stairs; follow them, and you find them bending over photographic views of that fearful battle-field, taken immediately after the action. Of all objects of horror one would think the battle-field should stand pre-eminent, that it should bear away the pain of repulsiveness. But, on the contrary, there is a terrible fascination about it that draws one near these pictures, and makes them loth [sic] to leave them. You will see hushed, reverend groups standing around these weird copies of carnage, bending down to look in the pale faces of the dead.[11]

By late 1862 or early 1863 Gardner had split with Brady, due to his inefficient business practices and failure to pay his photographers on a regular basis. During this period he became "photographist" at the headquarters of Major General Joseph Hooker, commanding the Department of the Potomac, and was tasked with "taking views on the march." By May 26, 1863 Gardner had opened a gallery in Washington with his brother James, taking with him many of Brady's former staff including James Gibson and Timothy O'Sullivan. As Second Vice-President of the St. Andrew's Society of Washington, DC, Gardner also recruited fellow society members John Reekie and David Knox as field photographers, both of whom worked for him until the end of the war.[12]

Situated on the northwest corner of Seventh and D streets, over Shephard and Riley's Bookstore, and opposite the *National Intelligencer* newspaper office, "Gardner's Gallery" was difficult to miss, with six huge signs fixed to the upper walls of the four-storey building advertising all forms of photography. By June 1 he had also published a catalog of images for sale entitled "Photographic Incidents of the War." Composed mainly of over 400 stereoscopic and large-plate views he took with him when he left Brady, it listed much of his own work, plus that of others such as George Barnard, James Gibson, David Woodbury, and Timothy O'Sullivan.[13] By May 1864 Gardner had a larger gallery under construction at 511 Seventh

EXCELSIOR.

GARDNER'S

PHOTOGRAPHIC

ART

GALLERY,

INTELLIGENCER BUILDING,

511 Seventh Street,

WASHINGTON.

The Largest and Most Complete

ESTABLISHMENT

IN THE COUNTRY.

[OVER.]

GARDNER'S

PHOTOGRAPHIC INCIDENTS

AND

MEMORIES OF THE WAR,

THE ONLY COMPLETE

Pictorial History of the Rebellion

CONSISTING OF

VIEWS OF.

AND

SCENES ON THE BATTLE-FIELDS

OF THE

FIRST BULL RUN, FAIR OAKS, SAVAGE STATION,
MECHANICSVILLE, GAINES' MILL, CHICKAHOMINY,
MALVERN, HILTON HEAD, PULASKI, CHANTILLY,
SECOND BULL RUN, SOUTH MOUNTAIN, ANTIETAM;

SHARPSBURG, HARPER'S FERRY, FREDERICKSBURG,
CHANCELLORSVILLE, GETTYSBURG, VICKSBURG,
BRANDY STATION, CULPEPER, MINE RUN, CEDAR RUN,
WILDERNESS, SPOTTSYLVANIA COURT-HOUSE,
NORTH AND SOUTH ANNA, COLD HARBOR,
PETERSBURG, FORT FISHER, RICHMOND,

TOGETHER WITH

PORTRAITS OF ALL THE DISTINGUISHED GENERALS

OF THE ARMY.

PHILP & SOLOMONS, Publishers and Sole Wholesale Agents, Washington.

(Top) Established by Alexander and James Gardner above the Shephard & Riley Sutler's Stationery Store at the corner of 7th & D streets in Washington, DC, by May 1863, "Gardner's Gallery" was covered with signs advertising stereoscopic "Views of the War," as well as *cartes de visite*, album cards, Imperial-sized photographs "Plain, Colored, & Retouched," ambrotypes, hallotypes and ivorytypes. (Library of Congress)

(Inset top) This back mark was used on *cartes de visite* produced by "Gardner's Gallery" in Washington, from about May 1863 until May 1864.
(Courtesy of the National Portrait Gallery, Smithsonian Institute)

(Below) Advertising the enlarged "Photographic Art Gallery" established by Alexander Gardner during the summer of 1864, this handbill was probably distributed in 1865, as it mentions "Memories of the War" and the list of battles photographed includes Petersburg and Richmond. (Courtesy of Bob Zeller)

Street, "a few doors above the Intelligencer office," which, according to that newspaper, would be "fitted up with especial reference … to a capacious and properly arranged skylight."[14] The Gardners claimed that their new "Photographic Art Gallery" would be the "Largest and Most Complete Establishment in the Country."

Following Lee's second invasion of the North, which culminated in three momentous days of battle at Gettysburg, both Gardner and Brady traveled to Pennsylvania to photograph the battlefield separately. Accompanied by Gibson and O'Sullivan, Gardner arrived there first, on the evening of July 5, two days after Lee's failed "Grand Assault," of which "Pickett's Charge" was a part. Once again he and his operators photographed the dead of both North and South as they lay where they had fallen. Brady and his operators, David Woodbury and Anthony Berger, who also managed his Washington gallery, arrived ten days later and well after the bodies had been buried. Among the classic images Brady created was a stereoscopic negative of three captured Confederates laden with blanket rolls in front of a stack of wooden rails, which has since become an iconic image of the Civil War.

By August 1, 1863, prints from Gardner's Gettysburg negatives were available for sale, and a correspondent of the *Evening Star* newspaper at Washington commented, "In the whole range of photographic achievement

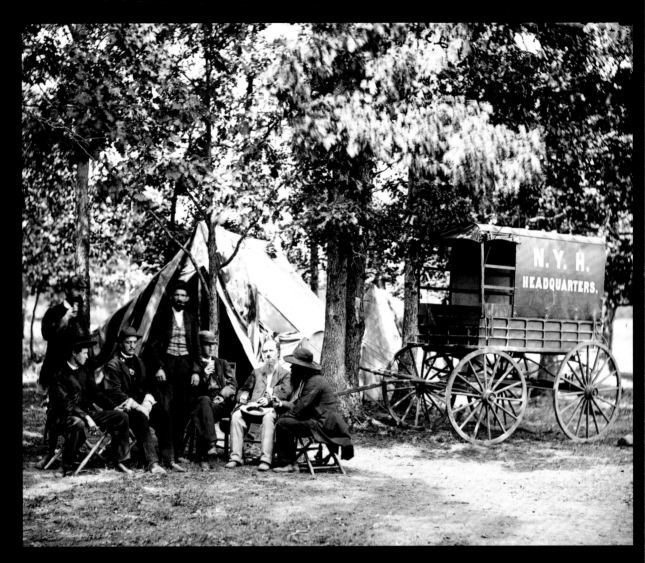

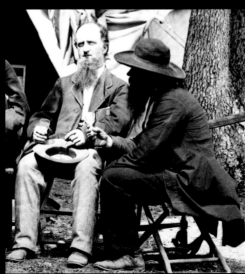

(Left) A newspaper editor and photographer in Scotland before he migrated to the US, Alexander Gardner would have had much in common with the editorial staff of the *New York Herald*. With Timothy O'Sullivan probably behind the camera, he sits at right talking to correspondents and their assistants at their "Headquarters in the Field" at Bealeton, Virginia, in August 1863. Note the wagon with "N.Y.H. Headquarters" sign-written on the side. The detail shows a silhouetted Alexander Gardner revealing his hands and fingernails blackened from using photographic chemicals to develop his wet plate collodion glass negatives. (Library of Congress)

that has come under our notice, we have seen nothing superior to these vivid sunlight representations of war scenes by Gardner." Intriguingly, this report also mentioned that the photographer was "taken prisoner at one time by the Confederates, while zealously engaged in the prosecution of his art." The likelihood that this actually happened is slim, as the bulk of Lee's army had withdrawn into Virginia by the time Gardner had set up his camera.[15]

At 21 years of age, Timothy H. O'Sullivan was the youngest of the leading photographers in the North. Employed by Matthew Brady before the Civil War, he worked under the tutelage of Alexander Gardner at the Washington gallery from 1856 until early 1862, when he was dispatched to join the staff of Brigadier General Egbert Viele to photograph maps and Union operations at Beaufort and Port Royal, South Carolina, from December 1861 to May 1862. Following the success of the naval operation against forts Beauregard and Walker guarding the entrance to Port Royal Sound on November 7, 1861, Union forces had consolidated their victory by occupying the city of Beaufort. Advancing north they took St. Helena Sound and continued up to the rivers on the south side of Charleston, where they were halted by Confederate opposition. As a result, the siege of Charleston began and continued until the last days of the war. During his time in this theater of the war, O'Sullivan captured images of the interior of forts Beauregard and Walker at the entrance to Port Royal Sound, the Coosaw Ferry to Port Royal, the wharf at Hilton Head, and the nearby Mills Plantation on Port Royal Island.

Described as being "as good with the rifle as the camera," ambrotypist William D. McPherson of Concord, New Hampshire was appointed captain of a company of sharpshooters being recruited for service with the

(Above) Born either in Ireland or on Staten Island around 1840, Timothy O'Sullivan was employed by Matthew Brady as a teenager. Learning the art of photography at the Washington gallery under the tutelage of Alexander Gardner from 1858, he worked with Brady in Virginia and South Carolina from 1861. Joining Gardner's studio about May 1863, he produced classic images of the Gettysburg battlefield and siege of Petersburg. (National Portrait Gallery, Smithsonian Institution, gift of Larry J. West)

(Right) Sentinels of the 76th Pennsylvania Infantry or Keystone Zouaves stand guard on the wharf at Hilton Head, South Carolina, which provided a vital supply line for the troops probing north toward Charleston. They appear surprised to discover they were being photographed by Timothy O'Sullivan in this previously unpublished detail.
(Library of Congress)

United States Sharpshooters during September 1861.[16] Born in Boston, Massachusetts, in 1833, McPherson opened his first gallery in Chelsea, Vermont, in 1855, where he advertised that he was producing "Cutting's Ambrotypes." By 1856 he was established in Concord, New Hampshire, and as late as August 8, 1861, operated a studio in the Merrimack Block. According to the *Independent Democrat*, by this time he specialized in

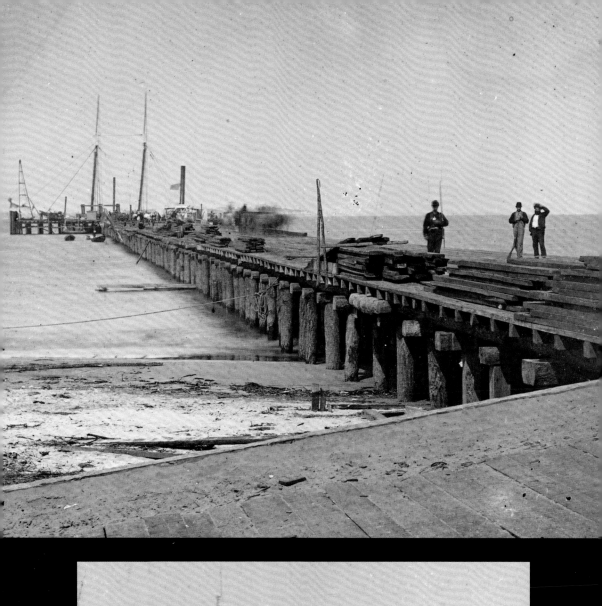
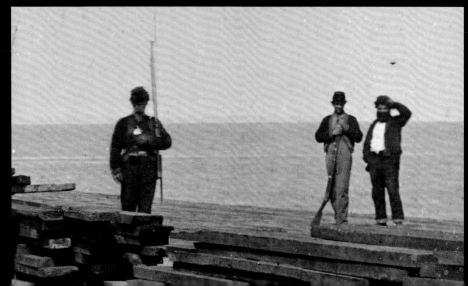

This detail from a stereoscopic view by McPherson & Oliver during the siege of Port Hudson, Louisiana in 1863 shows the Union naval nine-inch Dahlgren gun battery, commanded by Lieutenant Commander Edward Terry, looking north-northwest toward the Confederate fortifications. Shown in the act of loading the guns, a seaman at center can be seen sponging out the barrel while another seaman on the gun at left appears to be pricking the vent hole. (Robin Stanford collection, Library of Congress)

"taking pictures of a superior quality called Hallotypes, from a Mr Hall the inventor." He was also an accomplished flautist and singer, and had taken part in several "Concerts of Miscellaneous Music" at the Phoenix Hall in Concord in 1860.[17]

Swept up by the patriotism of the day, McPherson obtained a commission as captain of a company of sharpshooters on September 19, 1861, and had enlisted 70 recruits at his headquarters at the Lancaster House in Concord by mid-October. With full ranks his company left for Washington on December 14, where it was mustered in as Co. G, 2nd US Sharpshooters.[18] Attached to the First Brigade, Third Division, Army of the Potomac, the regiment was involved in the battles of Gainesville and Second Bull Run on August 29–30, 1862, during which Co. G took heavy casualties. The 2nd US Sharpshooters next took part in the charge at South Mountain, Maryland on September 14, capturing the

heights, and three days later lost over 25 percent of those present for duty in action on Miller's cornfield at Antietam. With thinned ranks and in need of reorganization, the regiment went into camp near Lovettsville, Virginia, where McPherson resigned and was discharged from duty on October 31, 1863.

Resuming his old occupation, McPherson went south to New Orleans and had established a gallery in Union-occupied Baton Rouge by early 1863, going into partnership with another photographer known today only as Oliver. McPherson and Oliver took numerous views of the city, plus military encampments and Union navy activity. They photographed Union batteries involved in the siege of Port Hudson, which lasted from May 22 through July 9, 1863, and a series of *cartes de visite* of its captured Confederate fortifications were included with the official report of the action by the Engineers of the Nineteenth Corps, Department of the Gulf. McPherson and Oliver were probably the "2 photographers" mentioned in a report written by Captain John C. Palfrey, US Engineers at Port Hudson on July 13, 1863 to Brigadier General Charles P. Stone, Chief of Staff, Department of the Gulf, which stated, "One photographer will remain here, to take the views already ordered, and the other will probably go to New Orleans, to print the impressions with greater facility."[19]

In early 1864, McPherson and Oliver accompanied the unsuccessful Red River campaign to capture Shreveport, Louisiana. By August of that year they were in Mobile Bay, Alabama, to photograph Fort Morgan, and the views they produced accompanied the official report sent to Washington by Brigadier General Delafield, US Army Chief of Engineers.

McPherson and Oliver are also credited with producing the classic images of Gordon, or "Whipped Peter," the slave with the "scourged back" who escaped from a Louisiana plantation in March 1863, gaining freedom when he reached the Union encampment near Baton Rouge. Photographed on April 2, 1863, these images first came to the notice of the Northern press in June 1863 when *The Liberator*, the abolitionist newspaper edited by William Lloyd Garrison, included a short commentary entitled "The Dumb Witness," which stated, "There has come to us, from Baton Rouge, the photograph of a former slave – now, thanks to the Union army, a freeman." The sender of the image was Major Jansen T. Paine, surgeon of the 1st Regiment, Louisiana Native Guards or 73rd US Colored Infantry, who enclosed it with a letter to his brother advising:

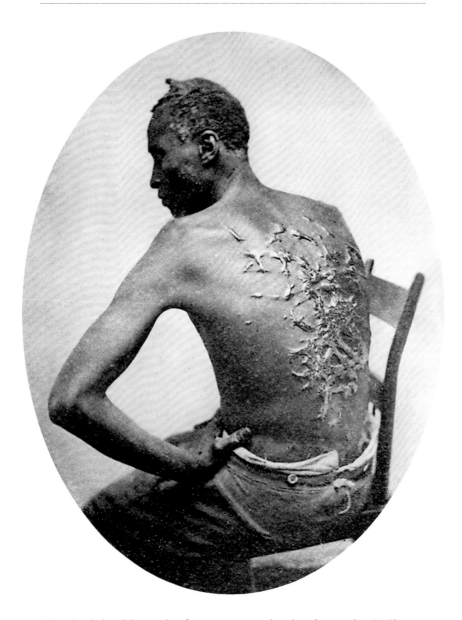

This colored glass slide was taken from a negative attributed to photographers McPherson & Oliver, and shows the "scourged back" of Gordon, or "Whipped Peter," the escaped slave. This image probably did more toward the final abolition of slavery than any other produced during the Civil War period. Enlisting in the 2nd Regiment, Louisiana Native Guard (74th US Colored Infantry), Gordon was promoted to the rank of sergeant and was later reported to have fought bravely in the Union assault on Port Hudson. Nothing further is known about his life. (War Department/National Archives)

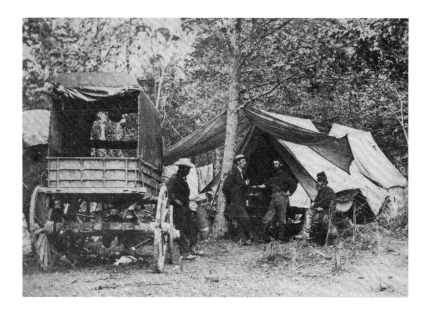

Photographed in camp circa 1864, Captain Andrew J. Russell, official photographer of the
United States Military Railroads, stands second from right at the entrance to his tent with
his hand resting on his camera.
(National Portrait Gallery, Smithsonian Museum, gift of Larry J. West)

I send you a picture of a slave as he appears after a whipping. I have seen,
during the period I have been inspecting men for my own and other regiments,
hundreds of such sights – so they are not new to me; but it may be new to you.
If you know of any one who talks about the *humane manner* in which the
slaves are treated, please show them this picture. It is a lecture in itself.

In another brief report, the same journal commented, "This card
photograph should be multiplied by one hundred thousand, and scattered
over the States. It tells the story in a way that even Mrs. [Harriet Beecher]
Stowe cannot approach because it tells the story to the eye."[20] Also
reproduced as engravings in *Harper's Weekly* on July 4, 1863, these images
received wide circulation and did much to promote the campaign for the
abolition of slavery in the whole of the United States by December 1865.

By the end of 1864, McPherson and Oliver had established a gallery at 133 Canal Street in New Orleans, and produced a series of city views. However, their partnership was dissolved in 1865 and McPherson continued to work on his own until his death from yellow fever aged just 39 on October 9, 1867, having led a very full life albeit one cut very short. An obituary in the *Independent Democrat* of Concord, New Hampshire, dated November 7 of that year stated that he "possessed a fine musical taste, and participated in several musical concerts in this city in past years as a flute performer. He was a genial man, and many friends will regret to hear of his death."

A portrait and landscape painter resident in Hornellsville, New York, on the eve of the war, Vermont-born Andrew J. Russell also colorized ambrotypes for photographer William L. Sutton, whose gallery was in Young's New Block on Main Street, Hornellsville. Caught up in the patriotic fervor following the fall of Fort Sumter, toward the end of April 1861 Russell was using his talent to paint "American flags, of any size."[21] By July 1862, with the assistance of La Fayette W. Seavey, he had painted a series of "thirty-five distinct views, besides a large portion of a moving panorama," which included "scenery of skirmishes, battles, encampments, cities, shipping, harbors, bombardments, and nearly every principal place and battle of interest connected with the present war." Russell's "Panorama of the War of 1861–2" subsequently toured throughout the Northern states during 1862 to encourage enlistment in the Union Army.[22] Meanwhile, in August 1862, Russell recruited and commanded an infantry company in Hornellsville, New York, which was enrolled as Co. F, 141st New York Volunteers. When he left for the front during the following month, Seavey took over the running of his studio.

While his regiment was stationed in the Washington defenses in 1862, Russell began to take photographs after being assigned to Brigadier General Herman Haupt, chief of the United States Military Railroad (USMRR). In order to disseminate his construction techniques, from "beanpole" bridges to "arks" to serve as floating warehouses, Haupt distributed reports to other Union armies and theaters of war that included Russell's photographs as illustrations. A report written on February 24, 1864, by J. H. Devereux, superintendent of the military railroads, described how an infantry captain became involved in photography. "To aid his written statement, photographs of the work thus started on the Potomac were required. And, with the view to make use of a photographic instrument

Ordered to photograph the destroyed railroad bridge at Fredericksburg so that Union engineers might see what they needed to repair should Hooker capture the town, Captain Andrew J. Russell, or his assistant, used a long-range lens in a camera set up on Stafford Heights to produce views on April 8, 1863. As the camera was moved around several times to capture different angles of the bridge, curious Confederate troops began to emerge from nearby buildings across the river. Presumably not feeling threatened by Federal sharpshooters, some of the Confederates eventually gathered at their end of the bridge to pose for Russell's camera. A similar event had occurred at this same location on December 13, 1862, when Union and Confederate troops had gathered at opposite ends of the destroyed bridge to exchanged salutations. Note the wooden "Quaker gun" peering out of one of the windows of the mill house at left. Several more Confederates can be seen inside the top window of the building behind the mill. (National Archives)

Photographed by Captain A. J. Russell several hours after the 6th Maine Infantry stormed
the stone wall on Marye's Heights during the second battle of Fredericksburg on May 3,
1863, Confederates lie dead where they fell along a shallow rifle pit. The detail reveals that
"Capt. Russell Phot" has been written under the Pattern 1853 Enfield Rifle Musket
probably dropped by the nearest fallen Confederate infantryman. (National Archives)

found in the storehouse of the Orange [& Alexandria Railroad] Line, Capt A. J. Russell of the 141st N.Y. Vols. was detailed to the Military Railroads as the operator or artist."[23] Russell was trained in the wet plate collodion process by Egbert G. Fowx, a civilian photographer who was already employed by the USMRR and also worked for Matthew Brady. On March 1, 1863 Russell was detached from his regiment and appointed to permanent duty with the USMRR.

Acquiring two new cameras for his photographic department, which consisted of one servant and one laborer, Russell had the rare opportunity to use his new equipment to photograph the Army of the Potomac in action and the enemy at close quarters. On April 8, 1863, he photographed the destroyed railroad bridge at Fredericksburg, Virginia in preparation for later repair by Federal engineers, and curious Confederate troops gathered on the opposite side of the river to pose for his camera. Shortly after the capture of Marye's Heights by the Union Sixth Corps, commanded by Major General John Sedgewick, during the Second Battle of Fredericksburg on May 3, 1863, Russell crossed the Rappahannock River with General Haupt and produced one of the most moving photographs of the Civil War when he found Confederate dead lying in a rifle pit behind a stone wall.

During July 1863, Russell was appointed acting assistant quartermaster for the construction corps, and also performed ordnance officer duties for the railroad department. Meanwhile, with continued assistance from Egbert Fowx, his photographic work progressed apace and prints from his negatives, either in sets or smaller collections, were widely distributed by order of General Haupt. By mid-February 1864, more than 6,500 of his large photographs and 368 small ones had been sent to President Lincoln and 67 others in the administration or the military. Lincoln received 151 large albumens and 88 small images, which no doubt included stereoscopic views, on four dates from May 1863 through February 1864. Secretary of War Edwin M. Stanton, Postmaster-General Montgomery Blair, and Secretary of the Treasury Salmon P. Chase also received sets of prints. In overall command of the military railroads as quartermaster general, Brigadier General Montgomery C. Meigs received over 150 Russell images. Other generals in receipt included Grant, Meade, Halleck, Burnside and Hooker. One set "with description" was gifted to Admiral Stepan Lissovsky, commanding the Russian fleet that visited the East Coast of the US in December 1863. A personal friend of Admiral Farragut, Lissovsky was part

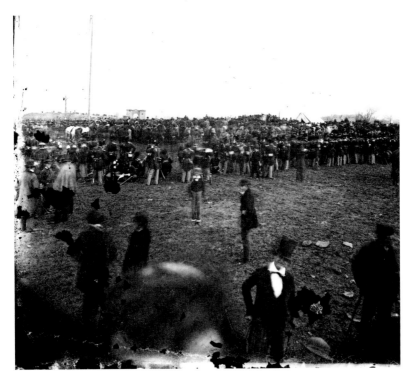

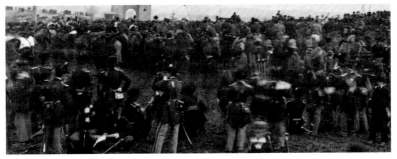

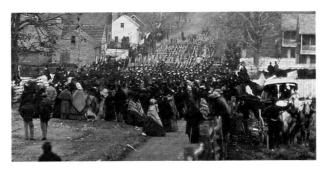

(Top) Photographed by one of Alexander Gardner's assistants, crowds guarded by troops gather around President Abraham Lincoln as he delivers his Gettysburg Address during the dedication ceremony at the Soldiers' National Cemetery on November 19, 1863. As with other photographers among the crowd, Gardner probably perched his dual lens camera on a platform atop a folding stepladder. Note the back of a partially bald head in the foreground that may have belonged to Gardner, who was balding in similar fashion.
(Library of Congress)

(Center) Enlisted men of the 5th New York Heavy Artillery in full dress uniform and serving as infantry form part of the cordon of soldiers surrounding the ceremony. The mounted troops seen farther away were possibly part of the 12th Pennsylvania Cavalry.
(Library of Congress)

(Bottom) Possibly climbing a tree, local photographers the Tyson brothers, of the Excelsior Photographic Gallery, produced this view of the procession leading out to the Evergreen Cemetery at Gettysburg, Pennsylvania at about 10.30 am on July 19, 1863.
(National Archives)

of a Russian technical team that visited the States in 1862 to examine the new monitor construction of John Ericsson.

On November 19, 1863, Alexander Gardner, David Woodbury and Anthony Berger (for Brady), Peter S. Weaver and David Bachrach, plus the Tyson brothers of the "Excelsior Photographic Gallery" at Gettysburg, gathered to create views of the dedication by President Abraham Lincoln of the Soldiers' National Cemetery being prepared for the fallen of the battle of Gettysburg, of which only 1,188 of about 7,000 had been interred by November 19, 1863.

By 1862, Anthony Berger was the manager of Brady's Washington Gallery and had photographed Lincoln on several occasions, the most recent being to assist painter Francis B. Carpenter in the completion of the painting of the president seated in his office/Cabinet Room known as "The First Reading of the Emancipation Proclamation Before the Cabinet." On November 23, 1863, David Woodbury wrote from Washington, DC to his sister Eliza, "I went to Gettysburg on the 19th with Mr. Burger [sic] the superintendent of the Gallery here. We made some pictures of the crowd and Procession. We took our blankets and provisions with us expecting the

crowd would be so great that not more than half would find lodgings. We found no trouble in getting both food and lodging."[24]

Peter S. Weaver established the "Gem Photograph Gallery" on Baltimore Street in Hanover, Pennsylvania, in 1861. His father Samuel wrote on November 26, 1863, that he "assisted Peter of getting a Negative of the large assembly on the Semetary [sic] ground, which I think is very fine, we have not as yet printed any Phot. of the Negative …" None of Weaver's images of the actual dedication ceremony appear to have survived, and although there are nine different extant photographs of the procession and ceremony, none can be accredited to a specific artist with any certainty. Of the surrounding battleground at that time, a report in the *Cincinnati Daily Commercial* commented, "The battle-field of Gettysburg has been gleaned of every relic. The breastworks of each army are still visible, and the trees of Wolf Hill and Little Round-top give evidence of the terrible execution of the artillery and musketry fire in this protracted and deadly conflict."[25]

The brother-in-law of Timothy O'Sullivan, William R. Pywell also became involved in photography during the war. Although little is known about his prewar career, a mention of a "show-card writer" producing "neat cards that all businessmen use" called "Willie R. Pywell," in the *Evening Star* of Washington, DC, on June 19, 1861, may refer to his earlier occupation. By 1863, Pywell was employed by Matthew Brady and later Alexander Gardner. Active in the Western Theater of the war, he photographed in and around Vicksburg, Mississippi, in February 1864, and produced a detailed stereoscopic view of the crowded levee at Memphis, Tennessee, illustrating its function as major supply base for the Union river campaign from March 1862.

The work for which George N. Barnard is best known began on December 28, 1863, when he was employed by the Topographical Branch of the Department of Engineers, Army of the Cumberland. By the end of 1863 the tide of war had turned dramatically in favor of the Union in the Western Theater of operations. Confederate forces had been defeated at Chattanooga on November 23–25, which stabilized the Federal position in southern Tennessee. The successful defense of Knoxville from November 29 through December 4 had extended Union control over the eastern part of the state. These important victories permitted the massing of troops in Tennessee in preparation for an advance into Georgia which would cut the Confederacy in half. On October 16, 1863, General

Photographed at Matthew Brady's gallery in Washington, DC, *circa* 1865,
George N. Barnard began his career as a daguerreotype artist in Oswego, New York, in
1846 and became a pioneer in the field of documentary photography, capturing dramatic
views of a huge mill fire in 1853. Relocating to Syracuse, New York, in 1854, he became
involved in wet plate collodion photography. He later worked for Brady, who hired him in
the late 1850s. Heavily involved in capturing classic views of the war in Virginia until
1863, Barnard went south and west and, employed by the Topographical Branch of the
Department of Engineers, Army of the Cumberland, followed General William Tecumseh
Sherman's army during its "March to the Sea" in 1864.
(National Portrait Gallery, Smithsonian Museum, gift of Larry J. West)

During their trip to Knoxville, Tennessee, in March 1864, George N. Barnard and Captain Orlando Poe photographed the railroad bridge at Strawberry Plains, which had been destroyed by the Confederates during the siege of Knoxville in November/ December 1863. As the photographer stood at right with the Anthony stereoscopic camera is not Barnard, it may have been his Nashville assistant David O. Adams. Note the earthwork fort with embrasures for guns in the background. (Library of Congress)

Ulysses S. Grant had been appointed to command the newly organized Military Division of the Mississippi, which combined the departments of the Ohio, the Cumberland, and the Tennessee, and by the end of the year these armies occupied a great arc from Vicksburg to Knoxville. On December 21, Grant established his headquarters at Nashville which became the Union command center for the western theater of the war.

Although the Department of the Cumberland was centered in Chattanooga, Barnard's office was in Nashville, where he had charge of the army's photographic operations under the supervision of Captain of Engineers Orlando M. Poe. Barnard officially began his work for the Department of Engineers in New York City on December 28, 1863, by purchasing photographic supplies from E. & H. T. Anthony. Arriving in Nashville a short time later, he worked at the Topographical Office at

89 Church Street. His main assistant was New York-born David O. Adams, who resided in Danville, Indiana, and whose occupation was listed as an "artist" when he enlisted in Co. A, 4th Indiana Cavalry on July 24, 1862, serving as a "Teamster." Having developed a chronic case of "diarrhea and piles" in December 1862, Adams was sent home for convalescence and was subsequently assigned to lighter duty as a photographer in the Topographical Engineer Corps under Captain Poe.[26]

While photographing maps took up much of his time in Nashville and thereafter (see Chapter 5), Barnard was also called upon to produce *carte de visite*-sized portraits of various Union officers, and even sat for his own portrait. Poe seems to have encouraged this and collected autographed *cartes* of the most prominent visitors, including generals Sherman and Grant. Barnard's work outside the studio began in February 1864 when he was ordered by Major General William F. Smith to proceed to Chattanooga to take "such photographic views as will serve to illustrate that place and the military works in the vicinity." In particular during this trip Barnard produced views of the lines around Chattanooga from the top of Lookout Mountain, where he must have met with the Linn brothers. Poe used the photographs taken at Chattanooga as reference material for the completion of a map of the Chattanooga battlefield, and on March 10, 1864, mailed a photographic copy of it, also produced by Barnard, to the Engineer Department in Washington, DC.

During March 1864, Barnard once again left his map-copying duties in order to produce views of Nashville and Knoxville. Arriving at the latter place accompanied by Poe in a winter snowstorm which hampered their activity for several days, Barnard eventually managed to produce some sweeping panoramic views of the fortifications used by both sides during the siege, as well as other images of the overall topography surrounding the city. The official report of the work produced by Poe on April 11, 1864, stated that it was accompanied by "photographic views … intended to illustrate still further the locality rendered historical by the siege of Knoxville. They are the work of Mr. George Barnard, photographer at the chief engineer's office …" In response to a request from Quartermaster General Montgomery Meigs for several sets of these views, which were duly supplied, Poe added in a PS, "Mr. Barnard, the photographer who made the views, desires me to say that it was done under great disadvantages of wind & cold, to which I can testify."[27]

(Left) A newspaper editor and photographer in Scotland before he migrated to the US, Alexander Gardner would have had much in common with the editorial staff of the *New York Herald*. With Timothy O'Sullivan probably behind the camera, he sits at right talking to correspondents and their assistants at their "Headquarters in the Field" at Bealeton, Virginia, in August 1863. Note the wagon with "N.Y.H. Headquarters" sign-written on the side. The detail shows a silhouetted Alexander Gardner revealing his hands and fingernails blackened from using photographic chemicals to develop his wet plate collodion glass negatives. (Library of Congress)

that has come under our notice, we have seen nothing superior to these vivid sunlight representations of war scenes by Gardner." Intriguingly, this report also mentioned that the photographer was "taken prisoner at one time by the Confederates, while zealously engaged in the prosecution of his art." The likelihood that this actually happened is slim, as the bulk of Lee's army had withdrawn into Virginia by the time Gardner had set up his camera.[15]

At 21 years of age, Timothy H. O'Sullivan was the youngest of the leading photographers in the North. Employed by Matthew Brady before the Civil War, he worked under the tutelage of Alexander Gardner at the Washington gallery from 1856 until early 1862, when he was dispatched to join the staff of Brigadier General Egbert Viele to photograph maps and Union operations at Beaufort and Port Royal, South Carolina, from December 1861 to May 1862. Following the success of the naval operation against forts Beauregard and Walker guarding the entrance to Port Royal Sound on November 7, 1861, Union forces had consolidated their victory by occupying the city of Beaufort. Advancing north they took St. Helena Sound and continued up to the rivers on the south side of Charleston, where they were halted by Confederate opposition. As a result, the siege of Charleston began and continued until the last days of the war. During his time in this theater of the war, O'Sullivan captured images of the interior of forts Beauregard and Walker at the entrance to Port Royal Sound, the Coosaw Ferry to Port Royal, the wharf at Hilton Head, and the nearby Mills Plantation on Port Royal Island.

Described as being "as good with the rifle as the camera," ambrotypist William D. McPherson of Concord, New Hampshire was appointed captain of a company of sharpshooters being recruited for service with the

(Above) Born either in Ireland or on Staten Island around 1840, Timothy O'Sullivan was employed by Matthew Brady as a teenager. Learning the art of photography at the Washington gallery under the tutelage of Alexander Gardner from 1858, he worked with Brady in Virginia and South Carolina from 1861. Joining Gardner's studio about May 1863, he produced classic images of the Gettysburg battlefield and siege of Petersburg. (National Portrait Gallery, Smithsonian Institution, gift of Larry J. West)

(Right) Sentinels of the 76th Pennsylvania Infantry or Keystone Zouaves stand guard on the wharf at Hilton Head, South Carolina, which provided a vital supply line for the troops probing north toward Charleston. They appear surprised to discover they were being photographed by Timothy O'Sullivan in this previously unpublished detail.
(Library of Congress)

United States Sharpshooters during September 1861.[16] Born in Boston, Massachusetts, in 1833, McPherson opened his first gallery in Chelsea, Vermont, in 1855, where he advertised that he was producing "Cutting's Ambrotypes." By 1856 he was established in Concord, New Hampshire, and as late as August 8, 1861, operated a studio in the Merrimack Block. According to the *Independent Democrat*, by this time he specialized in

One of numerous photographs of Atlanta produced by George N. Barnard after his arrival there in mid-September 1864, this view of the railroad depot and the "Car Shed," or Union Passenger Station, shows two locomotives with tapered balloon stack. Union soldiers are busy in and around the large engine shed in the background. Most of the crew of this USRR locomotive seem to have spotted Barnard setting up his camera and were happy to take time out to pose for him. (Library of Congress)

Following the appointment of Grant to overall command of all Union armies on March 12, 1864, William Tecumseh Sherman succeeded him as commander of the Military Division of the Mississippi. On May 1, Sherman began his march into Georgia, but Barnard did not follow the army. Instead, he remained in Nashville for most of the summer months photographing maps and documents, plus important buildings and installations in and around the city. The battle for Atlanta began on July 22 and ended 41 days later when the Confederates under Lieutenant General John Bell Hood, commanding the Army of the Tennessee, evacuated the city after setting fire to 81 rail cars containing ammunition and other military supplies, which resulted in the largest explosion of the Civil War. Meanwhile, on September 5, Poe sent a telegraph to Barnard in Nashville: "Join me at Atlanta, with Photographic Apparatus. Bring your assistants, and materials with you."[28]

Several days before Barnard left for Atlanta, Jacob Coonley arrived in Nashville, having been awarded a contract by Quartermaster General Meigs to photograph all USRR structures and property along the strategic railroads in Tennessee, Georgia, and Alabama. The two photographers met fleetingly and Coonley recalled, "We had but a short time to remain together, as he, with the rear guard, were ordered to report to Atlanta and left immediately."[29] Reaching Atlanta in mid-September, Barnard reestablished his photographic facility and, although he continued to duplicate maps, also produced numerous stereo and large format views of the captured city, including the blasted remains of Hood's supply train and surrounding railroad yards. He also photographed much of the city that would be destroyed by fire when Sherman began his "March to the Sea."[30]

When Sherman departed a burning Atlanta on November 15, 1864, Barnard was ordered to accompany the army. However, he took no

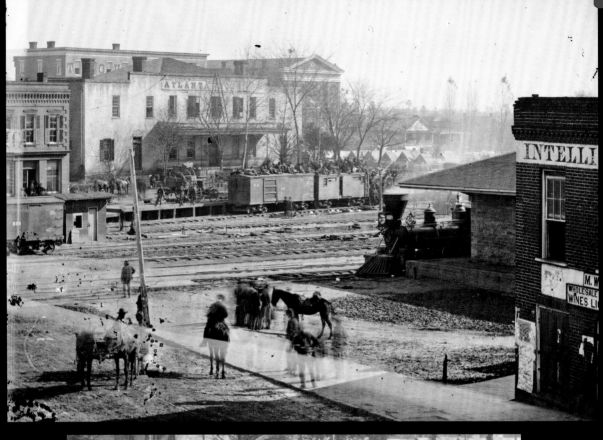

(Left) Taken from a third-story window of a building on Whitehall Street toward the railroad tracks and the Atlanta Hotel, Barnard recorded a wealth of detail in this view of Atlanta. This scene represents a strange juxtaposition. In the background panicked civilian passengers overload the freight train trucks of possibly the last train to leave the city, while a small group of soldiers in the center of the image entertain themselves by gathering around a commercial stereoscopic viewer of the type patented and manufactured in 1861 by S. D. Goodale & Sons, of Cincinnati, Ohio, which rotated stereoscopic views, creating the impression of movement. The brick-built newspaper office of the *Daily Intelligencer* stands at right. Published by Jared I. Whitaker, ex-mayor of the city and commissary-general of Georgia State Troops, the newspaper stopped production in May 1864 as Sherman's army approached. (Library of Congress)

photographs during the next three weeks, probably because the army was moving too quickly to permit him to set up his camera for any satisfactory length of time. Furthermore, as they cut a 60-mile wide swath of devastation toward the Atlantic coastline, Sherman's troops left nothing of significance or worthy of photographic opportunity in their wake. Although Barnard remained with Sherman when the army occupied Savannah in December, he did not join the march into South Carolina at the beginning of 1865, but instead was dispatched to New York, probably to deliver negatives he had produced for E. & H. T. Anthony and to acquire supplies.

Still at Nashville, Jacob Coonley spent the next few weeks completing his assignment, of which he wrote later:

This work called for negatives 9x13 inches, and Messrs Anthony & Co. contracted to take all the stereoscopic negatives I could make on the trip at five dollars each … As the work I had to do extended over a large tract of territory, a special train for my exclusive use and a car were fitted out for the work in hand. This was done by using a box car and making a dark room in one end, with a barrel fastened up for a tank to hold water, of which we required considerable, as the plates used were 12x16 inches in size. The rest of the space in the car was utilized as a kitchen, where all the cooking was done, and in one corner berths were arranged for sleeping, with a stove, mess chest, cooking utensils, and all the implements and paraphernalia necessary for making pictures; frequently four or five men were also domiciled in this space,

(Left) Having been taught by Barnard before the Civil War, Jacob Coonley joined him in Nashville to photograph the railroads and stayed there to provide a visual record of the last great battle in the west.
(National Portrait Gallery, Smithsonian Institution, gift of Larry J. West)

(Right) Originally published to accompany his "Photographic Reminiscences of the Late War" in *Anthony's Photographic Bulletin* in 1882, this drawing shows Coonley and an assistant escaping back to their railroad "photo car" with Confederate cavalry in pursuit.
(Anthony's Photographic Bulletin, 1882)

and it is easy to see that there were no rooms to let; nevertheless, sometimes we had a boarder for a day or two at a time.[31]

During this period, Coonley and his assistants often faced disruption and delay as the Confederates burned bridges and trestles and tore up track, ahead of them. They also sometimes left the line of fortifications protecting Union-held territory under military escort, but were still in danger of being cut off and captured by the enemy. According to the photographer, "To have seen us backing out in a hurry on two occasions when the enemy's cavalry were discovered a short distance off would perhaps have been fun for some people, but we did not wait to inquire what they wanted, or to make a picture of them, having pressing business elsewhere about that time."[32]

During November 1864, General John Bell Hood led the Army of Tennessee north toward Nashville in a last desperate attempt to force Union troops out of Georgia. By December 1, elements of Major General George H. Thomas's army had reached Nashville and prepared for its defense. Hood reached the outskirts of the city the next day. But being weakened by losses in battle at Franklin on November 30, he did not attack and erected breastworks on a line of hills running parallel to those of the Union army. For the next 12 days Thomas waited for the severely cold, wet weather to improve before he could launch an assault in which he intended to destroy Hood's army. Meanwhile, Hood's troops suffered in their exposed trenches.

Returning to Nashville just before the battle commenced, Jacob Coonley prepared to photograph what he could of events as they unfolded. He would later state, "As soon as the battle was well under way, I had an ambulance with drivers take me as near as possible to make negatives of every thing in sight, two days being given to this work."[33] According to photographic evidence, he

Prior to setting out to document the battle of Nashville, Jacob Coonley photographed the main campus building of the Western Military Institute, which had served as a hospital for Federal officers in the city since 1862. Closer examination of this image reveals the military field ambulance he acquired from there parked near the main entrance, together with three horses saddled and ready to go. The detail shows a white blanket or sheet draped down the side of the vehicle. In all probability, this covered the medical insignia designating it as an ambulance so that Coonley could negotiate the battlefield without his transportation being commandeered for medical needs. (Library of Congress)

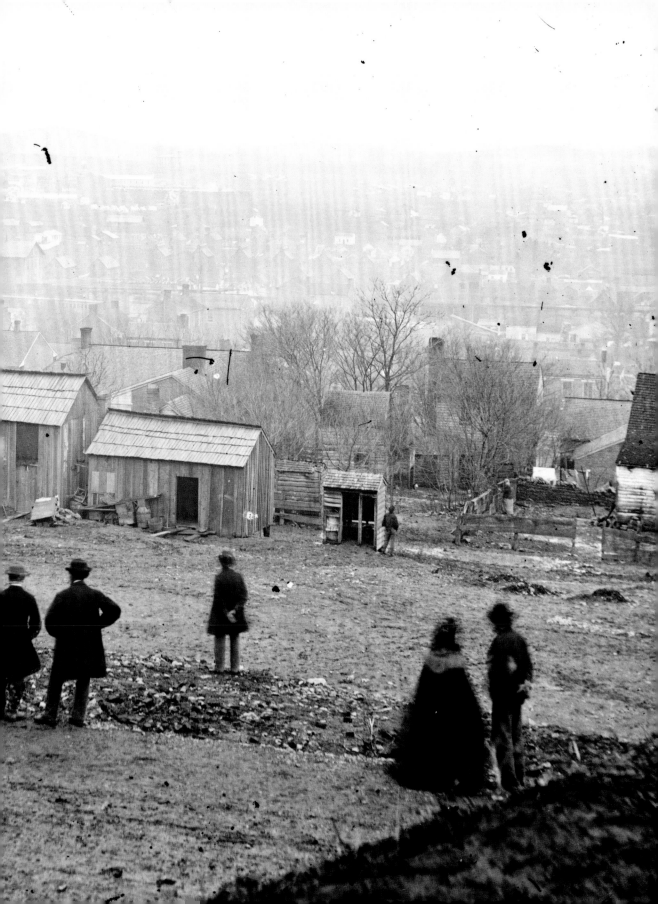

(Previous pages) Standing on the slopes of Capitol Hill in Nashville and facing southwest, these citizens were photographed by Jacob Coonley as they watched the battle of December 15, 1865. In the distance Steedman's division would have been making its diversionary attack on the Confederate right flank. Across the middle distance from right to left run the trestles supporting the Nashville & Chattanooga Railroad. In the distance can be seen tents of the Union army among buildings. (Library of Congress)

acquired a field ambulance from the hospital for officers established in the campus building at the Western Military Institute in Nashville.

With the arrival of slightly more clement weather but hampered by fog, General Thomas prepared to attack Hood's battle line on both flanks. Before daylight on December 15, Major General James Steedman's division launched a diversionary attack on the Confederate right flank and contained it for the rest of that day. After noon, the 5th and 16th Corps under generals Thomas J. Wood and Andrew J. Smith respectively advanced along the rest of the front, forcing the Confederates to withdraw about two miles to a secondary line and capturing 25 guns and 3,000 prisoners. By that time, it was dark and fighting stopped for the day. The battle continued the next morning with Wood's corps advancing within about 250 yards of the new Confederate line to construct more breastworks. The renewed Union attack captured the enemy trenches on Shy's Hill and eventually those on Overton's Hill, and the remains of Hood's army broke and fled.

During the first day of the battle, Coonley set up his camera at the Capitol building, which was the highest point in the city, and took photographs of civilians and soldiers listening to the thunderous noise of battle and watching the distant floating smoke of artillery from the forts surrounding Nashville. On the second day he began by taking his camera up on to the roof of the Western Military Institute hospital building, from where he photographed distant views of Union Forts Negley, Morton and Casino on and around St. Cloud's Hill, with the Confederate lines shrouded in smoke and haze beyond. As the battle progressed, he traveled in his ambulance to the western slope of Fort Negley and then moved via the Franklin Pike to the western slope of Fort Casino in order to photograph more reserve troops.

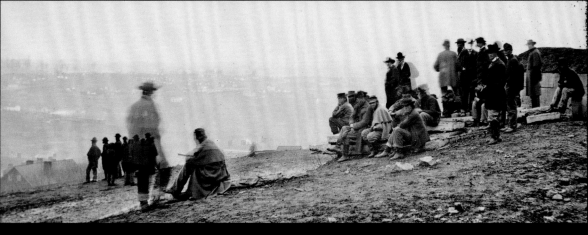

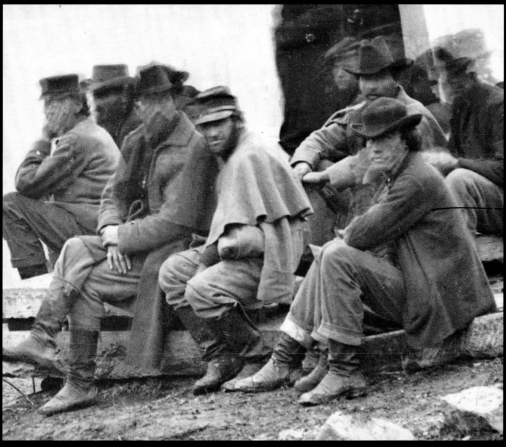

While on Capitol Hill photographing the battle of Nashville, Coonley turned his camera to capture a view of groups of Union soldiers and civilians trying to gain a glimpse of the battle as the Army of the Cumberland attacked. Not seen in close-up before, this detail shows a group of soldiers turning toward Coonley's camera to be immortalized on glass. They are all seated on concrete slabs probably intended for use in the completion of the grounds surrounding the Capitol building.
(Library of Congress)

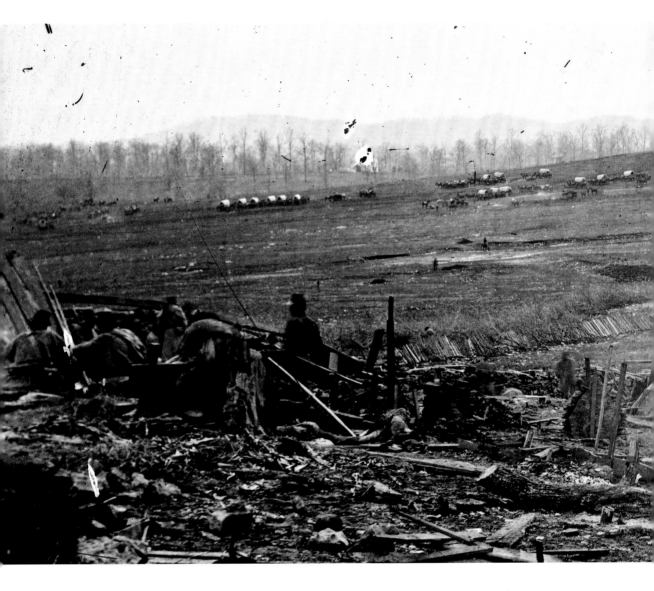

In this rare view by Coonley of Union troops on St. Cloud Hill, the men under command of
Brigadier General John F. Miller are seen resting and standing along the shallow trench behind
a breastwork in the Union reserve line south of Nashville. Many of them have leant their
muskets against the parapet ready for action. Makeshift wooden shelters have been constructed
behind the line for shelter from the elements and smoke rises from numerous fires lit for
warmth and cooking. The stacked bricks in the foreground were probably ovens.

(Library of Congress)

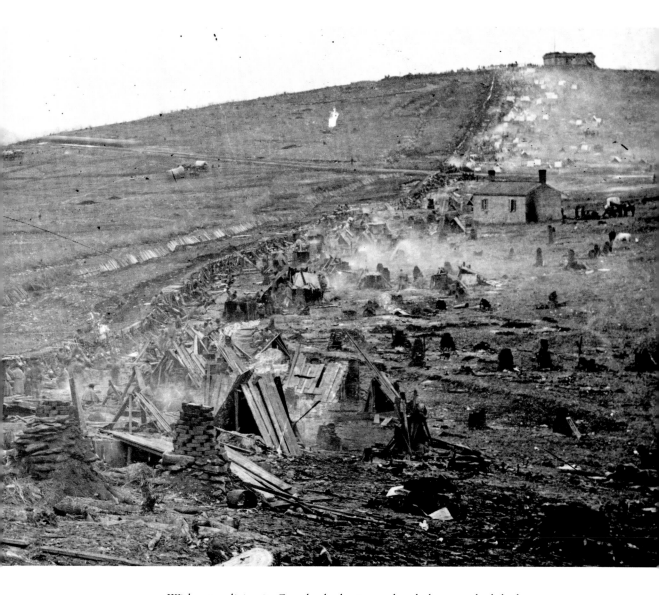

Without realizing it, Coonley had witnessed and photographed the last great battle in the West. General Thomas pursued the beaten and battered Army of Tennessee for ten days until it crossed the Tennessee River into Mississippi and continued its retreat to Tupelo, where Hood resigned. Coonley recalled of the aftermath of the battle of Nashville, "Then the rain came and continued for several days, so that I left there several days after the retreat of Gen Hood."

CHAPTER 5

"So great was the demand for maps ..."

PHOTOGRAPHY IN MAPS AND DOCUMENTS

In 1861, much of the United States was still a poorly mapped wilderness, and during the battles and campaigns of an unexpected civil war the field commanders of both Union and Confederate armies often required information about their theater of operation that was simply unavailable. Out of necessity, the conflict quickly brought together cartography with photography, as photographic copies of more accurately hand-drawn or lithographed maps based on the latest reconnaissance were produced and distributed among commanding generals and their staff.

The first recorded Civil War use of photography to reproduce maps occurred in July 1861, and also possibly involved spying and espionage. Accompanying General Irvin McDowell's advance into Virginia as a correspondent, cofounder of the *New-York Times* Henry J. Raymond described in some detail what the Confederate troops had left behind during their withdrawal to Manassas. After entering the abandoned campsite of a South Carolinian regiment at Fairfax courthouse on July 17, 1861, he wrote:

> One discovery was made of some significance. Gen McDowell has had the Topographical Engineers under his charge employed for several weeks in preparing a very minute and accurate map of this portion of the State. It had been brought to a very high state of perfection and was particularly valuable from the fact that no good maps of this county have ever been made. A few photographic copies of this map were made a few days since for the use of the War Department and of the officers engaged in the movement. *One of these maps was found in the camp of the Palmetto Guards.* Of course it could only have come there by the treachery of some person holding responsible position in our Government.[1]

Designated Co. I, 2nd South Carolina, commanded by Colonel Joseph B. Kershaw, the Palmetto Guard Volunteers had withdrawn hastily from Camp Kershaw, established in "a beautiful shady grove" about a quarter of a mile north of Fairfax courthouse, and served as part of the Confederate rearguard.[2]

Thirteen days later, a Boston newspaper published a report voicing further concern about "the discovery in the enemy's camp of a photographic map which had been privately made by order of the War Department." On this occasion it was hinted that McDowell's battle plan of July 21, 1861

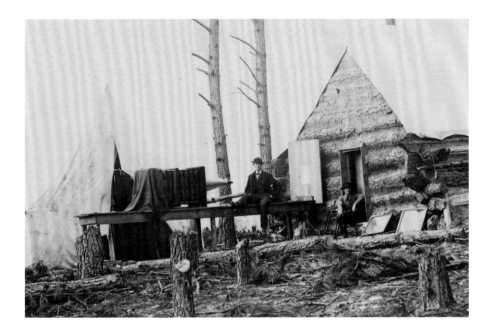

Entitled "Quarters of photographers attached to Engineer Corps in front of Petersburg, Virginia, March, 1865," this albumen print shows one of Alexander Gardner's photographers attached to the Federal Topographical Corps with large camera poised to photograph map sections or important military documents attached to a board leaning against the cabin wall.
(Library of Congress)

had been leaked, suggesting that the Union feint attack on the Confederate center at Blackburn's Ford and actual attack on their left flank on Matthews Hill via Sudley Springs Ford may have been marked on the photographic map that fell into enemy hands. The Boston report further stated:

Our division at Bull Run, which had been previously ordered to make a feigned attack, could not obtain the honor of an answer to its furious cannonade, the enemy knowing very well that no real attack was meant. [In the Shenandoah Valley, General Joseph E.] Johnston was reinforced just before the day when [General Robert] Patterson was to have attacked him simultaneously with an attack by McDowell against Beauregard.

Combined with evidence that Confederate spy Rose O'Neal Greenhow, a prominent socialite in Washington, was passing coded messages to Beauregard containing vital information regarding McDowell's plans, it seems highly possible that a captured photographic copy of a map may also have contributed to the outcome of the first major land battle of the Civil War.[3]

The first organized production of photographic maps for the Union army appears to have occurred in the Army of the Cumberland in 1861 under the direction of its chief topographical engineer, Captain Nathaniel Michler, who put together an effective map-making unit consisting of topographical engineers, draughtsmen, a photographic studio, and a map-mounting section. Photographers were also employed on the Peninsula in Virginia. On February 20, 1862, Brigadier General Andrew A. Humphreys, Chief of Topographical Engineers, 3rd Division, Fifth Corps, Army of the Potomac, reported that reconnaissance of the enemy's positions at or near Yorktown on the Chickahominy, and on the approaches to Richmond from that river, had been completed, and that detailed maps of "the scene of operations were prepared, multiplied by photography, and distributed to the commanders and staff officers of the various sub-divisions of the army."[4] Although none of the photographers involved were named in Humphrey's report, George N. Barnard was duplicating maps drawn by the Topographical Engineers for General George B. McClellan and the Army of the Potomac by the end of June 1862. When Barnard arrived at Nashville, Tennessee in January 1864 he began reproducing maps for the Topographical Engineer Corps, Military Division of the Mississippi, under the supervision of Captain Orlando Poe.

At all of these locations, original lithographed or hand-drawn maps were tacked flat to a board and photographed with either a 12x15-inch or

PART OF NORTHERN GEORGIA.

Compiled under the direction of Capt. Wm. E. MERRILL, Chief
Top'l Eng'r, D. C.,
From the Cherokee Land Maps,
Surveys of Top'l Engineers, D. C.,
State Map of Georgia and information.
SCALE, 1 INCH TO 4 MILES.

OFFICIAL ISSUE.

Wm. C. Margedant
Capt. & Supt. Top'l Dep't Office, D. C.

Printed in the Field, Chattanooga, Tenn. May 18, 1864.

(Right) Produced by "Margedant's Quick Method" under the supervision of Lieutenant Colonel Peter S. Michie, Topographical Engineers, on October 28, 1864, this section of a map "Showing country adjacent to Richmond and lines of defensive works surrounding the city" was copied from a photographic map found on the body of Confederate General John R. Chambliss, who was killed during the second battle of Deep Bottom on August 16, 1864. Turned over to chief topographical engineer Major N. Michler, it was reproduced for distribution. Within two days, the map was in the hands of all Federal field commanders in the region. (Library of Congress, Geography and Map Division)

18x22-inch camera. Maps could be enlarged or reduced in size as required by adjusting the distance between the camera and the original rendering. The copying of small maps the same size as photographic full plates presented no problem for the teams of Michler and Poe, but the system faced great difficulty when larger maps had to be photographed in segments. The relatively crude lens in the camera of the day created distortion around the edges of the developed prints, which made the accurate joining of segments difficult without a considerable amount of overlapping. This problem was overcome by Michler's assistant, Captain William C. Margedant. Having left his native Prussia in 1854, Margedant had worked as an engineer and architect in Cincinnati, Ohio before the war. Mustered in for three months' service as captain of Co. D, 9th Ohio Infantry on May 8, 1861, he reenlisted for three years in command of Co. G, 10th Ohio during the following June, and while serving with General William S. Rosecrans during the western Virginia campaigns developed a quick method of map reproduction.

Bypassing the camera completely, "Margedant's Quick Method" required the tracing of a map on thin tissue, which was then laid over small sheets of photographic paper, or a large piece of cloth, and exposed to the sun. The sun's rays passed through the tissue and darkened the photographic paper or cloth except under the ink lines. The end result was a negative copy of the map with roads, rivers, and place names appearing white against a dark background. Sometimes roads or railroads were hand-colored red and larger rivers blue. The small sections of paper were then pieced together, adhered to a canvas or cloth backing, and varnished for protection in all weathers. Larger cloth maps could also be pasted to a stiff backing or simply folded and tucked in a map case

Copy of Section of Photograph Map
captured from the Enemy

Showing country adjacent to Richmond
and

Lines of Defensive Works surrounding the City

Head Quarters Army of the James

(Top) The "Map of Richmond and part of the Peninsula" shows how separate full plate albumen prints of each photographed section of the original lithographed or hand drawn map were mounted on card and then stuck to a canvas or cloth backing. According to their invoice to the Confederate Engineer Bureau dated April 16, 1864, Sanxay and Gomert took 168 photographs of an original "Map of Richmond and part of the Peninsula," which would have produced seven duplicate maps consisting of 24 separate panels.
(Library of Congress, Geography and Map Division)

(Bottom) The title plate for a "Map of Richmond and part of the Peninsula" indicates it was produced for Major General J. F. Gilmer, Chief of the Engineer Bureau for the Confederacy, by photographers Richard S. Sanxay and Adolph Gomert. According to an invoice submitted by the photographers to Captain A. H. Campbell, this was part of a map photographed for duplication by April 16, 1864. (Library of Congress , Geography and Map Division)

or pocket. As many as 90 copies of any map were made for the army, and revisions could be made simply by altering the original tissue "master copy." Sometimes several updated editions of a map would be made during the same day as new intelligence was brought in by spies, scouts or topographers. Although it proved fast and effective, the dependence of Margedant's process on sunny days meant it could not be used in foul weather.

The Confederacy lacked a central map-making facility until the Photographic Engineer Bureau was set up in Richmond, Virginia, by Captain Albert H. Campbell, who was appointed by General Robert E. Lee as chief of the Topographical Office on June 6, 1862. Explaining how he supervised the development of a photographic process for reproducing maps, Campbell stated:

> So great was the demand for maps occasioned by frequent changes in the situation of the armies, that it was impossible by the usual method of tracings to supply them. I conceived the plan of doing this work by photography, though expert photographers pronounced it impracticable, in fact impossible. To me it was an original idea, though I believe not a new one, but not in practical use.[5]

Similar to "Margedant's Quick Method," Campbell's process involved an extra step. He used a tissue tracing of the map, but instead of placing it

CHIEF ENGINEERS OFFICE D.N.V.
MAJ. GEN. J.F.GILMER CHIEF ENGINEER.
MAP OF
VICINITY OF RICHMOND
AND PART OF THE
PENINSULA
FROM SURVEYS MADE
UNDER THE DIRECTION OF A. H. CAMPBELL, CAPT. P.E.C.S.A.
IN CHARGE TOPOGRAPH! DEP! D.N.V.
1864
Scale, about

CHIEF ENGINEERS OFFICE D.N.V.
MAJ. GEN. J.F.GILMER CHIEF ENGINEER.
MAP OF
THE
VICINITY OF RICHMOND
AND PART OF THE
PENINSULA
FROM SURVEYS MADE
UNDER THE DIRECTION OF A. H. CAMPBELL, CAPT. P.E.C.S.A.
IN CHARGE TOPOGRAPH! DEP! D.N.V.
1864
Scale, about

over photographic paper he laid it over glass wet plates and exposed them to the light. The resulting negatives were then used to print the map on photographic paper, producing a set of positive sections with black lines on white paper. Describing how his maps were completed and distributed, Campbell continued, "The several sections, properly toned, were pasted together in their order, and formed the general map, or such portions of it as were desired; it being the policy as a matter of prudence against capture to furnish no one but the commanding general and corps commanders with the entire map of a given region.[6] Based on examples of surviving maps, Campbell's method was also used by the Federal army before the end of the war.

By 1864, the Confederate Army of Tennessee had established a Photographic Engineer Bureau at Atlanta, Georgia, which was an important railroad and supply center. Having twice been arrested and released for attempting to smuggle photographic materials into the Confederacy, Andrew J. Riddle was clearly successful by 1864, as on May 7 of that year he sold "75 Sheets Photograph Paper" for "Reproducing Military maps of the Army of Tenn[essee] by Photography" to First Lieutenant John W. Glenn, Corps of Engineers, at Atlanta. On June 30 he supplied the same officer with "Gum Shellac," for varnishing photographic maps, "Liq[uid] Am[monia]" and "Hypo-sulphate Soda" for use as photographic fixing agents, a "Blanket for Photographic frame," "Gutta Percha Trays," and a "Printing Frame & glass" for sun-printing purposes. Conscripted as a private in the Confederate army at Macon, Georgia in July 1864, Riddle was appointed chief photographer of the Department of Tennessee by August 2 of that year, and supervised the work of other Confederate army photographers.[7]

Working under Riddle were Richard S. Sanxay and Adolph Gomert. On February 5, 1864, Sanxay and Gomert had patented a "Photographic Process for Duplicating Maps" in Richmond, Virginia, which was another version of the sun-printing process. Born in Germany in 1833, Gomert was listed in the 1860 census as a 27-year-old "carpenter" resident at Rapides, Louisiana. Before the war, Richard S. Sanxay was a junior second lieutenant in the Richmond Light Infantry Blues and, with James Chalmers, ran Sanxay & Co's studio at "Pratt's Old Gallery" from 1856 until 1859, producing ambrotypes and daguerreotypes at the "Sign of the Big Window" at 145 Main Street, Richmond.[8]

The Richmond Light Infantry Blues were mustered in as Co. A, 46th Virginia Infantry, also known as the 1st Regiment of Infantry, Wise Brigade, on June 17, 1861, and fought in western Virginia, on the peninsula, and in the Richmond defenses until September 1863, when they were transferred with their regiment to South Carolina, and served on James Island until November 1863. During this period Sanxay was detailed for duty with the Engineer Corps, probably as a photographer, on September 15, 1862. On November 5, 1862, he was absent without leave for the same purpose. He resigned his commission and was appointed to the Engineer Corps as a "Government Photographer" on February 26, 1864.[9]

Sanxay and Gomert worked at the Photographic Engineer Bureau together and separately under Riddle from February through December 1864, during which time they reproduced numerous maps including those of "Richmond and vicinity," "Richmond and the Peninsula," the "Confederate and Federal lines at Petersburg," "South Side of the James River," "East Virginia," "East North Carolina," and "East Tennessee." Also working for the Bureau during the same period were William D. Cooke and A. S. Bradley. Listed as a daguerreian colorist and artist in Richmond from 1859 through 1860, Bradley had worked in the studio of G. W. Minnis at 217 Main Street, and may have been responsible for adding color to the photo maps produced by Sanxay and Gomert.

Despite efforts to restrict the distribution of complete maps to commanding generals and corps commanders only, a vital map showing all of the fortifications and defence works around Richmond, Virginia was found on the body of Confederate Brigadier General John R. Chambliss, Jr. on August 16, 1864. Killed attempting to rally his troops during a Federal cavalry charge along the Charles City Road near Deep Bottom, Chambliss' body was recovered by a former West Point classmate, Union Brigadier General David Gregg. Accompanying Gregg on the occasion, Major W. G. Mitchell, aide-de-camp to Major General Hancock, reported "secured a most excellent map of Richmond and its defenses from his person. The map is of great value to us."[10] Although the remains of the dead general were returned to the Confederates during a truce the next day, the map was passed to Union topographical engineers. According to the report of First Lieutenant Peter S. Michie, a tracing of the map was lent to him by Major Nathaniel Michler, who was by this time chief engineer of the Army of the Potomac, and within 48 hours "seventeen copies

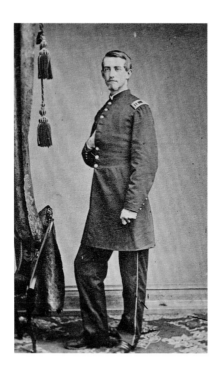

The son of Rear Admiral John A. Dahlgren, Ulric Dahlgren began his Civil War service in the Navy but transferred to the Army in May 1862, being appointed an *aide de camp* with the rank of captain and attached to Major General Franz Sigel's division, Department of the Shenandoah. Following extensive military service, he was wounded in action near Gettysburg on July 6, 1863, which resulted in a foot being amputated. Sufficiently recovered and fitted with a prosthetic by the spring of 1864, he received promotion to colonel of cavalry and returned to active service under the command of Brigadier General Judson Kilpatrick. He was killed during the failed raid on Richmond, Virginia on March 2, 1864, after which a document was discovered in his pocket containing "Special Orders" outlining a plot to assassinate President Jefferson Davis and his cabinet.

(National Archives)

(photographic)" were made and distributed to all Union commanding generals in the area.[11] Although this may not have hastened the fall of Richmond, which was not achieved for another seven months, it probably reduced casualties by preventing foolhardy attacks on well-defended Confederate positions.

According to this official receipt dated June 1, 1864, Confederate photographers Richard S. Sanxay and Adolph Gomert received $21.25 from the Engineer Bureau in Richmond, Virginia for making 85 photographic prints of the "Dahlgren letter." At the same time they produced 123 "General Maps of Eastern Virginia," 57 maps of the "Vicinity Petersburg, 652 of "Vicinity Richmond," and 31 of "Eastern Tennessee," for which they were paid a grand total of $289.75. (National Archives)

During the course of the Civil War, topographers and their photographic assistants in both North and South produced thousands of photo maps. In 1864, Jed Hotchkiss, chief topographical engineer of the Valley District, was responsible for an unknown number of copies from 101 different maps of the Confederacy's Valley District, 21 of which were via the photographic process by an unknown photographer. In 1863, the US Army generated 8,841 map sheets, 1,941 of which were photographic

copies of originals. The total for 1864 was 20,939, with 1,600 being photographic copies. The majority of the latter were issued during Grant's fast-moving Overland Campaign from May through July 1864.[12]

Army photographers also performed a vital role by duplicating important orders and documents. The most historically significant of these was the "Dahlgren letter." On March 2, 1864, 21-year-old Colonel Ulric Dahlgren, son of Rear Admiral John Dahlgren, was killed outside Richmond near King & Queen County courthouse during a failed raid on the Confederate capital led by Brigadier General Judson Kilpatrick, ostensibly to free about 13,000 Union prisoners-of-war on Belle Isle in the James River. Late that evening 13-year-old William Littlepage discovered Dahlgren's body and searched its pockets for valuables. Among other items he found a pocketbook and two folded documents, which he subsequently handed to his teacher Edward W. Halbach, who commanded a company of Local Defense Troops composed of youths aged from 13 to 17. Examining the documents, Halbach discovered that they contained "Special Orders" written on Union army stationery outlining a plot to assassinate President Jefferson Davis and his cabinet. One of these documents ordered, "The men must keep together, and well in hand, and once in the city, it must be destroyed and *Jeff Davis and Cabinet killed*."

Halbach immediately informed fellow Local Defense officer Captain Richard H. Bagby of his discovery, and Bagby handed the documents to First Lieutenant James Pollard, commanding Co. H, 9th Virginia Cavalry, whose small command had pursued and ambushed Dahlgren's force. Pollard brought them to the attention of his commanding officer, Colonel Richard L. T. Beale, who ordered him to ride posthaste to Richmond to present the documents to the Confederate high command. Pollard arrived in the capital at noon on March 4, where he handed them to General Fitzhugh Lee. Astonished at their contents, Lee immediately took them to President Davis and Secretary of State Judah P. Benjamin. Davis calmly instructed Lee to take the papers to the War Department on Franklin Street, where they were received by Secretary of War James A. Seddon. Having sought the approval of the President, Seddon called the correspondents of the Richmond newspapers to a conference at the War Department and gave them handwritten copies of the documents, the contents of which were published on March 5, 1864.[13]

In order to stir up further vitriol, Seddon ordered Major Albert Campbell, who was by this time in charge of the Topographical Department in the Department of Virginia, to produce photographic copies of the "Dahlgren Letter" to be widely circulated throughout the Confederacy and in "the Courts of Europe" as evidence of Union barbarism. As a result, army photographers Sanxay and Gomert supplied 138 copies of the letter by April 16, 1864. Within a few days, several copies of these were delivered under flag of truce by order of General Lee to General George Meade in an effort to establish whether Dahlgren's orders were sanctioned by the Federal government. By order of Colonel Alfred L. Rives, chief of the CS Engineer Bureau, a further eight copies were completed by May 2 and another batch of 85 copies by June 1, 1864.[14]

As Dahlgren's name was spelt incorrectly as "Dalghren" in many copies of the letter, they were considered in the North to be a forgery in order to "make out a case of brutality against the Federal Government." Nonetheless, suspicion in many Southern minds that President Lincoln condoned, if not authorized, the Dahlgren mission to kill Jefferson Davis, reinforced by the liberal circulation of photographic copies of Dahlgren's orders, may have put in motion the chain of events that led to revenge in the form of the assassination of Abraham Lincoln by John Wilkes Booth on April 14, 1865.

CHAPTER 6

"We had photographers & visitors on board ..."

THE CAMERA WITH THE NAVY

At the commencement of the Civil War, the Union Navy consisted of 82 vessels manned by about 7,600 enlisted men of all ratings and some 1,200 commissioned officers. By 1865 this had expanded to approximately 618 vessels manned by an overall total of 84,415 men, compared to 2.2 million in the Union Army. This provides a ratio of about one sailor to every 25 soldiers. According to an estimate by the Navy Department in Richmond, Virginia, only 5,213 sailors served in the much smaller Confederate States Navy, consisting of 753 officers and 4,460 enlisted men.[1] Most of the new volunteer officers in both navies desired to serve in the Navy temporarily rather than make the service a career, and were given an "acting" rank. Likewise, most of the enlisted recruits were rated as "Land's Men," meaning they had little or no experience at sea in their civilian lives. Others from the US prewar merchant marine, or other navies around the world, were often given higher ratings such as "Fireman" or "Ordinary Seaman" due to their background and experience.

Following the commencement of the "Anaconda Plan," begun on April 19, 1861, which involved the implementation of a blockade of all Southern ports in order to starve the embryonic Confederacy into submission, the task of the Union Navy was daunting as the Southern coast measured over 3,500 miles. A "brown water navy" manning gunboats was also required, to support army campaigns down the Mississippi River and in Northern Virginia. Prior to the Civil War, the US Navy had been mainly used to fighting single-ship actions, but as the conflict at sea unfolded it fought fleet actions, such as the capture of Port Royal on the South Carolina coast on November 7, 1861, and the Battle of Mobile Bay, off the coast of Alabama, on August 5, 1864.

Like his army counterpart, the Civil War sailor often availed himself of a photographer in his home town, or in port, to have his likeness taken to give to loved ones and friends. The relatively smaller number of sailors involved in the war makes *cartes de visite*, ambrotypes and tintypes of them much rarer than those of soldiers. Images of Confederate sailors are even rarer still. As with soldier imagery, some *cartes* are identified by the signature of the subject, or notation on the reverse from a family member. Where no identification is present, the photographer's imprint on the reverse confirms the location of the gallery visited. Similarly, some hard-cased images have identification concealed behind the image. Others may have the artist's name, gallery name or its address impressed on the brass mat or on the velvet plush inside the case. Others have the photographer's trade card behind the image.

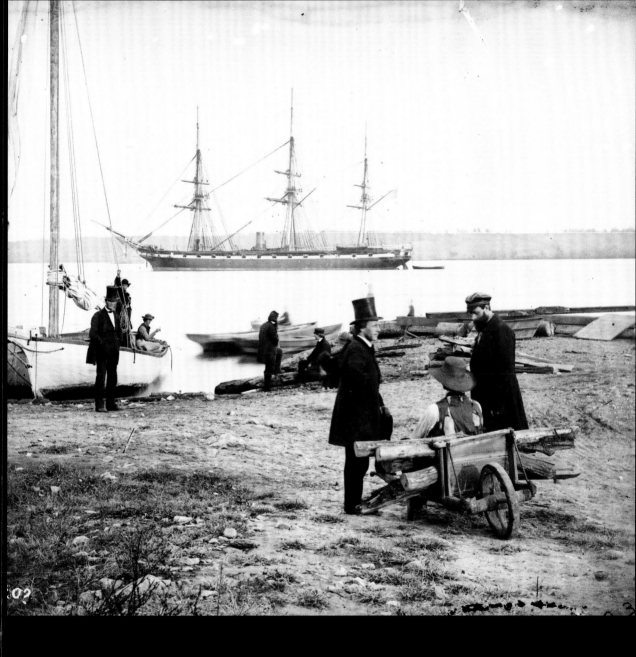

During January 1862 photographer James F. Gibson ventured out from Brady's
Washington gallery to capture this view of the steam frigate USS *Pensacola* departing the
Washington Navy Yard bound for Fortress Monroe on the Virginia Peninsula.
Commissioned in September 1861, this vessel had unreliable engines and was forced to
turn back for repairs before finally making its way unscathed past the Confederate shore
batteries on the Virginia banks of the Potomac River waiting to shell it.

(Library of Congress)

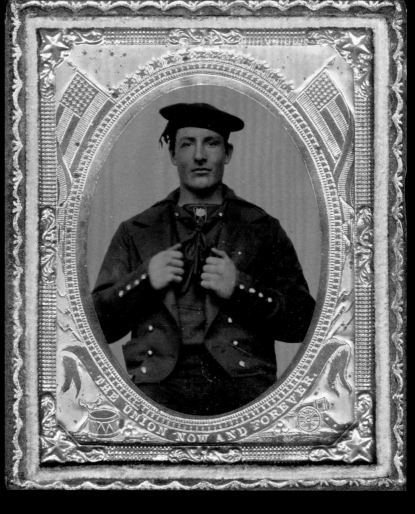

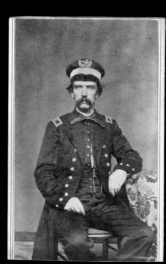

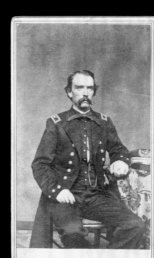

(Top) The unidentified sailor in this ninth-plate ambrotype behind a patriotic mat proudly wears his full dress double-breasted round jacket. A small shield bearing the stars and stripes is embroidered on the vest under his overshirt. In their time off-duty on board ship, sailors sometimes spent hours adding elaborate embroidery to their vests, which were reserved for special occasions such as being photographed. (Author's collection)

(Bottom left and center) This unidentified navy assistant surgeon decided on several poses at the gallery of Moore Brothers in Springfield, Massachusetts, and it is unusual that these two *cartes de visite* of that occasion survive together. Active as daguerreian artists at the "Star Picture Gallery" in Springfield from May 1859, Hiram and Chauncey Moore had moved to their "Photographic Rooms" in the Music Hall Block, Main Street by 1863, where they were producing "the latest Paris style of 'Carte de Visite.'" As fire destroyed much of their studio on July 24, 1864, these images were likely taken sometime before then. (Author's collection)

(Bottom right) Identified by an ink inscription as "James Reed, Mate, Steamer St. Clair," this "brown water navy" master's mate served on the Mississippi River and was photographed by D. P. Barr who advertised himself as an "Army Photographer" at Paducah, Kentucky. Originating from Pennsylvania, Barr also operated studios in Memphis and Vicksburg, Tennessee, either before or after opening this gallery.
(Author's collection)

As most of the Union fleet was at sea performing blockade duty, it was generally difficult for photographers to produce images of Navy vessels or crew members. Hence the best opportunity was presented when they were in harbor for supply or repair at locations such as Port Royal, South Carolina, or at the navy yards at Philadelphia, New York City or Boston. Some wet plate collodion photographers managed to carry their cameras, dark rooms and chemicals on board Navy vessels docked in port to produce images showing large groups of crew members. Others who operated galleries at locations such as that at Hilton Head, or those traveling in the rear of campaigning armies, photographed ship-bound sailors close to enemy lines and even in hostile waters.

One such artist was Brady operator James F. Gibson, who in January 1862 ventured across the Potomac River to Alexandria, Virginia, where he produced an image of the departure of the steam frigate USS *Pensacola* for Fortress Monroe. After a failed departure due to

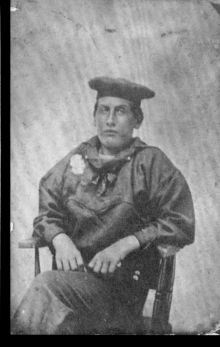

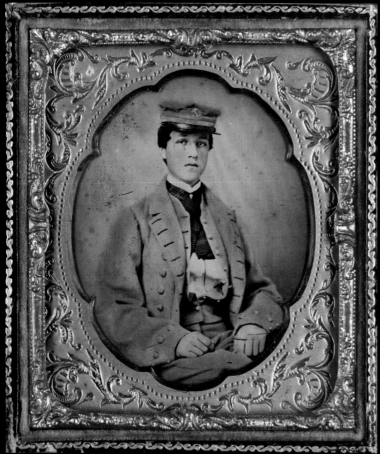
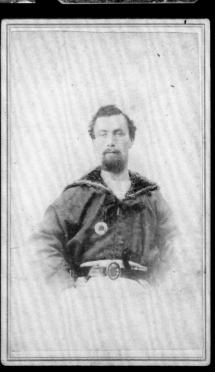

(Top far left) Photographers in or near seaports had an obvious incentive to include a naval theme in their backdrops. The gallery of Bullock & Co at 504 South 2nd Street, Philadelphia was only about two miles from the Philadelphia Navy Yard, hence wandering sailors would have encountered it on a reasonably regular basis. Listed as an "Artist" in the 1860 census, 24-year-old photographer John Bullock operated in partnership with 25-year-old Jessi H. Groom in Philadelphia from 1860 through 1861.
(Author's collection)

(Top center) Upon enlistment in the US navy at New York City on September 6, 1862, 16-year-old Second Class Boy Byron P. Drowne described his occupation as a "Photographer." Not old enough to manage his own gallery, he most likely assisted a local artist, such as P. Tenny Gates, who ran a studio in his home town of Plattsburgh in 1861. Serving with the South Atlantic Blockading Squadron off Charleston, South Carolina aboard the US tug *Catalpa*, Drowne wrote to his mother on October 21, 1864, "We have been to Port Royal … but I did not have time to have my picture taken for no one went near Hilton Head." He clearly had the opportunity to visit a gallery previously to this, as this *carte de visite* is dated "1863." (Author's collection)

(Top right) With parental permission, youths could enlist in the Union Navy at 13 years of age, and were rated as third, second, or first class boys according to their knowledge and physical ability. Third-class boys were paid $7 a month, second class $8, and first class $9.
The chief role of boys during battle action was to carry gunpowder from the powder magazine in the ship's hold to the ship's guns, either in bulk or as cartridges, to minimize the risk of fires and explosions. Hence, they were nicknamed "Powder Monkeys." In this very rare image, a powder monkey poses in a white frock and cap cover and proudly shows the "star" insignia on his sleeve, which may indicate he was a Boy First Class.
(Author's collection)

(Bottom left) One of the midshipmen who trained aboard the side-wheel steamer CSS *Patrick Henry* anchored near Drewry's Bluff, in the James River, from 1862 until 1864, this young fellow was photographed at some point after July 1863 when the school ship started classes. The lack of shoulder straps on his steel grey coat indicates that he had not yet achieved the rank of passed midshipman.
(Liljenquist Family Collection, Library of Congress)

(Bottom right) Images of Confederate enlisted seamen are extremely rare. The man in this partially hand-colored *carte de visite* appears to indicate a Southern provenance. He wears what is likely a Secession cockade pinned to his jumper, and has a pistol and bosun's whistle tucked in his waist belt, which is fastened by an unusual oval-frame buckle.
(Karl Sondstrom collection)

Based on their light-colored shirts and trousers and dark-colored silk handkerchiefs around their necks, the two unidentified sailors in this ambrotype may also be Confederate enlisted seamen. Both appear to have inverted anchor two-piece plates fastening their belts. (Anne S. K. Brown Military Collection, Brown University)

problems with her engine, this vessel finally managed to run the gauntlet of the Confederate batteries on the hostile bank of the Potomac River and reached Fortress Monroe to begin her war service. Later, while following the progress of the Peninsula Campaign in 1862, Gibson concentrated on naval activities in the James River and photographed officers and enlisted seamen of the USS *Monitor* on July 9, 1862. Earlier that year, on March 8, 1862, from her berth at Norfolk, Virginia, the Confederate ironclad *Virginia* had steamed into Hampton Roads where she sank the USS ship-of-the-line *Cumberland* and ran the USS frigate *Congress* aground. The next day the *Monitor,* having fortuitously arrived from New York to do battle with her Southern counterpart, initiated the first battle between ironclad warships in history. The two vessels fought each other to a standstill in a 3½-hour battle, but the *Virginia* was retired and eventually destroyed by the Confederates when Union forces occupied Norfolk on May 11, 1862. After this historic clash, the *Monitor* was involved in the failed attempt to force a passage up the James River toward Richmond in May 1862, but the approach was too heavily guarded by the guns of Fort

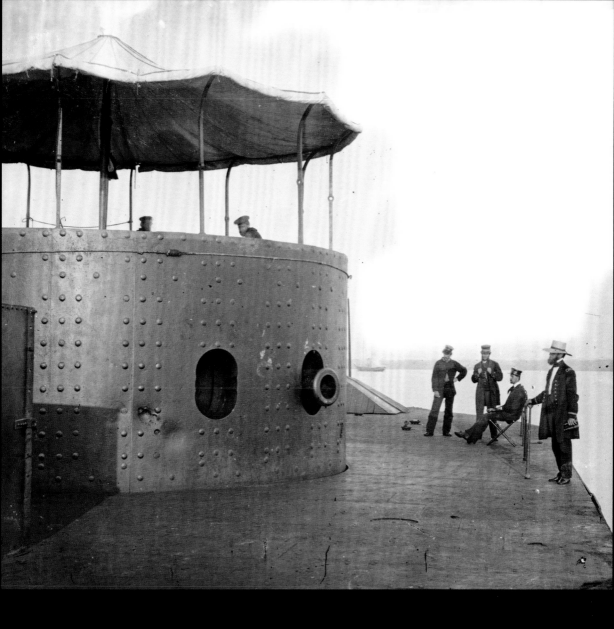

Boarding the USS *Monitor* in July 1862, James Gibson photographed the officers examining the turret dented during the first battle of the ironclads earlier that year. Standing second from left, Acting Master Louis N. Stodder would have a great interest in examining these dents. Initially stationed at the reversing wheel which turned the revolving turret, he was leaning against the inside wall of the turret with executive officer Lieutenant George S. Greene and Chief Engineer Alban C. Stimers when a shell from the *Virginia* struck. Stodder recalled, "I was flung by the concussion clean over the guns to the floor of the turret." Taken below, it was about an hour before he regained consciousness. He would earn a commendation during the sinking of the *Monitor* on December 30, 1862 for cutting with a hatchet the thick hawser line connecting the vessel to the USS *Rhode Island*. (Library of Congress)

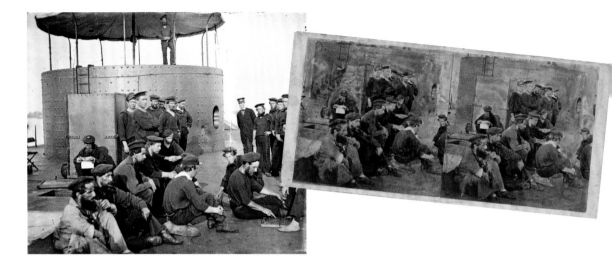

(Left) Crew members of the *Monitor* were assembled near the smoke box aft of the turret for the camera of James F. Gibson so that the dents in the armor caused by the *Virginia* are clearly visible. (Library of Congress)

(Right) This hand-colored stereoscopic view of the crew of the *Monitor* by Gibson was published as part of the series "Illustrations of General McClellan's Campaign on the Peninsula" in Alexander Gardner's "Catalogue of Photographic Incidents of the War" in September 1863. (Library of Congress)

Darling and other shore batteries on Drewry's Bluff. During the last week of June she also provided naval support along the banks of the James River, which covered the withdrawal of McClellan's army from the area.

During his visit on board the *Monitor* on July 9, 1862, Gibson concentrated on producing images of both officers and enlisted men posing with the battle-dented turret as a background, and took at least eight photographs on a blisteringly hot summer day. Of the occasion when the photographer came on board, Acting Lieutenant William Flye recalled, "I caused the turret to be revolved into such a position that it should show the port holes and the muzzle of our XI [inch] guns, as well as some of the shot marks on the turret. Then I took a position at the side of the vessel, not with a view to have my picture taken, but to see that every thing was

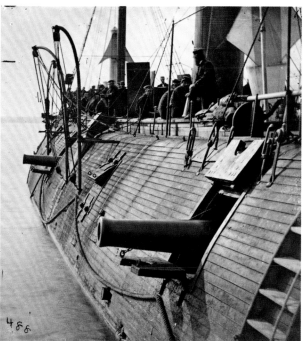

Some of the crew of the USS *Galena* gather on deck for James F. Gibson.
The two men seated nearest the camera are marines, as are three of the men farther amid
ship. The bearded officer standing with his foot on the gunwale, who was probably a
boatswain, is holding a speaking trumpet usually used for hailing ships at sea or giving
orders under a fire. (Library of Congress)

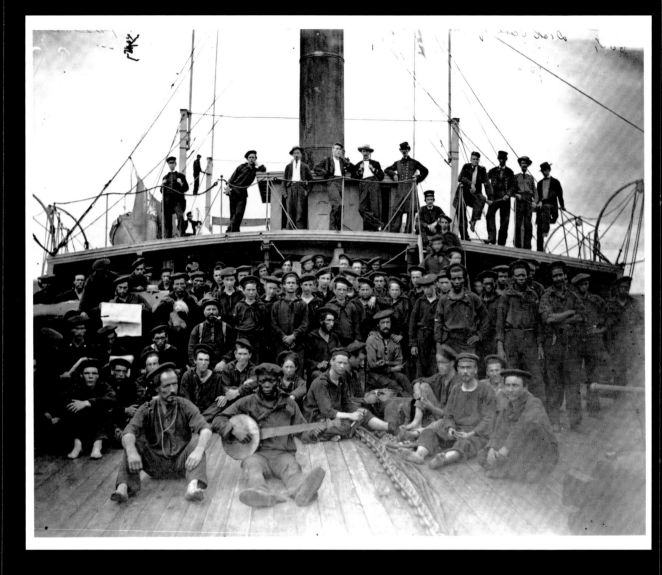

Originally a New York ferry, the USS *Hunchback* was converted into a Union Navy gunboat in January 1862 and formed part of the North Atlantic Blockading Squadron stationed off the coast of North Carolina and Virginia. By late 1864 she was in the James River looking for Confederate "torpedoes" when most of her crew assembled in her bow for a photograph as an operator from Matthew Brady's Washington gallery came on board. Clearly a popular individual, an African American seaman sits toward the front of the crew playing his fretless five-string banjo. The sailor sitting next to him appears to have been an "old salt" with bare feet and lanyard around his neck, at the end of which would have been a rope knife for working with ship's rigging. (National Archives)

properly done." During the same period Gibson photographed the captured gunboat CSS *Teaser* and the ironclad USS *Galena*, which had been damaged in action against the Confederate batteries at Drewry's Bluff on May 15, 1862. On this occasion the *Galena* was struck by 28 shots in the side and 17 on the deck from plunging fire. Twelve crew members were killed outright, two seriously wounded, and five slightly wounded.

First arriving at Hilton Head, South Carolina, on February 21, 1862, and returning in April to stay until May 1863, Henry P. Moore photographed several Navy vessels and crews anchored off Port Royal, including the ship of the line *Vermont* and mortar schooner *C. P. Williams*. He found the steam sloop *Pocahontas* in the Edisto River and, with her past service assisting in the withdrawal of the Federal garrison from Fort Sumter in April 1861, was probably very pleased to board and photograph her. As a banjo player, Moore was also probably delighted during his second period at Port Royal to capture several images of the "Wabash Minstrels," who took part in at least eight concerts aboard the screw frigate *Wabash* for their fellow seamen and troops from 1861 through 1864.

By early 1863 the war for the Union was not going well on land or sea. Although the Confederate Army of Northern Virginia had been repulsed at Antietam or Sharpsburg, Maryland, on September 17, 1862, it had escaped reasonably intact and inflicted a major defeat on the Northern Army of the Potomac at Fredericksburg, Virginia. As a result, the Federal military objective in the East was in disarray. In the West, the campaign for control of the Mississippi River stalled at Vicksburg, Mississippi, where a siege would last from May 18 through July 4, 1863. A mood of war weariness was evident throughout the North, and the mid-term elections, regarded as a referendum on the war, had shown a swing away from the Republican Party. Thus the Lincoln Administration began to apply increased pressure on its field commanders to achieve some success that would lift the national spirit. It was in this atmosphere that the Navy Department began to urge an attack on Charleston, South Carolina, which was regarded as the "cradle of secession" and the place where the Civil War began.

The first major Union naval attack on the forts in Charleston Harbor took place on April 7, 1863, and involved the largest deployment of monitors in action up to that time. The attacking fleet consisted of the *Weehawken, Passaic, Montauk, Patapsco, Catskill, Nantucket,* and *Nahant,*

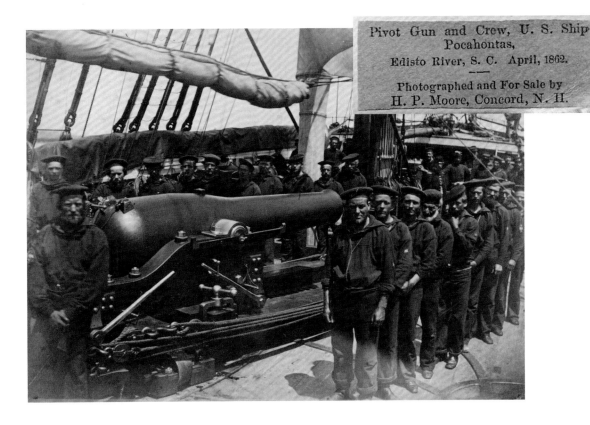

Pivot Gun and Crew, U. S. Ship
Pocahontas,
Edisto River, S. C. April, 1862.
—
Photographed and For Sale by
H. P. Moore, Concord, N. H.

Labeled "Pivot Gun and Crew, U. S. Ship Pocahontas, Edisto River, S.C. April 1862," this view was produced by photographer Henry P. Moore during his first period at Hilton Head. A fourth-rate steam sloop, the *Pocahontas* helped evacuate the Federal garrison from Fort Sumter in April 1861. Featured in this view with its crew of 20 men, the 10-inch Dahlgren smoothbore pivot gun was mounted amidships in front of the smokestack. The label was attached to the card-mounted albumen print of this image for sale at Moore's gallery in Concord, New Hampshire in 1862. (Library of Congress)

plus the tower ironclad *Keokuk*. Rear Admiral Samuel F. Du Pont commanded the operation aboard the ironclad flagship *New Ironsides*, which proved difficult to handle in the strong currents and shallower waters and was forced to pull out of the column of vessels attacking the harbor defenses. Following a slow approach, the *Weehawken* was struck by either a shell or "torpedo" below her waterline, despite having a 50-foot

"devil" attached to her bow designed to rake up and detonate such devices. Although this threw the column into disarray, it was the sheer disparity in firepower that determined the outcome of the action. In the course of the two-hour engagement, the Confederate artillerists got off more than 2,000 shot and shell, of which 520 hit. By contrast, the Union fleet fired only 154 shots due to a seven-minute loading time for the guns in the monitor turrets. Although the armor protected their crews, several vessels suffered damage that impaired their fighting capabilities, such as jammed turrets and gun-port stoppers. Worst damaged was the *Keokuk*, which sustained

As a musician, Henry P. Moore was probably delighted to have photographed five of the famous "Wabash Minstrels" when he went aboard the screw frigate USS *Pocahontas*, Rear Admiral Samuel F. Du Pont's flagship, during May 1863. The fiddle player seated at center may be English-born John Parker. A loom-maker by trade who made violins as a hobby, he had migrated to the US in 1857 and enlisted in the Navy at Philadelphia as a landsman on July 2, 1861. Combined with the ship's brass band and an opera troupe, the "Wabash Minstrels" staged at least eight concerts at Port Royal, during which, according to Commander C. R. Rodgers, the gun deck was "prettily decorated and lighted … the men sang well and the dances were very good." (New Hampshire Historical Society)

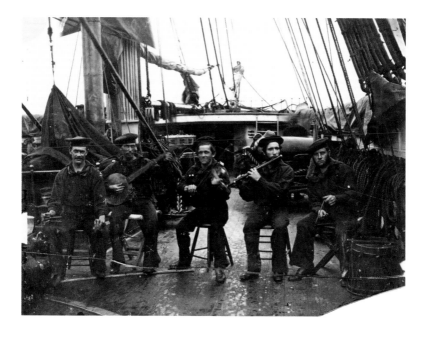

90 hits, including 19 shots at or below the waterline. Limping out of range, she sank about 1,400 yards off Morris Island and her two 11-inch Dahlgren shell guns were eventually salvaged by the Confederates. Hoping to renew the attack the next day, Du Pont was persuaded by his captains to call off the operation, which was considered a failure.

Charleston photographer George S. Cook was requested to make photographic copies of drawings or sketches of the monitor attack on Fort Sumter on April 7, 1863 probably made by an engineer officer during the action. Based on the subject titles on an invoice dated August 26, 1863, and signed by chief of engineers Major W. H. Echols, he supplied 100 copies of "Photograph of 'Plan of Attack on Fort Sumter on 7 April,'" 26 copies of "Devils [anti-"torpedo device attached to the bow of the *Weehawken*]," 15 copies of "Fort Sumter," and 56 copies of "Monitors," for which he was paid a total of $468.[2] Later that year, or early 1864, he made a photographic copy of "a very accurate drawing of the interior work [of Fort Sumter] made on 9th December, 1863, by Lieut John R. Key, post adjutant, C.S. Engineers, a young artist of much promise," which was not delivered to General Samuel Cooper, Adjutant and Inspector General, at Richmond, Virginia until April 17, 1864, due to "the want of proper materials and instruments."[3]

Appointed to command the South Atlantic Blockading Squadron on July 6, 1863, Rear Admiral John Dahlgren applied renewed efforts to capture Charleston. Positioning the monitors nearer to the harbor entrance at night, the city ceased to be an active seaport, with blockade runners weighing anchor at Wilmington, North Carolina instead. Dahlgren also frequently employed monitors to provide covering fire for Union Army actions, and fired on Battery Wagner on Morris Island for a week prior to the attack spearheaded by the 54th Massachusetts on July 18, 1863. Nearly two months later, the Confederates abandoned Morris Island during the night of September 6–7. Following the occupation of Morris Island, Dahlgren immediately demanded the surrender of Fort Sumter, which was promptly refused. Thus he ordered an attack the same day, which involved the monitor *Weehawken* being sent into the narrow channel between the fort and Cumming's Point on Morris Island to cut off communications to the south. Also planned was a combined Army/Navy boat assault on Fort Sumter during the night of September 8. Once again Navy plans came to grief as the *Weehawken* grounded in shallow water but remained unnoticed by the

Confederates until 7 am the next morning, when she came under concentrated fire from the batteries at forts Moultrie and Sumter and Sullivan's and James Island. Six other Union monitors, plus the *New Ironsides*, came to the support of the stranded *Weehawken*, which was eventually refloated with the help of tugs and limped back out to sea and safety.

Coincidentally, both Northern and Southern photographers captured historic images of the events on September 8, 1863, which represent some of the first combat photography, albeit from a distance. On the Northern side, 53-year-old veteran daguerreian artist Philip Haas, with partner Washington Peale, photographed the action involving the *Weehawken* from the beach on Morris Island. Lying about his age by stating he was 43, Haas had enrolled for three years as second lieutenant in Co. A, 1st New York Engineers, also known as Serrell's Engineer Corps, on August 30, 1861. Ordered to Port Royal, South Carolina with his regiment on December 14, 1861, he was detailed on detached service as a photographer on the staff of Brigadier General Ormsby M. Mitchell, commanding the Department of the South, on July 15, 1862. Working in a specially built wooden "Photographic Bureau" at Hilton Head, he was probably employed photographing maps and documents for General Mitchell, and on March 31, 1863 requested a private from the 76th Pennsylvania, or Keystone Zouaves, to serve as an assistant. After a bout of ill health Haas was honorably discharged from the army on May 25, 1863, but continued to photograph the siege of Charleston from Morris and Folly islands as a civilian during the rest of that year, being joined by Washington Peale, the son of Philadelphia artist James Peale, Jr. Roaming the campsites and batteries on Morris Island as the battle for control of Charleston Harbor raged, Haas and Peale produced approximately 40 glass plate negatives. Writing home about his war experience, Peale explained that he had "many narrow escapes." A report based on his letter published in the *British Photographic Journal* in December 1863 stated

One day he was working within a mile of the enemy's guns, and as he had to climb a pole which had been erected for his accommodation, with a platform on the top, and a ladder to facilitate the ascent, several shot were thrown at him, all well aimed, but faulty in range. At last a shell exploded near him, part of which struck the ladder while he was in the act of descending, and inflicted some severe bruises on his person, but did not interrupt his work.[4]

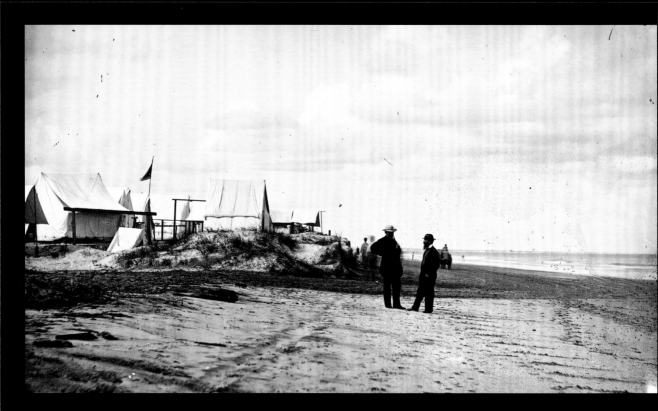

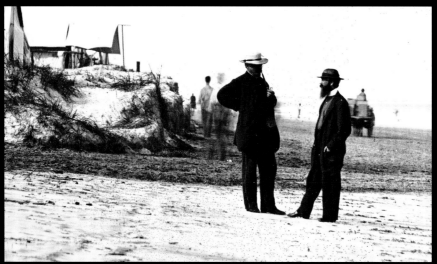

From original negative No. 22 and a print entitled "Morris Island, South Carolina. Unidentified camp," this view credited to Northern photographers Philip Haas and Washington Peale probably shows the two artists standing in conversation on a beach on Morris Island, with a Union encampment close by. Protected by the guns of Confederate Fort Moultrie, the coast of Sullivan's Island can be seen in the distance across the waters of Charleston Harbor. The man at left wears military trousers showing a seam stripe, which would fit with the previous military service of photographer Philip Haas as a second lieutenant of Co. A, 1st New York Engineers. (Library of Congress)

Soldiers and civilians stand in awe on a beach on Morris Island in Charleston Harbor on September 8, 1863, as a dramatic duel takes place between the USS *New Ironsides* and the guns of Forts Moultrie and Sumter. Smoke can be seen belching from a broadside being fired toward Fort Moultrie by *New Ironsides*. The faint outline of four of the six monitors also involved in the rescue of the *Weehawken* can also be seen in the distance through the smoke of battle. Unusually, the photographers' names "Haas & Peale" are scratched on the bottom right-hand corner of the glass plate. (Library of Congress)

One of the most spectacular of views produced by Haas and Peale shows soldiers and civilians gathered on a beach watching the *New Ironsides*, plus at least four monitors, coming to the rescue of the stranded *Weehawken*.[5]

The involvement of George S. Cook and James M. Osborn on September 8, 1863 was prompted by a request from Brigadier General Thomas Jordan, Beauregard's chief of staff, for the services of "a photographic artist" to "preserve a faithful delineation of the ruins of Fort Sumter and to show to future generations what Southern troops could endure in battle." According to a report in the *Charleston Daily Courier*

(Left) An example of the hard life experienced by seamen who made up the crew of the monitors in the Union Navy during the Civil War, Landsman Albert H. Angell was photographed at the gallery of Orrin C. Benjamin at 324 Fulton Street in Brooklyn soon after enlistment at the New York naval rendezvous on September 30, 1862. He lasted only eight months aboard the monitor *Catskill* before being honorably discharged, having developed pleurisy off Charleston caused by "exposure and severe service." (Author's collection)

(Right) The Confederate view of the Union navy operation to rescue the stranded *Weehawken* was captured by the camera of Charleston photographers George Cook and James Osborn, who had combined forces in response to a request from Brigadier General Thomas Jordan for photographs of the interior of Fort Sumter. Ignoring the danger presented by enemy shells from the Union warships, which continued to smash into the fort, they climbed on to the remains of its parapet and produced numerous views of its devastated interior before turning their camera to take one photograph that captured the *New Ironsides* at right, with two of the monitors, possibly the *Montauk* and *Passaic*, close by. (Library of Congress)

four days after the event, entitled "The Ironsides and two Monitors Taken – A Bold Feat," the two photographers reached the fort under fire intent on capturing views of its largely destroyed interior. Reminiscent of its 1861 report when Cook photographed Major Robert Anderson and his officers, the *Courier* related that they:

> coolly ascended to the parapet, planted their battery upon a gun carriage, and commenced work. The enemy, meanwhile, were throwing their eleven and fifteen inch shells against and into Sumter, rendering personal exposure hazardous in the extreme. Under these circumstances scene after scene from the dilapidated old pile was faithfully transferred to the plates until nearly every portion of the ruins – picturesque even in their deformity – had its "counterfeit presentiment." This done, the artists turned their attention to the fleet, and had the good fortune to secure, amid the smoke of the battle in which they were wreathed, a faithful likeness of the *Ironsides* and two Monitors.

Cook also requested permission from the post commander, Major Julius A. Blake, to venture outside the fort to take a photograph of its exterior from the water, but it was considered this would draw "additional fire from the fleet, and the project was abandoned."[6] With the help of tugs the *Weehawken* was refloated later that day and once again limped to safety outside the harbor.

During 1864, Egbert G. Fowx focused his camera on the North Atlantic Blockading Squadron and photographed the Union navy in the James River. Born in Kentucky, Fowx was listed as an "ambrotypist" living in Hampton, Virginia, by 1860. The son-in-law of songwriter, musician, and poet John Hill Hewitt, who became known as the "Bard of the Confederacy," he went North at the beginning of the war and by 1863 was employed as a photographer for the USMRR with Andrew J. Russell. Working for Matthew Brady by March 1865, Fowx spent time recording views of Union naval vessels in the river, including the monitors *Lehigh*, *Saugus* and *Mahopac*, and combined Army and Navy operations along its banks during the closing stages of the conflict.

In the Mississippi River and its tributaries, the new force of Union gunboats and river ironclads, together with regular Army units, began its campaign to penetrate the heart of the Confederacy. During the early months of the war, these vessels were built and crewed by the US Army, with the naval officers

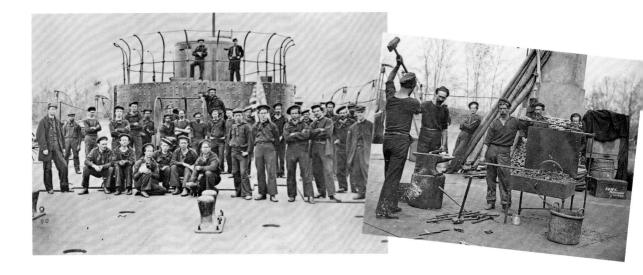

(Left) Photographed on the James River by Egbert G. Fowx in March 1865, some of the enlisted men of the monitor *Lehigh* pose on deck in front of the gun turret. Seamen often kept mascots and pets aboard ship, and one man kneeling holds a fighting cock while another nurses a white cat. A seaman in the rear holds a ship's flag, which was seldom seen aboard monitors. (National Archives)

(Right) During his time visiting one of the monitors, Fowx photographed a party of seamen working a blacksmith's forge and possibly making iron rivets for repair work to their vessel. The man at the bellows wears denim jeans over his navy trousers as protection against sparks. The photographer's portable dark-room and chemicals trunk, with "FOWX/Photographer" in signwriting on the side, stands at rear right. (National Archives)

commanding them being the only direct connection to the Navy. By the autumn of 1862, this "brown water" fleet, and their mission, was transferred to the Department of the Navy. Following the capture by February 16, 1862, of Forts Henry and Donelson, on the Tennessee and Cumberland rivers respectively, and Island Number Ten at the New Madrid or Kentucky Bend on the Mississippi River on April 7, 1862, Vicksburg was threatened. Becoming known as the "Gibraltar of the Confederacy," its capture was seen by President Lincoln as "the key" to Union victory in the war. With the fall of Vicksburg, the complete length of the Mississippi River would soon be in Union hands.

The Confederate States of America would be cut in two and vital supplies coming through Matamoras, Mexico, would be prevented from reaching the region east of the great river.

When the construction of the first Mississippi River City-class ironclad gun boats was begun by civil engineer and inventor James B. Eads in August 1861, photographer George L. Williams, of Williams and Cornwell, whose gallery was at 60 Fourth Street, St. Louis, Missouri, was employed to produce photographic copies of the original plans to assist with building the vessels, which consisted of the *St. Louis, Cairo, Carondelet, Cincinnati, Louisville, Mound City,* and *Pittsburgh.* Numerous Union Navy vessels on the Mississippi River were photographed by J. W. Taft, who operated the "Oak Gallery" at 282½ Main Street, Memphis from 1863 and advertised some of best "Sun Pictures known to the profession." Although running a busy portrait gallery, which produced *cartes de visite* of the likes of generals U. S. Grant and William Tecumseh Sherman, he, or his operators, also spent considerable time on the wharfs and river banks of the Mississippi at Memphis and Vicksburg with a larger wet plate collodion camera. Among the vessels photographed were Admiral Porter's flagship *Black Hawk,* the Cairo-class ironclad *Indianola,* and the timber-clad *Tyler.*

At his gallery on Main Street in Baton Rouge, Louisiana, Ohio-born photographer Andrew D. Lytle found little difficulty in catering for Union forces when they occupied the city on May 9, 1862, albeit possibly for spying purposes. Concentrating particularly on Union naval activities in the river, he photographed the screw sloop USS *Hartford,* Admiral David Glasgow Farragut's flagship. When the Union ironclads arrived from the Yazoo River, he produced numerous views of vessels such as the *Choctaw* anchored menacingly close to the riverbank.

The Confederate Navy had a number of heavily-armed ships known as commerce raiders on the high seas during the Civil War. Vessels such as the *Florida, Alabama, Georgia* and *Shenandoah* attacked US merchant ships worldwide and preoccupied numerous Union Navy vessels in the pursuit of these raiders. The CSS *Alabama* was built for the Confederate States by John Laird, Sons & Company at Birkenhead on the River Mersey opposite Liverpool, England, and was launched on May 14, 1862. During the course of a two-year period of service under command of Captain Raphael Semmes, she burned or sank 64 US vessels of various types, and never once docked at a Southern port.

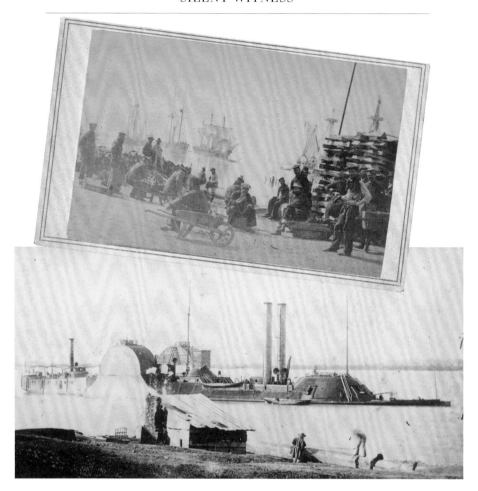

(Top) Photographed at Baton Rouge in 1863, possibly by Andrew D. Lytle, these seamen of Farragut's fleet wait and rest at a fueling station on the wharfside. Logs and blocks of wood are stacked either side. The vessel in the distance with sails unfurled is the sloop-of-war USS *Mississippi* which was soon after sunk in action while attempting to pass the forts guarding Port Hudson. (Library of Congress)

(Above) When the large Union navy ironclad USS *Choctaw* arrived off Bayou Sara near Baton Rouge in November 1864, Andrew D. Lytle took the opportunity of photographing her up close. His view of her starboard side shows the casemate forward and the paddle wheel boxes aft. Designed as a ram, she was too slow to function as one. The *Choctaw* was badly damaged during the bombardment of Haines' Bluff, on the Yazoo River in Mississippi during May 1863, being hit 53 times with many shots penetrating her flimsy armor. Repaired and repainted, she gave good service during the Red River Expedition of 1864. An unidentified timber-clad gunboat is seen at her stern.
(Andrew D. Lytle collection, LSU)

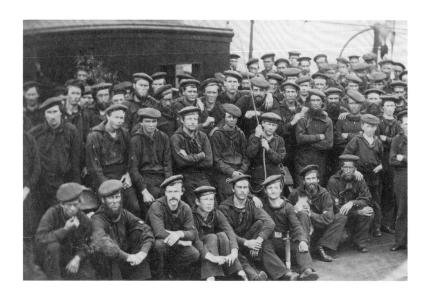

Permitted on board the ironclad USS *Choctaw*, Lytle photographed some of her 107 crew on deck amidships and gathered in front of the pilothouse with the smokestacks towering above them. The name of the vessel can be seen embroidered on the bands of the caps worn by some of them. The tender age of several of the boys, first and second class, in their midst is apparent in contrast with some of the more worldly-looking landsmen and seamen. This was possibly the last time these sailors would have the opportunity to be photographed before the war ended. (Andrew D. Lytle collection, LSU)

During her fifth main raiding voyage which began in August, 1863, the *Alabama* sailed from Brazil across the South Atlantic Ocean and cruised along the coast of the African continent. In need of repairs, Captain Semmes put into Table Bay, advising Sir Philip Edmond Wodehouse, governor of the Cape Colony and British High Commissioner for Southern Africa, that he would "pay the strictest attention to the neutrality of the British Government." Thousands of Cape people crowded the headlands to see the *Alabama* approach and watched her chase and capture the American barque *Sea Bride*, which she claimed was still in neutral ground, before she arrived in the Bay. Remaining at anchor in Table Bay for four days, the newspapers reported that "hundreds of the colonists crowded her decks," and were "hospitably received by Captain Semmes and his officers."

Standing by the 110-pounder rifled gun aboard the CSS *Alabama* during her visit to Cape Town, South Africa, in August 1863, Captain Raphael Semmes was photographed by local artist Arthur Green. His executive officer, First Lieutenant John McIntosh Kell, is in the background by the ship's wheel. This *carte de visite* was reproduced and lightly colorized in 1867 by E. Burmester of Cape Town, who advertised "A Large stock of Cape Views" that he had acquired when Arthur Green went out of business in 1864.
(US Naval History and Heritage Command Photograph)

On August 12, 1863, Semmes recorded in his log-book "Photographers & visitors on board."[7]

Among the crowd of curious visitors was photographer Arthur Green. Born in Halifax, Nova Scotia, Canada in 1832, he moved to the Cape Colony in the late 1840s. By 1853 he was employed as a clerk in the Office of Orange River Sovereignty at Bloemfontein. He toured Kaffraria as a photographer in the mid-1850s and operated a studio in Grahamstown in 1857. In 1861 he took over the management of a Cape Town studio previously run by Frederick York, but this establishment closed due to financial problems in 1862. By November of that year, Green had opened portrait rooms in Longmarket Street, Cape Town, and it was from these premises that he took a boat ride across Table Bay to photograph the officers and crew of the *Alabama* on August 12, 1863. Green once again

In another view aboard the CSS *Alabama* by Cape Town photographer Arthur Green, Sailing Master Irvine Bulloch leans on the framework of the hoist above the gun-room skylight. Standing at right is Paymaster W. Breedlove Smith, who was Captain Semmes' secretary. Another officer, who may be Lieutenant Kell, and a group of approximately seven seamen wearing a mixture of flat caps and brimmed hats gather at the stern by the flag-locker. A stamp on the back of this albumen print indicates that it once belonged to J. G. M. Bernard, the superintendent of the Boating Company of Port Elizabeth. The ink from this stamp can be seen showing through to the front of the photograph. (Courtesy National Museums Liverpool, Merseyside Maritime Museum)

became insolvent and his equipment was sold by public auction in 1864. Thereafter he worked as a photographic assistant until he left the Cape in 1866 and sailed to New York, where he died of pulmonary tuberculosis in 1873. Many of his negatives were purchased in public auction by photographic agent Emil Burmester, who offered prints for sale, including those taken aboard the *Alabama*, until at least 1867.[8]

The *Alabama* was eventually caught and sunk by the sloop-of-war USS *Kearsarge* outside the port of Cherbourg, France, in the most dramatic single ship action of the Civil War. Prior to the battle, most of the crew of the *Alabama* were photographed by François Rondin, whose "Maison

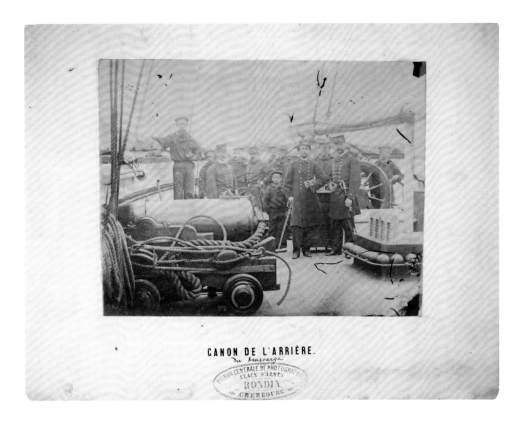

CANON DE L'ARRIÈRE.

Produced by French photographer François Rondin, who was permitted aboard the
victorious USS *Kearsarge* after the battle off Cherbourg in June 1864, this albumen print
shows some of the officers and men of the crew of about 150 gathered on the quarterdeck
near one of the 32lb broadside guns. From left to right, the four officers are Acting
Master's Mate Charles A. Danforth, Acting Gunner Franklin A. Graham, Midshipman
Edward E. Preble, and Acting Master's Mate Ezra Bartlett.
(François Xavier Crevel collection)

Centrale de Photographie" in the Place D'Armes et de la Republique in
Cherbourg was only a few blocks from where their vessel was moored on
June 11, 1864. In need of repairs after being at sea for nearly two years,
Captain Semmes found that the only dry dock facility that could
accommodate his ship there was that of the French Navy, and the French
government refused to get involved in repairing a Confederate warship.

In pursuit of the Confederate raider, the *Kearsarge*, under command of Captain John Ancrum Winslow, arrived three days later and took up station just outside the harbor. Realizing he was trapped, Semmes advised Winslow through diplomatic channels that his intention was to fight once he had prepared his crew for the action.

At about 10.00 am on June 19 the *Alabama* steamed out to meet the Union cruiser, and hundreds of French citizens gathered along the coastline to watch. In particular, the ensuing sea battle was witnessed by Édouard Manet, who afterwards produced a painting of the action, and John Lancaster, the owner of the English yacht *Deerhound*, who had offered his children a choice of church or a sailing trip to watch the dramatic events at sea.[9] In Cherbourg, François Rondin is believed to have taken his camera up into a church steeple at nearby Querqueville and, using an early form of "telephoto" lens, photographed the battle, which at a distance of about six miles would have been scarcely visible to the naked eye. Unfortunately, these views have not survived.

As the two warships duelled, they made seven circles at a distance of from quarter to half a mile. Although the *Alabama* had eight guns, as opposed to the seven aboard the *Kearsarge*, the more accurate firepower of the US vessel was decisive. After about an hour and a half, the *Alabama* was in a disabled and sinking state, having been holed in several places below the waterline, and her crew surrendered. More than 40 Confederate seamen were killed in action or drowned, and about another 70 were picked up by the *Kearsarge*. A further 30, including Captain Semmes and 14 of his officers, were rescued by the *Deerhound*. Instead of delivering the Confederates to the US warship, the yacht set a course for Southampton, thus enabling them to escape, much to the annoyance of Winslow and his crew. Only three men were wounded aboard the *Kearsarge*, one of whom died the following day. In March 1865, John Lancaster received a letter from President Jefferson Davis and the Congress of the Confederate States of America, offering their eternal gratitude for rescuing Semmes and his crew members.[10] When the *Kearsarge* docked in Cherbourg harbor for repairs and to deliver crew members of the *Alabama* ashore, François Rondin was permitted aboard to photograph the victorious crew.

CHAPTER 7

CLOSING SHOTS, 1865

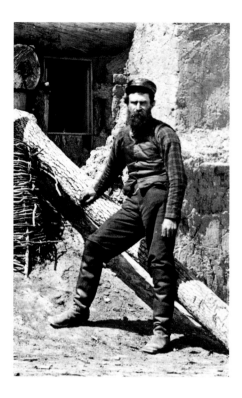

In April 1865, the intrepid photographer Thomas Roche stands in the Union siege lines outside Petersburg, Virginia in front of bomb-proof quarters in Fort Sedgewick, also known as "Fort Hell." (Library of Congress)

As the end of the war approached, some of the leading Northern battlefield photographers followed the Union armies as they closed in around the crumbling Confederacy. In Virginia they included Captain Andrew J. Russell, Timothy O'Sullivan, Thomas C. Roche and John Reekie, who were outside Petersburg as the siege reached its conclusion after a nine-month campaign. Toward the end of March 1865, Russell and Roche combined to photograph the construction of the Dutch Gap Canal, which was being built to cut off a bend on the James River controlled by Confederate forts, thus enabling Union navy vessels to approach the Confederate capital at Richmond.

An amateur photographer and late-comer to battlefield photography, Thomas Roche was a ticket agent in the shipping industry in the Williamsburg district of Brooklyn until at least 1863, although he was also involved in the photographic art, having been issued Patent Number 26,525 for a stereoscopic viewer on December 20, 1859. By February 1863 he had a gallery at the "corner of South Seventh and First streets, Williamsburg[a neighborhood in Brooklyn]," which he operated until February 6, 1865 when he advertised it for sale in the *New York Herald* "at a very low price." Following this he is believed to have worked on commission for E. & H. T. Anthony, and by April 1865 was at City Point near Petersburg, Virginia where he joined Andrew Russell.

Of this work with Roche, Russell recalled in 1882:

> The enemy were bombarding the works from Howlett's Point, throwing immense shells every few minutes, tearing up the ground and raising a small earthquake every time one of them exploded. He [Roche] had taken a number of views and had but one more to make to finish up the most interesting points, and this one was to be from the most exposed position. He was within a few rods [5½ yards] of the place when down came with the roar of a whirlwind a ten-inch shell, which exploded, throwing the dirt in all directions; but nothing daunted and shaking the dust from his head and camera he quickly moved to the spot, and placing it over the pit made by the explosion, exposed his plate as coolly as if there was no danger, and as if working in a country barn-yard. The work finished he quickly folded his tripod and returned to cover. I asked him if he was scared. "Scared?" he said, "two shots never fell in the same place."[1]

Of the eve of the final Union assault on Petersburg on April 2, 1865, Andrew Russell recalled that Roche entered his quarters at City Point announcing, "Cap, I am in for repairs and want to get things ready for the grand move, for the army is sure to move to-night or tomorrow night. The negatives on hand I wish to send North with some letters, prepare my glass and chemicals; in fact, get everything ready for the grand move, for this is the final one, and the Rebellion is broken, or we go home and commence over again."

His prophecy proved correct, for at 10 pm that night, and following news of the Union victory at Five Forks, Grant and Meade ordered a massive bombardment of the whole Confederate line defending Petersburg.

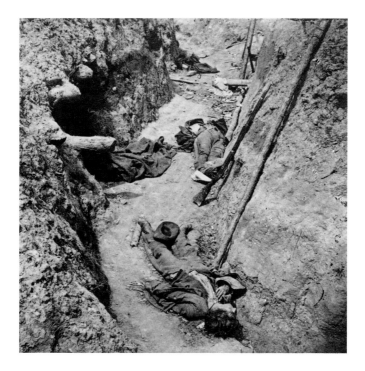

When he entered the trenches and earthworks of Fort Mahone, also known as "Fort Damnation," in the Petersburg defenses on April 3, 1865, Thomas C. Roche was intent on documenting the victory over a prostrate South, which was to be highlighted by images of dead Confederate soldiers. In so doing, he also documented the tragedy of war and the waste of human life. The youthfulness of many of the fallen revealed the desperate measures taken by the Confederacy during its final months. (Library of Congress)

At 2 am the next morning the bombardment stopped and the infantry assault began. Russell recollected:

At this moment the heavy boom of cannons were heard in the direction of Petersburg. Roche jumped to his feet, and rushing to the door said, "Cap, the ball has opened; I must be off," calling to his assistant. In the next quarter of an hour two horses were harnessed, everything snugly packed, and shaking my hand with a "we will meet to-morrow at the front," said "good bye," and

the wagon rattled off into the darkness of midnight towards that doomed city above which was such another display of pyrotechnics as few photos have ever witnessed – shells flying in all directions, leaving their trails of fire and fading away only to be replaced by others. This was not all. The whole world seemed alive; every road was teeming and the call to arms seemed to find a response from every foot of the ground; the rumbling of artillery, the clatter of cavalry, the tramp of infantry, the shrieking of locomotives, calling men to their posts, plainly told that the time had come – that the destiny of a nation hung in the balance. In the morning Petersburg was ours. I found Mr Roche on the ramparts with scores of negatives taken where the fight had been the thickest and where the harvest of death had indeed been gathered – pictures that will in truth teach coming generations that war is a terrible reality. A few minutes later I saw his van flying towards the war-stricken city, and in the wake of a fleeing enemy. Many were the records he preserved that day that will last while history endures, to relate the eventful story of a victory sorely won.

Following the collapse of the defences at Petersburg, President Davis and his cabinet left the capital via the Richmond & Danville Railroad for Danville, just north of the North Carolina border. Meanwhile, Lee ordered the remains of the Army of Northern Virginia to withdraw from Richmond, Petersburg, Chaffin's Bluff and Bermuda Hundred and head west in anticipation of finding supplies waiting for his exhausted troops at Amelia courthouse. He also hoped to join forces with those of Joseph E. Johnston in North Carolina.

On April 3, 1865, Roche crossed over to the captured Confederate lines and produced about 50 stereoscopic views of the dead he found in Fort Mahone, also known as "Fort Damnation," which was captured by the Union IX Corps commanded by Major General John G. Parke following a bitter struggle involving a Confederate counterattack. The trenches and earthworks were still strewn with the bodies of the fallen enemy, and Roche must have spent several hours working furiously in order to produce so many views. As he exposed one stereoscopic plate after another of fallen Confederate soldiers, Federal cavalry farther north dashed into Richmond to find much of the city in flames from fires started by the fleeing enemy. Receiving a communication that Richmond had fallen, President Lincoln determined to visit the city. According to the memoirs of Admiral David Dixon Porter, he greeted the news by saying, "Thank

Photographer John Reekie created this view of the first Union supply train to enter Petersburg on April 2, 1865. Due to the lack of movement of the column, he had time to take his camera to a vantage point to produce a glass stereoscopic view showing the halted wagons winding back into the distance. Not considered in detail before, this view shows curious civilians, who were probably African American, watching in amazement as the supply train enters the city. A Union infantryman stands on the corner talking with a civilian leaning against the fence. The sixth vehicle in the column is an ambulance wagon. Several of the nearest wagons have the badge of the 23rd Army Corps painted on their canvases, which is unusual as that corps served under Sherman in the Carolines Campaign.

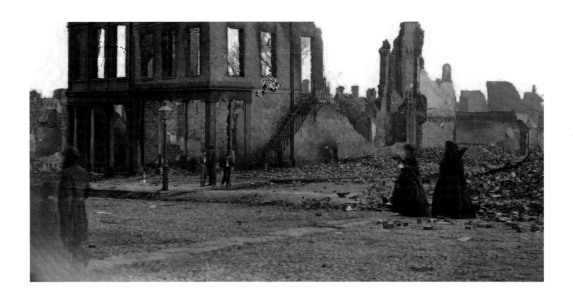

Photographing "the Burnt District" of Richmond, Virginia during April 1865, Alexander Gardner managed to capture this rare view of two Southern women dressed in black walking through the rubble and ruins of the city. Presumably they were in mourning having lost their husband, father or son in battle for the Confederate cause. Three youths stand on the opposite corner. Having been too young to serve in the military, they had nothing to fear from the occupying Union army. A wounded soldier with walking cane, accompanied by a small boy, walks off at left. (Library of Congress)

God, that I have lived to see this! It seems to me that I have been dreaming a horrid dream for four years, and now the nightmare is gone. I want to see Richmond."[2] Accompanied by Admiral Porter, Lincoln went up the James River aboard the side-wheel steamer USS *Malvern*, and entered the conquered Confederate capital on April 4 while the burnt-out buildings were still smoldering.

Alexander Gardner arrived from Petersburg the next day and immediately went to work. It was his first assignment behind a camera in the field since Gettysburg in November 1863, and he roamed Richmond for about two weeks photographing what became known as "the Burnt District," plus other important locations in and around the city such as the City Hall, Tredegar Iron Works, and State Arsenal. Upon his return to

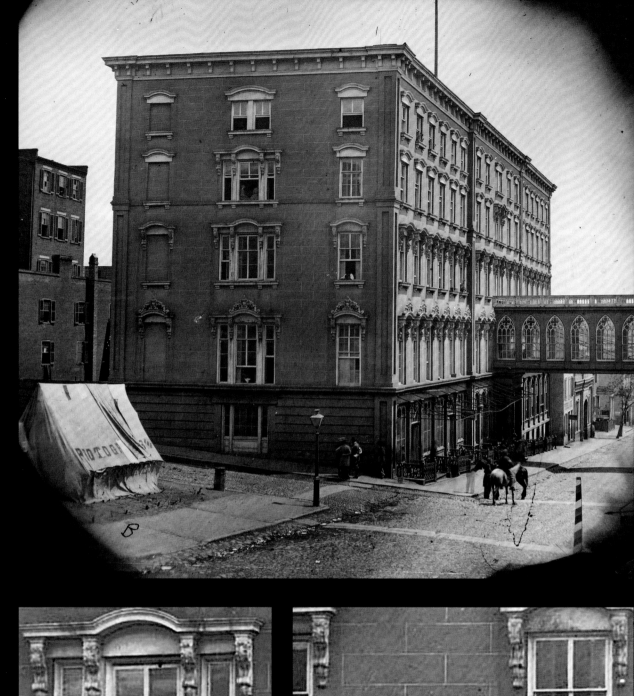

Advertising "Photographs and Ambrotypes" on its canvas, a photographer's tent is pitched next to the Ballard House at the corner of Fourteenth and Franklin streets in Richmond, Virginia, in April 1865. One of the principal hotels in Richmond during the Civil War period, the Ballard House probably served as temporary accommodation for photographers such as Gardner and Brady when they arrived in the fallen Confederate capital. In this previously unpublished detail, two women sit talking by an open window on the top floor. On a lower floor an African American rests on the windowsill with head on hands, seemingly indifferent to the fact he is now a free man. (Library of Congress)

Washington on April 20, the *Daily National Republican* commented, "His collection will be a most valuable contribution to the illustrations of the history of the rebellion." Having been attached to the headquarters of the Army of the Potomac as official "photographist" since Grant took command, Matthew Brady was also in Richmond by April 7 with "a full corps of artists" including Sam Denny and Anthony Berger, and within five days had sent to his Washington gallery "a large panoramic picture of the whole city, showing the burned part, Belle Isle, the prisons and the pontoon bridges across the James."[3] Also present in the city by this time was Thomas Roche, working for E. & H. T. Anthony and Andrew J. Russell.

One of these various artists photographed the notorious "Castle Thunder." A prison for Unionists, spies, and other civilian enemies of the Confederacy, it was first established in Richmond during March 1862 when Lumpkin's Jail, situated in an alley off Franklin Street, was converted into "Castle Godwin." In August of that year the inmates of "Castle Godwin" were transferred to a building that was previously Greanor's Tobacco Factory on Cary Street. According to a report in the *Daily Richmond Enquirer* the day before the move, the new prison was named "Castle Thunder" because it was "indicative of Olympian vengeance upon offenders of her laws," and one which "in point of sound, is as good as any other that could be chosen."

Following the surrender of the demoralized remains of the Army of Northern Virginia to Ulysses S. Grant on April 9, 1865, Robert E. Lee stayed at Appomattox for three days until the last of his soldiers had laid down their arms and been paroled. He then set out for Richmond. Two of his three sons, George Washington Custis Lee and William Henry Fitzhugh

"Rooney" Lee, rode with him, plus several aides, black servants, and a seriously wounded Confederate officer.

Following Lee's arrival back in Richmond, there was great interest among the photographers in the city to photograph him at such a pivotal moment in history. But while requests from both Roche and Gardner were refused, Brady had more success, having known and photographed Lee long before the war. When he first asked if Lee would sit for his camera, the defeated Confederate general is believed to have replied, "It is utterly impossible. How can I sit for a photograph with the eyes of the world upon me as they are today." But Brady was persistent, and asked an old acquaintance, Confederate Colonel Robert Ould, to appeal to the general. A district attorney in Washington before the war, Ould had become the chief Confederate officer in charge of prisoner exchange during the Civil War. Interviewed later in life, Brady stated that Ould and Mrs Lee persuaded the general to agree to be photographed, although as Brady put it, "It was supposed that after his defeat it would be preposterous to ask him to sit." But, Brady continued, "I thought that to be the time for the historical picture."

The next day, April 20, 1865, Brady came to the house and took a number of photographs. Four were of Lee alone and two of him with his aide, Colonel Walter Taylor, and his oldest son, Custis Lee, who had been captured at Sailor's Creek only three days before the surrender. As the light was most favorable there, Brady posed them beneath the overhang of the back porch of the basement at 707 East Franklin Street, with his assistant, probably Egbert Fowx, behind the lens. Only a few short accounts of this monumental event appeared in the contemporary press. On April 22, the Washington *Evening Star*, quoting from the now Union-controlled

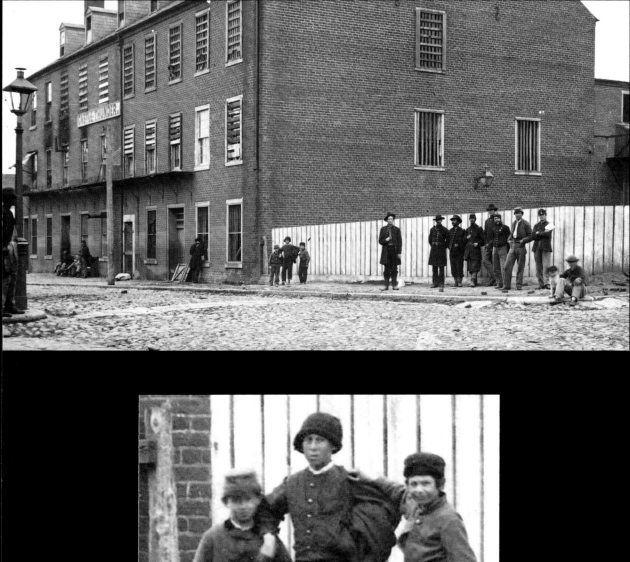

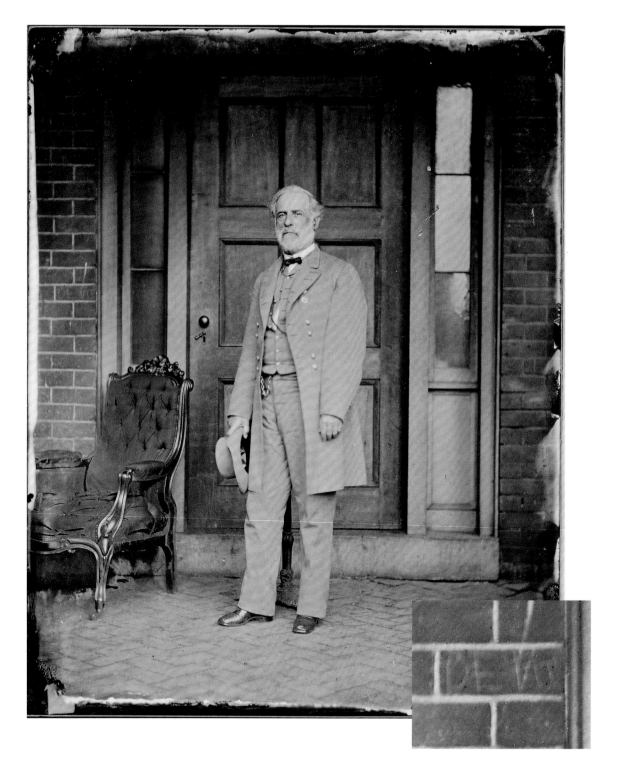

Six photographs of Robert E. Lee were taken by Matthew Brady and his assistants at his home in Richmond on April 20, 1865. A long-time acquaintance of Lee, Brady was anxious to photograph him, as historian Douglas Southall Freeman remarked, before "the fire of battle had faded from his eyes." For the occasion Lee wore a clean uniform and well-shined black shoes, but left aside his sword, waist sash and boots. The lack of braid on his coat sleeves was also a possible indication that he wished to appear less martial, thereby setting an example to his former troops to swallow their anger in defeat and return home to rebuild their lives. Only discovered in 2014 by a member of the Center for Civil War Photography, one of the bricks to the left of the door frame has the word "DEVIL" scrawled on it, which indicates that Lee was regarded as evil by some Unionists and Federal soldiers in 1865. (Library of Congress)

Richmond *Whig* of the previous day, reported, "General Lee and staff – or rather those who accompanied him to Richmond – were yesterday photographed in a group by Mr Brady, of New York. Six different sittings were then taken of General Lee, each in a different posture, and all were pronounced admirable pictures."[4]

In fact, things did not go completely smoothly on the occasion. Partway through the session, and while Lee was being photographed standing alone, someone noticed the derisive word "DEVIL" scrawled on one of the bricks to the left of the door behind him. An uncomfortable reminder that Lee was regarded as evil by many Unionists in 1865, the offensive graffiti was promptly scrubbed out and the rest of the photographs were taken. As further evidence that Brady did not want the image with the graffiti to be reproduced, it was later discovered that the photographic wet plate including it had the instruction "Do Not Use" scratched at the side.[5]

Meanwhile, having photographed the battle of Nashville and delivered the stereoscopic negatives commissioned by E. & H. T. Anthony, Jacob Coonley was back in New York City by April 1865 when news arrived of the proposed ceremonial raising of the Union flag once again over Fort Sumter. Lowered and surrendered on April 15, 1861, this flag had lain in the vaults of the Bank of Commerce for the last four years and was delivered in a neat metal box to the steamer *Arago*, bound for Charleston on April 11, 1865. As he was not included in the published list of passengers sailing south to Charleston for the ceremony aboard the steamers *Arago* or

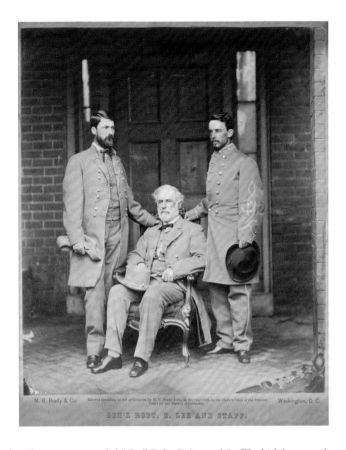

M. B. Brady & Co. Entered according to Act of Congress by M. B. Brady & Co., in the year 1865, in the Clerk's Office of the District Court for the District of Columbia. Washington, D.C.

GEN'L ROBT. E. LEE AND STAFF.

In this albumen print entitled "Gen'l Robt. E. Lee and Staff," which bears on the card mount the imprint "M. B. Brady & Co./Washington, D.C.," Lee was joined by his eldest son George Washington Custis Lee on the left and staff officer Lieutenant Colonel Walter H. Taylor on right. Not previously noted, the "DEVIL" graffiti had been removed before this image was taken. (Liljenquist Family Collection, Library of Congress)

Oceanus, Coonley must have arrived there via either the *Linda* or *Suwanada*, both of which were simply stated to have "a large number of passengers" bound for the same location.[6]

Set up on the shattered rampart of the fort, his stereoscopic camera captured the historic occasion unfolding on the parade ground below in stunning detail. Among the thousands in attendance were brevet Major

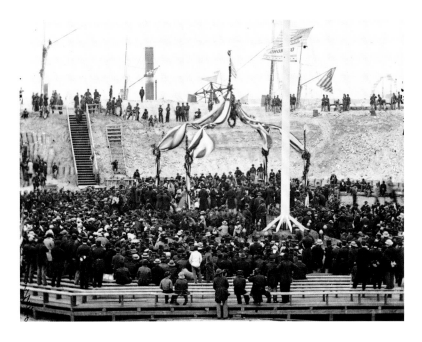

During a blustery day on April 14, 1865, Jacob Coonley photographed the raising of "the Old Flag" at Fort Sumter in Charleston Harbor. Some of the guns of the 3rd Rhode Island Artillery stand on the rampart in the rear. Smokestacks and flags of the steamers anchored by the fort are seen in the background. (Library of Congress)

General Robert Anderson, who surrendered the fort to the Confederates in 1861, plus abolitionists Rev Henry Ward Beecher and William Lloyd Garrison. The dignitaries gathered under an arched canopy covered in national banners made by "six Union ladies of Charleston," while the invited audience of several thousand was seated on the surrounding wooden benches. Coonley also captured views of the military in attendance.

He later recalled:

The surrender of Lee just before this event gave much importance to the ceremony, which was accompanied by speeches, music, and military display. The day was bright, there was a strong breeze blowing, and the harbor was gay with a great fleet of steamers and excursion boats, all decorated, with their

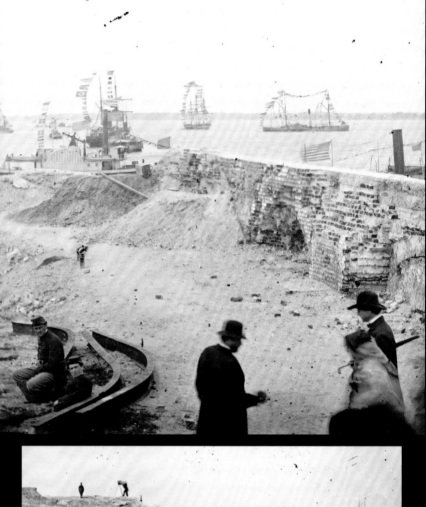

(Top) At some point during the ceremony at Fort Sumter on April 14, 1865, Coonley turned his attention to the sea. In this detail from a stereoscopic view, the side-wheel steamer *Diamond*, flagship of Major General Quincy A. Gillmore, the commander of Morris Island and Fort Sumter, is docked nearest the island, with other Navy and commercial vessels anchored close by. (Library of Congress)

(Bottom) Whether contrived or accidental, this view produced on April 14, 1865, of what remained of the sally port, or entrance, to Fort Sumter also captured another photographer at work on the parapet who may have been Jacob Coonley or Welsh-born William E. James, who was also hired by E. & H. T. Anthony to photograph the raising of "the Old Flag" at Fort Sumter. (Library of Congress)

flags standing straight out in the wind. The impressive sight and the great crowds of spectators will never be forgotten by those who were present. This was on the 14th of April. On that same night, in a Washington theatre, President Lincoln was laid low by the hand of an assassin. There being no telegraphic communication at that time between Washington and Charleston, it was two days before the news of Lincoln's death reached the city by steamer.

Coonley made 31 wet plate negatives of the Charleston celebration, following which he photographed the ruins in Charleston and then returned north for the final act in the drama that had taken four years to unfold.[7]

The camera captured nothing of Lincoln's assassination by John Wilkes Booth on April 12, 1865, the day Lee arrived in Richmond. Born in the border state of Maryland, John Wilkes Booth was a supporter of slavery and, following his attendance within the ranks of the Richmond Greys at the hanging of abolitionist John Brown at Charlestown, Virginia in 1859, became pro-Confederate and developed a hatred for Abraham Lincoln and his policies throughout the Civil War. This changed to fanaticism when he learned of the Dahlgren plot to kill Jefferson Davis in March 1864, and he determined to kidnap Lincoln and hold him to ransom in return for the release of Confederate prisoners of war.

Following Lee's surrender at Appomattox courthouse, the outraged Booth decided to assassinate the President. Assembling a loose-knit band of Southern sympathizers including David E. Herold, George A. Atzerodt,

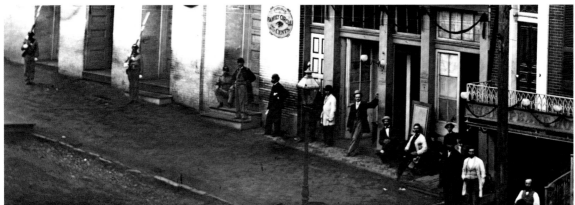

(Left) First opened by John T. Ford as a theater in 1861, "Ford's Athenaeum" was destroyed by fire in 1862, but was rebuilt and reopened in August 1863 as "Ford's Theater," by which time it had seating for 2,400 people and was called a "magnificent thespian temple" in the local press. Photographed during the days after Lincoln's assassination, the building is draped with black crepe. The detail below shows soldiers of the Veteran Volunteer Reserve Corps standing guard, as curious citizens gather on the sidewalk. A sign for a "Family Circus" on the wall probably illustrates entertainment of years gone by. The "Shakespeare House" next to the theater was possibly a "watering hole" for actors such as John Wilkes Booth. (Library of Congress)

Lewis Powell (also known as Lewis Payne or Paine), and John Surratt, a rebel secret agent, he learned that Lincoln and his wife would be attending the play *Our American Cousin* at Ford's Theater on Good Friday, April 14, 1865. Confiding to the other plotters that he would kill Lincoln, he assigned Powell to assassinate Secretary of State William H. Seward and Atzerodt to assassinate Vice President Andrew Johnson. Herold would assist in their escape into Virginia.

As a famous and popular actor who had frequently performed at Ford's Theater, Booth had free access to all parts of the venue. Slipping into Lincoln's box that evening at around 10 pm as the play progressed, he shot the President in the back of the head with a .41 caliber Derringer and then jumped down on to the stage. Catching one of his spurs on a flag decorating the box, he landed badly on the stage and broke his fibula. Still managing to rise to his feet, he brandished a large knife shouting "*sic semper tyrannis*" (Latin for "thus always to tyrants"), which was attributed to Brutus at Caesar's assassination and was also the Virginia state motto. The only one of the assassins to succeed, Booth escaped on a horse waiting for him outside the theater. Meanwhile, Powell managed to stab Seward, who was bedridden as a result of a recent carriage accident. But Seward survived despite being badly wounded. Atzerodt lost his nerve and made no attempt to kill Johnson, but spent the evening getting drunk.

Abraham Lincoln died at precisely 7.22 am on April 15, 1865. A black-edged report in the *Daily National Republican* of Washington that day stated, "By his side, at the time, was his eldest son, Captain Robert Lincoln, the physicians in attendance, Secretaries Welles, Stanton, Usher, Postmaster

Used as part of the evidence presented to the military commission to convict the conspirators, this view of the box in Ford's Theater in which President Abraham Lincoln was sitting when he was assassinated by John Wilkes Booth was produced by one of Matthew Brady's operators. Two of the flags draped from it on the night of April 14, 1865 belonged to the Treasury Guard Regiment, which was a Home Guard unit charged with defending Washington, DC. Booth is believed to have caught a spur on one of these flags as he leapt down on to the stage, causing him to fracture his leg. (Library of Congress)

General Dennison, Attorney General Speed, Assistant Secretary Field, of the Treasury Department, and ex-Surveyor Andrews. Mrs Lincoln was in an adjoining room, completely prostrated with grief. Mr. Lincoln was insensible from the moment he received the fatal shot until he died."

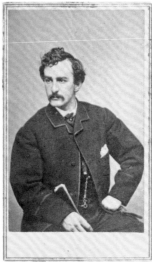

(Left and center) The poster produced by order of Colonel Lafayette C. Baker, head of the Union Intelligence Service, offering a total reward of $100,000 had cut-down *cartes de visite* of John Wilkes Booth and two of his accomplices pasted to it to aid with recognition and capture. The *carte* of Booth was photographed by Alexander Gardner, who was still in the employ of the Union Intelligence Service, sometime after the opening of his Washington gallery during 1863. (Library of Congress)

(Right) Found during a search of his mother's house at 636 Eighth Street, near the Washington Navy Yard, this *carte de visite* of David E. Herold was rephotographed by Alexander Gardner and multiple copies were produced for use on "wanted" posters used during the hunt for John Wilkes Booth and accomplices. (Library of Congress)

A total reward of $100,000 was offered for the capture of Booth and suspected accomplices Suratt and Herold by order of Secretary of War Edwin M. Stanton. Colonel Lafayette C. Baker, head of the Union Intelligence Service, ordered "wanted" posters produced to aid in the apprehension of the assassins, some of which had trimmed down *cartes de visite* adhered to them. The *carte* of Booth had been made by Alexander Gardner after the establishment of his Washington gallery in 1863. That of Herold was found when his mother's house at 636 Eighth

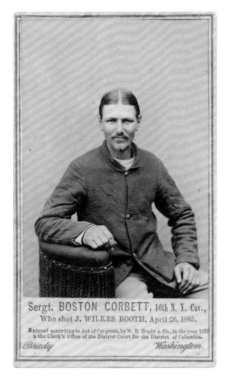

(Left) Celebrated as the man who "shot John Wilkes Booth," Sergeant Thomas P. "Boston" Corbett, Co. L, 16th New York Cavalry, was photographed by Matthew Brady on April 26, 1865. (Library of Congress)

(Right) Conspirator David E. Herold was photographed by Alexander Gardner within hours of being brought aboard the monitor USS *Saugus* in the Washington Navy Yard on April 27, 1865. (Library of Congress)

Street, near the Washington Navy Yard, was searched. Gardner rephotographed this and created multiple prints of it for the handbills. The source and photographer for the Surratt image used is unknown.

The outpouring of grief and mourning for Lincoln was publicly displayed in Northern cities, particularly at or near photographic studios. Wandering along Broadway in New York City on April 17, a reporter for the *Tribune* noted that Brady's gallery was "profound with woe. From the

roof to the awning are stretched long black ribands, relieved by rosettes at the top and bottom; and at the door photographs of the late President and the yet living Secretary." At his "Gallery of Art," Jeremiah Gurney had "placed upon the marble façade of his building a beautiful device. Upon either side of the central point appear the letters, white on a black surface, 'A. L.,' and from the corners of the building lines of black are drawn, meeting in a mixed rosette in the center." At his "Picture Gallery," Rufus P. Anson had placed a card reading, "Weep, gentle nation weep. The sad, the swift remove of him. Whom Heaven indulgent sent to Man: too good for Earth, to Heaven art thou fled, and left a Nation in tears." In general on either side of the street "*cartes de visite* of the murderer" were "exposed in windows gracefully shrouded in crape."

Booth and Herold escaped across Maryland, stopping at the home of Dr. Samuel Mudd for surgery on Booth's fractured leg. Seen in company with three of the conspirators in 1864, Mudd was a strong supporter of slavery, but his part in the assassination plot, if any, remains unclear. Crossing the Potomac River in a small canoe into Virginia, Booth and Herold reached the farm of Richard Garrett, south of the Rappahannock River, and sought refuge in his tobacco barn. Involved in the search operations and having traced the fugitives across Maryland and across the Potomac River into Virginia, First Lieutenant Edward P. Doherty, commanding a detachment of the 16th New York Cavalry, showed photographs of Booth, Herold and Surratt to residents near Garrett's farm. In his report he stated, "after exhibiting the photographs, we concluded that we were on their track."[8] On April 26, Booth and Herold were found in the tobacco barn, which was set on fire in order to smoke them out. Enduring the smoke and flames for about three quarters of an hour, Herold surrendered, but Booth refused and apparently began shooting at the soldiers, following which Sergeant Thomas P. "Boston" Corbett peered through the slats of the barn wall and, against orders that the assassin should be captured alive, shot him in the neck. Fatally wounded and paralyzed from the neck down, Booth died three hours later. His corpse and the prisoner Herold, plus Richard Garrett and his 12-year-old son Robert, were taken to Belle Plain Landing on the Potomac and transported to the Washington Navy Yard aboard the steamer *John S. Ides* for identification.

On arrival at the Navy Yard, Booth's body was transferred to the monitor USS *Montauk*, which had been assigned as a prison ship, where Surgeon

 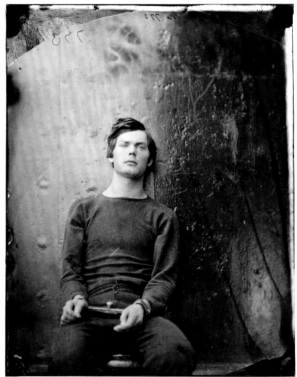

(left) Photographed by Alexander Gardner soon after arrest, Lewis Paine stands in front of a canvas sail-cloth screen with a Marine standing guard with loaded musket. (right) Manacled and wearing US Navy enlisted seaman's undershirt and drop-front trousers, Paine was later photographed seated against the gun turret of the monitor USS *Saugus*. (Library of Congress)

General Joseph K. Barnes conducted the autopsy on April 27, 1865. Present during the procedure were Alexander Gardner and Timothy O'Sullivan, who took one photograph of Booth's remains before they were removed from the *Montauk*. According to a report in the *Boston Traveller* two days later, the body was "then placed in an ordinary gray army blanket, in which it was sewed up. A plain, casket-shaped box, measuring 6 feet by 2 had been previously made in a joiner's shop … but it was not used." The negative plate

298

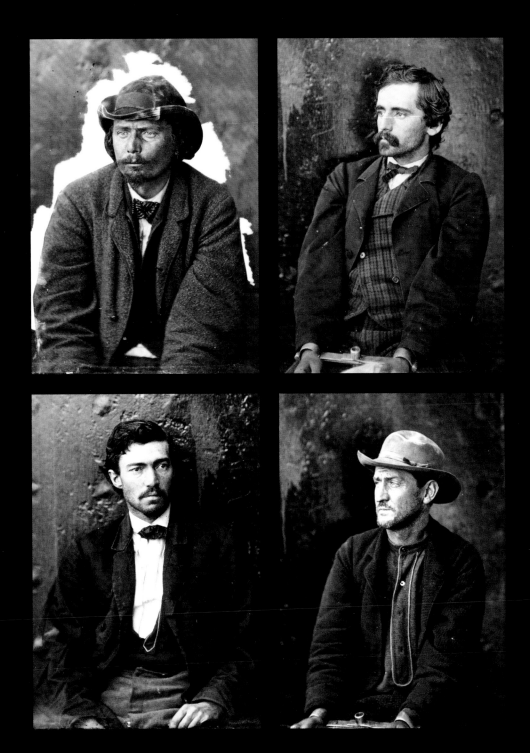

Each of the conspirators was brought up on the deck of the monitor *Montauk* and photographed by Alexander Gardner. They are (top left) George A. Atzerodt, (top right) Michael O'Laughlin, (bottom left) Samuel Arnold (strangely not manacled), and (bottom right) Edmund Spangler. Held at the Old Capitol Prison, Dr. Samuel Mudd and Mary Surratt, were not photographed by Gardner. (Library of Congress)

and print produced on this occasion was passed to Colonel Baker and never seen again, probably for fear its publication might have gifted martyrdom to the conspirators and glorification to the lost Confederate cause. However, Gardner was given full permission to make and sell multiple photographs of the other conspirators, who were brought up on deck one at a time and seated with the gun turret of the monitor as a backdrop.

According to the Washington *Evening Star* of April 28, 1865, when David Herold was brought up on deck he wore "dark gray pantaloons, light blue military vest, a faded blue jacket and black slouch hat. From the sullen frown on his countenance it would appear that he was rather averse to being photographed." The same newspaper commented that it was "some time before a satisfactory picture was got. On this occasion he appeared sullen, and he put on a pouty look as he took his seat in the chair and glanced with dissatisfaction in the direction of the wharf, where a number of spectators were watching every movement of the vessel, many of whom were his old acquaintances."

Lewis Paine was also imprisoned on the *Montauk*. Born in Alabama, he had served in the Confederate army throughout the Civil War, having lied about his age in 1861. Wounded at Gettysburg, he later rode with Mosby's Rangers before becoming involved with John Wilkes Booth. After failing to murder Secretary of State Seward, he lay low in Washington but blundered into military investigators searching the boarding house run by Mary Surratt and was identified and arrested.

Other conspirators incarcerated on the *Montauk* included George Atzerodt and accomplices Michael O'Laughlin and Samuel Arnold, plus Edmund Spangler, a stage hand who was believed to have aided Booth in his exit from Ford's Theater. The only conspirator to escape punishment was John Surratt Jr., son of Mary Surratt, who fled the country and served briefly in the Papal Zouaves in the Vatican City before his arrest and extradition from Egypt. By the time he returned to the US in 1867 the statute of limitations had expired on most of the potential charges and he was not convicted.

Not enjoying the privileged position Alexander Gardner had during most of the dramatic events in Washington from April to June 1865, Matthew Brady had to be content with photographing and selling *cartes de visite* of "Boston" Corbett, who mortally wounded John Wilkes Booth. Initially arrested for disobeying orders, Corbett was later released

(Left) Jeremiah Gurney had been Matthew Brady's main rival on Broadway, in New York City, for nearly 20 years. During the Civil War he had remained in his three-storey white marble studio, producing portraits of "Distinguished Persons of the Age" rather than undertaking the role of a battlefield photographer. As a "Copperhead," he had also been bitterly opposed to Lincoln's administration and this angered other photographers, including Matthew Brady, who had supported the war effort and thought he had no right to photograph the deceased president.
(National Portrait Gallery, Smithsonian Institution, gift of Larry J. West)

(Right) Discovered in 1952, this is the only print by Jeremiah Gurney to survive the destruction of all the glass negatives and prints of the deceased Lincoln by order of Secretary of War Edwin Stanton. (Abraham Lincoln Presidential Library and Museum)

and was largely considered a hero by the media and the public. After leaving the army, he became paranoid that Booth avengers sought to kill him, and always carried a revolver for personal protection. Heading west to Kansas, he was eventually committed to the Topeka Asylum for the Insane in 1887. He managed to escape after a few months and ended his days in east Minnesota, where he is believed to have died in a fire in 1894.

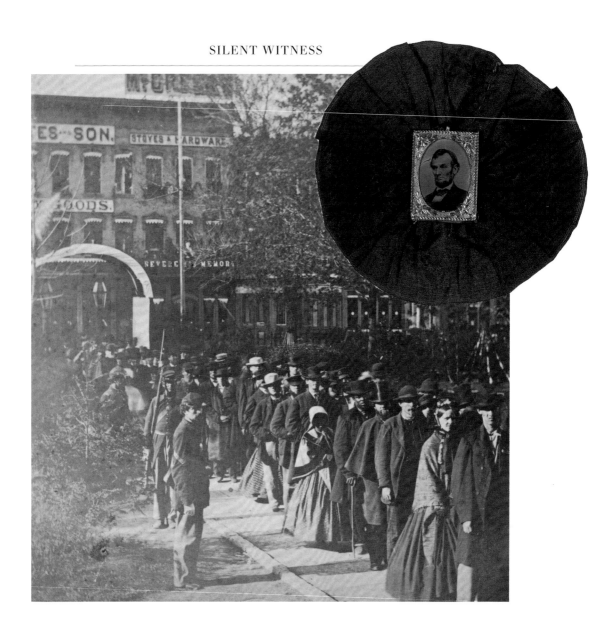

(Above) Citizens line up to enter the grounds of the Illinois State House at Springfield, Illinois through a specially built arch to view the body of Abraham Lincoln. The African American with the cane near the head of the line is Reverend Henry Brown. Employed by Lincoln before he left for Washington to become the President in 1861, Brown led Abraham Lincoln's horse "Old Bob" behind his coffin during the funeral procession from Springfield to Oak Ridge Cemetery on May 4, 1865. (Library of Congress)

(Top) Worn by James J. Christie, this mourning rosette has at its center a gem-size tintype of the late President taken by Anthony Berger on February 9, 1864.
(Library of Congress, Alfred Whital Stern Collection of Lincolniana)

As part of the evidence presented to the Military Commission to convict the eight arrested conspirators, which began on May 24, 1865, both Brady and Gardner were requested to photograph the interior of Ford's Theater from different points. Gardner also photographed Lincoln's funeral parade in Washington before the funeral train began its journey to Springfield, Illinois.

After its arrival in New York City on April 24, Jeremiah Gurney, who had been Brady's chief rival on Broadway for nearly 20 years, obtained permission to photograph Lincoln's body with the lid of the casket removed as it lay in state in City Hall. Gurney placed his tripod at a vantage point in the vestibule about 40 feet from the resting place and 20 feet above it. Once the casket had been opened, two officers stepped forward with arms folded to be part of the scene. Admiral Charles Davis stood near the head of the casket, while Major General Edward D. Townsend, who had been designated to supervise Lincoln's funeral, was near its foot. According to an account in *The World* of New York City published the next day, "Twenty-five minutes were allowed for the operation … The very subdued light at this place necessitated an unusually long period for taking the picture. The previous preparations having been completed, the company in the Governor's Room stood back to allow the light from the central front window to stream upon the coffin, and the view was taken satisfactorily." Using two cameras, one of which had four lenses, Gurney took a number of photographs of the mournful occasion.

When Secretary of War Edwin Stanton learned that Lincoln's remains had been photographed, he ordered the Provost Marshal, Brigadier General J. B. Fry, to seize the plates and convey them to the office of General John A. Dix, commanding the Department of the East, stating that the taking of a photograph of Lincoln's remains had been expressly forbidden by Mrs Lincoln. Stanton subsequently received appeals to save the Gurney negatives from leading abolitionist Henry Ward Beecher and Henry J. Raymond, owner of the *New-York Times*. They urged that General Dix might postpone destroying the negatives until Stanton had seen them. Stanton remained unmoved and had the glass negatives and prints destroyed – all but one print, which was discovered in the papers of Lincoln's secretary John Nicolay in 1952.

On May 10, 1865, President Andrew Johnson declared that the rebellion and armed resistance was virtually at an end, and made plans

(Top) Alexander Gardner produced four large photographs of the execution of the four Lincoln conspirators on July 7, 1865, which were described by the *National Daily Intelligencer*, of Washington, DC, three days later as "a perfect portraiture of the scenes and actors in the dread tragedy." (Library of Congress)

(Bottom) One of Alexander Gardner's assistants had another camera placed on the roof of the Arsenal, which looked down into the jail yard and captured the whole scene after the execution. The photographs produced by Gardner were taken from one of the open first floor windows of the building at left. (Library of Congress)

with government authorities for a formal review to honor the troops. It was also his intention to change the mood of the capital, which was still in mourning following Lincoln's assassination. On May 23 and 24, 1865, the "Grand Review of the Armies" took place and the troops paraded down Pennsylvania Avenue in a final march to commemorate the end of the Civil War. Three of the leading Federal armies were close enough to participate in the proceedings. Commanded by General George G. Meade, the Army of the Potomac, which had accepted the surrender of Lee at Appomattox, was joined by the Army of Tennessee, under General John A. Logan, which arrived via train. The Army of Georgia, now under General Henry A. Slocum, had just completed its Carolinas Campaign and accepted the surrender of the largest remaining Confederate army under Joseph E Johnston.

Of this occasion the *Daily National Republican* reported, "Brady and Gardner, the famous photographers, had each a tower erected commanding a view of the stand occupied by the President [Andrew Johnson] and Cabinet and Lieut. Gen. [Ulysses S.] Grant ... and several pictures were made by each."[9] Also present was Jacob Coonley who, with the assistance of David Woodbury, produced stereoscopic views for Anthony, and recalled later, "I shall never forget that great pageant, as for two days a formidable host of hardy veterans marched through the nation's capital under the eyes of their commanders."[10]

The trial of the seven conspirators, which lasted 49 days, was concluded on June 30, when Herold, Powell, Atzerodt and Mary Surratt were sentenced to be hanged. Dr. Mudd, O'Laughlin and Arnold were sentenced

to life imprisonment, while Spangler received a six-year sentence. Gardner was the only photographer admitted to the Old Arsenal Prison to photograph the hanging of the four Lincoln conspirators on July 7, 1865, being located in the upper window of "the old shoe shop building" in the center of the prison yard. At 12 noon all eyes "turned in that direction. Presently a window was raised, and forthwith was seen protruding the familiar snout of the camera, showing that the inevitable photographer was on hand. Gardner's good-humored face presently was seen over the camera, as he took 'a sight' at the gallows, to see that it was focussed properly."[11] At 1.26 pm a hand was waved and the deed on the scaffold was done. As he was present at the beginning, so the photographer was present at the end, producing the closing shots of the last main act of the Civil War.

AFTERWORD

The power of photography was present throughout the Civil War as both military and political events were captured for posterity on copper, glass, iron and paper. In particular, the widespread distribution of *carte de visite* portraits of leaders and popular figures, and gallery exhibitions of larger albumen prints, had a major impact on public opinion in both the North and the South.

Although the classic image of the bearded John Brown in 1859 was a one-off daguerreotype, countless copies of it were produced and distributed in albumen format during the following years, which did much to amalgamate abolitionist forces against slavery. The later portrait of runaway slave "Whipped Peter" served as further propaganda for the abolitionist cause.

The "rugged dignity" of the "Cooper Institute" albumen by Matthew Brady in 1860, and the thousands of reproductions of this image distributed thereafter, helped Abraham Lincoln become president in 1861. Indeed, when artist Francis B. Carpenter, who painted "First Reading of the Emancipation Proclamation of President Lincoln," saw this image, he remarked in his diary, "The effect of such influence though silent is powerful." The "speaking likeness" of Major Robert Anderson, the hero of Fort Sumter, produced under extraordinary circumstances in Charleston Harbor, and mass produced in New York City, also did much to rally mass support for the Union cause.

The stark imagery of the "Dead of Antietam" displayed in Brady's gallery on Broadway in New York City in 1862 brought home to much of the Northern population the horror of war. This was compounded during the following two years by similar photographs of the carnage at Gettysburg and outside Petersburg.

The thousands of accurate maps duplicated by photographic means, whether via the development of prints from glass wet plates or "Margedant's

Quick Method," enabled field commanders in both Union and Confederate armies to conduct campaigns and battles with greater success. On at least two occasions captured photographic copies of maps had played a very significant role in the course of the conflict.

One of the most significant effects of photography was its impact on the tragic conclusion to the Civil War. The distribution of photographic copies of the "Dahlgren" letter revealing the Northern plot to kidnap or assassinate Jefferson Davis and his cabinet likely led to the fateful act of revenge against Lincoln in Ford's Theater in 1865. And during the final scenes in this great drama, photography continued to play an important part as a *carte de visite* portrait helped hunt down and kill assassin John Wilkes Booth.

What of the multitude of photographers who produced countless thousands of intimate portraits of soldiers and loved ones in hometown studios or campsite tented galleries? Little is known about so many of them, yet they surely brought families close together when far apart, and lifted the spirit of both Northern and Southern soldiers and sailors in times of great adversity. Many of these "artists" and "photographists" found their livelihood cut short toward the end of the war. On February 2, 1865, Horatio F. Winslow, who operated a gallery at 227 Sixth Avenue in New York City, placed an advertisement in the *Herald* stating, "For Sale – The Business of a Photographer at a military post near the city; a car, with instruments complete for the business; a good chance for a young man. Apply at Winslow's Gallery …" [1] Five days later, N. A. & R. A. Moore, of Hartford, Connecticut, advertised that their "First Class Gallery" was closing on March 15, on which date they advised "we shall destroy all our Negatives, (more than 700) and close up our business." [2]

The greatest financial failure was that of Matthew Brady. During the war, he spent over $100,000 in order to create or acquire from others over 10,000 photographic plates. His hopes that the US government would buy these photographs at the end of the war were dashed when it refused to do so. As a result, he was forced to sell his studio and became bankrupt. Although Congress eventually granted him $25,000 in 1875 for what was left of his inventory, he remained deeply in debt and died penniless in a charity ward in 1896.

Other prominent photographers made a successful living from their art. E. & H. T. Anthony had published the first of a large series of Civil

War stereoscopic views by Brady and his staff in 1862. By 1864 these were for sale under the title "War Views," and from 1865 continued to be published as the "War for the Union" series. Another series of stereoscopic views entitled "Photographic Incidents of the War" published by Philip and Solomons, of Washington, DC, and including the photography of Gardner, O'Sullivan and Gibson, was for sale from 1863 onwards. In Concord, New Hampshire, even the more obscure Henry P. Moore was selling "Stereoscopic Views, new style" by 1870, and advertised for more agents to sell them, stating "Can make big pay." [3]

Also published by Philip and Solomons, the seminal two-volume work *Gardner's Photographic Sketch Book of the War* first became available at the end of January 1866 and contained 100 original albumen prints of scenes from Bull Run to Appomattox, with descriptions of each view by the photographer. The publication of these very expensive volumes was probably the catalyst for *Photographic Views of the Sherman Campaign* during the same year. Endorsed by Generals Orlando Poe and William Tecumseh Sherman, this book displayed 61 albumens of the Western Theater of the war by Barnard.

Despite such varying fortunes, these many colorful individuals with their collodion and cumbersome cameras created a magnificent photographic legacy which today helps us understand and appreciate more fully the great events of 1859 through 1865. Whether a little-known ambrotypist in an obscure attic gallery, or a traveling battlefield photographer in a rickety wagon, they were silent witnesses to a period in American history which saw the end of slavery and helped make the United States the great nation it is today.

GLOSSARY OF
TECHNICAL TERMS

Albumen: Egg white mixed with sodium chloride, or salt, used to produce a photographic print from a wet plate negative.

Ambrotype: A photograph on glass made by a variant of the wet plate collodion process invented by Frederick Scott Archer in the early 1850s, and patented in 1854 by James Ambrose Cutting.

Collodion: A volatile combination of gun cotton, alcohol, ether and potassium iodide. The resultant syrupy mixture was used in the process of producing glass negatives from which positive albumen prints could be made. Also used to produce ambrotype images on glass plates and melainotype images on iron plates.

Daguerrotype: A photographic process invented by Louis Daguerre in 1839 with mirror-like surface produced on an iodine-sensitized, silver-covered, copper plate developed by exposure to mercury vapor.

Hallotype: Invented by John Bishop Hall and Jeremiah Gurney in 1857, this process involved overlaying with exactness two or more identical, translucent photographs between glass plates, with a backing of white reflective material.

Imperial Photograph: A large-size albumen photograph measuring 17x20 inches invented by Matthew Brady in 1857.

Ivorytype: A photographic process invented in 1857 by Frederick A. Weinderoth to create the effect of a hand-painted ivory miniature. Two paper prints were made of the same image with the weaker print painted and made transparent with varnish being laid over a stronger one. Both were sealed with beeswax between glass plates.

Melainotype:	Invented in 1853 by Dr. Adolphe-Alexandre Martin, and also known as a ferrotype or tintype, this was made by creating a direct positive image on a thin sheet of iron coated with black "japanned" varnish.
Photograph sizes:	*Whole Plate:* 6½x8½ inches (16.5x21.5 cm)
	Half Plate: 4¼x5½ inches (11x14 cm)
	Quarter Plate: 3¼x4¼ inches (8x11 cm)
	Sixth Plate: 2¾x3¼ inches (7x8 cm)
	Ninth Plate: 2x2½ inches (5x6 cm)
	Sixteenth Plate: 1.375x1.625 inches (3.5x4 cm).
Potassium Iodide:	A light-sensitive chemical emulsion used to sensitize glass photographic plates.
Sodium thiosulfate:	Used as a photographic fixer often referred to as "hypo" from the original chemical name hyposulphite of soda.
Stereograph:	Also known as a stereoscopic view, the principle was discovered by Sir Charles Wheatstone in 1838 and, as later developed, involved placing side by side on a card mount two almost identical photographs. When viewed with a stereoscope, invented by Sir David Brewster in 1849, the two photographs become one and appear three-dimensional.
Wet plate:	A collodion glass negative from which positive albumen prints could be made.

NOTES & BIBLIOGRAPHY

References in the format 2:7 refer to page and column numbers: in this example, page 2, column 7.

INTRODUCTION

1. Andrew J. Russell, "Photographic Reminiscences of the Late War," *Anthony's Photographic Bulletin*, Vol. XIII (July 1882), pp.212–13.
2. See "Fire," *Boston Daily Advertiser* (Boston, MA), March 1, 1864, 1:7; and "Great Fire in Springfield. Music Hall and Five Other Buildings Destroyed. Total Loss $122,000, Insurance," *Springfield Republican* (Springfield, MA), July 30, 1864, 3:2. References ending in 3:2 and similar refer to page and column numbers. The first number is the page number and the second the column number, so in this case it would be page 3, column 2.
3. Robert N. Scott, *The War of the Rebellion: A Compilation of the Official Records of the Union and Confederate Armies*, Series 4, Vol. 2 (Government Printing Office, Washington DC,1900), p.517. Hereafter *ORs*.
4. "Great Rush," *Newark Daily Advertiser* (Newark, NJ), June 20, 1863, 3:3.
5. See "Brady's Gallery," *New York Herald* (NY), January 2, 1860, 5:5; "Manchester & Bros.," *General Advertiser* (Providence, RI), May 18, 1861, 1:6; and "Wood's Premium Photographs!" *Macon Telegraph* (Macon, GA), April 8, 1861, 3:5.
6. See "Cutting's Ambrotypes," *Vermont Journal* (Windsor, VT), September 28, 1855, 3:4; and "Pages from a Veteran's Note-Book. Some Account of the Career of Mr. J. F. Coonley," *Wilson's Photographic Magazine*, March 1907, p.105.
7. "Cartes de Visite," *The Press* (Philadelphia, PA), March 22, 1862, 1:3.
8. "The Heroes of Peace and The Heroes of War," *The Potter Journal* (Coudersport, PA), October 23, 1861, 4:3.

CHAPTER 1

1. "Church Anti-Slavery Society," *Boston Evening Transcript* (Boston, MA), May 25, 1859, 4:1.
2. "Charleston Intelligence … Nov. 21," *Baltimore American and Commercial Advertiser* (Baltimore, MD), November 23, 1859, 1:4.
3. Asia Booth Clarke, *The Unlocked Book: A Memoir of John Wilkes Booth by his Sister* (Putnam & Sons, NY,1938), pp.111–112.
4. For the work of Osborn & Durbec see "Select Views," *Charleston Daily Courier* (Charleston, SC), August 2, 1860, 1:2; "Stereoscopic Views of Charleston," *Charleston Mercury* (Charleston, SC), August 6, 1860, 2:3; "Southern Enterprise," *Charleston Daily Courier*, August 27, 1860, 2:8; "Photography in Charleston," *Charleston Mercury*, November 1, 1860, 2:1; and "Caution. To the Public Generally," *Charleston Daily Courier*, October 17, 1860, 2:8. See also Andy Douglas House, "Charleston's Civil War Photographers: Osborn & Durbec," *Battlefield Photographer: The Newsletter for the Center for Civil War Photography*, Volume 13, Issue 1 (April 2015), pp.7–8.
5. Thomas Butler Gunn Diaries, Vol. 15, pp. 8, 28, 33, 62, 64, 78, 87 & 107; Lehigh University, Bethlehem, Pennsylvania (unpublished).
6. "Cook's Portrait Gallery," *Charleston Daily Courier* (Charleston, SC), September 2, 1856, 2:7.
7. *Census of the City of Charleston, South Carolina, For the Year 1861* (Evans & Cogswell, Charleston SC, 1861), p.110.
8. Gunn Diaries, Vol. 15, p.159.
9. See "Major Anderson Taken – Another Triumph of Gun-Cotton," *American Journal of Photography*, March 1, 1861, pp. 298–300. For newspaper reports see "Major Anderson Taken," *Charleston Mercury* (Charleston, SC), February 11, 1861, 2:1; "An Invitation," *Charleston Daily Courier* (Charleston, SC), February 14, 1861, 1:6; and "Important from Charleston," *The World* (NY), February 25, 1861, 1:1.

10. See "Photographic Views of the Seat of the War," *New Orleans Daily Crescent* (New Orleans, LA), May 18, 1861, 2:4; and "From the Seat of the War," ibid., May 27, 1861, 2:5.

11. "Photographic Views of our Army near Fort Pickens," *New Orleans Bee* (New Orleans, LA), May 16, 1861, 1:5.

12. Leslie D. Jensen, "Photographer of the Confederacy: J. D. Edwards," in William C. Davis (ed.), *Shadows of the Storm – Volume One of The Image of War 1861–1865* (Doubleday & Company, Inc., Garden City, NY, 1981), p.346.

13. *Macon Telegraph* (Macon, GA), February 22, 1861, 1:5.

14. *Montgomery Daily Mail* (Montgomery, AL), November 1, 1860, 2:6.

15. "The New Administration," *New York Tribune* (NY), March 5, 1861, 8:3.

16. "Art Matters," *Evening Star* (Washington, DC), March 14, 1861, 3:3.

17. "The Inauguration of Abraham Lincoln, President of the United States," *Evening Star* (Washington, DC), March 4, 1861, 3:3.

18. "Letter from Maria M. Sheetz to Mrs Swisshelm, Washington, DC, March 4, 1861," *St. Cloud Democrat* (St. Cloud, MN), March 21, 1861, 2:6.

19. "Cook Account Book," 1860–1862, Valentine Richmond History Center.

20. *Charleston Daily Courier* (Charleston, SC), April 25, 1861, 2:6 and 7.

21. "Destructive Fire," *Charleston Mercury* (Charleston, SC), December 5, 1861, 2:1.

22. *Charleston Mercury* (Charleston, SC), August 9, 1861, 2:2.

23. See "The Ruins of the Burnt," *Charleston Mercury* (Charleston, SC), March 24, 1862, 2:1. For a full account of the photography of James M. Osborn see Andy Douglas House, "Charleston's Civil War Photographers: Osborn & Durbec," *Battlefield Photographer*, Vol. 13, Issue 1 (April 2015), pp. 3–11, 14–17.

24. "The Chamber of Commerce," New-York Times, April 20, 1861, 8:1.

25. "Union Demonstration of the Merchants," New York Herald, April 18, 1861, 8:1.

26. Georgeanna Woolsey Bacon and Eliza Woolsey Howland, *Letters of a Family during the War for the Union, 1861–1865*, Vol. 1 (printed for private distribution, 1899), pp.44–45.

27. "Marshaling for Battle," *The World* (NY), April 22, 1861.

CHAPTER 2

1. Carter L. Hudgins and Elizabeth Collins Bromley, *Shaping Communities: Perspectives in Vernacular Architecture, VI* (The University of Tennessee Press, Knoxville, TN, 1997), p.225.

2. "Change Makes Change," *The Press* (Philadelphia, PA), March 1, 1862, 3:4.

3. See "Momentous 'News' Items from the Northern Papers," *Daily Picayune* (New Orleans, LA), May 24, 1861, 2:1; and "City Intelligence – Our Volunteers at Tangipahoa," *New Orleans Bee* (New Orleans, LA), May 21, 1861, 1:4.

4. *Daily Picayune*, quoted in Margaret D. Smith and Mary L. Tucker, *Photography in New Orleans: The Early Years, 1840–1865* (Baton Rouge: Louisiana State University Press, 1982), pp.102–3.

5. See "Ambrotypes!! Photographs!!! Carte de Visite," *Nashville Daily Union* (Nashville, TN), July 13, 1862, 4:5; "The Gallery of Fine Arts," ibid., August 26, 1863, 4:1; and ibid., May 28, 1863, 3:1.

6. See "A Generous Proposal," *Clarksville Chronicle* (Clarksville, TN), August 30, 1861, 3:1; and "At It Again!" *Clarksville Chronicle*, October 25, 1861, 3:4.

7. National Archives and Records Administration (NARA), Record Group 109, Compiled Military Service Records (CMSRs), Microcopy 323, Texas, Rudolph Cordes, Fold3. com, image 22753036.

8. "Photographs for Friends," *Macon Telegraph* (Macon, GA), April 6, 1861, 2:3 and "Wood's Gallery," ibid., 2:7.

9. See "Letters from the Volunteers," *Augusta Chronicle* (Augusta, GA), April 7, 1861, 3:2; and "The Oglethorpes Photographed," *Macon Telegraph* (Macon, GA), April 8, 1861, 1:3.

10. See "Prepare for the Worst!!" *Macon Telegraph* (Macon, GA), April 6, 1861, 2:7; and "Attention! 5th Regiment Georgia Volunteers," ibid., May 13, 1861, 1:7.

11. See "Flag Presentation to the Clinch Rifles," *Daily Chronicle & Sentinel* (Augusta, GA), March 10, 1861, 3:1; "Photograph of the Clinch Rifles," ibid., March 14, 1861, 3:1; and "Closing Out Sale," ibid., September 9, 1862, 3:3. See also NARA, CMSRs, M266, Georgia, Roll 0127, J. W. Perkins.

12. NARA M797, "Case Files of Investigations by Levi C. Turner and Lafayette C. Baker," Roll 0048, Case File No. 1623, A. J. Riddle.

13. See Robert S. Davis, *Ghosts and Shadows of Andersonville: Essays on the Secret Social Histories of America's Deadliest Prison* (Mercer University Press, Macon, GA, 2006), p.135; and Robert H. Kellogg Papers, 1862–1865. Diary: 1864, MS 68013 Box 1 Folder 1, Connecticut Historical Society, Hartford CT.

14. See *Charleston Daily Courier* (Charleston, SC), April 8, 1861, 1:3; and Edmund Ruffin, *The Diary of Edmund Ruffin: Toward Independence: October 1856-April 1861*, Vol. I (Louisiana State University Studies, Baton Rouge, LA, 1972), p. 607.

15. See "English Photographic Goods," *Charleston Mercury* (Charleston, SC), November 25, 1862, 1:6; and NARA, CMSRs, M267, Roll 147, South Carolina, C. J. Quinby.

16. See Peter E. Palmquist and Thomas R. Kailbourn, *Pioneer Photographer from the Mississippi to the Continental Divide: A Biographical Dictionary, 1839–1865* (Stanford University Press, Stanford, CA, 2005), pp.453–54; Arthur W. Bergeron, Jr., *Guide to Louisiana Confederate Military Units 1861–1865* (Louisiana State University Press, Baton Rouge and London, 1989), p.159; and "McClelland Guard," *Daily True Delta* (New Orleans, LA), June 25, 1861, 3:1.

17. Francis Trevelyan Miller (ed.), *Photographic History of the Civil War*, Vol. 1 (The Review of Reviews Co., NY, 1911), p.44.

18. Mark Martin, "An Eye of Silver: Andrew D. Lytle, Baton Rouge Photographer, 1858–1917," *Louisiana History: The Journal of the Louisiana Historical Association*, 47, no. 3 (2006), pp.333–66.

19. See "Camera-Spy of the Confederacy," *State Times Advocate* (Baton Rouge, LA), October 15, 1950, pp.57–58; and ibid., April 20, 1957, 9:7.

20. NARA, M345, Union Provost Marshals' File of Paper Relating to Individual Civilians, Roll 0235, Nathanial Routzhan.

21. See "Photography in Richmond," *Daily Dispatch* (Richmond, VA), August 23, 1860, 2:3; and "The Fine Arts," ibid., January 14, 1860, 4:3.

22. "The Picture of General Jackson," *Southern Illustrated News* (Richmond, VA), July 11, 1863, 12:1.

23. D. A. Serrano, "Southern Exposure: The Life and Times of C.R. Rees," *North South Trader's Civil War*, Vol. 36, No. 2 (2012), p.32.

24. See "Steam Ambrotypes," *Daily Dispatch* (Richmond, VA), July 30, 1858, 2:2; and ibid., February 14, 1859, 2:3; and February 16, 1859, 2:3.

25. NARA, CMSRs, M324, Roll 384, Second State Reserves, C. R. Rees.

26. Information about Robert M. Smith courtesy of Dr. David Bush, Director of the Center for Historic and Military Archaeology, Ohio.

27. See "Excelsior Sky-Light Gallery," *The Compiler* (Gettysburg, PA), August 29, 1859, 3:6; "Tyson Brothers," ibid., January 7, 1861, 2:6; and "Carte de Visite," ibid., March 10, 1862, 3:3.

28. "Local Photographer Left Town: Civil War Reminiscences," *Gettysburg Times* (Gettysburg, PA), October 22, 1983, p.6. Reprinted from the *Philadelphia Weekly Times*, March 29, 1884.

29. "Battle-field Views," *The Compiler* (Gettysburg, PA), December 14, 1863, 3:5.

CHAPTER 3

1. "From Burnside's Army Corps. From Our Own Correspondent – Camp near Fredericksburg, Va, August 23, 1863," *New York Tribune* (NY), August 23, 1862, 2:1.

2. "From the Army of the Cumberland," *Boston Traveler* (Boston, MA), March 26, 1864, 4:3.

3. Peter C. Sears, Co. D, 33rd Massachusetts Infantry, to Amelia B. Sears, October 4, 1863; Levi McLaughlin, Co. L, 3rd Pennsylvania Heavy Artillery, to Sarah Herr, April 27, 1864; and Charles Parker, Co. I, 31st Maine Infantry, to Clara Dyer, March 4, 1865, *Spared & Shared 7* website.

4. See John G. B. Adams, *Reminiscences of the Nineteenth Massachusetts Regiment* (Wright & Potter Printing Company, Boston, MA, 1899), p.6; and Isaac Gause, *Four Years with Five Armies* (Neale Publishing Company, New York & Washington, 1908), p.35.

5. Quattlebaum letters courtesy of Terry Burnett. See also "Joe Quattlebaum's War," *Military Images* (Spring 2017), p.48.

6. James King Wilkerson to mother, June 13, 1862, James King Wilkerson Papers, David M. Rubenstein Rare Book and Manuscript Library, Duke University, NC.

7. T. J. Gaughan, *Letters of a Confederate Surgeon, 1861–1865* (Hurley, Co., Camden, AR, 1960), pp.220–21. Le Rosen charged only $1 per photograph in 1861.

8. William Chickering, Co. G, 11th Massachusetts Infantry, to his mother Mrs Priscilla Pickering, April 4, 1862, *Spared & Shared 10* website.

9. Drury James Burchett, Co. K, 14th (Union) Kentucky Infantry, to "Annie," June 14, 1864, *Spared & Shared 9* website.

10. Asa Holmes, Co. A, 114th New York Infantry, to his family, July 21, 1863, *Spared & Shared 10* website.

11. John D. Billings, *Hardtack and Coffee* (George M. Smith & Co., Boston, MA, 1887), p.333.

12. "The Manassas Victory!" *Carolina Observer* (Fayetteville, NC), July 29, 1861, 2:2.

13. *Livingstone Union* (Mount Morris, NY), July 31, 1861, 2:5.

14. Mark H. Dunkleman, *Gettysburg's Unknown Soldier: The Life, Death, and Celebrity of Amos Humiston* (Praeger Publishers, Westport, CT, 1999), p.104.

15. Jacob Coonley, "Photographic Reminiscences of the Late War," *Anthony's Photographic Bulletin* (September 1882), p.311.

16. "Diary of Henry F. Pitcher, a member of the 33rd New York Regimental Band," pp.15–16, 17–18, 32, 44. GLC06889.01, The Gilder Lehrman Institute of American History. Coonley and his assistants took at least another 13 photographs of the

33rd New York during August 1861.

17. See "Life at Fortress Monroe," *New-York Times*, June 15, 1861, 2:4; and "Fortress Monroe," *New York Tribune*, June 12, 1861, 4:5.

18. See "Photographs from the Seat of the War," *Vermont Phoenix* (Brattleboro, VT), December 12, 1861, 2:5; "Richmond is not yet Taken," ibid., September 4, 1862, 3:6; and "A Generous Donation," *Watchman* (Montpelier, VT), October 21, 1864, 3:1.

19. "From Burnside's Army Corps," *New York Tribune*, August 23, 1862, 2:1.

20. "History of Convalescent Camp, Va.," *The Soldier's Journal* (Rendezvous of Distribution – late Convalescent Camp, VA), February 24, 1864, 1:3.

21. "Letters from Port Royal. Hilton Head S.C., February 23, 1862," *Independent Democrat* (Concord, NH), March 13, 1862, 2:7. In 1860, Henry P. Moore had produced views of the Vermont & Canada Railroad and crossed the Atlantic to have them produced as engravings by "a process only used in Scotland." See *Portsmouth Journal of Literature and Politics* (Portsmouth, NH), November 24, 1860, 2:4. Captain James F. Randlett commanded Co. F, 3rd New Hampshire Infantry.

22. See "Letter from Port Royal," *Independent Democrat* (Concord, NH), March 27, 1862, 1:3: and D. Eldredge, *The Third New Hampshire and All About It* (Press of E. B. Stillings and Company, Boston, MA, 1893), pp.112–13.

23. "A New Hampshire Artist," *Manchester Daily Mirror* (Manchester, NH), March 19, 1862, 2:2.

24. Janet B. Hewett (ed.), *Supplement to the Official Records of the Union and Confederate Armies* (Broadfoot Publishing Company, Wilmington, NC, 1996), p.3 and 7.

25. *Official Records*, Series 1, Vol. 46, Part 1, p.664.

26. "Regimental Band," *Bennington Banner* (Bennington, VT), June 13, 1861, 2:7.

27. See "The Killed and Wounded at Bethel," *Albany Evening Journal* (NY), June 12, 1861, 2:3; "History of the Battle of Bethel," ibid., June 17, 1861, 2:6; "Incidents of the War. Number VII. Fortress Monroe, Va.," *Commercial Advertiser* (NY), June 18, 1861, 2:3; and "New York Items," *Boston Evening Transcript* (MA), June 18, 1861, 1:7.

28. See "Camp of Instruction for Seventeen Thousand Men," *Daily Missouri Democrat* (St. Louis, MO), August 24, 1861, 2:5. See also John Ertzgaard, "The Elusive Photographer: Benton Barracks," *Military Images* (May-June 1989), Vol. 10, No. 6, pp.24–25; and Mike Medhurst and Brian Boeve, "The Backdrops of Benton Barracks: A Survey of Six Painted Canvases Used by St. Louis Photographers to Bring Soldiers into their Studios," ibid., (Winter 2016), Vol. 34, No. 6, pp.50–52.

29. Byron R. Abernathy (ed.), *Private Elisha Stockwell, Jr. Sees the Civil War* (University of Oklahoma Press, Norman, OK, 1958), p.10 and 34.

30. See *The Rolla Express* (Rolla, MO), August 31, 1861, 2:4; "Col. Wyman's Regiment … Camp Rolla, Head Quarters 13th Illinois Regiment, July 24, 1861," *Chicago Daily Tribune* (Chicago, IL), July 24, 1861, 1:3; and *Rolla Express*, October 11, 1862, 1:2.

31. "Save the Dimes," *Cincinnati Daily Commercial* (Cincinnati, OH), October 19, 1861, 2:5.

32. See "Special Order No. 1," *Nashville Daily Union* (Nashville, TN), July 17, 1863, 3:3; ibid., November 3, 1863, 3:1; and NARA M345, Union Citizens' File, A. S. Morse.

33. Francis Trevelyn Miller, *The Photographic History of the Civil War*, Vol. 1, *The Opening Battles*, (The Review of Reviews Co., NY, 1911), p.40 and 42.

34. "The Federal Tax," *Nashville Daily Union* (Nashville, TN), November 26, 1862, 1:6.

35. NARA M345, Union Citizens' File, E. W. Blake.

36. George H. Thurston, *Directory of Pittsburgh and Vicinity for 1857–'58* (George H. Thurston, Pittsburgh, PA, 1857), p.239. Thomas P. Adams was listed at 84 Fourth. See also "Union Provost Marshals' File of Papers relating to Individual Civilians," Papers Relating to Citizens, compiled 1861–1867; NARA M345, Record Group 109, Roll 0002, Thomas P. Adams.

37. NARA M345, Union Citizens' File, James Coleman.

38. *The Free South* (Beaufort, SC), June 13, 1863, 2:2 and 4:4.

39. See *The New South* (Port Royal, SC), November 14, 1863, 4:3; and "Our Morris Island Letter," ibid., January 23, 1864, 2:2.

40. "Photographs," *The Free South* (Beaufort, SC), March 26, 1864, 4:4; and "Edw. Sincliar [sic] & Co.," ibid., May 21, 1864, 4:4.

41. *The Hospital Transcript* (Hilton Head, SC), July 1, 1865.

42. *The Free South* (Beaufort, SC), October 24, 1863, 2:4.

43. "Old Rosie is our Man," *Nashville Daily Union* (Nashville, TN), October 22, 1863, 3:2.

44. Mark Dunkelman and Michael Winey, "Precious Shadows," *Military Images*, Vol. 16, No. 1 (July–August, 1994), p.7.

45. "Private Journal of Dr James Theodore Reeve, 1863–1864" (Wisconsin Historical Society, Madison, WI), p. 12–13.

46. See *Evening Telegraph* (Harrisburg, PA), March 26, 1864, 3:1; and "Crimes and Casualties," *The Troy Weekly Times* (Troy, NY), April 2, 1864, 1:4.

47. John Henry Otto, David Gould and James B. Kennedy, *Memoirs of a Dutch Mudsill* (Kent State University Press, Kent, OH, 2004), p.220. For the full story of the death of William B. Roper see Richard Young, "Lookout Mountain and the Fatal Fall of Soldier/Photographer William B. Roper," *Battlefield Photographer: The Journal of the Center for Civil War Photography*, Volume 14, Issue 2 (August 2016), pp.16–25.

CHAPTER 4

1. Vicki Goldberg (ed.), *Photography in Print: Writings from 1816 to the Present* (University of New Mexico Press, NM, 1988), p.205.

2. "George N. Barnard," *Anthony's Photographic Bulletin*, April 1902, p.127.

3. W. A. Croffut, *An American Procession, 1855–1914* (Little, Brown, and Company, Boston, MA, 1931), p.50.

4. "Photographs of War Scenes," *Humphrey's Journal of the Daguerreotype and Photographic Arts*, Vol. 13, No. 8 (August 15, 1861), p.133.

5. See Steve Woolf, "Brady Discovered in Rare First Bull Run-related Photograph," *Battlefield Photographer*, Vol. 13, Issue 3(December 2015), pp.16–18.

6. "Photographs," *The World* (NY), May 17, 1864, 2:2.

7. E. T. Whitney, "Reminiscences," *Photographic Times and American Photographer*, 14:159 (new series no. 39) (March 1884), pp.122–24.

8. "Photographs," *The World* (NY), May 17, 1864, 2:2.

9. "Evacuation of Centreville and Manassas," *Philadelphia Inquirer* (Philadelphia, PA), March 13, 1862, 1:2.

10. "Editor's Easy Chair," *Harper's New Monthly Magazine*, November 25, 1862, p.853.

11. "Brady's Photographs. Pictures of the Dead at Antietam," *New-York Times*, October 20, 1862, 5:3.

12. Josephine Cobb, "Photographers of the Civil War," *Military Affairs*, Vol. 26, No. 3 Civil War Issue (Autumn, 1962), p.132; and "St. Andrew's Society of Washington," *Daily National Republican* (Washington, DC), November 28, 1864, 2:6.

13. "Alex. Gardner – Photographic Artist," *Daily National Intelligencer* (Washington, DC), May 26, 1863, 3:5.

14. "Gardner's Photographs," *Daily National Intelligencer* (Washington, DC), May 2, 1864, 3:4.

15. "The Fine Arts," *Evening Star* (Washington, DC), August 1, 1863, 2:1.

1 . "Sharpshooters," *Independent Democrat* (Concord, NH), September 26, 1861, 2:5.

17. See "Cutting's Ambrotypes," *Vermont Journal* (Windsor, VT), September 28, 1855, 3:4; "Hallotypes," *Independent Democrat* (Concord, MA), August 8, 1861, 2:5; and "Concert," *New Hampshire Patriot* (Concord, NH), February 8, 1860, 3:3.

18. "Sharpshooters," *Independent Democrat* (Concord, NH), December 19, 1861, 2:5 and Capt C. A. Stevens, *Berdan's United States Sharpshooters in the Army of the Potomac 1861–1865* (The Price-McGill Company, St. Paul, MN, 1892), p.5.

19. *ORs*, Series 1, Vol. 26, Part 1, p.639.

20. "The 'Peculiar Institution' Illustrated," *The Liberator* (Boston, MA), June 12, 1863, 94:4 and 95:5. A resident of Charlestown, Massachusetts, Jansen T. Paine served with the 31st Massachusetts Infantry in Louisiana as assistant surgeon in 1861 and 1862, and was assigned to the 73rd US Colored Infantry as surgeon on September 27, 1862.

21. See "Have We An Artist Among Us?" *Hornellsville Tribune* (Hornellsville, NY), April 18, 1861, 3:2 and 3; and "Editorial Items," ibid., April 25, 1861, 2:5.

22. See "Russell's Panorama of the War," *Hornellsville Tribune* (Hornellsville, NY), July 23, 1862, 3:1; and "Russell's Panorama of the War," *Jackson Citizen* (Jackson, MI), October 29, 1862, 3:1.

23. NARA, Record Group 92, Box 815, Quartermaster General's Consolidated Correspondence File, "Photography" sub files, letter of February 24, 1864, by J. H. Devereux to Col D. C. McCallum.

24. Craig Heberton, "Abraham Lincoln at Gettysburg," abrahamlincolnatgettysburg.wordpress.com.

25. "From Harrisburg," *Cincinnati Daily Commercial* (Cincinnati, OH), November 21, 1863, 3:6.

26. See Keith F. Davis, *George N. Barnard: Photographer of Sherman's Campaign* (Hallmark Cards Inc., Kansas City, MO, 1990), p.64; and NARA, Indiana Index Cards, David O. Adams, fold3 image 294168012.

27. See *ORs*, Series 1, Vol. 31, Part 1, pp.314–15; and NARA, RG 92, Box 815, "Photography" sub file, Quartermaster General's Consolidated Correspondence File, O. M. Poe letter of April 26, 1864 to M. C. Meigs.

28. Davis, *Barnard*, 78.

29. Jacob Coonley, "Photographic Reminiscences of the Late War," *Anthony's Photographic Bulletin*, September 1882, p.311.

30. See John Kelley and Bob Zeller, "George Barnard's Atlanta: Burned and Reborn," *Battlefield Photographer*, Vol. 12, Issue 3 (December 2014), pp.10–19.

31. See Coonley, "Pages from a Veteran's Note-Book," p.106; and "Photographic Reminiscences of the Late War," p.311.

32. "Photographic Reminiscences of the Late War," p.312.

33. See Coonley, "Pages from a Veteran's Note-Book," pp.106–07; and John Kelley, "Shadowing Jacob Coonley as he Photographs the Battle of Nashville," *Battlefield Photographer*, Vol. 11, Issue 1 (April 2013), pp.7–13.

CHAPTER 5

1. "From Gen. McDowell's Army," *The New-York Times* (NY), July 20, 1861, 1:4.
2. "Camp Kershaw, Fairfax C. H., July 1, 1861," *Charleston Daily Courier* (Charleston, SC), July 10, 1861, 1:4.
3. "Information for the Enemy," *Boston Daily Advertiser* (Boston, MA), July 30, 1861, 2:2.
4. *OR*s, Series 1, Vol. 11, Part 1, pp.152–53.
5. Albert H. Campbell, "The Lost War Maps of the Confederates," *The Century*, January, 1888, 480. See also William Gladstone, "Civil War Photo Maps: The Happy Union of Photography and Cartography During the First 'Modern' Wars," *Military Images*, Vol. IV, No. 2 (September-October 1982), p.17.
6. Frances H. Kennedy, *The Civil War Battlefield Guide* (Houghton Mifflin Co., NY: 1998), p.72.
7. NARA M346 Confederate Citizen's File, Roll 0864, Doc. 199, A. J. Riddle; Roll 0901, Doc. 142, Sanxay and Gomert.
8. "Ambrotypes and Daguerreotypes," *Daily Richmond Enquirer* (Richmond, VA), October 28, 1856, 1:6; and "25 Cent Ambrotypes," *Daily Dispatch* (Richmond, VA), January 18, 1858, 2:6.
9. NARA M324, Compiled Service Records of Confederate Soldiers, Roll 902, 46th Virginia Infantry, Richard S. Sanxay.
10. *OR*s, Series 1, Volume 42, Part I, p.242.
11. Ibid., p.661.
12. Gladstone, "Civil War Photo Maps," p.16.
13. "The Late Raid," *Daily Richmond Enquirer* (Richmond, VA), March 5, 1864, 1:4.
14. See "Dahlgren's Orders To Be Photographed," *The Sentinel* (Richmond, VA), March 23, 1864, 2:1; "The Orders of Col. Dahlgren," *Alexandria Gazette* (Alexandria, VA), April 21, 1864, 2:2; "The Instructions of the Late Colonel Dahlgren," *Cleveland Leader* (Cleveland, OH), June 13, 1864, 2:3; and NARA M346 Confederate Citizen's File, Roll 0901, Doc. 142, Sanxay and Gomert.

CHAPTER 6

1. Ronald S. Coddington, *Faces of the Civil War Navies: An Album of Union and Confederate Sailors* (Johns Hopkins University Press, Baltimore, MD, 2016), p.x, xvi.
2. NARA, Confederate Citizen's File, Roll 190, George S. Cook.
3. *OR*s, Series 1, Vol. 35, Part 1, pp.115–16.
4. "Foreign Correspondence," *British Journal of Photography*, Vol. X, December 1, 1863, p. 476.
5. Milton Kaplan, "The Case of the Missing Photographers," in Renata V. Shaw, *A Century of Photographs, 1846–1946* (Library of Congress, Washington, DC, 1980), p.54.
6. "The Ironsides and two Monitors Taken," *Charleston Daily Courier* (Charleston, SC), September 12, 1863, 1:2.
7. "Confederate Cruisers at the Cape," *Watchman and Wesleyan Advertiser* (London, England), September 30, 1863, 312:4; and "Journal of the Commander of the Confederate States' Steamer Alabama," August 12, 1863, LPR43 Box 2, Alabama Department of Archives and History.
8. Marjorie Bull and Joseph Denfield 1970, *Secure the Shadow: The Story of Cape Photography From its Beginnings to the End of 1870* (T. McNally, Cape Town, SA, 1970), pp.193–94.
9. Tom Bingham, "The Alabama Claims Arbitration," *The International and Comparative Law Quarterly*, Vol. 54, No. 1 (January 2005), p.7. Owner of the Kirkless Coal and Iron Company, John Lancaster possessed Hindley Hall in Wigan, Lancashire.
10. *Official Records of the Union and Confederate Navies in the War of the Rebellion*, Series I, vol. 3, pp.665–69.

CHAPTER 7

1. Andrew J. Russell, "Photographic Reminiscences of the Late War," *Anthony's Photographic Bulletin*, Vol. XIII (July 1882), pp.212–13.
2. Admiral David Porter, *Incidents and Anecdotes of the Civil War* (D. Appleton and Company, NY, 1885), p.294.
3. "Richmond Taken by Brady," *Evening Star* (Washington, DC), April 12, 1865, 2:5.
4. "Latest from Richmond," *Evening Star* (Washington, DC), April 22, 1865, 2:1, quoting from Richmond *Whig* of April 7,1865.
5. Michael D. Gorman, "Lee the 'Devil' Discovered at Image of War Seminar," *Battlefield Photographer*, Volume 3, Issue 1 (February 2006).
6. "Local Intelligence," *New York Semi-Weekly Express* (NY), April 11, 1865.
7. "Pages from a Veteran's Note-Book. Some Account of the Career of Mr J. F. Coonley," *Wilson's Photographic Magazine*, March 1907, p.107.
8. *OR*s, Series I, Part 1, p.1319.
9. *Daily National Republican* (Washington, DC), May 23, 1865, 2:4.
10. Coonley, "Veteran's Notebook," p.107.
11. "The Photographer About," *Evening Star* (Washington, DC), July 7, 1865, 3:2.

AFTERWORD

1 "For Sale," *New York Herald*, February 2, 1865, 3:4.

2 "A First Class Gallery Closing Out," *Hartford Daily Courant*
 (Hartford, Connecticut), February 7, 1865, 1:6.

3 "A Few More Agents Wanted," *Independent Democrat*
 (Concord, New Hampshire), March 3, 1870, 3:6.

PRIMARY SOURCES

American Journal of Photography, New York (1858–67)

Anthony's Photographic Bulletin, E. & H.T. Anthony & Co.,
 New York (1870–1902)

Bacon, Georgeanna Woolsey and Howland,Eliza Woolsey,
 *Letters of a Family during the War for the Union, 1861–
 1865*, Vol. 1. Printed for Private Distribution, (1899)

Cook Account Book, 1860–1862, Valentine Richmond
 History Center

Census of the City of Charleston, South Carolina, For the Year
 1861, Evans & Cogswell, Charleston, (1861)

Greenwood, Henry, *British Journal of Photograph,*. Liverpool,
 UK(1864–Present Day)

Gunn, Thomas Butler, Thomas Butler Gunn Diaries, Vols.
 1–22. Lehigh University, Bethlehem (unpublished)

Harper's New Monthly Magazine, Harper & Bro. New York
 (1850–99)

Hewett, Janet B. (ed.), *Supplement to the Official Records of the
 Union and Confederate Armies*, 100 vols, Broadfoot
 Publishing Company, Wilmington, (1994–2001)

Humphrey's Journal of the Daguerreotype and Photographic Arts,
 S. D. Humphrey. New York, (1852–62)

Journal of the Commander of the Confederate States' Steamer
 Alabama, LPR43 Box 2, Alabama Department of Archives
 and History

Kellogg, Robert H. Kellogg, Robert H. Kellogg Papers, 1862–
 65, Diary: 1864. MS 68013 Box 1 Folder 1, Connecticut
 Historical Society. Hartford

National Archives and Records Administration, M797, "Case
 Files of Investigations by Levi C. Turner and Lafayette C.
 Baker"

National Archives and Records Administration, M345, Union
 Provost Marshals' File of Paper Relating to Individual
 Civilians

National Archives and Records Administration, M346,
 Confederate Citizen's File

National Archives and Records Administration, Record Group
 92, Box 815,

Quartermaster General's Consolidated Correspondence File

National Archives and Records Administration, Record Group
 109, Compiled Military Service Records

Photographic Times and American Photographer. Scovill
 Manufacturing Co. New York, (1881–94)

Pitcher, Henry F., Diary of Henry F. Pitcher, a member of the
 33rd New York Regimental Band, The Gilder Lehrman
 Institute of American History. GLC06889.01.

Reeve, Dr. James Theodore, Private Journal of Dr. James
 Theodore Reeve, 1863–64, Wisconsin Historical Society,
 Madison, Wisconsin

Ruffin, Edmund, *The Diary of Edmund Ruffin: Toward
 Independence: October 1856–April 1861*, Vol. I., Louisiana
 State University Studies, Baton Rouge, (1972)

Scott, Robert N., *The War of the Rebellion: A Compilation of the
 Official Records of the Union and Confederate Armies,* 128
 volumes. Government Printing Office, Washington, DC
 (1880–1901)

Spared & Shared websites. http://wjgriffing.wixsite.com/
 sparedandshared5/websites

The Century, The Century Company, New York (1881–1930)

Thurston, George H., *Directory of Pittsburgh and Vicinity for
 1857 – '58*, Pittsburgh, PA: George H. Thurston, 1857.

United States. Naval War Records Office. *Official Records of the
 Union and Confederate Navies in the War of the Rebellion.*
 30 vols. Washington, DC. 1894–1922)

Wilkerson, James King, James King Wilkerson Papers, David
 M. Rubenstein Rare Book and Manuscript Library, Duke
 University, NC.

Wilson's Photographic Magazine, Edward L. Wilson, New York,
 (1889–1914)

NEWSPAPERS

Albany, New York, *Albany Evening Journal*
Alexandria, Virginia, *Alexandria Gazette*
Augusta, Georgia, *Augusta Chronicle*
Augusta, Georgia, *Daily Chronicle & Sentinel*
Baltimore, Maryland, *Baltimore American and Commercial Advertiser*
Baton Rouge, Louisiana, *Daily Advocate*
Beaufort, South Carolina, *The Free South*
Bennington, Vermont, *The Bennington Banner*
Boston, Massachusetts, *Boston Daily Advertiser*
Boston, Massachusetts, *Boston Evening Transcript*
Boston, Massachusetts, *Boston Evening Traveler*
Boston, Massachusetts, *The Liberator*
Brattleboro, Vermont, *Vermont Phoenix*
Canton, Mississippi, *American Citizen*
Charleston, South Carolina, *Charleston Daily Courier*
Charleston, South Carolina, *Charleston Mercury*
Chicago, Illinois, *Chicago Daily Tribune*
Cincinnati, Ohio, *Cincinnati Daily Commercial*
Clarksville, Tennessee, *Clarksville Chronicle*
Clarksville, Texas, *Northern Standard*
Cleveland, Ohio, *Cleveland Leader*
Concord, New Hampshire, *Independent Democrat*
Concord, New Hampshire, *New Hampshire Patriot*
Coudersport, Pennsylvania, *The Potter Journal*
Fayetteville, North Carolina, *Carolina Observer*
Findlay, Ohio, *Hancock Jeffersonian*
Gettysburg, Pennsylvania, *Gettysburg Times*
Gettysburg, Pennsylvania, *The Compiler*
Harrisburg, Pennsylvania, *Evening Telegraph*
Hartford, Connecticut, *Hartford Daily Courant*
Hempstead, Arkansas, *Washington Telegraph*
Hilton Head, South Carolina, *The Hospital Transcript*
Hornellsville, New York, *Hornellsville Tribune*
Jackson, Michigan, *Jackson Citizen*
London, England, *Watchman and Wesleyan Advertiser*
Lynchburg, Virginia, *Lynchburg Daily Virginian*
Macon, Georgia, *Macon Daily Telegraph*
Manchester, New Hampshire, *Manchester Daily Mirror*
Montgomery, Alabama, *Montgomery Daily Mail*
Montgomery, Alabama, *Montgomery Daily Post*
Montpelier, Vermont, *The Watchman*
Mount Morris, New York, *Livingstone Union*
Nashville, Tennessee, *Nashville Daily Union*
Newark, New Jersey, *Newark Daily Advertiser*
New Bern, North Carolina, *Weekly Progress*
New Orleans, Louisiana, *Daily Picayune*
New Orleans, Louisiana, *New Orleans Bee*
New Orleans, Louisiana, *New Orleans Daily Crescent*
New York City, New York, *Commercial Advertiser*
New York City, New York, *Frank Leslie's Illustrated Newspaper*
New York City, New York, *New York Herald*
New York City, New York, *New York Times*
New York City, New York, *New York Tribune*
New York City, New York, *New York Semi-Weekly Express*
New York City, New York, *The World*
Philadelphia, Pennsylvania, *Philadelphia Inquirer*
Philadelphia, Pennsylvania, *The Press*
Port Royal, South Carolina, *The New South*
Providence, Rhode Island, *General Advertiser*
Raleigh, North Carolina, *Semi-Weekly Standard*
Raleigh, North Carolina, *Spirit of the Age*
Rendezvous of Distribution, Virginia, *The Soldier's Journal*
Richmond, Virginia, *Daily Richmond Enquirer*
Richmond, Virginia, *Southern Illustrated News*
Richmond, Virginia, *The Daily Dispatch*
Richmond, Virginia, *The Sentinel*
Rolla, Missouri, *The Rolla Express*
San Antonio, Texas, *Hempstead Courier*
Selma, Alabama, *Morning Reporter*
Springfield, Massachusetts, *Springfield Republican*
St. Albans, Vermont, *St. Albans Messenger*
St. Cloud, Minnesota, *St. Cloud Democrat*
St. Louis, Missouri, *Daily Missouri Democrat*
Troy, New York, *The Troy Weekly Times*
Tyler, Texas, *Tyler Reporter*
Washington, DC, *Evening Star*
Washington, Pennsylvania, *Reporter and Tribune*
Washington, DC, *Daily National Republican*
Windsor, Vermont, *Vermont Journal*

SECONDARY SOURCES

Abernathy, Byron R. (ed.), *Private Elisha Stockwell, Jr. Sees the Civil War*, University of Oklahoma Press, Norman (1958)

Adams, John G. B., *Reminiscences of the Nineteenth Massachusetts Regiment*, Wright & Potter Printing Company, Boston (1899)

Bergeron, Jr, Arthur W. *Guide to Louisiana Confederate Military Units 1861–1865*, Louisiana State University Press, Baton Rouge & London (1989)

Billings, John D., *Hardtack and Coffee*, George M. Smith & Co., Boston (1887)

Bull, Marjorie, and Denfield, Joseph, *Secure the Shadow: The Story of Cape Photography From its Beginnings to the End of 1870*, T. McNally, Cape Town, RSA (1970)

Clarke, Asia Booth, *The Unlocked Book: A Memoir of John Wilkes Booth by his Sister*, Putnam & Sons, New York (1938)

Coddington, Ronald S., *Faces of the Civil War Navies: An Album of Union and Confederate Sailors*, Johns Hopkins University Press, Baltimore (2016)

Croffut, W.A., *An American Procession, 1855–1914*. Little, Brown, and Company, Boston (1931)

Davis, Keith F., *George N. Barnard: Photographer of Sherman's Campaign*, Hallmark Cards Inc., Kansas City (1990)

Davis, Robert S., *Ghosts and Shadows of Andersonville: Essays on the Secret Social Histories of America's Deadliest Prison*, Mercer University Press, Macon (2006)

Davis, William C., (ed.), *Shadows of the Storm* – Volume One of *The Image of War 1861–1865*, Doubleday & Company, Inc, Garden City, New York (1981)

Dunkleman, Mark H., *Gettysburg's Unknown Soldier: The Life, Death, and Celebrity of Amos Humiston*, Praeger Publishers, Westport (1999)

Eldredge, D., *The Third New Hampshire and All About It*, Press of E. B. Stillings and Company, Boston (1893)

Gause, Isaac, *Four Years with Five Armies*, The Neale Publishing Company, New York & Washington (1908)

Gaughan, T. J., *Letters of a Confederate Surgeon, 1861–1865*, Hurley, Co., Camden (1960)

Goldberg, Vicki (ed.), *Photography in Print: Writings from 1816 to the Present*, University of New Mexico Press, (1988)

Heberton, Craig, "Abraham Lincoln at Gettysburg", abrahamlincolnatgettysburg.wordpress.com.

Hudgins, Carter L., and Bromley, Elizabeth Collins, *Shaping Communities: Perspectives in Vernacular Architecture, VI*. The University of Tennessee Press, Knoxville, (1997)

Incidents of the War, A bi-monthly magazine founded by D. Mark Katz, 1986–88.

The International and Comparative Law Quarterly, Cambridge University Press, Cambridge, UK (1952 – present day)

Kennedy, Frances H., *The Civil War Battlefield Guide*, Houghton Mifflin Co., New York (1998)

Louisiana History: The Journal of the Louisiana Historical Association, 57 vols, New Orleans (1960–2017)

Military Affairs, American Military Institute, Washington, DC (1941–88)

Military Images: Photographic History of the U.S. Soldier and Sailor 1839–1920, A bi-monthly magazine founded by Harry Roach, (1979 – present day)

Miller, Francis Trevelyan (ed.), *Photographic History of the Civil War*, ten vols. The Review of Reviews Co., New York (1911)

North South Trader Civil War: The Magazine for Collectors & Historians, A quarterly magazine founded by William S. Mussenden, published by Stephen W. Sylvia (1973 – present day)

Otto, John Henry et al., *Memoirs of a Dutch Mudsill*, Kent State University Press, Kent (2004)

Palmquist, Peter E., and Kailbourn, Thomas R., *Pioneer Photographer from the Mississippi to the Continental Divide: A Biographical Dictionary, 1839–1865*, Stanford University Press, Stanford (2005)

Porter, Admiral David, *Incidents and Anecdotes of the Civil War*, D. Appleton and Company, New York (1885)

Shaw, Renata V., *A Century of Photographs, 1846–1946*, Library of Congress, Washington, DC (1980)

Smith, Margaret D., and Tucker, Mary L., *Photography in New Orleans: The Early Years, 1840–1865*, Louisiana State University Press, Baton Rouge (1982)

Stevens, Capt C. A., *Berdan's United States Sharpshooters in the Army of the Potomac 1861–1865*, The Price-McGill Company, St. Paul (1892)

Zeller, Bob (ed.), *Battlefield Photographer: The Newsletter for the Center for Civil War Photography* (2003–2017)

Zeller, Bob, *The Blue and Gray in Black and White*, Praeger Publishers, Westport (2005)

Zeller, Bob, *The Civil War in Depth: History in 3D*, Chronicle Books, San Francisco (1997)

Zeller, Bob, *The Civil War in Depth, Vol. II: History in 3D*, Chronicle Books, San Francisco (2000)

INDEX

References to images are in **bold**.

2/18·2

ΦΡΙC

2/6-2